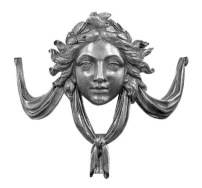

Nicholas Penny

The Materials of
SCULPTURE

YALE UNIVERSITY PRESS
New Haven and London · 1993

For Mary

Designed by Gillian Malpass

Set in Linotron Garamond and Sabon by Best-set Typesetter Ltd, Hong Kong
Printed in Singapore by C.S. Graphics PTE Ltd

Library of Congress Cataloging-in-Publication Data

Penny, Nicholas, 1949–
 The Materials of sculpture / by Nicholas Penny.
 p. cm.
 Includes index.
 ISBN 0–300–05556–0 (hardback)
 ISBN 0–300–06581–7 (paperback)
 1. Sculpture materials. I. Title.
NB1202.P46 1993
730′.028—dc20 93–3574
 CIP

A catalogue record for this book is available from The British Library

Frontispiece: Michelangelo, *Virgin and Child* (detail), probably 1521–3,
Apuan (Carrara) marble, Medici Burial Chapel, San Lorenzo, Florence.

Contents

Acknowledgements

Work began on this book when I was teaching at the University of Manchester, but most of the research for it and thought about it dates from my five years as Keeper of the Department of Western Art at the Ashmolean Museum in Oxford. In selecting illustrations—which deliberately combine the famous with the unfamiliar—I have been influenced by the collections that I happen to know best: many have been drawn from the Victoria and Albert Museum and from the British Museum, and, of course, many works illustrated are in the Ashmolean Museum. The latter is, of all the more compact but comprehensive collections in the world, perhaps the one best adapted to the study of the various materials and techniques of sculpture. The greatest benefactor of the Ashmolean, the scholar and collector Charles Drury Fortnum, hoped that such a study might one day be considered as a part of the education offered by Oxford University, and I have sometimes imagined this book as serving to demonstrate one way in which this might be achieved.

The task of obtaining photographs has been made much easier by Sheila Lee and also by Michael Dudley and the obliging staff of the Photographic Department in the Ashmolean Museum. I am grateful also to Stuart Smith for the care and sensitivity he displayed when making photographs for me in difficult locations and dire weather conditions, and to Valerie Bennett for executing an emergency task with skill and dispatch.

I am indebted to many colleagues – scholars, conservators, curators, scientists and (in one or two cases) sculptors and craftsmen – who have supplied me with vital information and discussed problems, and examined objects either with me or for me. They include David Armitage, Claire Barry, Caroline Cartwright, Stephen Cox, Vivian Davis, Aileen Dawson, Andrea De Marchi, John Eddy, Livy Ekechukwu, Caroline Elam, Laurie Fusco, Peter Fusco, Kathleen Garland, Charles Hope, Julie Hudson, Ian Jenkins, John Larson, Mary Levkoff, Roger Ling, Linda Scheifler Marks, Sarah Medlam, Roger Moorey, Donald Myers, Mark Norman, Clare Pollard, Tony Radcliffe, Jessica Rawson, Ashok Roy, Rosalind Savill, Corinne Sherrard, Jack Soultanian, Andrew Topsfield, Marjorie Trusted, Shelagh Vainker, Bernard Watney, Catherine Whistler, Helen Whitehouse, Jon Whiteley, Philip Ward-Jackson, Frank Willett, the late Nigel Williams, Paul Williamson, Norbert Yopek, Wladimir Zwalf.

In addition, I must thank the following for their courtesy in answering

1 Detail of pl. 44.

vii

enquiries and for other help: Craig Clunas, Sarah Collins, Paul Craddock, John Donaldson, James Draper, Nick Durnan, Joseph Dye, Marzia Faietti, Anne Farrer, Ken Hammer, Ellen Howe, Dona Kurtz, Alastair Laing, John Mallet, Vera Magyar, Eunice Martin, Hazel Newey, Graham Parlett, Jerry Podany, Julian Reade, John Ruffle, Michael Spink, Dick Stone, Sue Stronge, Jane Thurston-Hopkins, Christine Walker, Ton Wilmering, Marc Wilson, Tim Wilson.

Whilst working on this book I have steadily increased its scope and in doing so I have not only benefited from consulting the *History of World Art* and the *Dictionary of the Decorative Arts* by John Fleming and Hugh Honour — two of the most useful books published in recent decades — but have been encouraged by the range of their curiosity and sympathy.

When I first began to work on this book I discussed the material almost daily with my friend and colleague Roger Jones: in completing it I have used his books and, to illustrate it, a few of his photographs, but have missed his critical guidance. It owes much to him and much to other friends, above all Francis and Larissa Haskell. Mary Wall has not only shared (or at least indulged) my passion for many of the sculptures examined here but has sharpened everything that I have written about them. Malcolm Baker, who read the book in draft form, made many valuable suggestions and criticisms. Gillian Malpass has been unfailingly encouraging and tolerant and attentive, and the book owes much to her imagination as designer and editor.

2 Detail of pl. 188.

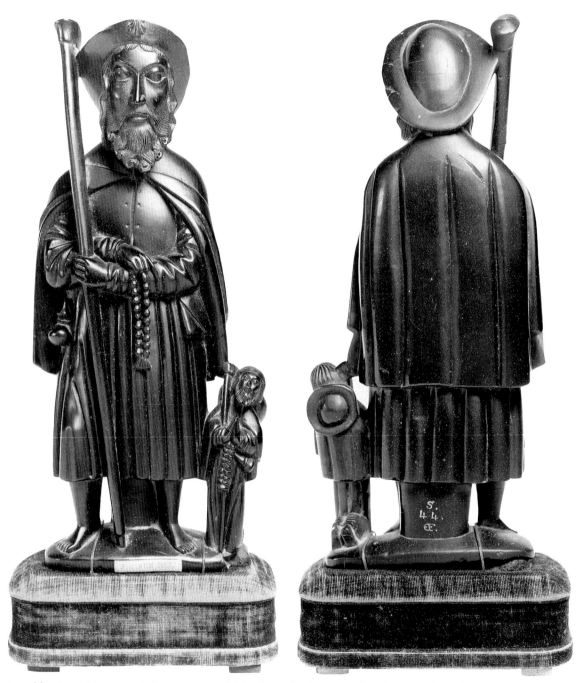

3a and b Spanish (Compostella), jet statuette of Saint James the Greater with a pilgrim, perhaps sixteenth century, 21 cm. high (including integral plinth), Ashmolean Museum, Oxford.

Introduction

IF WE ARE TO UNDERSTAND a work of art, it obviously helps to have some knowledge of the material of which it is made. Sculpture is made of many different materials, and it is not always easy to find out about them. There are admirable books that provide instruction in carving stone, modelling clay or casting bronze. But the methods used today are not always the same as those used in the past, and some great sculptures have been made out of materials, such as rock crystal, rhinoceros horn or basanite, that are no longer in use. Moreover, the status of a material can change. Was a material considered sacred? Was it alien? Was it rare? Was it available in large sizes? Was it available only in certain shapes? Was it hard to work? Such questions are asked throughout this book. Their importance becomes obvious when, for example, we examine a small sculpture made of an unfamiliar material, such as jet.

Jet is a black fossil, a kind of lignite, related to coal, and found in lumps, either embedded in shale or released from it by the sea and then washed ashore. It is hard, with a uniform texture, and lustrous when polished. During the nineteenth century it was fashioned into small items of jewellery – beads, eardrops, brooches – on an industrial scale, chiefly at Whitby on the Yorkshire coast. It occurs also in northern Spain, where it was made, from the late Middle Ages onwards, into amulets, badges, rosaries and statuettes of saints. The chief centre for such work was Santiago de Compostella, one of the greatest pilgrimage sites of Europe on account of the shrine there of Sant Iago, Saint James the Greater, after whom it is named. Figures of the saint were made for sale to the pilgrims, who took them to distant parts of Europe: the example illustrated here (pls 3a and b) was said to have come from Sicily. The material of which such figures were made must have greatly contributed to their appeal, for jet, like other rare and beautiful stones, was sometimes supposed to possess magical properties – as is suggested by its frequent use for amulets against the evil eye.

The size of these statuettes was determined by the size of the lumps of jet that were available. The one illustrated here is among the largest to have survived. The flatness of the figure is common to almost all carvings of this kind, the result of the lenticular form of the lumps, which is also reflected in the way the diminutive kneeling pilgrim leans out from the plinth. Jet can be filed and rubbed into rounded shapes to exhibit its glossy surface, but the difficulty of cutting it is always apparent and prescribes the rigidity and

1

angularity – most attractively, in this case, the parallel grooves of the beard terminating in stiffly turned curls which are based on those of the late twelfth-century stone carvings of the Puerta de la Gloria in the local cathedral.

Jet, though hard, fractures easily if dropped or struck, and almost all the figure carvings of this type have suffered losses. Thus the carvers tended to avoid undercutting and perforations, as well as fragile projections. Saint James's arms are folded tightly against his chest, his staff is attached to his body and hat, and the pole is thickened for strength. There are perforations – ugly in shape and, one senses, uneasily contrived – but an additional column of support is provided for the saint's left leg.

This statuette, like all jet statuettes known to me, exhibits very clearly the limitations of the material – or seems to do so, for the limited abilities of the craftsmen who were responsible for such work must also be taken into account. The toes of the saint are indicated by a series of equal grooves, the easiest way to carve such details in any material. Yet we should be cautious in concluding that this style of carving was dictated by the material – indeed, as we have observed, some of the mannerisms derive from the stone carvings on the cathedral.

We may be certain that any material which is 'pure' shining black, like jet, or snow white, like some calcite 'alabaster' and some marble and jade, will possess a special glamour; but very little written evidence survives to hint at the different values attached at different dates to the colours of stones and metals. Novelty was no doubt most often valued. Yet so too could be a bronze patina that looked ancient. Rarity was always a factor, and the ancient Egyptians even esteemed silver above gold, the latter being so much more abundant locally. The diorite in which effigies of the divine rulers of ancient Sumeria were fashioned and the brass in which the royal sculpture of Benin was cast came from distant lands. So did ivory, whether in Japan or Byzantium, and many hardwoods and hardstones were also exotic in origin.

It would be hard to make out of a single piece of jet a larger sculpture than the statuette of Saint James illustrated here, and indeed its composition reflects the characteristic shape of the material. Similarly, as will be shown, the curve of shells, tusks and horns is ingeniously incorporated, or disguised, in the larger carvings made out of those materials. In addition, many types of stone can be quarried only as slabs rather than blocks. This encourages sculpture in relief, or at least a flattened presentation of the figure. Size is, of course, related to rarity. Jet was valued for its own sake: exceptionally large pieces were especially prized. The same applies to jade, but here an additional factor was involved, for the largest boulders of jade, unlike the largest lumps of jet, are of a size that makes it difficult to transport.

So accustomed are we to the services provided by modern engineering that our response to the colossal granite sculptures of the Egyptians or to monolithic column shafts or to large statues of marble is greatly diminished. When white marble was revived in Europe as a material for sculpture, its glamour was

inseparable from its rarity and the purity of colour that made it suitable as a material for sacred offerings, comparable indeed to precious metal. It was also available in far larger blocks than the stones previously used for statues. Such large blocks were, however, hard to locate in the rock face, and many blocks had to be abandoned when they had been half or fully extracted, on account of flaws. Waste was thus far greater than usual – as were the dangers and difficulties of restraining the sledges that carried the marble down the slopes. Unsurprisingly, therefore, value was not calculated simply by dimensions: a huge block would cost far more that ten times as much as one a tenth of its size. If a large statue in marble was regarded as a triumph of technology, then this was still more the case with a large statue in bronze or clay, as becomes clear only if we have at least some knowledge of casting and firing.

No less important than the rarity of a material and the size and shape available to the sculptor are its hardness and its fragility. The function of the sculpture can make fragility highly undesirable. Had jet statuettes made in Santiago not been intended for pilgrims, they might have been different in appearance. Most of them have holes for suspension and rather inadequate plinths: they were made to be worn. Wherever possible, information on such matters is supplied in this book – or speculation encouraged. It is worth emphasising that only one work of art illustrated here (Daniel Chester French's statue of Lincoln; pl. 54) was designed for viewing by electric light, yet hardly any of them can now be seen without it.

Certain types of intricate miniature carving continue to excite much the same amazement that they did in their own time – chains of jade, cages of ivory, Christian or Buddhist narratives condensed onto the stone of a cherry or a boxwood bead are examples – but awareness of the difficulty of working some materials at all is unusual today. Many people are surprised to learn that porphyry or rock crystal cannot be cut with metal tools. Knowledge of the hardness of a material and the consequent labour involved in working it is essential not only for the appreciation of sculptures among the 'rarities' and 'curiosities' collected by the wealthy and powerful, but also for an under-standing of the temple sculpture of southern India or of Egypt.

For ages marble could not be chiselled, for the task demanded metal tools harder than those used for limestone or wood. Today we tend to take such tools for granted, and intricately carved marble is so common that it may not strike us as marvellous. Yet when the Corinthian capital was first employed in the Greek temples it was surely admired not only as a light and elaborate crown to the column shaft, but as an example of virtuoso undercutting and perforation. It would often have been difficult to go further without rendering the capital unsound as a support or too minute in design to be effective when viewed from the ground.

Once we know that jet came from a distant place, was available only in small sizes and was believed to have magical properties, or that marble was available in very large pieces but only at great expense, or that porphyry

3

cannot be carved with metal tools, we have reconstructed something of the original impact that sculpture in such materials would have possessed. On the other hand, much of the knowledge that this book is intended to supply played no part in the response that would have been expected from the public for which the sculpture was made. The numerous joins in large wooden sculptures are not visible beneath the gilding and colouring – nor is the type of wood (always local and fairly common). Even the connoisseurs who were most excited by the translucency of porcelain or the colour of jade, who were most aware of the rarity of a material or of the intricacy of its working and the precision of its finish, seldom took much interest in the artist's methods. It would be possible to write a book on the materials of sculpture that would be divided between consideration of qualities which would originally have seemed remarkable to the owner or the public for which it was made, and investigation of matters important to the artist.

Similarly, much of the sculpture in this book may be divided into that which was made for worshippers and that which was made for connoisseurs. In the former category the material can be very important for the sculpture's appeal, but more commonly it is concealed by colouring and gilding which were designed to make the sculpture seem more vital and more precious. Not only wooden sculpture was treated in this way, but also the marble statues of ancient Greece and China, the limestone Saints of the great French cathedrals and the schist Buddhas of Gandhāra. In their original state, the sculptures would have looked completely different. Connoisseurs were certainly attracted by gilding, but they would have been attracted also by less obvious types of rarity in materials, curious patinas in metal or natural colours in wood, and, of course, by the evidence of the skill and imagination of the creator – the traces of the artist's hand – for which reason bare clay, unacceptable in a humble figure offered in a temple or placed in a grave, was welcome in the cabinet rooms of the grandest French eighteenth-century houses. However, not all the sculpture discussed here falls neatly into one or other of these categories, and sculpture in one category has often moved into the other.

A more obvious way in which a book on this subject might be organized is according to techniques, with distinct sections on carving, modelling and casting. In fact, differences between these processes are emphasized throughout this book, but modelling and casting were carried out in the same or similar materials, and moulded work was often modelled as well. In the first half of the book the chapters progress from hard minerals to softer, organic materials: from jade and granite to wood and ivory. Materials soft enough to be moulded or modelled follow, and the book concludes with hard and soft metals.

One objection to this method of organization might be that carving is discussed before modelling, although it is easier to attain some proficiency in the latter (not least because mistakes are more easily rectified and the tools are simpler to handle), and modelling is the process in which students are now generally instructed first. However, the conventions of modern education

must not be mistaken as a model of the progress of the arts in early civilizations, for soft materials had no historical priority over hard; nor is there any good reason for supposing that artists who excelled in the carving of ivory or stone always prepared themselves by modelling in clay or wax, or even underwent a preliminary training in these materials.

A book on the materials of sculpture in use today, or, indeed, one that focuses on the great sculptural traditions of the Mediterranean – on Phidias, Praxiteles, Lysippus, Donatello, Michelangelo, Bernini, Canova – would probably begin with wax, the material in which a very small sketch model, a first idea, is most commonly worked out, and would then progress to clay, out of which a larger sketch model, and perhaps a more finished model, is most conveniently fashioned. Consideration would then be given to the process of firing, whereby the small sketch model might be made more durable, and to casting in gypsum plaster, whereby the larger model of clay might be preserved. Then the processes of marble carving and bronze casting would be reached . . . The relationship between these materials is discussed at various points in this book, but there are many others to explain or suggest, and these would not have been apparent had the book been structured along lines that emphasized this particular chain of connections.

Moreover, the book gives serious consideration to types of stone carving that are not based on models in wax or clay and to traditions of gem cutting in medieval Europe and in Asia; and to the working of hardstones where we do not know what type of preparatory models, if any, were employed. In addition, it examines works of art in wax, clay and plaster that were finished works of art in their own right, as well as the preparatory models executed in these same materials.

This book was originally intended to be confined to the sculpture of Europe in the last six centuries – but I soon realised that this would not allow me to indicate, let alone trace, the earliest uses of the materials involved or the origins of the techniques of sculpture with which I was concerned. Nor would it have allowed me to make the sort of cross-cultural comparisons that stimulate an assessment of how universal or unusual are certain problems and ambitions in sculpture. While I have deliberately made the book international in scope, there is no attempt at anything like 'fair' coverage of all periods and civilizations – very little on either African or native American art has, for instance, been included. Not every type of sculpture is surveyed. There is little on lacquer, nothing on papier mâché, welded steel or fibreglass. On the other hand, some of the sculpture that is discussed is generally classed as pottery, furniture or jewellery.

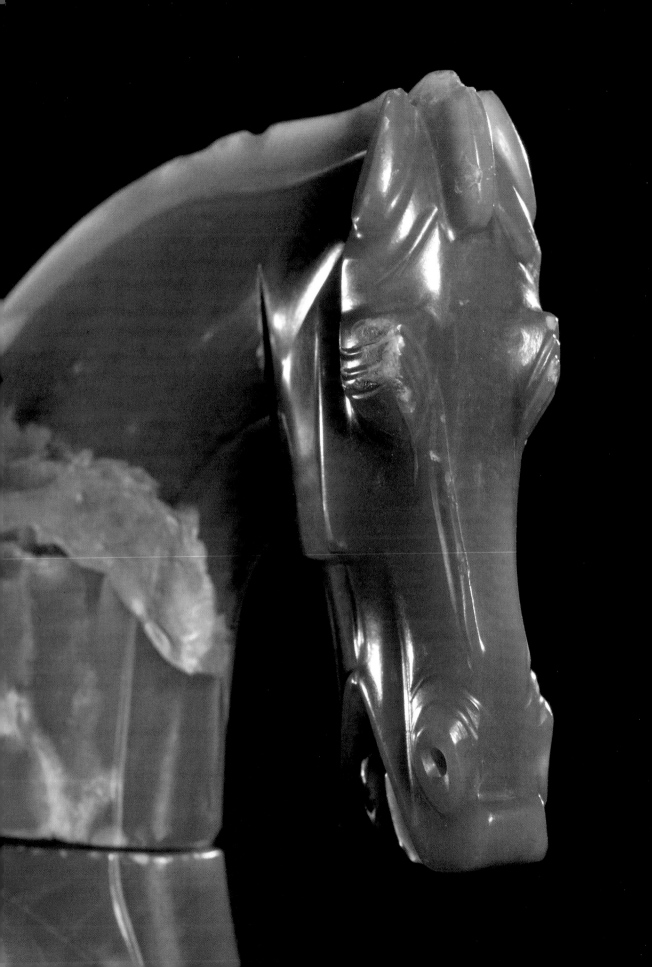

1 *The Hardest Stones*

No HARD OR BEAUTIFUL MINERAL has enjoyed a more ancient or widespread appeal than jade, or nephrite, a stone of many colours – including milky white, pale smoky grey, melon green, spinach green, rich golden brown and, more rarely, black – which takes a polish that enhances its colour and translucency, is cool and oily to the touch and has a beautiful sound when struck.

Jade was detected during the last century in Alaska and British Columbia by Chinese labourers employed to build the Canada-Pacific Railway, and a few odd boulders have been recorded in parts of western Europe, but it is more commonly found in New Zealand, where the Maori people have long used it, and in Mexico, where it was greatly valued by the native peoples (including the Aztecs, who offered large lumps of it as tribute to the Spanish and were puzzled when it was received with indifference). Some of the most beautiful jade sculpture was made in Mughal India. But it is chiefly associated with Chinese civilization.

The Chinese obtained their jade from Khotan, an oasis in the desert of Turkestan, at first in the form of pebbles and boulders collected from riverbeds, but by the twelfth century AD also in the form of rocks prised, with the help of fire, from the mountains near Yarkand in the same area. Later it was obtained further north, in Siberia, from Lake Baikal and its environs.

Jade seems to have been worked in China before 3000 BC. At first it may well have been valued, as were flints, as a cutting tool and weapon, for it is heavy and keeps a sharp edge. But it appears soon to have achieved sacred status on account of its beauty, hardness and durability. Its magic properties are reflected in the use to which it was put in burials, plugging the orifices of the corpse, and in some cases formed into grave suits made of more than two thousand plaques joined together with gold thread. The vessels and disks that are among the earliest works in jade to survive served some ritual purposes, the nature of which is unknown.

Jade was seldom obtained in large pieces, especially when it was available only from riverbeds. Usually a boulder would be less than a foot long, and the colossal wine bowl of black jade in the Round Fort, Beijing, made for the emperor in the eighteenth century or the dark green sarcophagus of Tsar Alexander III are quite exceptional. The pebbles or boulders were first sliced by wire or blade saws (or a row of such) – or rather by abrasive paste which they worked – and then the slabs were shaped with other saws, and with drills and rubbers, all employing abrasives.

4 Detail of the sculpture in plate 6. Enlarged.

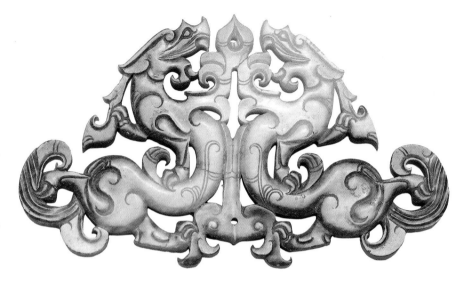

5 Chinese, double-sided jade pendant of dragons, fifth-fourth century BC, 9 cm., Freer Gallery of Art (Smithsonian Institution), Washington, D.C. The pendant has been broken in three and mended.

Recognition of this immensely laborious method transforms our understanding of an object such as the pendant made during the late Zhou dynasty, in the fifth or fourth century BC, which represents a pair of dragons clambering up a central support: a symmetrical design, pleasingly contrasting with the irregular pattern of the pale grey and purple-brown stone (pl. 5). The flatness of the pendant is obviously conditioned by the thin slab from which it was made, and the heraldic rigidity of the design is a reminder of the resistance of the stone. But, to the people who made and treasured this sculpture, the intricate cutting into claws and spurs and cusps, and the curls incised on its smooth surfaces, represented a triumph of technology, for it was the rounded edge or curved line, as distinct from the straight cut of the saw or round hole of the drill, that was difficult to achieve.

Intricacy was valued in the working of jade, but monumentality was often attained – nowhere more so than in the fragment of a horse of pale green jade retrieved from a tomb of the Han dynasty (206 BC–AD 220). The fragment consists of two pieces: one representing the horse's head, which is more or less complete, the other its lower neck and chest, which is broken (pls 4 and 6). The whole horse was probably made of half a dozen pieces, with the joins perhaps concealed by a gold harness. Although it was clearly conceived 'in the round', there is still a survival of the idea of jade as something worked out of a slab, for the sides of the head are flat, and cut away at a sharp angle. Its outline, especially that of the muzzle, is also angular, as is the modelling of the cheek. In the ear and nostril we can see that a drill has been used. But the hardness of the material is most evident in the avoidance of detail: even the mane has been left unmarked. It is this, above all, that gives the work its grandeur and enables us to imagine that it would be effective on a colossal scale.

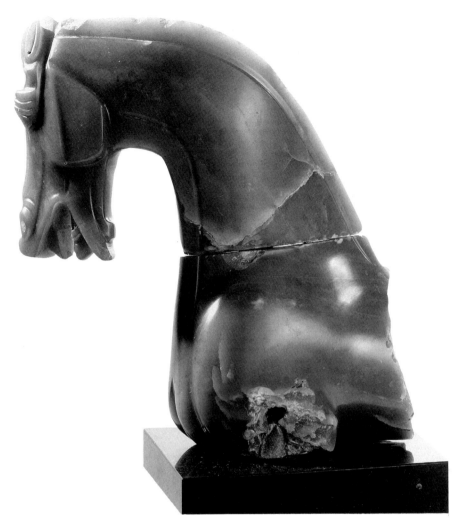

6 Chinese, fragments of a jade horse, Han dynasty, 14 cm. high, Victoria and Albert Museum (Eumorfopoulos Collection), London.

Some of the stone masks made for funereal or ritual use in ancient Mexico have a similar monumentality – for instance, one of green jade probably made in Teotihuacan (a great ceremonial centre and America's first city) between AD 250 and 600, which was acquired from the Spanish conquerors of Mexico by the Medici. This has a comparable geometrical character, but still greater angularity (pl. 7). The ears are rectangular, the nose is flat at the end, the nostrils are uneasily rounded and tightly pressed into the side of the nose. The outline of the upper lip is formed by three separate lines rather than a single flowing one, and none of the rounded surfaces moves easily into any other. The ears are drilled for pendants that have not survived, the eye sockets were probably originally filled with shells, with a piece of obsidian for the iris, and the mouth was painted red, with white for the teeth. Such additions, like the gold of the horse's harness, would have enhanced the brilliant green colour of the stone.

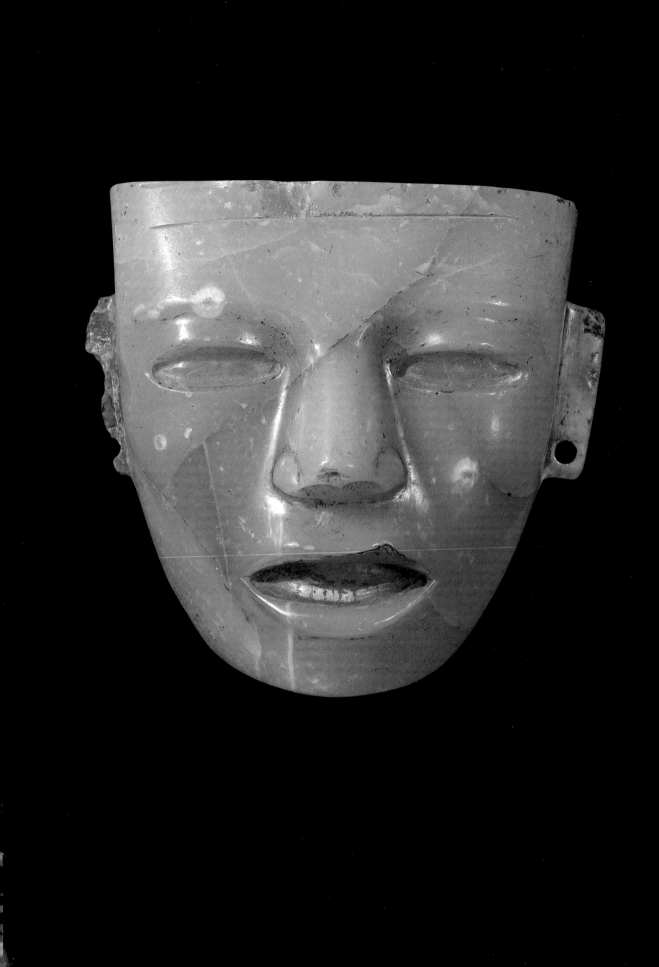

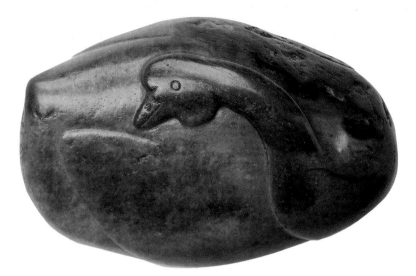

8 Chinese, jade goose,
*c.*AD 200, 9.2 cm. long,
Arthur M. Sackler Gallery
(Smithsonian Institution),
Washington, D.C.

In China a tendency to fashion jade figures in the round became more prevalent by the later years of the Han dynasty, when the demand increased for miniature sculptures to delight the connoisseur – objects to be handled and turned, to calm the mind and delight the imagination, rather than offerings to the dead, or images of the divine. Such statuettes are often of animals whose very shape was adapted to that of the pebble from which they were made – a coiled chimera, for instance, or a curled-up elephant – and sometimes the slightly rough surface of the jade pebble with its dark brown 'skin' was deliberately left unworked, at least in a few parts. Such is the case with a jade sleeping goose illustrated here (pl. 8) which may be regarded as a sculptural simile, for we might claim that the subject is the pebble itself and that the suggestion of the form of a goose is intended only to enhance our awareness of the beauty of its golden brown colour and its shape. Perhaps such deliberate restraint and minimal working of the stone could be appreciated only once it had become less of a challenge to fashion highly elaborate forms out of jade.

The Chinese devised sophisticated treadles to drive improved metal tools, but, most significantly, they began (certainly by the fifteenth century) to employ 'black sand' (corundum or emery) in place of 'yellow sand' (quartz) or 'red sand' (garnet) as the abrasive agent. The difficulty in working the stone becomes steadily less obvious, and by the eighteenth century many of the favoured subjects were often delicate in form – the fine-stemmed branch of peonies, the thin-legged grasshopper, the long-sleeved princess – matching the paler colours of the stone itself, so suggestive of softness – of peeled grape or pear, tender shoots in spring, submarine life. Looking at such work it is difficult to remember that jade is so hard that steel cannot even scratch it.

During the eighteenth century the production of jade seals, statuettes and snuff-bottles increased, and the Chinese began to produce such trifles out of

7 Mexican, jade mask,
*c.*AD 250–600, 17.3 cm.
high, Museo degli Argenti
(Palazzo Pitti), Florence.

11

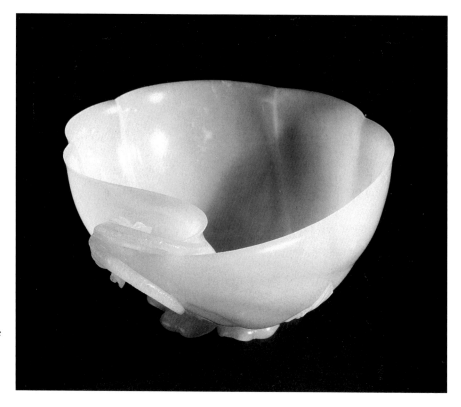

9, 10 and 11 Mughal
court workshops, jade wine
cup, completed 1656/7,
18.7 cm. long, Victoria
and Albert Museum,
London.

other materials. Most notable among these was a stone from Burma which is as hard as jade but of a different structure, and lavender, white or vivid apple green in colour. Long regarded as a type of jade, it is now distinguished as jadeite. Some types of quartz – chalcedony, smoky quartz, rose quartz – were also popular. So was soapstone, or steatite, often similar in colour to jade but far softer – indeed as easy to work as jade was difficult – which was mined chiefly near Foochow and Kwangtung.

The sources of Chinese jade in central Asia were not far from the homeland of the Mongol Genghis Khan who in the early thirteenth century conquered both China and Iran, and of Timur, who also conquered Iran and whose empire extended south to Delhi. A large slab of black jade served as Timur's cenotaph, and his successors in the fifteenth century had cups of jade with dragon handles made for them – jade, they are said to have believed, would crack if poison was placed in it. When Mughal rule was established in India in the second half of the sixteenth century by Akbar, a descendant of both Genghis Khan and Timur, jade was imported there. Mughal court art, which was partly inhibited by the traditional Islamic aversion to the representation of living beings, provided few opportunities for independent figurative sculpture, and jade was used primarily for jars and boxes, dagger hilts and sheaths. Such objects did, however, assume animal and vegetable forms.

12

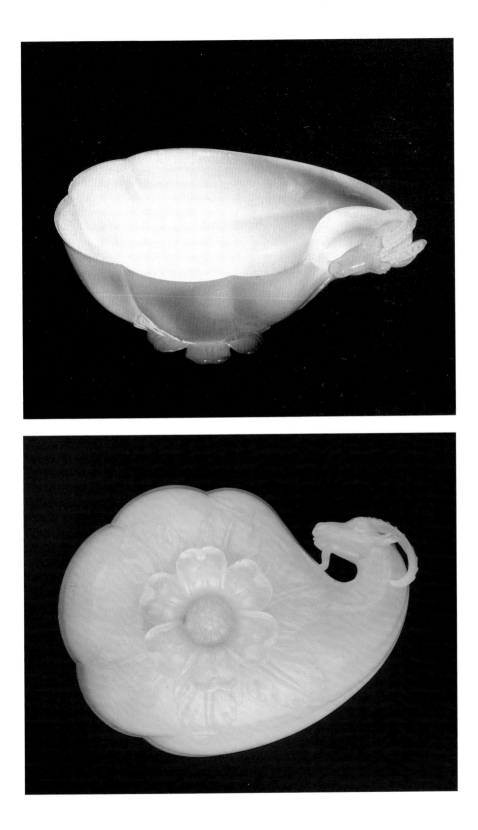

A white jade wine cup belonging to Akbar's grandson, Shah Jahan, is inscribed with a date that corresponds with AD 1656–7, the year before he was imprisoned by his son. The lobed bowl is in the shape of a half gourd, but the handle takes the form of the head of an ibex (pls 9, 10 and 11). The sweep of the animal's ridged horns cunningly complements the curve of the neck. No less exquisitely calculated is the way in which the delicate ears make contact with the horns, and the beard unites with the bowl. The foot takes the form of a lotus flower, the leaves nestling between each swelling lobe. The cup is designed to be turned in the light and examined against it. White flower and white goat arise from the white stone with the ease of poetic metaphors. The lotus was a motif much favoured in Indian art. The vessels of ancient Persia had often incorporated the heads of goats, rams and stags and the like (pl. 223). Their combination suggests to the historian the deliberate blending of the disparate cultures that characterized the Mughal court.

The Mughal courts excelled in the working of clear quartz or rock crystal as well as jade, and employed it for much the same purposes. Rock crystal is harder than jade, although the fibrous structure of jade makes it as difficult to work. The transparency of rock crystal was once regarded as far more remarkable than it is today: it was not until the late fifteenth century that glass of comparable clarity was manufactured. Rock crystal was highly prized by the ancient Egyptians, who used it for the eyes of their statues, and in the courts of ancient Rome and Byzantium. The art of working it survived in Cairo and flourished there under the Fatimid caliphs. It continued to be practised in the Near East, whence it passed to China and to western Europe. From the late twelfth century, vessels of rock crystal – some of them ancient but in new mounts, and some of them modern – were among the greatest treasures of European rulers, brought out for use on the altars of the richest churches – or display on the palace banqueting table, as would have been the case with the cup and cover in the form of a fabulous bird, probably made for the celebrations in 1589 of Ferdinando de' Medici's marriage to Cristina of Lorraine by the workshop of the Sarrachi brothers in Milan, then the chief European centre for the working of such stones (pl. 12).

Obtaining large pieces of rock crystal without flaws or impurities is difficult, and an object of this size and with such fine extremities would have been possible only if assembled out of separate pieces, just as the jade horse was. In this case the mounts survive – gold bands decorated in enamel with a black and blue arabesque pattern. In addition to the three principal pieces of which the cover is constructed, there are numerous drops of crystal mounted in gold, suspended from the wings. These are designed to tremble in air stirred by the heat of candles.

The forms were shaped using the same abrasive agent, 'black sand' (corundum or emery), that was employed in working jade. Where they are merely turned and hollowed and polished, as in the foot, stem and cup, the difficulty of working the material is not evident, as it is in the angular neck and tail. The

12 Probably Milanese workshops of the Sarrachi brothers, rock-crystal *tazza* with a lid in the form of a fantastic bird, *c.*1589, 31.5 cm. high, Museo degli Argenti (Palazzo Pitti), Florence.

14

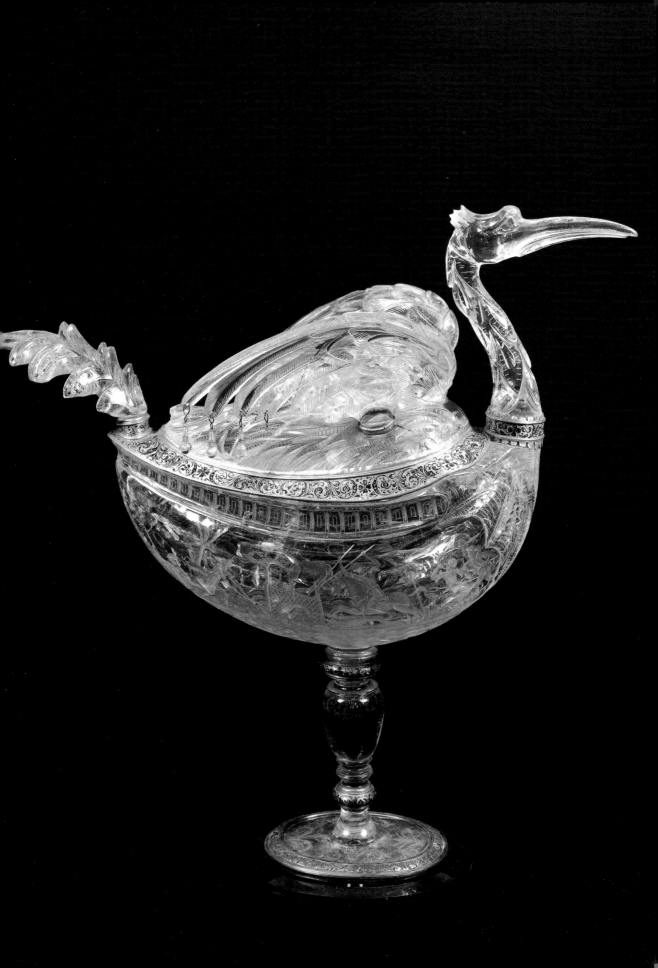

hardness of the quartz is more apparent still in the lines decorating the surface: the straight parallel hatching with which the feathers are marked and the engraving of the hunting scene on the cup, which has a stiffness, most obvious in the treatment of the trees, betraying the fact that it has been cut by means of a miniature jeweller's wheel. The sculptor or sculptors aspired to create out of a lump of rock a thin pointed beak, sinuous neck, open wings and ruffled tail, and to imitate in this immensely hard stone the softness of feathers. Their failure to transcend the material promotes awareness of the boldness of the undertaking. Moreover, the worried, bristling character of the bird, which makes it so memorable, depends upon the jagged cutting. The sculpture also has a witty if slightly grotesque appeal: a creature that sits upon icy water is made out of a stone that resembles ice or water (*crystallos*, indeed, means clear ice), and is also a vessel that can contain ice or water.

Numerous hardstones are, in fact, like rock crystal, types of quartz — not only rose quartz and smoky quartz, but amethyst, cornelian, chalcedony, bloodstone and agate. These have been highly valued in all phases of European civilization, and fashioned into great, if usually miniature, works of art. Methods of cutting them with abrasives worked by tiny drills and wheels were developed by the earliest Mediterranean and Near Eastern civilizations for the purpose of engraving intaglio or hollow seals. These, when pressed into warmed wax or prepared clay, left reliefs that served as a mark of ownership or authority.

A seal of the fifth century BC engraved with a standing heron perhaps by Dexamenos of Chios (who signed a similar seal of a heron in flight) illustrates the spare elegance of design and economy of means that were characteristic of the finest ancient Greek work in this medium (pls 13 and 14). The subject might even have been selected to demonstrate the linear quality of wheel-cutting. In the plaster impression each raised, thread-like line corresponds with a cut of the wheel — the lines of the wing made with a thicker wheel than those of the tail below. The drill has been employed only for the eye, which registers as a raised dot in the impression. The stone is a chalcedony, and the shape scaraboid — that is, domed on the reverse of the cut face, in the manner of the beetles or scarabs that were sacred in ancient Egypt.

A certain amount of small-scale sculpture in the round was also made out of such hard stones — the Roman imperial family in the early first century AD commissioned small portrait busts in chalcedony, for instance. But far more common were hardstones that were formed into miniature reliefs known as cameos. These were often cut out of banded agates found in Arabia and India, termed onyx when they are black and white, or sardonyx when the colours are brown or red and white. One stratum of the stone was left for the background and another used for the head or figures presented in relief. The art of cutting cameos was first perfected at the Hellenistic courts, above all at that of the Ptolemies in Alexandria, and was enthusiastically patronized by the Roman conquerors of Egypt.

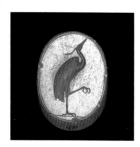

13 Greek, perhaps Dexamenos, chalcedony seal of a standing heron, third quarter of the fifth century BC, 0.02 cm. high, Museum of Fine Arts, Boston (Francis Bartlett Donation). Enlarged.

14 Plaster impression from seal in plate 13. Museum of Fine Arts, Boston (Francis Bartlett Donation). Enlarged.

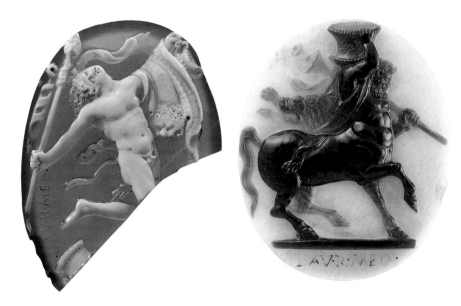

15 (far left) Perhaps Sostratos, cameo of a dancing satyr, *c.*40–30 BC, 3.6 cm. high, Museo Nazionale, Naples. Enlarged.

16 Roman court artist, cameo of an excited centaur, *c.*AD100–150, 5 cm. long, Museo Nazionale, Naples. Enlarged.

Many modern historians of the art of this period do not even mention the working of hardstones, yet engraved gems were at the time among the most highly prized works of art. A broken oval-shaped cameo of a dancing faun illustrated here is an example of such sculpture at its best. It may be one of the pieces made by a gem engraver called Sostratos, working in Alexandria for Mark Antony between 40 and 30 BC (pl. 15). Its fame is reflected by the existence of numerous inferior replicas. The intoxicated follower of the god Dionysus holds in one hand a thyrsus with a fluttering ribbon attached to it, and a wine cup (*kantharos*) in the other. A lion pelt is suspended from his arm. Where the stone has been broken we can discern the upper part of a vase for mixing wine (*krater*). The vitality of the composition, which seems about to burst out of its oval confines, depends on flowing and rippling lines which are exceptionally difficult to cut in so hard a material. This stone consists of two main strata, white used for the figure, and a translucent honey gold for the background, but there is another layer of pinky brown between these which the artist has employed for the inside of the pelt against which the faun's body is contrasted on one side, and for the insides of the lion's back legs which, together with his tail, fly out behind him. Only when magnified (as here) can we appreciate the artist's technique – above all, his use of the miniature drill for hair, eyes, nostrils and the points of shadow in the lion's head and the faun's left hand.

The paler stratum of stone was not always left for the figure. In an exceptionally splendid and large sardonyx cameo of a centaur, probably made for a later Roman court, perhaps that of Hadrian, the scheme is reversed (pl. 16). The figure, another wild follower of the god Dionysus, is for the most part cut out of a dark brown stratum which is, in the most salient portions, nearly black. Intermediate between this stratum and the white of the back-

17

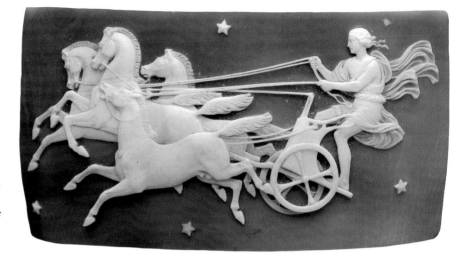

17 Tommaso Saulini, shell cameo of a chariot with a male driver drawn by four horses, *c.*1840, 9.4 cm. long, British Museum, London. Signed by the artist in the lower left corner. Designed to be set in an ornamental mount of a hair comb. The shell is probably the Black Helmet (Cassis tuberosa).

ground is a rich orange which at its thinnest – the inside of the *krater*, the end of the candelabrum over the centaur's shoulder, the legs of the lion pelt – is a brilliant yellow. The yellow and orange need the white behind them if they are to glow, and it must be admitted that the beauty of the stone is displayed at the expense of the coherence of the image, for we do not expect an animal to have two legs orange and two black. In this case it is not the holes of a drill but the short, sharp incisions of the wheel that are apparent on close scrutiny – in the hoofs, the bristling hair and the furrowed head.

On both of these cameos 'LAVR.MED.' is engraved, standing for Lorenzo de' Medici, who acquired them in the late fifteenth century. The enormous value that such a collector placed on gems of this kind did much to encourage their imitation or forgery by skilled craftsmen, chiefly in Italy, for several centuries – a phenomenon not unlike the repetition of ancient jades in China. During the early nineteenth century large white conch shells became popular for cameos made in Italy, usually with designs similar to those favoured for hardstones. The white of the outer shell was reserved for the figure, and cut back to the pale greys and pinky browns of the shell lining – subtle colours with a smoky depth to them. Only two strata are available, but the white can be so thin that the darker colour shines through. The shells were far cheaper and far more easily worked than hardstones, and shell cameos are larger than all but the most exceptional cameos made of onyx or sardonyx.

Very large hardstone cameos are often irregular in shape because the strata are never straight or exactly parallel. In shell cameos the curvature of the shell is always apparent, and, of course, it is very obvious in larger cameos. One such, carved with elegance and skill in the mid-nineteenth century by the Roman engraver Tommaso Saulini, was intended as the ornament of a hair comb, to which this curvature was perfectly adapted (pl. 17). The subject, a quadriga, or chariot with four horses, such as is often represented in antique

18

hardstone cameos, was a great challenge because of the complex, overlapping forms of spoked wheels and legs. The translucency of the lowest areas of relief is ingeniously used to suggest distance and avoid confusion.

In the ancient world the desire to invent a substitute for gemstones seems to have been one of the major stimulants to innovations in glass-making. Layers of differently coloured glass were fused to imitate banded agates. In the most famous examples of this technique the figures are cut out of opaque white glass on a dark cobalt blue, but there is one fragment that shows Dionysus and a satyr in opaque white glass on a translucent green ground with a pattern of broken bands intended to resemble the mineral malachite (pl. 18). Whilst this was clearly inspired by hardstone cameos, it is worth pointing out that no vases made of hardstone could have been carved as cameos, and that neither malachite nor any deep-blue mineral has strata that could be cut to form a cameo.

The making of such overlay, or cased, glass was also developed in eighteenth-century China – especially for the cutting of snuff-bottles in imitation of those in patterned hardstones – and in nineteenth-century England by John Northwood (1836–1902). A greater softness and subtlety of modelling in the white figures than was possible in cutting a hard upper layer of glass or stone could be achieved when the figures were built up by painting successive layers of ceramic, as in the technique of *pâte-sur-pâte* porcelain perfected by Marc-Louis-Emanuel Solon (1835–1913) in his exquisite work for the Sèvres and Minton factories in the final decades of the nineteenth century. But such work belongs rather to the margins of painting rather than to those of sculpture.

18 Roman or Alexandrian, glass cameo of a dancing satyr (the fragment probably of a vase), *c.*50 BC–AD 50, 5 cm. high, Dunbarton Oaks (University of Harvard), Washington, D.C. Probably damaged by acid cleaning.

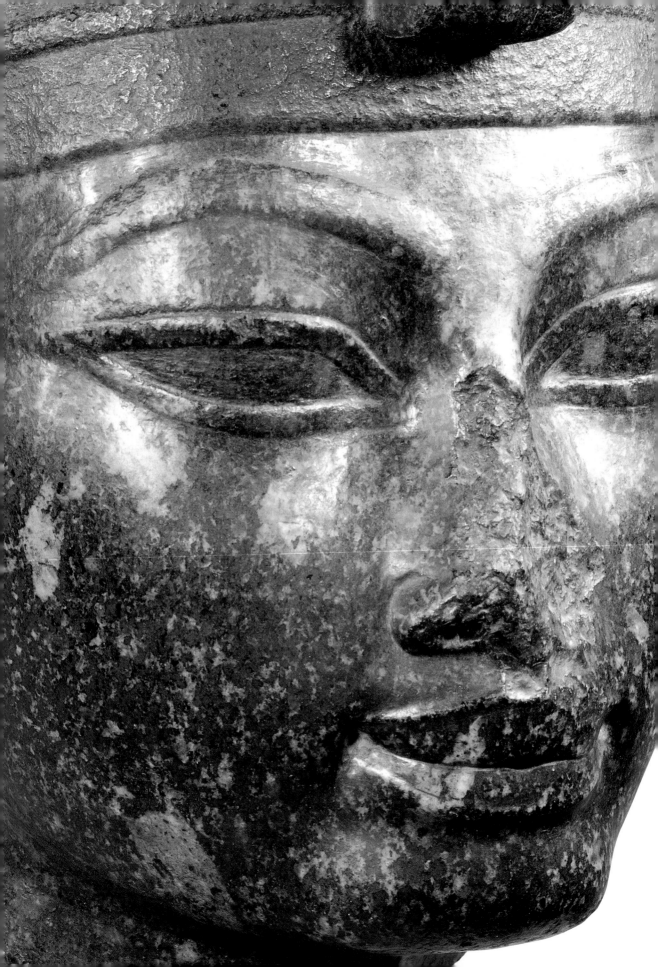

2 *Granite and Porphyry*

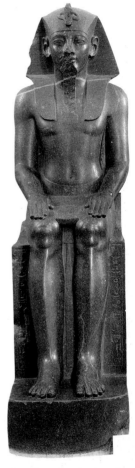

WHEREAS JADE, ROCK CRYSTAL AND AGATE are obtainable for sculpture only in small pieces, granite (composed of feldspar, mica and quartz) is one of the most common of the igneous rocks. It is the stuff of which whole mountains are made, and it is found in all parts of the world. But it is immensely hard, and for centuries the travellers who encountered the colossal monolithic shafts of Egyptian granite used for the portico of the Pantheon in Rome and the great obelisks and fountain basins of the same city found it marvellous – and bewildering – that such stones had in the distant past been cut out of remote mountains, turned, polished and transported there. When reliable reports and actual fragments of the colossal granite sculptures of the ancient Egyptians reached western Europe in the late eighteenth century it seemed even more astonishing. Granite had occasionally been worked in shallow relief, for architectural ornament where it was the local building stone, and for the stiff figures of sixteenth-century calvaries in Brittany, but, before the advent of improved metals and power-driven tools in the nineteenth century, the idea of making statues out of it was seldom seriously entertained by sophisticated sculptors.

It was evidently with some difficulty that the explorer and entrepreneur Giovanni Battista Belzoni cut his name into the plinth behind one heel of the colossal seated portrait of King Amenhotep (Amenophis) III which he removed from Thebes in 1820 and which now presides over the entrance to the Egyptian Gallery of the British Museum (pl. 20). And it is striking that the letters forming his name are far less finely shaped than the hieroglyphs that identify this god-king. Amenhotep, who ruled from 1391 to 1353 BC, was the ninth member of the eighteenth recorded dynasty of rulers of Egypt. The Egyptian Empire was then at its greatest extent – stretching from the Sudan to Syria – and also at peace. The king had over a thousand portrait statues made of himself. He pioneered the use of streaky pale-brown quartzite for some of the largest statues, including the monolithic colossi seventeen metres high – the so-called Colossi of Memnon – which still astonish the visitor to Thebes. The statue in the British Museum is of black 'granite' – properly granodiorite, one of the hardest of igneous rocks. This stone is not in fact a uniform black but has a brown and grey tint with gold flecks. Not unusually, the piece out of which this statue was carved includes numerous streaks as well as one distinct band of a dirty pink colour (evident in the neck and shoulders).

20 Egyptian, statue of Amenhotep III enthroned, granodiorite, *c.*1391–1353 BC, 290 cm. high, British Museum, London.

19 Detail of pl. 32.

21

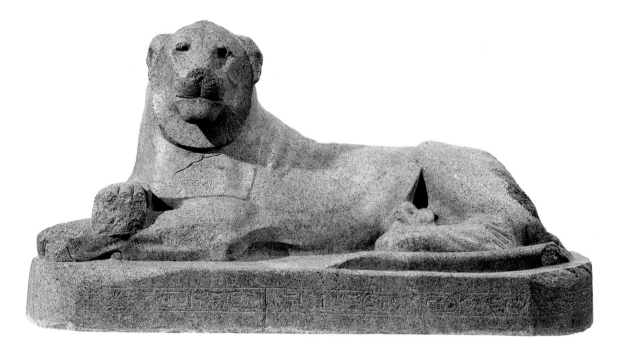

21 Egyptian, granite lion, *c.*1391–1353 BC, 205 cm. long, British Museum, London. The eye sockets are not polished.

No less popular than granodiorite for monumental sculpture was an orange pink granite with distinctive large, shiny flakes of feldspar. This was, for example, used for a pair of lions erected as sentinels before the temple of Amenhotep III at Soleb in Nubia (pl. 21). These black and red stones, known in antiquity as 'stones of Ethiopia', were quarried at Siene near Assuan in Upper (southern) Egypt continuously from the first dynastic period (around 3000 BC) to the third century AD and were transported down the Nile.

Blocks were extracted from the mountain with wedges, roughed out with picks and then pounded and ground into shape. At what point metal was employed in this process is not known – it could have been used for the wedges, the picks and the rubbers, and it certainly came to be employed for the saws and drills that were used with abrasives – but lumps of harder stone, such as dolerite, would have been most useful for pounding, the abrasives of sand were more important for grinding down than the tools by which they were worked, and no metal known to the Egyptians would have actually cut the stone. The polishing was presumably achieved with 'black sand', or emery. The technology had been derived from the methods of working of the many spectacular and beautiful hardstones of Upper Egypt into vessels, but for sculpture of such a size armies of workmen would have been required Given the mechanical nature of the labour and the scale of organization involved, it comes as no surprise to discover that a grid should have been employed to guide the workmen.

A concern to waste neither labour nor material must have encouraged the extraction of more or less rectangular blocks in series, and such blocks would

22

have provided just the flat surfaces required for the grid. The word quarry derives from the Latin word for square. The form of a seated statue such as that of Amenhotep III might seem surprising in this connection, but the L-shape might have not been inconvenient in a stepped quarry, and in any case it would have been possible to saw two interlocking L-shaped blocks from a single rectangular one with little waste.

Methodical procedures, essential for the efficient co-ordination of regiments of workers, must have encouraged the geometry conventional in the compositions of such sculpture. Thus the legs of the seated Amenhotep III are vertical; the segmental curvature of his collar is repeated in that of his breast; the lion's mane is simplified to an oval disk from which a rectilinear face protrudes and a rectangular bib is suspended. There were, however, other reasons for such geometry. Most obviously, it united the sculpture with the architecture of the great temples of limestone and sandstone for which they were made.

The frontal, symmetrical posture of the statue of Amenhotep, with his hands quite flat on his knees, was deemed as appropriate for a deified king as the short kilt, fake beard, headcloth and collar. If the rigidity of limb and immobility of features suggest the serenity of a higher being, then this has been achieved at the expense of anatomical plausibility, for our forearms could not rest flat on our thighs if our backs are straight (nor could thumbs normally be aligned with the outstretched fingers of an open hand). In the case of the lion, however, the geometrical simplifications seem to arise from, or at least to suggest, the animal's bones (especially the ribs and elbows), muscles and folds of flesh. There is a latent vitality: the body is partly alert. He would have appeared still more so originally when his eyes were inlaid, perhaps with some other polished stone.

Our awareness of the block from which massive Egyptian sculpture was made derives partly from the avoidance of undercutting, projection and perforation. Thus the lions are recumbent, the thrones of seated figures (like that of Amenhotep III) are solid, the parted legs even of striding bare legged men are united by a wedge of stone; arms, even when not touching the body, are joined to it with a plate of stone; and rams' horns, hawks' wings and beards are never detached from the head, back or neck. The effort that would have been required in reducing a massive block merely to accommodate one small projection must have been discouraged. This may help to explain the compact shapes of Egyptian sculptures, yet economy of labour cannot adequately explain the avoidance of undercutting and perforation. No labour was spared in polishing the surfaces nor in the working of detail – the crisp outlining of nails, beard straps and eyes, not merely with incised lines but with fine lines raised in relief.

There is, in fact, a technical explanation for avoiding undercutting and perforation. Such stone can be shaped only by hammering – by direct blows at right angles to the surface – which made undercutting very difficult and

perforation very risky. Hammering at a small area to achieve, say, the space between arm and chest, could have caused a statue to shatter and would certainly have weakened it. It should also be remembered that statues were believed to provide an everlasting dwelling place for a spirit. Hence the use of the most durable stones, and hence, perhaps, the avoidance of any technique that might have weakened the mass.

Not all Egyptian hardstone sculpture has a uniform finish. Indeed during Amenhotep III's reign two distinct styles of working in granodiorite are apparent. On the colossal seated statue (pl. 20) every surface is highly polished, but the head from a life-size statue of the king wearing the Khepresh crown illustrated here (pl. 22) is polished only in the flesh areas. It is also very different in style – rounder, softer, less tightly linear and schematic. Traces of paint have been found on one sculpture of this kind and we may conjecture that the eyes and crown, which have been left slightly rough, would have been coloured. The pigment or its gesso priming would have adhered better to an unpolished surface. That the colour of the grano-diorite was itself appreciated is, however, clear from the fact that it was polished. Its colour may also have been symbolic: certainly it was known by the same name, *kemet*, that was given to the black silt of the Nile, and to the fertile land of Egypt itself.

One other great sculptural tradition employed igneous rock for monumental sculpture: that of the southern parts of the Indian subcontinent. The many igneous rocks of the region, whole outcrops of which were carved (and in many cases have been half eradicated by the sea air), include granite, basalt, diorite, monzonite and granodiorite, all exceptionally hard stones of related character. These sculptures have little in common with those made by the ancient Egyptians. Illustrated here is a typical statue of Nandī (pl. 23), the young humped bull, especially favoured by and closely associated with the Hindu god Śiva, erected in the courtyards of the numerous temples of that god. The material is almost certainly porphyritic basalt, a rock common in the Deccan Traps. It may have been made from a rectangular block, but, if so, no evidence of this remains. There is no obvious viewing point and, indeed, none is entirely satisfactory: the viewer must move round the sculpture, which was conceived entirely in the round. And there is nothing angular about it, nothing of the discipline of verticals and horizontals. The sculptor emphasizes the rounded projections – nose, bent knees, hump, testicles, rump and the stumps of immature horns – all of which invite the touch. Bone, muscle, structural power are absent, and even the folded legs seem rubbery compared with those of the Egyptian lions. But this, too, perhaps enhances the tactile appeal, the accessibility of this affable divine creature.

There is no inhibition about perforation or projection – Nandī's bent front leg is free and his ears protrude – but these are carefully managed, and on the whole the forms remain compact and undercutting is avoided. The bands on

22 Egyptian, fragment of a life-sized statue of Amenhotep III wearing the Khepresh crown, granodiorite, *c.*1391–1353 BC, 34 cm. high, Musée de Louvre, Paris.

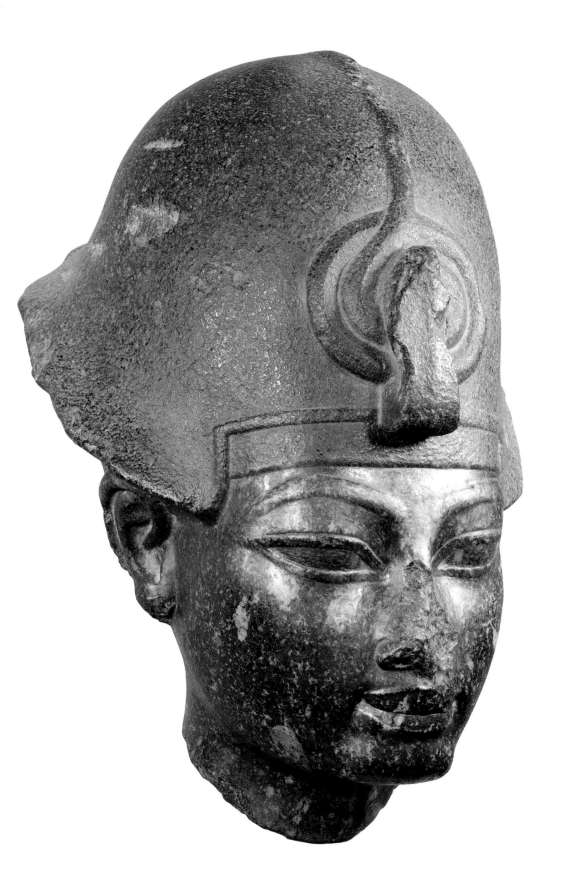

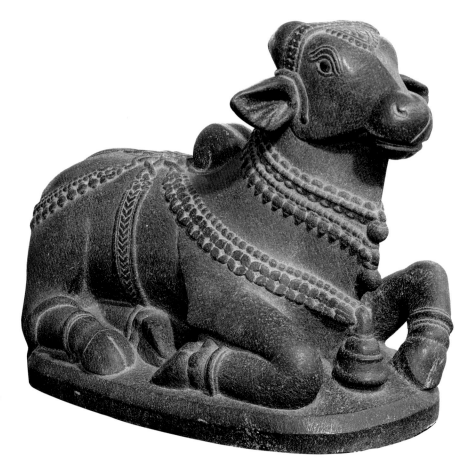

23 Southern Indian, *Nandī*, porphyritic basalt, sixteenth or seventeenth century, 69.9 cm. long, Ashmolean Museum, Oxford.

24 Southern Indian, *Sapta Matkra*, greenstone, tenth century, 116 cm. high, Arthur M. Sackler Gallery (Smithsonian Institution), Washington, D.C.

the ankles, the garlands on the head, the tasselled and bell-hung straps are all relatively soft-edged because they have been worked with a steel punch driven into the stone more or less at a right angle, bursting it. The only slight evidence of striations, where a tool has been struck into the stone at an angle, are on the unadorned surfaces.

This sculpture of Nandī, and others of the same type, are unusual in being free-standing. Most stone sculpture of the subcontinent of India is carved in high relief, and the slab from which it is made is evident, forming a backplate and frame. And yet in the finest stone sculpture made in south-eastern India under the Chola dynasty, the forms seem to grow out of the face of the stone into a fully rounded figure. A statue of about AD 1000, carved out of greenstone – an igneous rock rich in feldspar and augite and perhaps from Kanchipuram, west of Madras – illustrates this perfectly (pl. 24). It represents one of the seven mothers created by Śiva to drink the blood shed by the demon, Andhaka. Her jewellery and other ornaments seem to merge with the body, and the streaming hair seems to melt into the background. This owes much to the continuous, flowing lines (and the avoidance of straight lines

26

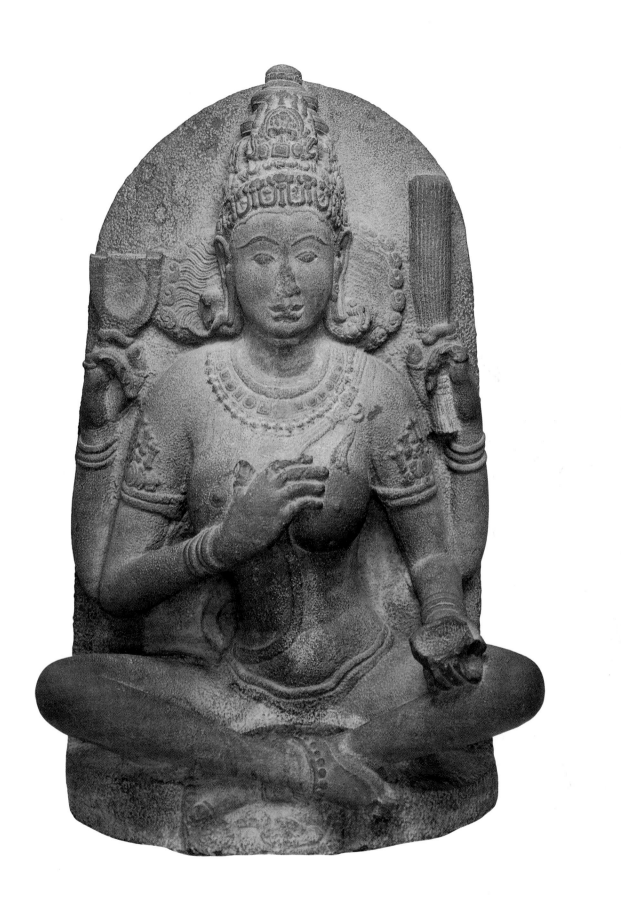

even where, as in the raised fly whisk, they might be expected), but it owes more to the overall texture, which both softens the forms and imparts a subtle vibrancy to the surfaces equivalent to that which is characteristic of chalk or charcoal drawings. The stone is darkest on the knees and other salient parts, where rubbed by the handling of the devout, but this stone and others like it are never given a polish resembling those of Egypt.

Some of the characteristics of southern Indian sculpture in hard granulitic rock depend upon the tools and skills then available, and, whatever the difficulties of working this rock, they were probably outweighed by the difficulties of transporting softer rocks in sufficient quantities.

In the last century granite became an important material for heavy engineering in western Europe and North America: sea walls and lighthouses, cobbles and curbstones were made of it. In architecture it was favoured not only for foundations and for rugged rusticated basements but for polished column shafts. It was cut by new steam-powered saws, raised by cranes and transported by rail. When modern sculptors have employed granite it has often been for practical reasons. It will survive severe frost, salt air, and heavy pollution better than other stones. 'I do not know of any white or grey marble that will not go to pieces in time', wrote the American sculptor Daniel Chester French in 1915, when he and the architect of the Manhattan Bridge were debating out of which material to make the colossal seated figures personifying Manhattan and Brooklyn that were to adorn the pylons. 'Granite is the most unsympathetic material of sculpture that I know', French continued, and yet blocks of a pale grey granite, supplied by the Victoria White Granite Company, were chosen for the statues, which were completed in the following year (they now stand outside the Brooklyn Museum; pl. 25). It is revealing that, when French was wondering whether there might be an alternative to granite, his half-size models were already complete. It is unlikely that the design would have been much modified by him if another material had been employed. With the use of modern technology, most of the forms that a sculptor is likely to wish to create in marble or stone can be cut out of granite also, especially in a monumental work intended for the open air, where thin projections, intricate detail and fine textures would in any case be imprudent.

During the same period that French was working on the Manhattan Bridge, younger sculptors in Scandinavia were taking a more positive attitude towards the granites and other igneous rocks of their native lands. The statue of Mads Rasmussen (pl. 26) in the museum founded by him in Fåborg was made by Kay Nielsen in 1912–14 and is of black rock, with a polish that emphasizes the philanthropist's plump cheeks, puffed chest, and watch swelling in the tight waistcoat pocket, as well as the buttocks and breasts of the lesser mortals – females and infants – who cling to his trousers like pets. Contemporary with Nielsen's sculpture is the Susanna fountain by Carl Milles, where the smooth rounded surfaces are made more reflective by a film of moving water: 'Imperceptibly he seems to repeat the rounded contours of the smooth rocks of the

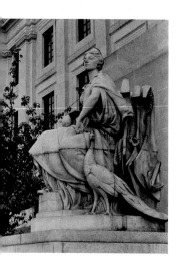

25 Daniel Chester French, colossal statue of Manhattan, grey American granite, 1914–16, 390 cm. high, 20 tons in weight, Brooklyn Museum, New York (since 1963; it was formerly at the entrance to the Manhattan Bridge).

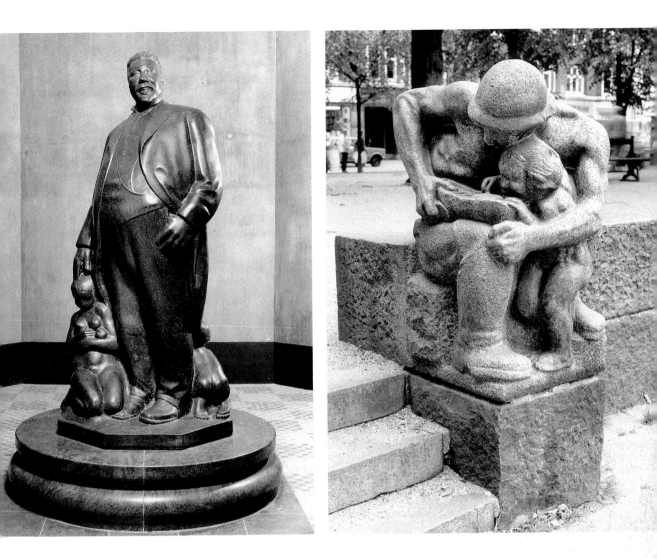

Swedish hills and islands, whose surfaces have been rounded and rubbed by the transit of endless glaciers.' A different approach is found in Nielsen's statues in Copenhagen's Blaagaardsplads of 1913–15 (pl. 27). Here the pink granite is left rough to suit the ragged character of the workmen represented and to match the blocks of the wall and the steps – the architecture into which they are locked – but here, too, undercutting is avoided and hollows are shallow, although accumulated dirt makes them seem deeper than they are. Granite had found favour in the nineteenth century as a material for the pedestals of public sculpture, which were carefully calculated in height so as to prevent common people climbing on to them to insult the heroes they support. This early twentieth-century sculpture which converts the common people into heroes is designed to endure abuse and indeed is regularly climbed over by local children.

26 (above left) Kay Nielsen, portrait statue of Mads Rasmussen, black igneous rock (granite?), 1912–14, 250 cm. high, Fåborg Museum.

27 Kay Nielsen, group of a labourer instructing a child, red granite, 1913–15, unmeasured, but size of life, Blaagaardsplads, Copenhagen.

* * *

The rocks employed by the ancient Egyptians for their monumental sculpture were probably chosen more for their size and durability than for their beauty. But for statuettes, seals and vases the Egyptians displayed a passion for rare and beautiful minerals. It was in Alexandria under the Ptolemaic dynasty that the cutting of cameos and the fashioning of vases out of sardonyx and other agates, described in the first chapter of this book, were first perfected.

The most highly prized Egyptian stone to be employed for sculpture on a large scale was basanite, commonly confused with basalt (and still usually described as such on museum labels). This is a 'greywacke', a by-product of the decomposition of basaltic rock. It varies from a dark green to a rusty brown and often incorporates darker streaks. Basanite, the 'stone of Bekhen', came from the sacred mountain Uadi Hammâmât in the Egyptian desert where it was located and whence it was extracted with great difficulty, usually in relatively small lumps from within a matrix containing other rocks. Only sculptures of high quality were carved out of basanite, and before the conquest of Egypt by Alexander the Great (in about 332 BC) it was reserved for statues of the gods. The head of a youth (pl. 28), probably made in Alexandria in the first century BC, is distinguished not only by the modelling of the flesh, at once soft and firm, but by the stimulating contrast of texture between these smooth surfaces and the texture of the tightly curled hair. Basanite is not as hard as basalt or granite, although Pliny claimed that it has the hardness as well as the colour of iron, but its sculptural qualities were perhaps especially likely to be appreciated by connoisseurs of hard, dark rocks – diorite, basalt and dark granite – for the nature of its grain is far more seductive.

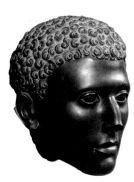

28 Alexandrian, head of a youth, greywacke (basanite), probably first century BC, 24.5 cm. high, British Museum, London.

Closely related to granite is porphyry, which is composed of feldspar and quartz set within a fine matrix. It is not uncommon and can be found, for example, in Cornwall and in Greece, on Minorca and in northern Italy. It occurs in many colours, but among the ancient Romans the word porphyry referred to a stone of deep purple, regularly speckled with white or pink feldspar, which was extracted from a mountain in Egypt – Mons Igneus, or mountain of fire, now Gebel Dokhan. (Indeed, porphyry means 'purple stone'.)

This porphyry – 'imperial porphyry' as it is sometimes described – was certainly quarried under the Ptolemies, but there is no evidence that it then enjoyed special prestige for sculpture. The Romans adopted it for architectural purposes – for basins and monolithic column shafts, often of great size, and for paving and wall cladding – as well as for sculpture. Use of this material was to a large extent controlled by the emperors, and towards the end of the Empire it came to be associated with the sacred aura of the emperor, whose tomb was made of porphyry and whose heirs were born in a chamber of the same material. Even after the dissolution of the Empire of the West, porphyry enjoyed a special prestige, for the dream of reviving Roman imperial authority was never forgotten. However, the quarries had been closed in the early fifth century, and the only way of obtaining the material was to reuse what

30

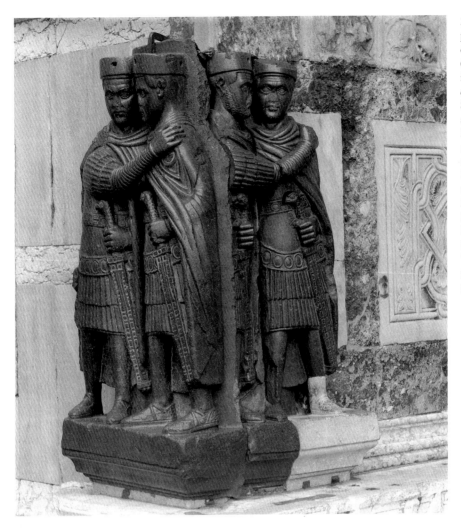

29 and 30 Roman, two pairs of embracing commanders, Egyptian ('Imperial') porphyry, early fourth century AD, *c.*130 cm. high, basilica of Saint Mark, Venice. The statues, traditionally known as 'I mori', represent the Tetrarchs, the four rulers of the Roman Empire under the system instituted by the Emperor Diocletian in the late third century and broken up by Constantine in the early fourth century. The slots in the caps probably contained precious stones.

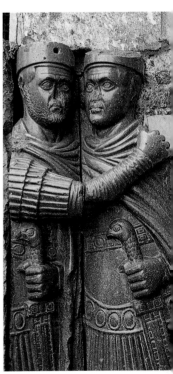

remained of ancient Roman architecture and sculpture, as well as the blocks of unworked stone that remained in Rome. The porphyry disks set into medieval church floors in Rome were sawn from ancient columns found among the ruins. Those ornamenting the façades of Venetian palaces were cut from columns looted from Constantinople (some of which had, long before, been removed from Rome). The stone could be sawn and polished only with great difficulty, and by then the art of working it into sculpture had been lost.

In addition to columns of porphyry the Venetians removed from Constantinople two groups made in Egypt in about 300, each depicting in very high relief a pair of commanders embracing (pls 29 and 30), which originally stood on ledges projecting from column shafts. These were set up at a corner of the basilica of Saint Mark. The block outline, the stiff postures and the avoidance of hollows – also the treatment of fingers, folds, creases and the corrugations

of the brow as schematic parallel rolls—indicate a drastic departure from the sculpture of marble and bronze in the Greek tradition, such as had served earlier porphyry workers. Such a change of style was determined, at least in part, by the difficulty of working the material.

Porphyry carving is a case in which ancient art presented a special challenge to modern European technology. Few who approach the fifteenth-century façade of the church of Santa Maria Novella in Florence today notice the tablet of porphyry, sharply cut with eighteen large letters in the ancient Roman style, spelling the name BERNARDO ORICELLARIO (the second name being Latin for Rucellai), which is set on the riser of the step below the central doorway (pl. 31). By the time Vasari was writing, it was credited to the ingenious architect of the façade, Leon Battista Alberti, although it had, in fact, been completed in the early sixteenth century. Vasari notes that the chisel was not capable of such work and that a small revolving brace drill had been employed, fitted with small copper disks which were sprinkled with emery.

The first craftsman since antiquity to master the cutting of figures in porphyry may have been the gem engraver Pier Maria Serbaldi da Pescia, at the end of the fifteenth century, and he managed to do so only with the use of jewellers' drills and wheels, and thus could work only on a small scale, to which porphyry, with its prominent speckles, is seldom suited. The first modern craftsman to work the material on a large scale was Francesco Ferrucci, called Francesco del Tadda, a mason from Fiesole who in about 1555 executed Vasari's design for the exquisite basin of the fountain, crowned by Verrocchio's bronze putto embracing a dolphin, in the courtyard of Palazzo Vecchio in Florence. During the 1560s and 1570s he made profile portraits of the Medici family (and of Jesus Christ) which were set against oval plaques of local green serpentine (*verde di Prato*), and he made one major figure, composed of five or six pieces: a statue of Justice, which in 1581 was placed on top of an ancient column of Egyptian granite (a column that had been removed from the Baths of Caracalla in Rome by Pope Paul III and presented to Grand Duke Cosimo I, who erected it in 1566 in Piazza Santa Trínita, in Florence). Tadda died in 1586, but his son Romolo and grandson Mattia continued to work the material, as did other workshops in Florence and Rome and later Paris.

31 Florentine, slab inscribed in Roman capitals with the name of Bernardo Rucellai, Egyptian ('Imperial') porphyry, *c.*1510, the letters 5 cm. high, the slab 115 cm. long, riser of the step into the principal door of the west front of Santa Maria Novella, Florence.

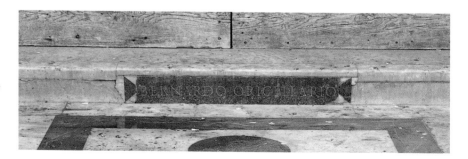

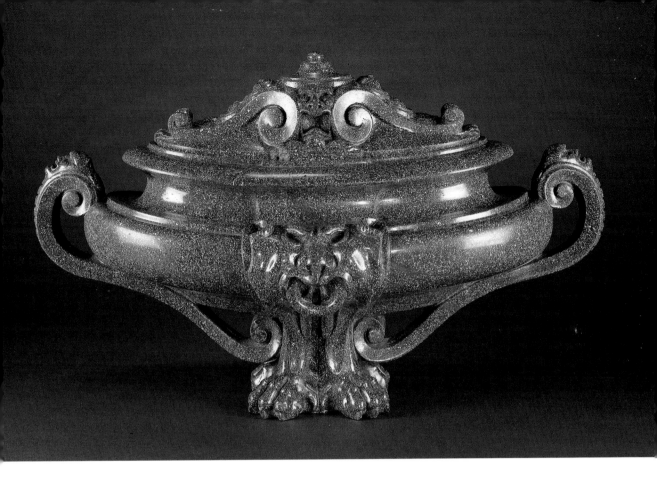

An exceptional urn adorned with grotesque masks which must have been designed by a leading Florentine architect or sculptor (pl. 32) illustrates the skills that Florentine craftsmen had acquired by the 1580s. Its unusual flatness suggests that it must have been made out of a section of an antique column shaft. It has a small stand, of four lion's feet, and a deeply hollowed neck; dynamic plasticity is supplied by the volutes that rise with tense metallic curves from the lion's feet to the swelling belly of the urn. The hollows of the eyes of the large leonine masks and the open mouths of the smaller masks on the lid have been left rough, probably to facilitate the fixing of other coloured stones (lapis lazuli for the former, bloodstone for the latter, perhaps). Only on close examination of the urn do we become aware of the difficulty of working porphyry. The deeply cut lines – for instance, in the scrolls of the lid or between the dewlaps dangling from the masks (and beneath the rings) – are thick and rounded in section. It was supposed that the ancients had possessed some forgotten method of tempering metal tools, and the Grand Duke Cosimo was credited with devising a herbal essence that was vital to Tadda's success in making his steel chisels sufficiently hard. The latter no doubt did use such chisels, but he knew that the true 'secret' of the ancients lay in their use of abrasives. It is only when we turn from igneous rocks to less hard metamorphic rock that the history of metal becomes central to the history of sculpture.

32 Florentine, covered urn with grotesque masks, Egyptian ('Imperial') porphyry, c.1580, 52.8 cm. high, 87.9 cm. long, National Gallery of Art, Washington, D.C. (gift of Lewis Einstein).

33

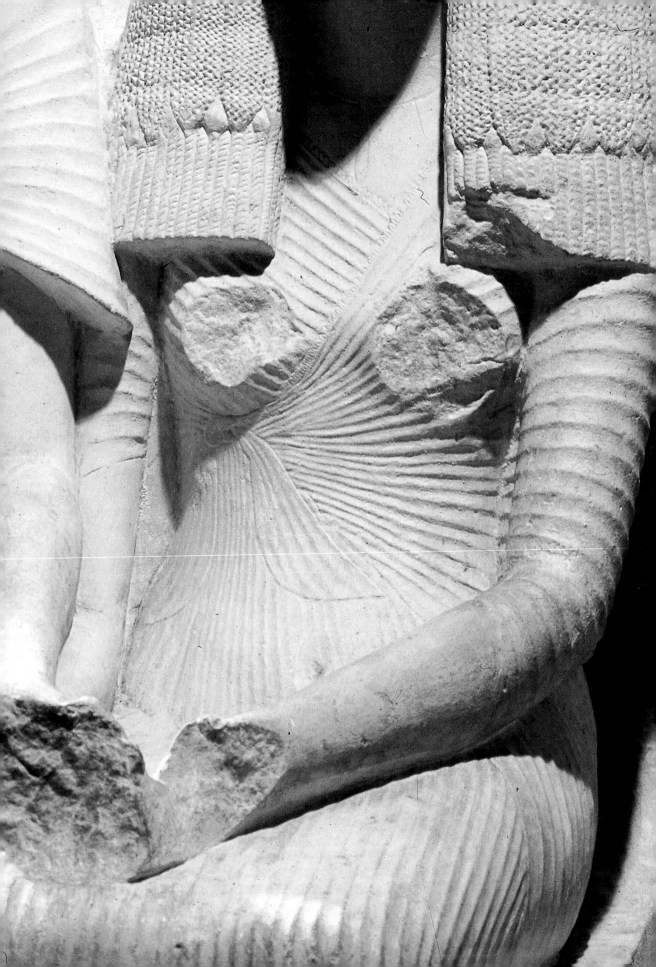

3 *White Marbles and Alabasters: Part 1*

S O CLOSELY IDENTIFIED IS WHITE MARBLE with European art, so easily taken for granted as the chief material for the most serious sculpture, that it is easy to forget that it was rarely available in northern Europe between the decline of the Roman Empire and the late fourteenth century. Moreover, it was not exploited by the early civilizations that flourished in the valley of the Tigris and Euphrates and by the side of the Nile. These civilizations did, however, use a white stone – softer, more translucent, often brilliant white, and easily polished – a stone that came to be known as alabaster, after the Egyptian town Alabastron, where much of it was mined. However, the name alabaster has now been appropriated by geologists for a stone of similar qualities but of different composition. The more up-to-date museums tend to label ancient alabaster as calcite – correctly, for it is a calcium carbonate of lime deposited by water as it percolates in caves and hollows and around the mouths of springs. Here it will be described as calcite 'alabaster'. Its modern trade name is 'onyx marble'.

Some of the earliest surviving sculptures are made of calcite 'alabaster' – statuettes of gods, offerings and charms. The ancient Egyptians hollowed it out into fragile translucent cups modelled on the stems and flowers of the lotus, and used it also for the sturdier vessels in which the internal organs of the dead were preserved. The stoppers of the chests made to contain the entrails of King Tutankhamun, who died in 1352 BC, take the form of a portrait of the king (pl. 34). He wears a headdress with the heads of a vulture and a cobra projecting from the brow (carved from separate pieces of alabaster and inserted). Black for the eyes and red for the lips enhance the brilliance of the white. Elsewhere a contrast was supplied by different minerals, as, for instance, when hard, shiny black obsidian handles were given to an alabaster casket.

The objects made by the Egyptians out of calcite 'alabaster' were small. It seems that the Assyrians were the first to use a soft white polished stone for monumental sculpture. When their empire had expanded to dominate the entire area between Iran and Egypt, King Ashurnasirpal created in 879 BC a new capital, Nimrud, on the Tigris. Extensive use was made there of stone quarried twenty miles upstream at Mosul – 'Mosul marble'. This is, in fact, hydrous calcium sulphate, or gypsum, the alabaster of the modern geologist,

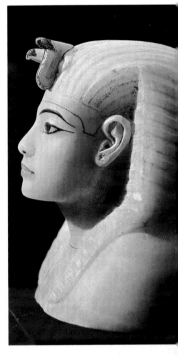

34 Egyptian, stopper of a chest containing the entrails of King Tutankhamun, calcite 'alabaster', *c*.1352 BC, 24 cm. high, Cairo Museum. One of a set of four.

33 Detail of pl. 36.

35

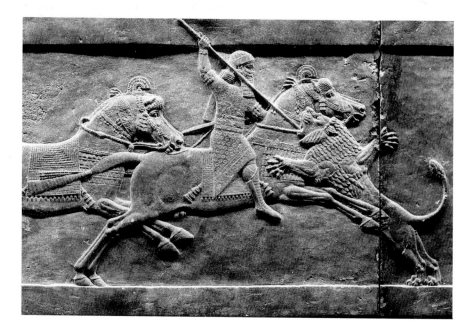

35 Assyrian, *King
Ashurbanipal slaughtering
lions*, gypsum alabaster,
*c.*645 BC, *c.*68 cm. high,
British Museum, London.

which we shall call 'gypsum alabaster'. Gangs of prisoners extracted blocks of
this material which were then carved into colossal guardian monsters for the
internal entrances of the great halls of the palaces, or cut into slabs which
were built into the palace walls and then carved *in situ*.

Other Assyrian cities were similarly adorned, including Nineveh – still
nearer to the Mosul quarries – where the famous reliefs of about 645 BC,
representing the ritual slaughter of captive lions by King Ashurbanipal, were
discovered (pl. 35). It has been conjectured that careful drawings were made
on the alabaster slabs by an artist who perhaps also worked on the mural
paintings higher on the walls, with the carving delegated to teams of reliable
workers. The sculpture is remarkable for its densely concentrated patterns – of
ornamental fabrics or curled beards, for example – much of it minute and
mechanically repetitive. Despite the value that was probably attached to
conspicuous evidence of labour, it is unlikely that this style would have been
adopted had it not been for the fact that alabaster is comparatively easy to cut.
It is a style to which we shall return in a later chapter.

The Assyrian gypsum alabaster sculptures were long buried and are now the
colour of milky coffee, but when freshly cut from the rock the stone is a
greyish white. The reliefs were painted, although it is not clear to what
extent, and perhaps some parts were left bare. The background was certainly
blue, and details were picked out in black and red. Such colouring would
have soon worn off, had the sculpture been exposed to the elements, but
gypsum alabaster was anyway too soft to be used externally.

In Egypt, although the calcite 'alabaster' was not available in pieces large
enough for monumental sculpture, there was abundant limestone of a more

36 Egyptian,
commemorative statue of
a married couple,
limestone, *c.*1350 BC,
132 cm. high, British
Museum, London.

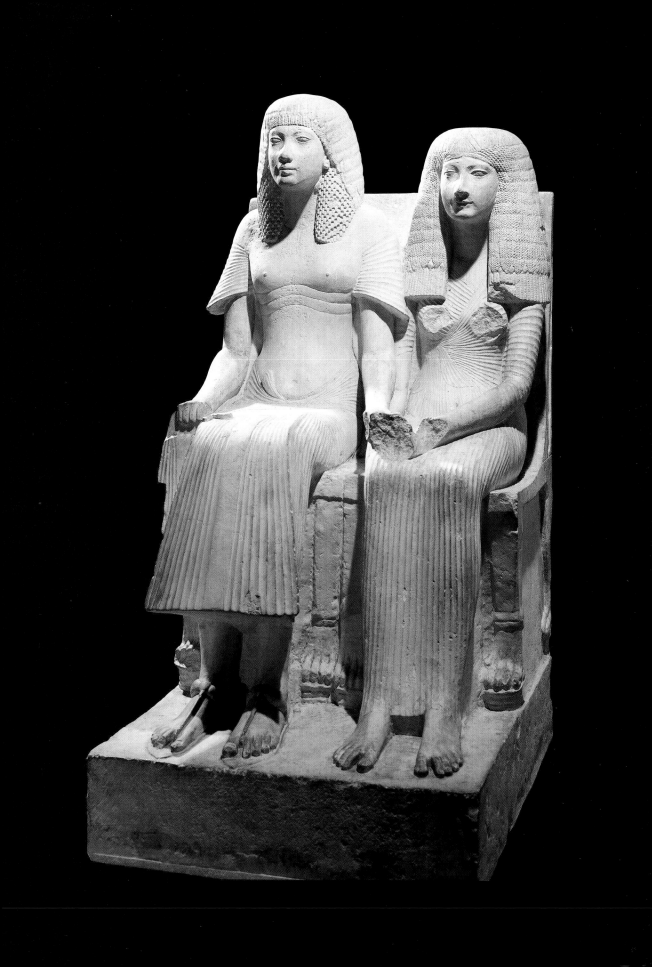

usual type – formed by fossilized deposits – which was pale beige or cream in colour. Some of this was very densely textured, more like chalk than the limestones used for building in northern Europe, and permitted very precise cutting.

A commemorative statue of a man and his wife sitting side by side, made in about 1350 BC, typifies the larger pieces carved by the ancient Egyptians out of single blocks of limestone (pls 33 and 36). The razor-sharp fluting of the draperies create in low relief a pattern of great elegance and complexity, most notably where the loose ends of the knot lie on top of the crossed lines of the garment tied tightly beneath the woman's breasts. This particular sculpture may not have been coloured, but only because it was probably never finished. The gain in verisimilitude might well have inhibited awareness of such artistic effects – even if the crispness of carving was very little diminished by the thin undercoat sometimes used to seal the surface before paint was applied. This type of limestone was better suited to exposure than were calcite 'alabaster' or gypsum alabaster, though the finer carvings were none the less vulnerable to rain and wind.

Limestone, when crushed and heated so that its structure is changed, becomes the metamorphic rock marble: compact and crystalline, sparkling when broken or cut, slightly translucent, receptive to many degrees of polish, often obtainable in large blocks more or less uniform in colour, and hard (although absorbent enough to be vulnerable to frost). Marble seems first to have been used for sculpture by the inhabitants of the Cyclades, the islands that form stepping-stones across the Aegean from Greece to Turkey. Statuettes of nude figures, seldom more than a foot long, and usually female – goddesses, it may be, or slave girls, or spirits – have been found on the islands in tombs, dating from about 3000 BC.

These figures invariably face straight ahead, with their arms folded across the chest (pl. 37). The simple, sharp edged shapes suggest that they were scratched in outline on the smoothed-down face of a lump of marble with a blade, which would then be used to cut around the form. The surface looks as if it was then rubbed down, with breasts and nose left salient, and the neck and limbs rounded off in varying degrees. The lines between the arms and legs and the toes, the line at the neck (perhaps for a necklace), the outline of the inverted triangle indicating pubic hair, are all cut more or less straight. The figures were evidently designed to recline (although they are now generally exhibited upright), and this passive state suits their apparently mute and unseeing demeanour, prompting the idea that they are meant to represent spirits. And yet the faces may well have been painted with eyes and mouths.

The Cyclades are rich in minerals that were then highly valuable: obsidian, a black volcanic glass from which large cutting-blades could be obtained; emery, in its powdered form a highly effective abrasive; pumice, a soft volcanic stone that was of great value as a polish. All of these minerals, which furnished the islanders with the means to work their white marble, were

37 Cycladic, *Woman*, Naxian or Parian marble, c.3000 BC, 16.2 cm. high, Ashmolean Museum, Oxford.

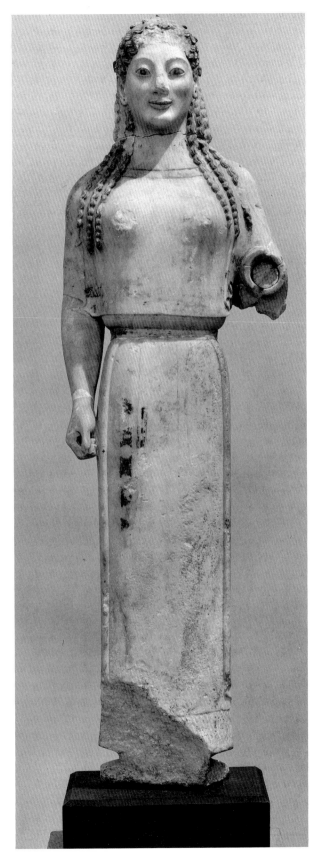

38 'The Rampin Master',
the *Peplos Kore*, probably
Parian marble, *c.*530 BC,
117 cm. high, Acropolis
Museum, Athens.

exported, yet the marble itself seems not to have been. This is not surprising, for it was not extensively quarried or mined and thus only pieces of a relatively small size were easily available. The peoples who traded with the Cyclades could have obtained pieces of calcite 'alabaster' for their statuettes from many other sources, and white marble became important internationally only in the seventh century BC, by which time the Cyclades had long been integrated into the civilization of mainland Greece.

In Greece sculpture had been made out of wood, and also out of the local limestones and sandstones, which could be cut by the bronze tools of carpenters. To crack and hammer marble into rough blocks, to lever and lower these from the mountainside, to chisel them into column drums, capitals, entablatures and life-size statues was possible with bronze but became far easier with iron. Moreover, chisels of hardened iron could shape marble with an oblique stroke as well as could a punch at right angles. The metallurgical revolution cannot explain the rapid increase in popularity of marble for temples and for outdoor statues of a commemorative or votive character – hundreds of idealized youths, both male and female, alert, as if poised to serve a deity, set up in Greek cemeteries and sanctuaries – but it was a precondition for this phenomenon.

In the second half of the seventh century BC the Greeks came into close contact with Egypt, where they were employed as mercenaries and granted trading privileges. The extent to which they were influenced by Egyptian art is much debated. They must certainly have known of the stone sculpture and architecture there and probably something of the quarrying technology too. In the marble of Naxos, the first Cycladic island to be systematically quarried by the Greeks, they found a material which could survive outdoors better than most limestone but could none the less be carved with comparable precision. Though not as hard or as durable as granite, it was far easier to work. Moreover, it possessed the whiteness and some of the translucency of calcite 'alabaster', although this was not at first significant as a factor in its popularity, since the statues carved from it were no less completely coloured than were Egyptian limestone figures.

One of the most beautiful of the *kore*, the young female votive or commemorative figures to survive from the 'archaic' period of Greek art, is the so-called *Peplos Kore*, made in about 530 BC (pls 38 and 40). The symmetry – in the dressing of her hair as well as the distribution of weight – may remind us of Egyptian statues, but the weight of the *peplos* (the cloth covering her upper body) and of her plaits, still more the substance of her rippling hair, springing off the head rather than clinging to it, had been seen in no earlier stone sculpture. Also novel was the care taken to separate the soft, rounded flesh of the right arm from the dress beside it, and the fact that her left forearm originally projected to hold her offering and was made from a separate piece of stone. Traces of the original colouring survive to an unusual degree, enabling us to discern how much more vivid the features would have been. The flesh

39 Plaster cast of the *Peplos Kore* with conjectural reconstruction of attachments and colour, 129 cm. high (including *meniskos* but not plinth), Archaeological Museum, Cambridge University. The cast was purchased in 1975 and decorated in the same year by Bruno Laymann of Basle.

we might suppose to have been left as white marble, but in male statues it seems to have been given a ruddy colour. In addition, this figure would have had a wreath, ear pendants and shoulder brooches of precious metal, and, projecting from the crown of the head, a metal disk on a spike, so as to protect the face from bird droppings (pl. 39).

Unpainted marble was more easily accepted, or at least less easily concealed, in the temples, although many architectural parts were coloured. The Ionic capitals of the Erechtheum in Athens (pl. 41) dating from the late fifth century, more than a century after the *Peplos Kore*, still retained in the eighteenth century evidence of the red paint that was used as a background for the tiny, stylized palm ornaments on the collar resting on top of the shaft. Some red was found also in the hollows of the exquisitely calculated coiling line of the volute, which gives such tension and vitality to the cushion. There was gold in the eye of the volute, and glass beads of three different colours were inserted in the interstices of the guilloche, the plaited ornament below the cushion (pl. 42). As with the calcite 'alabaster' sculpture of the ancient Egyptians, the idea seems to have been to decorate the white stone rather than to conceal it.

Large pieces of marble could be shipped from the island quarries – though not easily or cheaply – and doubtless it was for this reason that the practice was adopted of combining heads and hands of white marble with draped bodies made of local wood or limestone. The most spectacular surviving example of such acrolithic sculpture, as it was called, is a late fifth-century life-size cult statue probably of the goddess Aphrodite (pl. 44), from one of the Greek colonies in Italy. The uncovered head, feet and forearms were made of marble, the wind-swept drapery of limestone, in the crevices of which traces of pink, blue and two shades of red pigment have been found. Obviously, had the flesh parts been fully coloured, there would have been little point in employing marble – though the marble may have been tinted and the features touched with colour.

40 (above left) Detail of the sculpture in plate 38.

41 (above right) Athenian, Ionic capital from the Erechtheum, Pentelic marble, 421–405 BC, Acropolis, Athens.

42 T.C. Donaldson, coloured glass beads from the guilloche ornament of an Ionic capital from the Erechtheum, watercolour, 1841–2, 3.7 cm. high, 5.8 cm. long, British Museum, London. (Department of Greek and Roman Antiquities).

41

The swirling, clinging, lifted and flying drapery of this statue is quite different from anything carved in any previous civilization. The evidence that it was coloured is incontrovertible, but it cannot have been painted in the manner of the *Peplos Kore*, for such ornamental patterns would have confused, or been confused by, the numerous ridges and folds of drapery.

A sculptor named Kallimachos, who worked in Athens in this period – the late fifth century – and was famous for the lightness and elegance of his figures and their complex, flowing and fluttering drapery, is also credited with the invention of the Corinthian order which, in the first half of the fourth century, was popular in Doric buildings as an internal order and soon afterwards became the most popular order for Greek architecture. The Corinthian capital, composed of curling acanthus leaves and scrolling tendrils arranged around a bell (pl. 43), could, in its earliest forms, be effectively coloured – the bell to contrast with the tendrils, the inside of the leaves to contrast with the outside – but, as this type of capital became more elaborate, reaching a climax in the early Roman Empire, colour would have contributed less (pl. 67).

43 Greek, capital from the tholos at Epidaurus, Greek marble, *c.*350 BC, Archaeological Museum, Epidaurus.

The introduction of high relief and of deep undercutting, also the increasing use of shadow – what modern sculptors, significantly, call 'colour' – must have been the chief reason for the increasing tendency to leave marble unpainted, at least in parts. Once marble had become a material that was left bare, or, rather, only waxed and tinted, connoisseurship of the different varieties became possible. Or it may be that the new quarries opened up to meet the increasing demand for marble made more varieties available and so stimulated an interest in them.

Marble from Naxos has large crystals but is not translucent; this is also true of marble from other Greek islands, most notably Thasos (in the north Aegean), where the marble is especially sparkling. That of Paros, in the Cyclades, extensively exploited from the sixth century onwards, tended to be slightly grey when quarried, but the best Parian marble, that extracted from mines in Mount Margessa, was exceedingly fine-grained and snow white, and of a translucency comparable with some calcite 'alabasters'. This Parian marble was used exclusively for sculpture, but it was very rarely available in blocks large enough for single figures. Pentelic marble from Mount Pentelikon, of a fine texture but less pure in colour, sometimes tending towards a beautiful gold, was the material chiefly used for architecture and sculpture in Athens, which was but a short distance away.

44 Colonial Greek (southern Italian or Sicilian), cult statue probably of Aphrodite, limestone and Parian marble, *c.*400 BC, 230 cm. high, J. Paul Getty Museum, Malibu.

Demand for marble increased enormously after the conquest of Asia Minor by Alexander the Great and the establishment in the third century BC of Hellenistic kingdoms, which required cult statues and temples that were Greek in material as well as in style. The prestige of Greek art ensured that the Romans were importing Greek marble even before they had conquered Greece and controlled its quarries. Under the Romans new quarries were opened and existing ones greatly extended, at Aphrodysias and Dokimeion in present-day Turkey and on the island of Proconnesos (Marmara, as it is known

today). There, in addition to blocks for statues and buildings, marble sarcophagi, for the most part of mediocre quality, were mass-produced for use in all parts of the Empire.

The Romans also discovered the white, dove-grey and streaky grey-and-white marbles of the Apuan Alps, the branch of the Apennines on the western coast of Italy between Pisa and La Spezia. By the second half of the first century BC white Apuan marble had begun to be employed in Rome, and soon after it was used in Gaul and North Africa. Portrait busts of the emperors found at Lullingstone and a statuette of the goddess Luna found at Woodchester, in the frontier province of Britain, were made of it, although local limestone would probably have been more usual for larger cult statues, such as that of Mercury in the temple at Uley in Gloucestershire (excavated in fragments together with thousands of bones of sacrificed sheep and chickens). Production at Luni, the Roman quarry town in this area of Italy, seems to have gone into decline by the late third century AD, perhaps because of the silting of the port. In any case, demand for marble in Italy declined in the years to come owing to bigotry and barbarism: statues of pagan gods and temples in the style of the Greeks were forbidden; the erection of public statues, like many other forms of civic life, had fallen into disrepute or merely begun to seem a futile vanity.

The quarries of the eastern Mediterranean flourished much longer. The marble of Proconnesos is streaked and banded with pale bluish grey which looks particularly splendid in columns – the Romans, unlike the Greeks, valued monolithic shafts – and as cladding for walls, where sheets were arranged to form symmetrical patterns – 'book-matched', as the furniture-makers call it. Vast quantities of this marble were used to adorn the new capital of the eastern empire, Constantinople, whence masses of it was looted by the Venetians. Thus one of the best places to admire it is the cathedral of Torcello – on the pavement, the wall of the choir, the cladding of the apse, the monoliths of the nave – and the basilica of Saint Mark, where 'the shadow, as it steals back' from the column shafts of the façade, reveals 'line after line of azure undulation, as a receding tide leaves the waved sand'.

Gradually the range of marbles available to sculptors began to contract. In some parts of the Empire none was easily obtained except by reusing earlier sculpture and buildings. The artist who carved a bust portrait of a bearded and balding man (pl. 45) out of streaky Proconnesos marble must have been one of the finest sculptors of his day, yet it would be rash to presume that he would not have preferred to use Parian or Apuan marble.

* * *

45 Roman, male portrait head, Proconnesos (Marmara) marble, probably *c.*AD 240–50, 25.5 cm. high, J. Paul Getty Museum, Malibu.

As the use of marble for sculpture declined in much of the Mediterranean, it became – entirely coincidentally – highly popular in China, in west central

Hopei, in the region of Ting-chou and Pao-ting, south-west of Beijing. Between the early sixth and the mid-eighth centuries this became a centre for the carving of small sculptures of the Buddha and of his holy followers, the Bodhisattvas. Over two thousand such sculptures were excavated from a temple site there in 1954, many retaining much paint. Larger works were certainly produced, of which the largest to have survived is the Amitābha Buddha, now situated in the north staircase of the British Museum (pl. 46). The figure is made of a single pier of marble, almost nineteen feet in length, which is fitted into a broad lotus-shaped base. Sadly, the statue was cut in half earlier in this century to facilitate its transport. No Greek and only a couple of Roman marble statues of this size survive, although many were certainly made. This reminds us of a highly important property of marble. When a gigantic ancient Roman statue of the Nile was discovered in the sixteenth century it was regarded as astonishing, not only for the quality of its carving, but because few if any modern quarries had yielded a block of any kind of stone of comparable size.

The size of the British Museum's Buddha, as well as its frontal character, the way it leans forward slightly, and the rough carving of the back, are characteristic of the tradition of sculptures which were set in caves – cut out of the 'living' rock. Buddhist temples of this type (derived from examples in the north of India) were made in China from the fourth century onward, and they were usually dominated by one colossal image of the Buddha. Such cave sculpture was of stucco or of stone, but both materials were painted, and we may be certain that the Buddha in the British Museum was coloured too, even though the marble is of great beauty, not unlike some Greek island marbles, in being composed of large crystals, but with a trail of grey specks floating across the lower part of the body like cinders on snow. What colours were used is uncertain, but microscopic traces of both ultramarine blue and copper green applied in an egg medium have been found on a comparable sculpture. The indentation in the centre of the forehead – the sacred spot, or *urna* – would originally have been set with rock crystal.

The Buddha's left hand and forearm, raised in the gesture of bestowal, and his right hand, signifying fearlessness, were separately carved and attached in much the same manner as the projecting arm of the *Peplos Kore* (pl. 38). Such attachments would have been concealed by the priming required as a ground for the paint. It is not easy to explain why the top of the Buddha's head and the sides of the neck are uncarved, unless there were plaster or clay attachments. Behind the statue there would have been a giant halo or aureole, possibly made of slabs of marble, but more probably of gilt wood. On either side there would have been a Bodhisattva.

The base, inscribed with the names of pious subscribers, records the date of completion, 585, during the Sui dynasty, and the original setting, a temple in Hancui village. The Amitābha Buddha was the supreme Buddha of the Pure Land sect, whose worship entailed no special austerities in this life and

46 Chinese, *Amitābha Buddha*, Hopei marble, AD 585, 548.6 cm. high, British Museum, London.

promised rebirth in paradise. The threadlike folds and the edges of the thin drapery are carved with repeated curves and ripples, akin to the curls of the hair and the lines of the benevolent lips and brows. The gentle and consoling rhythm of this carving is unlike anything in the sculpture we have seen in Mediterranean marble sculpture but resembles the limestone statuary of the Egyptians in that it consists of low-relief embellishment of an elementary shape. The same is true of the life-size figures of marble carved centuries later under the Ming dynasty, used to line the routes to imperial tombs; here, however, the low relief is denser and more ornamental in spirit.

These marble tomb-figures seem not to have been coloured, perhaps because they stood in the open air, and there is evidence that the natural colouring of marble was admired in China by the eighteenth century, when marble patterned in a manner suggestive of misty landscapes, quarried at Da-Li in Yunnan province, was set into Cantonese furniture or framed as an ornament to be placed on a table. Such an interest comes as no surprise, given the Chinese regard for jade. But in China marble never approached jade in prestige, nor, after Buddhism ceased to play a central role in the education of the Chinese ruling class, was sculpture like that of the great Amitābha Buddha much admired.

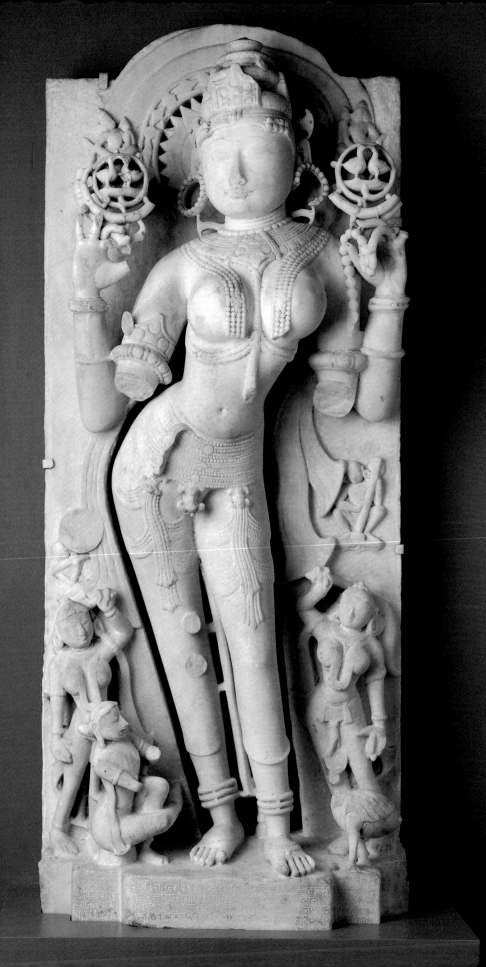

4 *White Marbles and Alabasters: Part 2*

WHITE MARBLE, WHICH PLAYS SO LARGE A PART in the history of Mediterranean sculpture and so significant if more limited a part in the history of art in China, occurs also in some areas of Rajasthan and Gujarat in India. It was used in Jain temple sculpture especially in the eleventh and twelfth centuries, most notably in the Vimla Sha Temple on Mount Abu. A fine and important example is a statue of Sarasvati, goddess of wisdom and knowledge, holding, in each of her upper hands, a pair of pecking geese encircled by tendrils (pl. 47). A third hand, now lost, would have made a gesture of charity, and a fourth, also lost, would have held a book. In the frame around her there are diminutive musicians, attendants with flywhisks, and her attribute, or mount, a headless gander.

The inscription on the base records that the statue was erected in 1153 to replace (and perhaps in some measure to replicate) one erected in 1069 which had been accidentally damaged. The new sculpture was the work of the sculptor Jagadeva, and was commissioned by the officer Parasurama (perhaps a descendant of the patron of the earlier statue). Here there are traces of colour, but different in character from any that we have encountered in Egypt, Greece or China. It seems to have been confined to the shallow incised outlines of iris, eyebrows and lips, and of decorations in the hair and perhaps elsewhere. Such coloured lines must have dramatized the swelling forms into which they bite, as well as enhancing the whiteness of the marble. The perforation of the block around legs and torso, and the zig-zag piercing of the halo, not only give freedom to the body but remove any idea of solidity from the relief slab. In the raised hands and the ear ornaments we marvel at the precarious undercutting. Perhaps the methods employed in such work encouraged the tendency to turn fingers, tendrils and jewellery into abstract tracery of rounded section.

The Mughal conquerors of India used white marble for much of their finest architecture. At first it was combined with red sandstone, as in the tomb of Humayun in Delhi of 1562–72; later it covered the entire surface, as in the Taj Mahal at Agra, completed in 1653. The marble for the Taj Mahal was not available locally; it was quarried near Makrana, 120 kilometres north-west of Jaipur. But the weightless radiance of such a building – flushed by the light of the rising and setting sun, glowing by moonlight, duplicated in water –

47 Jagadeva, *Sarasvati*, marble, 1153, 120.8 cm. high, Los Angeles County Museum, gift of Anna Bing Arnold.

49

48 Indian (perhaps Agra), upper portion of an arched screen, Makrana marble, *c.*1650, 45.5 cm. high, 74 cm. wide, Messrs Spink and Son Ltd, London.

demanded the use of the material. The decoration of the white marble with green-and-red stone inlay of patterns half abstract and half floral, and the piercing of complex geometric patterns (jalee work) into the marble to create screens (pl. 48) which made subtle divisions of light and shade and exhibited the translucency of the material, make it clear that the beauties of marble were never more respected or exploited than they were by the Mughals. But their Islamic affiliations prohibited figure sculpture, especially the monumental figure sculpture with which this material is so closely associated in Europe, and for which it had been employed in Jain temples in India itself.

The use of marble by the Mughals owes much to traditions originating in earlier Islamic art further to the west. Elaborate pierced marble screens were used in Ottoman mosques of the sixteenth century, and similarly complex patterns of inlay in marbles of different colours (*ablaq*) were favoured in Islamic Syria in the twelfth and thirteenth centuries. Both art forms in turn owed something to the ways in which marble had been used in the Byzantine Empire, to which these territories had previously belonged. Religious imagery was also prohibited by the Byzantine Church between 726 and 843 but this does not explain the taste in ecclesiastical art for elaborate abstract, or nearly abstract, patterns developed long before this date and well illustrated by a parapet panel (pl. 49) made in the sixth century for the church of San Vitale in Ravenna, one of the principal Italian cities of the Byzantine Empire.

In the centre of this panel there is a Cross. Two large and four small birds occupy other spaces. At first the panel looks repetitive and symmetrical in pattern, but closer examination reveals its variety. We soon discern that it is composed of quatrefoil frames filled with cruciform leaves, and of circular

50

frames within which the leaves spin. Next we notice that some leaves spin clockwise and some anti-clockwise. The pattern, though perhaps derived from those of Persian textiles, is not two-dimensional. The frames seem to separate themselves from the borders at the top and the side (but not lower) edges, and they flow from circle to quatrefoil, weaving behind and in front of each other as they do so. The swelling surfaces, originally polished, give off more interesting reflections than would flat ones and add to the vitality and elasticity of the composition. The marble is from Proconnesos, where, indeed, it is likely that the carving was made, and the streaks of grey which are characteristic of this marble enliven the pattern they cross, just as the small differences in the colour of the dye lend variety to the repeats of a Persian carpet, even if this effect may not have been calculated as part of the appeal of either.

The prefabricated nature of so much of the marble carving – screens, capitals, figurative reliefs – made at Proconnesos itself, rather than at the sites for which it was intended, made it easier to remove and apply elsewhere. The façade of the basilica of Saint Mark is encrusted with slabs and column shafts, some plundered from Constantinople and others perhaps transferred from Byzantine churches in Italy. Other medieval Italian cities also compiled their churches out of earlier buildings. The builders of the façades of San Miniato al Monte and the octagonal Baptistery in Florence employed white Greek marble from the ruins of local Roman architecture as well as Roman capitals and column shafts inside. The Pisans plundered marble from Roman sites for their cathedral but supplemented this with marble from Monte Pisano just outside the city. The Sienese, on the other hand, found a local marble at Montagnola for their cathedral. In all these cases, and in many others, white marble was combined with coloured stones – in Florence with dark green serpentine from Monte Ferrato north of Prato (*verde di Prato*, as it is generally known), in Siena

49 Byzantine (perhaps Marmara), screen panel, Proconnesos (Marmara) marble, *c.*AD 550, 72 cm. high, 126 cm. long, 6.5 cm. wide, Museo Nazionale, Ravenna.

with dark serpentine from Crevole in Chianti and elsewhere, and the red limestone of Montieri.

The Genoese, as well as looking for ancient Roman ruins that they could use, also turned their attention to the Apuan Alps which the Romans had quarried. By the twelfth century columns and capitals were being sent from the neighbourhood of Carrara for use in Genoa, though the purer white 'statuary' marble was not, it is thought, exploited there before the second half of the thirteenth century. Thereafter there was a steadily increasing demand from the cathedrals of Pisa and Siena, whose builders found that the white marble of the Apuan Alps was either superior to or more easily extracted than the local marble, for sculpture especially, and then, during the fourteenth century, from of the rival city of Florence, where there were no local marble quarries. The Sponda quarry near Carrara supplied vast quantities of marble for the cathedral of Florence and its bell-tower during the early fourteenth century. New quarries were opened at Polvaccio and Colombara during the course of the century under Florentine sponsorship and for Florentine use. The marble was generally shipped to Pisa and thence up the Arno to Siglia, whence it was carted into the city, but, when it was necessary to avoid Pisa for political reasons, the whole journey had to be made by cart.

The demand for white marble that led to the reopening of the quarries of the Apuan Alps – as decisive an event in the history of western European art as the development of painting in an oil medium in the Netherlands – was stimulated by architectural requirements. Sculptural imagery was increasingly being incorporated into buildings. If we bear in mind that the sculpture was conceived of, especially at first, as integral with the architecture, it is easier to understand why it was not painted, as figure sculpture was in the cathedrals north of the Alps and as ancient Greek and Roman marble sculpture had been. Colour was used on the bell-tower of Florence, and still more on the high altar tabernacle inside the granary and shrine of Orsanmichele: there is much gilding, coloured glass and mosaic inlay, in the latter, and coloured stones – *verde di Prato* (already mentioned) and the russet-coloured limestone, which bleaches to a lovely pink, from Cintoia and Monsummano (near Pistoia), in the former. The illustration here (pl. 50) show one of the series of hexagonal reliefs on the bell-tower today (faithfully copied from those carved by Andrea Pisano in about 1340, which have now been taken indoors). In addition to the framing green and pink, the background of the relief is roughened to form a key for some sort of veneer or coating – perhaps for blue glass, such as is used as a background for the allegorical figures a little higher up. In this architecture, as in that of Mughal India, framing and ornament (here including figure sculpture) were white, contrasting with colours that were inserted or recessed. Pisano was a goldsmith, and coloured stone or glass was used here exactly as enamels were in gilt copper or silver at that date.

It was said of the tabernacle in Orsanmichele that white marble was chosen in place of silver. Even if untrue, the story gives an idea of the prestige this

50 Part of the Campanile, Florence, showing the copy after the relief by Andrea Pisano and workshop, *Venatio (the Art of Hunting)*, Apuan marble, *c.*1340, 83 cm. high, Museo dell'Opera del Duomo, Florence.

material enjoyed. An inscription on the façade of the cathedral of Pisa boasts that it is unrivalled in its splendour because it is made of marble that is 'white as snow'. In northern Italy the conviction that only marble was suitable for a truly splendid church must have been as strong as the conviction that it should be made in the Gothic style. This is confirmed in the case of Milan. The cost and difficulty of transporting marble from the Apuan Alps drove the Milanese in the late fourteenth century to search for an equivalent in the mountains north of the city, which were part of their territory. A white marble frequently flushed with pink and sometimes peppered with grey was quarried at Candoglia, sledged down to the banks of the River Toce, floated from there into Lago Maggiore and thence down the Ticino to the canal, the Naviglio Grande, and into the city, where it was cut into cladding and pinnacles and thousands of statues for the cathedral – and *only* for the cathedral. The marble of Milan cathedral contrasts even more strongly with the brick, the dingy conglomerates and limestones (*ceppo*), and the grey granites of the rest of the Milan than do the marble churches of Florence with the local brown sandy limestone (*pietra forte*) and fine-grained sandstones (*pietra serena* and *pietra bigia*) used in the other buildings there. Candoglia marble is similar in colour and texture to the marble (strictly a cryptocrystalline dolomitic limestone) that came from Zandobio and other quarries and that, by the fourteenth century, was being used in Bergamo for ecclesiastical purposes – most memorably for the monoliths and their lion supporters in the porch of Santa Maria Maggiore facing Piazza Rosate (pl. 51).

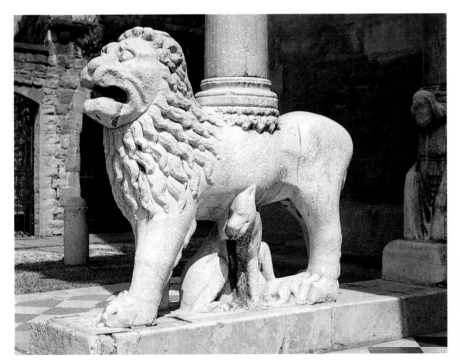

51 North Italian, lion supporter, Zandobio marble, *c.*1350, 144 cm. in height to the top of the base on the lion's back, porch of Santa Maria Maggiore, Bergamo.

52 Donatello, *Saint John Evangelist*, Apuan marble, 1408–15, 210 cm. high, Museo dell'Opera del Duomo, Florence. A side view to show the shallowness of the figure and the flat back. The statue is hollowed to enable it to be hoisted more easily into position.

Gradually the figure sculptures on these Italian Gothic churches increased in size and importance relative to the architecture to which they were attached. The statues of prophets and sibyls carved in Pisa in the late 1260s out of local marble by Giovanni Pisano for the façade of Siena cathedral – among them the prophet Haggai, a weathered and shattered but still-powerful fragment (pl. 76) – were over life-size and set in a row of niches high above the ground rather than concentrated in a portal, as would have generally been the case with such sculpture in a Gothic cathedral north of the Alps. Florence cathedral and bell-tower ('Giotto's tower') were similarly adorned by sculpture commissioned in the early fifteenth century, from Donatello and Nanni di Banco among others.

The architectural character of these sculptures is well demonstrated by Donatello's *Saint John Evangelist*, which was erected on the façade of Florence cathedral in 1415 (pl. 52). The elongation of the upper half of the body, the inclination of the head and the length of the neck (masked by the beard) reflect, as do similar features in Giovanni Pisano's sculpture more than a century earlier, the sculptor's concern to compensate for the angle at which the figure would be seen. The shallow projection of the knees and the flatness of the seated body when viewed from the side were dictated by the depth of the niche for which it was made. Although carefully designed for the architecture of the cathedral, these sculptures could be appreciated as separate works of art and even physically separated from it: one of the figures made by Donatello for the cathedral, his *David* of 1408–9, was transferred in 1416 to the town hall, the Palazzo Vecchio.

Some of the cathedral's statues were also conceived of in the round, most remarkably the *giganti*, the colossal ones intended to crown the buttresses of the new dome. One of these, a Hercules, was made in 1463 by Agostino di Duccio, and a second, of David, was projected. The David was originally to have been carved out of four blocks, but in December of 1466 a single block of sufficient size was extracted from the Polvaccio quarry. To reduce its weight prior to transport the figure was blocked out at Carrara. On arrival, it was found to have been spoiled by the mason's miscalculations and thus lay unused in the cathedral yard until August of 1501, when the cathedral authorities and the officers of the Guild of Woolworkers (which paid for the cathedral's adornment) allocated it to Michelangelo. However, the *David*, when completed in 1504, was set up, not on the cathedral, but outside the Palazzo Vecchio. Thus, heroic public sculpture in marble independent of architecture, such as had flourished in ancient Rome, was revived, almost accidentally, by the Church.

In his life of Michelangelo, Vasari likened the *David* to the huge marble sculptures made in antiquity that had survived in Rome, the *Marforio*, the *Tiber* and the *Nile* (river gods recently excavated), and the horse-tamers of Monte Cavallo (which had survived above ground). The growing interest in ancient Roman sculpture, and the rapidly increasing ambition to create

portrait busts and free-standing statues of gods and heroes and nymphs gave additional prestige to white marble, for it was, of course, the material from which most ancient examples of such work had been made. Thus white marble came to be regarded, during the sixteenth century, as the 'correct' material for sculpture in the antique style, as well as the most splendid material for architecture.

Although white-marble sculpture was at first thought of chiefly as ornament for architecture, separate small figures and groups were certainly being exported from Italy to northern Europe by the early fourteenth century. Marble was also exported in the form of blocks and was then carved by local craftsmen, for example for the reliefs, statuettes and elaborate architectural framework of the high altar of Cologne cathedral in the early years of that century, and in subsequent decades for altars at cities such as Liège on the Meuse. However, the most remarkable use of white marble outside Italy was for the French royal tomb effigies in the abbey of Saint-Denis. The earliest of these to be made of this material was that of Isabella of Aragon (pl. 53), first queen of Philip III, which was completed by 1275 and precedes the use of white marble for such a purpose in Italy. The innovation was an extraordinary one and was no doubt immensely expensive, perhaps as costly as gilt metal. It has much less depth than similar effigies of the same period in other materials, which suggests that it was made, not from a block newly quarried in Italy, but from a slab from the centre of a monolithic Roman column shaft. With the exception of this and some other royal tomb effigies, few large sculptures in white marble can have been seen outside Italy before a Madonna and Child carved by Michelangelo, commissioned for the cathedral of Bruges and sent there in 1506. It was only during the sixteenth century that white marble became the customary material for almost all figure carving of a large size and of the highest quality, first in Italy and then, after Italian sculptors had been summoned to work at the court of Francois 1er, in France.

53 Parisian, recumbent sepulchral effigy of Queen Isabella of Aragon, marble, c.1271–5, 176 cm. long, 48 cm. wide at feet, 16 cm. high at the crown (the highest point), basilica of Saint-Denis. The marble is slotted into the black 'marble' slab to which architectural elements, also of white marble, were originally attached. The angel supporters at the pillow have been lost, but their hands remain.

All of Michelangelo's sculpture, with the exception of a few bronze statues, was executed in white marble. Although Bernini in the seventeenth century used travertine as well, all his most highly valued sculpture was in white marble. And this was true, too, of Canova, active during the late eighteenth and early nineteenth century. More will be said of the work of these great Italian sculptors in the chapter that follows. For the purpose of this survey it is important to distinguish Canova, Bernini and Michelangelo from the equivalent sculptural genius of the fifteenth century in Italy, Donatello. Most of his marble statues were made for Florence cathedral and its bell-tower, or for the exterior niches of Orsanmichele. Some of his relief sculptures were made of white marble, but one of his finest, and the largest, the *Annunciation* in Santa Croce in Florence, was carved in *pietra serena*, the beautiful sandstone of Fiesole, and crowned with putti of terracotta. The same stone was used also for his heraldic lion, the *Marzocco*, and for his life-size standing female *Dovizia*, perhaps the most famous and conspicuous of all his sculptures, now known only in copies, which crowned a column in the Mercato Nuovo in Florence. His relief of the *Entombment*, with other relief carvings now lost, prominently incorporated in the high altar of the church of the Santo in Padua, was carved out of a limestone transported by river from the Nanto quarry on Monte Berici.

During the sixteenth century the white marble of the Apuan Alps was exported in steadily increasing quantities. In the 1580s it was used even by the ruler of Morocco for his new palace at Marrakesh (paid for with equal quantities of sugar). During the seventeenth century it became the dominant sculptural material in Spain, the Netherlands and England, as it had long been in France and Italy. The spread of classical ideals, the influence of Italian sculptors, improved transportation, and effective marketing by the merchants based in Genoa, some of them Flemish, who had had, since the sixteenth century, a controlling interest in the quarries near Carrara, all played a part in this. During the early nineteenth century, when the marble industry there was reorganized by Napoleon's sister Elisa Baciocchi, Princess of Lucca, and the prefabrication of architectural parts and the mass production of busts of Napoleon and other popular items was encouraged (as had been the practice in the ancient Roman quarries), trade was continued with Britain, where numerous marble monuments were required to commemorate Napoleon's enemies. It is estimated that by the late sixteenth century 1,000 tons of marble were extracted annually from the quarries near Carrara; by the mid-nineteenth century this had risen to 40,000, and by 1914 to 1,150,000.

New technology was notoriously slow to affect the traditional methods of quarrying, but the increase in production was not only stimulated by demand. It reflects the introduction of explosives, the successive use of water power, steam power and then electricity for saws and polishers, and the invention of cranes, cableways, railways and of wire saws.

There were rival marble quarries. The Florentines, keen to reduce transport

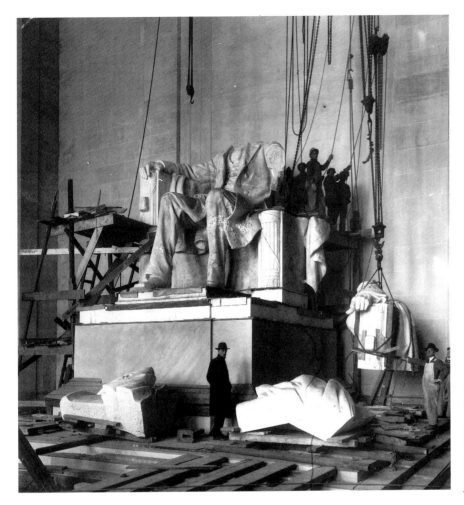

54 Daniel Chester French, *Abraham Lincoln*, Georgia State marble, 1911–22, 617.7 cm. high, Lincoln Memorial, Washington, D.C. The photograph showing the installation was taken in January 1919.

costs as well as their dependence on foreign sources, resolved in the mid-fourteenth century to use the marble quarries of the Campiglia in the Maremma instead of Carrara. But they seem to have changed their minds soon afterwards. Later, they sought statuary marble in the portion of the Apuan Alps that belonged to them, finding it at Seravezza, on Monte Altissimo near the town of Pietrasanta. The quarries there had first been exploited in the early sixteenth century by Michelangelo – very reluctantly, for he was content with the marble from Carrara and preferred carving sculptures to quarry management – and then more systematically in the middle of the century. The Grand Duke of Tuscany forbade the use of statuary marble from any other source in Florence. These quarries continued to thrive intermittently but seldom provided serious competition for Carrara. In the nineteenth century Greek quarries were reopened and enjoyed some success, and, in the early years of this century, considerable use was made of native marbles in the U.S.A. The famous massive seated statue of Abraham Lincoln completed by Daniel Chester French in 1919 (pl. 54) was carved out of twenty blocks of the coarse-grained white marble obtained from the quarries near Tate in Pickens

County, Georgia, whilst the exterior of the memorial temple in Washington, D.C., in which the statue was placed was made of Colorado-Yule marble, quarried near the town of Marble. In less patriotic circumstances, however, imported marble – 'Italian Bianco P' – was usually preferred by French and by other leading American sculptors – and, of course, by Getulio and Attilio Piccirilli and their assistants, the Italian *praticiens* who did most of the carving.

The chief objection to white marble was its vulnerability to frost and to other atmospheric conditions – a problem that increased north of Italy and limited its use for sculpture outdoors. Some types of Apuan marble available in the nineteenth century were reputed to be especially durable: that of Ravaccione, a quarry on Monte Sagro, west of Carrara, the slightly grey marble used for Marble Arch in the dirty centre of London and for the garden statues at Chatsworth on the frozen and mossy hills of the Peak District has indeed survived extraordinarily well in both situations.

Anxieties about marble led to the use of pale granites for public sculpture in the late nineteenth and early twentieth centuries, as has already been mentioned in Chapter 2, and it was often observed that other white or near-white stones have survived better than statuary marble from Carrara. This is certainly true of the white limestone that was quarried in Istria, near Trieste. The Venetians who conquered this region in the late ninth century shipped the stone across the Adriatic to embellish their city, and it became the chief building stone there.

Indoors, Istrian stone could not be mistaken for marble – for it is not white and is not polished (by sculptors, that is; perpetual handling, as on the coping of bridges, turns it a shiny yellow). However, when exposed to the elements, Istrian stone turns as white as snow – although always with thin threads of fracture on the surface. Huge blocks of it were available – each of the broad capitals of the arcade and each of the large and complex narrative groups on the corners of the Doge's Palace (pl. 55) is carved out of one. The groups, which are compressed, and also adjusted to the corner site, consist of figures as boldly and intricately undercut as those amid the flamboyantly fragile gothic cresting of the ogee gables of Saint Mark's, carved in the same years by the same sculptors out of white Carrara marble. Such marble cannot at a distance be distinguished from Istrian stone and was more costly to obtain, but since it was harder to work it may have been believed to be more durable.

The material of which the monument to Vittorio Emmanuele in Rome was made is generally described as white marble, and indeed the stone, a white limestone quarried near Brescia, is known as 'Botticino marble'. Many other limestones that can be polished are commonly (and commercially) described as marbles. Botticino marble is, in fact, easier to carve than real marble, especially when it has been freshly quarried, and the surface lends itself to more minute texturing than does the crystalline marble. The exquisite carvings on the late fifteenth-century façade of Santa Maria dei Miracoli in

55 Perhaps Lamberti family or other Tuscan workshop, *Judgement of Solomon*, Istrian limestone, *c*.1410, unmeasured, but the figures slightly larger than life, corner of the Doge's Palace beside the Porta della Carta. The base and arcade capital are of the same period and the same material.

Brescia (pl. 56) are perhaps the finest examples of ornamental work in this material. The detail illustrated shows the lowest portion of one of the pilasters. Within it four sirens with singing mouths and sharp eyes (inlaid with dark stones) support another pilaster. Parts of the leaves above their

59

56 Perhaps Giovanni Gaspare Pedoni, lower portion of an ornamental pilaster, limestone (Botticino 'marble'), *c.*1500, each harpy approximately 28 cm. high, façade of Santa Maria dei Miracoli, Brescia.

heads and the two central legs, which were daringly undercut, have been broken off; but the original tooling is preserved – very fine claw-chiselling in the moulding of the pilaster frame, and punching in the background of the pilaster within the pilaster.

Another alternative to white marble for western European sculpture is gypsum alabaster. The chief mines and quarries of the material during this period were in the Midlands of England – it was carved nearby in Nottingham, Derby and Burton-on-Trent, and further away in York and Lincoln. The earliest-known full-length effigy made of it, in the parish church of Hanbury, Staffordshire, is of about 1300; by the mid-fourteenth century it was much in demand for sculpture commissioned by the English court, and from the fourteenth to the sixteenth centuries it was exported all over Europe in the form of high reliefs carved on blocks of about 45 by 20 by 10 centimetres which could be assembled within an oak frame to form an altarpiece. Gypsum alabaster was available elsewhere in Europe – in Catalonia, the Netherlands, France and Germany – but it was generally harder to carve and was not so extensively exported, nor was it developed as an industry.

English alabaster is often streaked or mottled with rusty brown from iron oxides and some of it resembles animal fat in both colour and translucency. Only when pure white or with a few russet marks was it considered beautiful, and such pieces seem usually to have been preserved for important tomb

effigies. It was, however, difficult to obtain large enough pieces for this purpose. In the fine effigy of Sir Reginald Cobham (who died in 1446) which lies beside that of his wife on their tomb in the chancel of the Collegiate Church (pl. 57) which he founded in 1431 at Lingfield in Surrey, the veins of colour unavoidably included were confined to the grimacing Moor's head upon his helm and the sea-wolf by his feet (pls 58 and 59). The effigy would certainly have been coloured in parts – one of the attractions of alabaster is the ease with which it can be painted and gilded – but not as completely as were the majority of the altarpiece reliefs.

The high value attached to the best gypsum alabaster by the most ambitious European rulers is exemplified by the tomb of Philip the Bold, Duke of

57 London workshop, tomb of Sir Reginald, 3rd Lord Cobham, and his second wife, Ann Bardolf, chest of limestone with paint and brass lettering, effigies of gypsum alabaster with some paint and gilding, c.1446–53, Lady Cobham's effigy 201 cm. long, Collegiate Church of Saint Peter and Saint Paul, Lingfield, Surrey.

61

58 Detail of the
sculpture in plate 57,
showing the helm with the
crest of a Saracen's head
and the crown (retaining
some paint) of Lord
Cobham's hair. The helm
63 cm. long.

Burgundy, in the Charterhouse at Dijon. The sculptor, Claus Sluter, had to travel to Paris in 1392 to obtain a piece of suitable quality and size for a life-size effigy of the duke (destroyed during the French Revolution). This he obtained from a Genoese merchant (the quarry source is not specified). The fashion for white-alabaster effigies must have been stimulated by the white-marble effigies used for the tombs of the French royal family in Saint-Denis, and it is possible that, by travelling to Paris and approaching a Genoese merchant, Sluter had been hoping to obtain white Italian marble. The huge slab upon which the effigy was placed, the cladding for the tomb-chest and

the plinth for the whole tomb, were made of polished black limestone from Dinant, on the Meuse, south-west of Namur, which formed part of the duke's extensive dominions but was a very long way from Dijon. White limestone from Tonnerre, fifty miles north-west of Dijon, served for the Gothic arcade surrounding the chest, while for the tiny angels originally inhabiting the tracery and for the mourners winding their way in and out of the openings gypsum alabaster from Vizille near Grenoble, far to the south-east, was used – blocks of a suitable size for these statuettes were easily obtained.

Sluter's mourning figures (pls 60 and 61) are milky white, inclining to

59 Detail of the sculpture in plate 57, showing the sea-wolf at the feet of Lord Cobham.

60 Claus Sluter and collaborators, portion of the frieze of mourners around the tomb of Philip the Bold, Duke of Burgundy, gypsum alabaster figures, with polished black limestone, completed 1411, the figures *c.*40 cm. high, Musée des Beaux-Arts, Dijon (formerly Chartreuse de Champmol). The gothic arcading is a nineteenth-century reconstruction.

a warmer colour in some areas and including a few golden brown veins. Touches of colour and gilding were employed, for example for the hems of robes and the emblems of office, but otherwise the alabaster was not coloured, and this departure from usual practice is likely to have been influenced by Italian marble sculpture or, more probably, by ivory, which had generally been only partly painted and the colour of which had always been appreciated. The glowing alabaster mourners contrasted with the matt white stone of the tracery, which partly concealed them, and, more obviously, with the higher polish of the black stone, in which they were reflected. The rounded forms of the figures, the deep cavities where hoods and sleeves swallow heads and hands, their soft, yielding but heavy drapery, all gain from the translucency of alabaster which gives so much interest to the shadows. But Sluter was careful, in carving the features, to ensure that they were not too melting and indefinite.

Although gypsum alabaster had been replaced by white marble for chimneypieces, altarpieces, choir screens and tomb sculpture in England, Spain and the Netherlands, it was still employed in some parts of Europe,

especially, at the close of the seventeenth century, for small sculpture. Lazar Widman used it in Bohemia during the mid-eighteenth century for groups such as that of Saturn carrying off children (pl. 62). This elaborate composition is ingeniously carved in a manner reminiscent of much eighteenth-century sculpture in ivory, although somewhat larger in size. The stone is white but with a few brown streaks in it and a network of translucent veins, giving it an organic appearance, even more so than that of ivory, and this, together with its softness, makes it an almost alarming material in which to see naked flesh represented.

In Britain during the nineteenth century Gothic architecture was revived with a fervour unequalled elsewhere in Europe. There was a reaction against white marble, which was condemned as an alien material, unknown to the medieval sculptors in Britain and associated with pagan classicism. Alabaster consequently returned to favour for tomb sculpture, while local limestones and sandstones were more often employed for architectural sculpture. Yet in the homes even of ardent lovers of the Middle Ages there would be portrait busts in the hall and full-length nymphs in the conservatory, carved out of

61 Claus Sluter and workshop, mourners from the tomb of Philip the Bold, Duke of Burgundy, gypsum alabaster, completed 1411, 41.3 cm. high (figure with bare head), 41.2 cm. (nobleman with forked beard) and 41.6 cm. high (nobleman with a rosary), Cleveland Museum of Art. The figures are from the same series as those represented in pl. 60 and are represented in Dijon by plaster casts.

Italian marble, and in the drawing-room statuettes in the biscuit porcelain made by the firm of Copeland under the trade name 'Parian ware'. This porcelain was deemed to emulate, in its purity of colour, fineness of grain and seductive translucence, the most prized of all of the white marbles among the ancient Greeks and Romans when their civilizations were in their prime.

In this century, and in Britain especially, some sculptors, influenced by the doctrine of truth to material, have preferred stones with more obvious limitations and have distrusted the versatility of white marble. The nature of that versatility – so essential for the understanding of European sculpture – is the subject of the next chapter.

62 Lazar Widman, *Saturn with two children*, gypsum alabaster, *c*.1750, 44.5 cm. high, Los Angeles County Museum of Art.

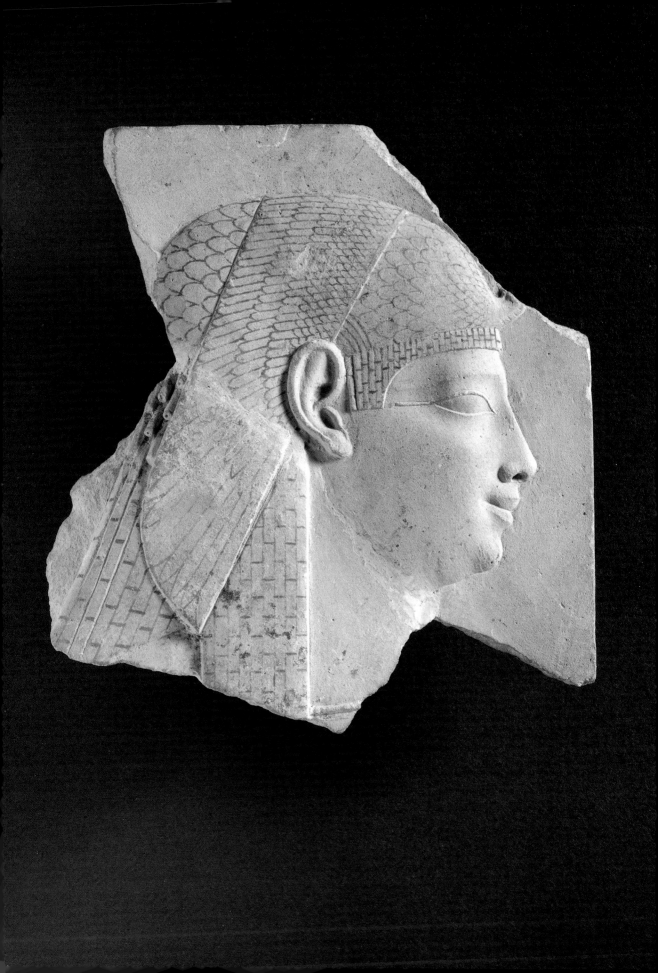

5 *The Versatility of Marble*

IN A PORTRAIT STATUE of a husband and wife carved in about 1350 BC, which has already been described as an example of ancient Egyptian limestone sculpture (pl. 36), there is the same absence of undercutting, perforation and projection that is characteristic of monumental Egyptian sculpture in granite. It is not merely that the seat is treated as a solid block: the legs seem also to be attached to it. The stone beneath the kilt and lower legs of the man is not undercut – it is not even cut straight back. At the point where they meet, the arms of the two figures, instead of being conceived as two distinct rounded forms, seem locked together.

There is no reason why limestone should be treated in this way and a thousand years earlier in Egypt such sculpture had sometimes been more deeply cut. Perhaps there was a reluctance to depart from conventions that had evolved for the working of harder stones, or a desire to imitate in portraits of mortals the conventions employed for statues of deities, which were chiefly made of these harder stones. In contrast, life-size Egyptian wooden figures (pl. 113) have spaces between their legs and arms which hang free from their bodies. As we shall see, such figures were usually assembled, whereas stone sculpture was reduced from a single block, with drawings on the smoothed faces serving as a guide.

A miniature relief in fine limestone of the profile head of the goddess Isis (or a Ptolemaic queen in this guise), which may have been a sculptor's trial piece, exemplifies the sort of precise preliminary drawing with red earth that seems to have been characteristic of Egyptian, as also of Assyrian, sculpture (pl. 63). It was used for statues as well as for relief sculpture, and, indeed, this carving which was begun in relief is continued, where the back of the head meets the edge of the stone, in the round.

Greek marble sculpture of the archaic period was similar to, and surely influenced by, Egyptian stone statuary: it, too, must have been carved following drawn guidelines. But the legs of the nude male figures are divided, and the arms, of both male and female figures (such as the *Peplos Kore*), are detached from the side of the body. The Greeks drastically lightened the block. A simple explanation for this is that wooden statues served as the models for stone ones. Some sculptures of wood certainly enjoyed sacred status in Greece (as was not the case in Egypt), and perhaps there was an incentive to imitate them exactly in stone. A similar hypothesis has been advanced for the replication, or rather commemoration, of timber construction in the forms of

63 Egyptian, sculptor's trial piece, with the head of Isis or a Ptolemaic queen as Isis, limestone with red pigment, *c*.200 BC, 10.3 cm. high, Ashmolean Museum, Oxford.

69

the Doric temples that the Greeks built out of stone. Furthermore, Greek sculptors are known to have worked in both materials, and many statues were indeed made of wood (painted and gilded), with marble extremities. Such works have not survived and so are not mentioned in most histories of Greek art, but it is clear from Pausanias's description of Greece written in the second century AD that they were not only numerous but important.

Greek sculptors not only perforated the stone to imitate the detached limbs of wooden sculpture but also added separately carved forearms which projected from the front face of the block: the *Peplos Kore* (pl. 38) is typical of the female figures in that there is a socket into which such a forearm would have been fitted with a deep and tightly fitting tenon join. In other instances heads or the lower legs were added, but the projecting additions are more common, and more significant, for sculpture constructed in this way cannot be planned entirely by drawing on the block. No doubt such drawings remained important, but Greek sculptors must soon have learned to use other materials for their models, and stone carvers who were influenced by the methods, or who emulated the appearance, of wood carvings were also ready to imitate work in clay or wax. Marble sculpture gained rapidly in plasticity, that is, in its ability to imitate effects of modelling in a soft material in which undercutting — whether of curling hair or folded cloth — was easily achieved and in which forms were as often and as easily built up or pulled out as they were cut back or dug out.

This was not the first time that such a transfer of plastic forms to glyptic sculpture had taken place. Among the ancient marble figures from the Cyclades there are some that represent harpists (pl. 64). They are designed in silhouette, cut out of one or other of the faces of a slab, and much of the cutting is angular. However, it seems obvious that such works were inspired by clay models, which were no doubt less planar in composition and softer in character. It is as easy to devise a small figure with such an open pose out of rolls of clay as it is laborious to carve one out of stone.

If the use of wooden models for Greek marble sculpture perhaps reflects a certain conservatism, then what happened in Greek sculpture between the sixth and fourth centuries can be explained only by an unprecedented interest in artistic innovation and experiment, much of it stimulated by this transfer of ideals from one artistic medium to another. A novel vitality may be discerned in the hair of the *Peplos Kore*. The locks of an athletic victor, one of the most beautiful of all surviving Greek marbles and now at Petworth (pls 65 and 66), possess the freedom, indeed disorder, of real hair. Or so one might be tempted to claim. What it more closely resembles is hair that has been 'permed', that is, modelled and set by the hairdresser. The sculptor is imitating the way hair was represented in bronze, which was in turn cast from a model, or rather from models, made in wax and assembled; for Greek metalworkers, as we shall see, were skilled at adding separately wrought elements to their sculpture — not only ear ornaments, wreaths or spears, but

64 Cycladic, tomb figure of a harpist, Naxian or Parian marble, *c*.2800–2600 BC, 29.2 cm. high, Metropolitan Museum of Art, New York, Rogers Fund, 1947.

ringlets and sometimes, numerous curls. If it is important when considering Greek sculpture of the archaic period to remember that the carvers in marble also worked in wood, then it is of no less importance for the appreciation of the innovations of their successors to recall that they also often made work in bronze, which involved modelling in both wax and clay.

This particular marble sculpture is thought to be derived from a bronze statue of an athlete, now lost. Not only the treatment of the hair, but the cutting of the eyelids (which in the bronze would have been hollowed out to receive hardstones or glass paste) and the outlining of the lips (which in the bronze would have been made of, or plated with, another metal), suggest this. Whether or not this particular work is a replica of a celebrated bronze (as has perhaps too easily been assumed) it is certain that the reproduction of

65 and 66 Roman, head of a Greek athlete (fragment of a statue falsely mounted as a bust), fine-grained unidentified Greek marble, probably early first century AD, 18 cm. high (excluding bust), the National Trust Collection, Petworth House, Sussex.

73

67 Roman, Corinthian capital, fine-grained unidentified marble, much restored in plaster, early first century AD, 60 cm. high, Museo Nazionale Romano (cloister), Rome. Fished from the Tiber at Tor di Nona, *c.*1900.

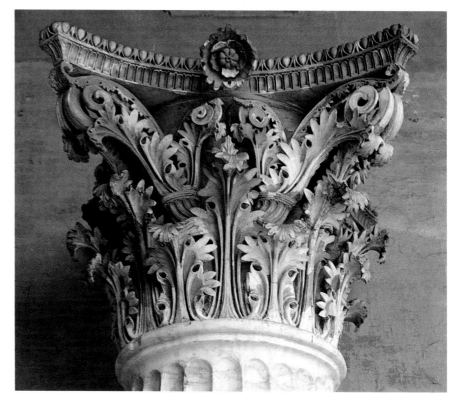

68 (facing page left) Roman, *Apollo Belvedere*, probably Apuan marble, 224 cm. high, *c.*AD 120, Belvedere Courtyard, Vatican Museums. A copy of a bronze by Leochares of the fourth century BC. The sculpture is shown without its modern restorations but with the neat cuts and dowel holes made to fit such.

marble copies of acknowledged Greek masterpieces was an important industry throughout the Roman Empire by the first century AD.

The thin overlapping and overhanging leaves of the Corinthian capital (pls 43, 67), like the tangled locks of the Petworth athlete, must have originated in metalwork, in which such elements could be separately wrought and assembled. Significantly Kallimachos, reputedly the inventor of this type of capital, is recorded as working in both bronze and marble. But such capitals were imitated by sculptors in marble, which was far less costly than bronze, although perforation and undercutting as well as the detail in the carving require great skill. This type of Greek capital eventually became canonical and was copied in marble and stone for hundreds of years with only minor modifications throughout the Roman Empire and then again after the Renaissance throughout the western world.

New possibilities in marble carving were revealed by the efforts of artists to emulate effects more easily achieved in other materials, but when bronze statues were simply copied in marble, the limitations of the material were inevitably exposed. By making the legs solid and the rest of the body hollow, the sculptor in bronze can support a horse on its four legs, indeed often on three of them, and sometimes even on two. A marble statue of a horse would require a pillar, a heap of rocks or a squatting barbarian beneath its belly.

74

Similarly, the weight of a human torso carved in marble cannot be supported on legs that are widely separated, especially when one heel is raised.

In the marble sculpture of the *Apollo Belvedere* (pl. 68), which is a copy, probably made in the first century AD, of a bronze original of the fourth century BC by Leochares, we find a block beneath the god's left foot and a tree trunk supporting his right arm. It is unlikely that either stump or block were part of the bronze original. The hanging drapery, however, which helps

69 (above right)
Gianlorenzo Bernini,
Apollo and Daphne, Apuan
(Carrara) marble, 1622–5,
243 cm. high, Villa
Borghese, Rome.

support the god's left arm, also imparts majesty to the figure. This must have been a feature of the original. Fine cloth is more easily imitated in metal; the folds on one side of the marble drapery do not correspond with those on the other, as we suppose they would have done in the bronze. Thus the open pose of a sculpture like the *Apollo Belvedere* cannot be achieved without distracting structural expedients, and the final work in thin metal cannot be imitated in marble. It is also extravagant to cut such a form from a marble block.

'Piecing' was always common in Greek and Roman marble sculpture. Deep drapery folds across the waist of a Venus might conceal a join; portrait heads were inserted into busts and statues, the join corresponding with the edge of a breastplate or cloak. However, if, like the *Apollo*, the figure was nude, such a join could not be concealed, and was rarely attempted. An idea of the block out of which the *Apollo* was cut can be obtained by imagining the case that would be needed to contain it. The vast amounts of padding that would be required under the arm correspond to the marble that would have been wasted (or perhaps carefully salvaged to serve for a statuette or a portrait bust).

The *Apollo Belvedere* was excavated in Rome in the late fifteenth century and soon became not only the most famous statue, but the most admired work of art in western Europe. What to us may seem to be unhappy expedients, obtrusive proof that the sculpture is merely a translation, did little to discourage sculptors from creating works in a similar spirit. The group of *Apollo and Daphne* (pl. 69) created by the young Gianlorenzo Bernini for the villa of Cardinal Scipione Borghese in Rome, a villa that was filled with ancient marble sculpture, is one of the most extraordinary examples of this. In it the slow, deliberate movement of the *Apollo Belvedere* is accelerated; here all props and struts are ingeniously concealed, with the nature of the objects represented by them contradicting the very idea of support. Thus the carved leaves that spring from Daphne's raised hands are tied together and united with her head by a branch of marble, which, however, takes the form of her hair blown up into the leaves. It would be impossible for Apollo to remain upright without the support provided by Daphne, to whom he is attached where he touches her, where her hair streams onto his shoulder and where some laurel touches the cloud of drapery that floats across his waist – at each of these points there is a firm bridge of marble, but, again, the form discourages analysis of function.

Bernini's group was made from a single piece of marble (with a few additions to the rocks of the base, made in the late eighteenth century to adjust it to a larger pedestal). Carving around the figures was exceedingly difficult, and the undercutting of the paper-thin leaves, the blown-back drapery and the strands of hair is work of extraordinary virtuosity. This was delegated to the specialist carver Giuliano Finelli. We tend to think of sculpture like this as a pictorial conception ingeniously executed in marble,

70 Joseph Nollekens, *Diana*, Apuan (Carrara) marble, 1775–8, 126 cm. high, Victoria and Albert Museum, London.

but consideration of the underlying structure reveals that every compositional idea was conditioned by a profound knowledge of the practical problems of carving.

Not all European sculptors producing marble statues of the finest quality to place beside antique ones in the galleries of palaces and villas went to such lengths to conceal the supports. Indeed, some sculptors regarded conspicuous supports as legitimate, and no doubt licensed by ancient practice. Between 1775 and 1778 the English sculptor Joseph Nollekens carved a statue of Diana for Wentworth Woodhouse (pl. 70), the great country house of the Marquis of Rockingham, which included a collection of ancient Roman sculpture. The figure is running and shooting. (Though not copied from a bronze original, the spiral pose was, significantly, inspired by a small bronze statuette.) There is a tree stump of marble between the goddess's legs. The bark swirls round as it never would in nature, so that we think of it as participating in the figure's movement. But there is also a bar of marble joining the outstretched arms. This we must remove in our imagination, just as we must add the bow that she shoots.

71 Antonio Canova, *Cupid and Psyche*, Apuan (Carrara) marble, 1787–93, 155 cm. high, Musée du Louvre, Paris. The brass handle beside Psyche's foot was originally used to rotate the group.

In gallery sculpture of this kind, 'piecing' was generally avoided. It was, however, practised extensively in restoring the ancient Roman sculptures that were excavated, usually in a broken and frequently in a fragmentary state, and sometimes, when fine or extensive projections were required for modern work, such as the translucent wings in Canova's group of *Cupid and Psyche* (pls 71 and 72), they were added. Other parts of this sculpture were also separately carved: the vase that Psyche has dropped, and Cupid's quiver, as well as part of the drapery and rock below the heroine. In some other sculptures the ancient Greek practice of using gilt metal accessories, including necklaces and bracelets, was revived, which enabled joins to be concealed.

None of the sculpture we have been considering could have been made without the use of the drill. This enabled the straight arm of the *Peplos Kore* to be separated from the body beside which it hangs, and made possible all the other far more complex perforations in the sculpture of Bernini, Nollekens

78

72 Rear view of Canova's *Cupid and Psyche* (pl. 71).

and Canova. It was the drill, too, that enabled the Greek sculptor to create, or to imitate, the deep curls of the hair on the athlete's head at Petworth. Files have removed much of the evidence of its use, but on close scrutiny circular holes in the depth of the hair and, in a few places, chains of such holes, betray the use of the drill, as they tend to do also in the hollows of Corinthian capitals. Kallimachos, who was said to have invented such capitals, was also famous for innovations in his use of the drill. The drill and other tools for working marble sculpture demand a separate chapter.

6 The Traces of the Tool

SOPHISTICATED ROMAN COURT SCULPTORS of the second century AD employed drills with an ostentatious virtuosity that is exemplified by an extraordinarily well-preserved bust of the Emperor Commodus in the guise of the deified Hercules (pl. 73). The lion's pelt wrapped around the emperor's head is deeply cut to contrast with the writhing worms representing the hair and beard. The eyes of the emperor seem to gaze at a higher world, whilst he holds, effortlessly, the hero's club and the apples of the Hesperides (which give immortality). The broad expanse of his flesh is contrasted with the miniature forms of the support – deliberately inadequate in appearance and including cornucopias with leaves and fruit picked out with a miniature drill. Oil lamps would no doubt have kept the highlights and shadows tremulous upon the highly polished surfaces and within the deep hollows of the bust. We may imagine its miraculously floating in the dark interior of the imperial palace, gleaming white amid the richly coloured marbles.

With the drill impressive results can be achieved quickly, and Roman sculptors of the second and third centuries depended more and more on this. A good example is provided by a massive sarcophagus (pl. 74) sent to Italy from Dokimeion deep in Asia Minor. The modelling of the figures of the couple commemorated in the centre of the sarcophagus is bold, with all the hollow drapery folds, like the spiral flutes of the columns that flank them, cut by the drill running obliquely to the face of the marble. The acanthus capitals of the columns, the egg-and-dart ornament of the entablature and the concavities of the shell within the pediment have been adjusted in size so that they, too, can be represented in drilled shorthand. They are quite altered from their prototypes in Greek architecture several hundred years before. Only a thin membrane of marble remains to divide the dark shadows.

In subsequent centuries architectural ornaments underwent stranger transformations, well exemplified by a capital (pl. 75) that was toppled to the ground in the great new imperial city of Constantinople (now Istanbul). The popularity of the arcade, with brick arches springing from columns, involved a revision of the shape of the Corinthian capital: it was now conceived of as a massive block, with the surface drilled through in a simplified leafy pattern. It cannot be claimed that this is simply a labour-saving substitute for carving more three-dimensional leaves and tendrils, for the drill-holes were given a variety of shapes and were all laboriously undercut, by means of files and rasps

73 Roman, bust of the Emperor Commodus deified as Hercules, Pentelic marble, c.AD 200, 118 cm. high, Capitoline Museum, Rome.

81

74 Roman, central portion of a severely weathered sarcophagus showing a married couple or allegory of Union, Phrygian (Dokimeion) marble, early third century AD, 117 cm. high, Museo dell'Opera del Duomo (courtyard), Florence. Sarcophagi of this type were exported to Italy from Asia Minor.

rather than chisels, so that the surface resembles a woven textile miraculously detached from the solid core. This delight in cutting the stone into weightless, pierced, abstract forms, exemplified also by the parapet at Ravenna and by the jalee screen illustrated in an earlier chapter (pls 48 and 49) may be supposed to have more to do with the tools favoured than with the material employed, but not many stones can be made to emulate the basket and the net, and white stone contrasts most effectively with the shadows created by drilling into it or through it.

82

75 Byzantine, Corinthian capital, Proconnesos (Marmara) marble, *c.*550, unmeasured, Istanbul.

The ancient figurative carving most familiar in Italy during the Middle Ages was that on sarcophagi of the second and third century AD. The study of these must have encouraged the use of the drill. Giovanni Pisano, working in the late thirteenth century, was especially aware of its expressive potential, as is clear from the fragments of one of his prophets for Siena cathedral (pl. 76) – clearer, indeed, than he intended, for weathering has worn away much of the surface, leaving the holes more conspicuous than they originally were. But the most remarkable innovations in the handling of the drill belong to the seventeenth century. Comparison between the treatment of hair in Bernini's *Apollo and Daphne*, essentially an arrangement of locks, and that of the *Apollo Belvedere*, essentially an arrangement of curls, prepares us for the broad handling of the hair of Bernini's portrait of Thomas Baker (pls 77 and 78). Only one large size of drill was used here, and it was driven deep into the mass of the hair so that not only the cheeks but part of the brow are framed in shadow. In some places a run of drill-holes is partly filed down, for instance where the uppermost locks above Baker's left eye flop over the longer locks below, but in other places – directly above the centre of his forehead and in several places beside his right cheek – those holes have been left more obvious than in other work by the sculptor that was designed to be viewed at close quarters, and it is, in fact, likely that Bernini was forbidden to complete this bust of an English diplomat, for Pope Urban VIII wished to prevent anyone from receiving the privilege of a portrait by his court sculptor unless it was with his consent or at his command.

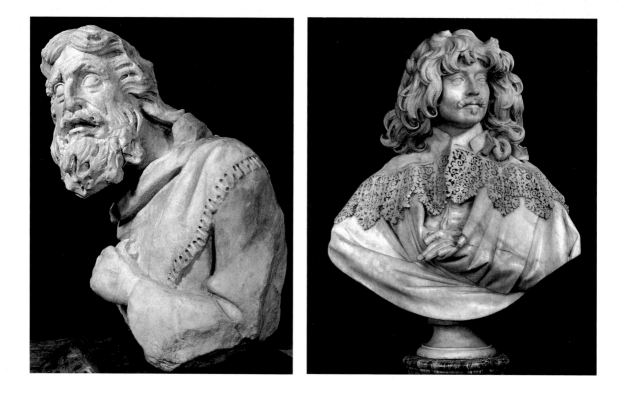

76 (above left) Giovanni Pisano, fragment of a statue of the Prophet Haggai, Apuan marble, 1284–96, 63.8 cm. high, Victoria and Albert Museum, London.

77 Gianlorenzo Bernini and assistant, *Thomas Baker*, Apuan (Carrara) marble, 1637–9, 81.6 cm. high, Victoria and Albert Museum, London.

78 (facing page) Detail of pl. 77.

79 (page 86) Michelangelo, *Virgin and Child* (*Medici Madonna*) Apuan (Carrara) marble, probably 1521–3, 226 cm. high, Medici Burial Chapel, San Lorenzo, Florence.

80 (page 87) Detail of pl. 79.

There is no attempt to disguise the fact that the perforations in the lace collar, where they are continuous, consist of combined drill-holes. These create a pattern that is uneasy on the eye, like a blur or vibration, discouraging careful scrutiny. It is, all the same, near enough to the look of real lace to disappoint by its mechanical and coarse character, and it is highly distracting, drawing the eyes away from the face. It may have been the work of an assistant.

Before Baker's collar was drilled, the parallel grooves of a claw chisel were used to create the swirling pattern that animates the surface of the marble. Such tool marks are also very apparent in the hair. Ancient Greek and Roman sculptors used the claw chisel, but when its traces were deliberately left in a finished carving this was, it seems, intended to create a rough, overall texture, thus avoiding the flat appearance of a smooth surface when viewed from a distance. Very finely grooved tooling is not uncommon in medieval limestone sculpture, but the purpose of this was to provide a key that would prevent the white ground which was originally applied on top from flaking off.

Whereas much ancient Greek and Roman marble was carved without the use of the claw chisel, in most European stone sculpture since the sixteenth century this tool has been a crucial intermediary between the point chisel, used for the rough shaping of the block, and the flat chisel, used for the final cutting. The form of the claw chisel (tooth chisel in North America, and *gradina* in Italy) varies, from a chisel with two long points (the *calcagnolo* or *pied de biche*) to a notched flat chisel (*dente di cane*), and its 'bite' depends upon the angle at which it is driven. In Michelangelo's *Medici Madonna* (pl. 79)

84

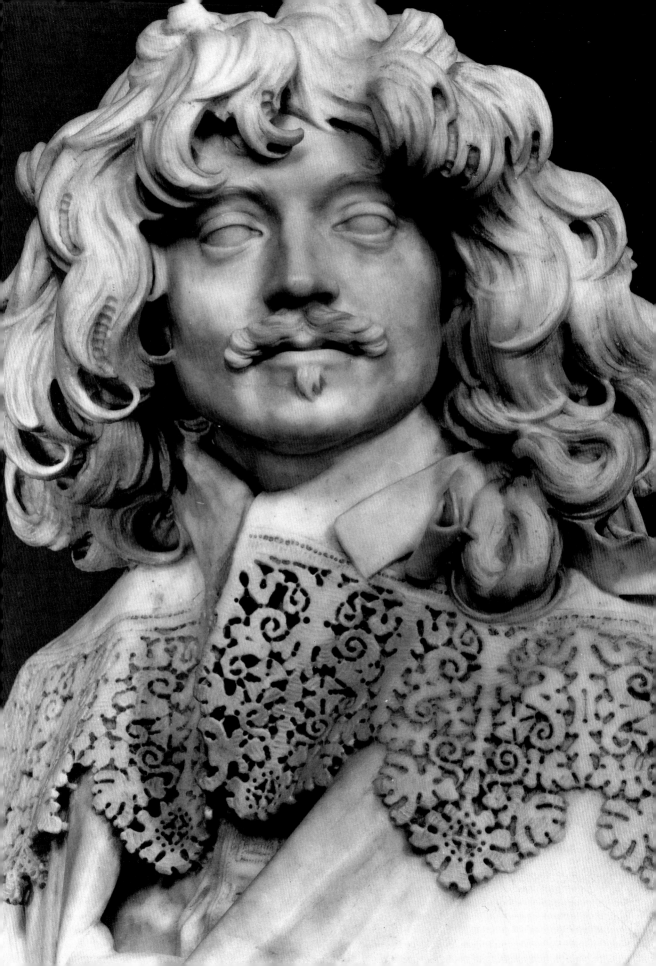

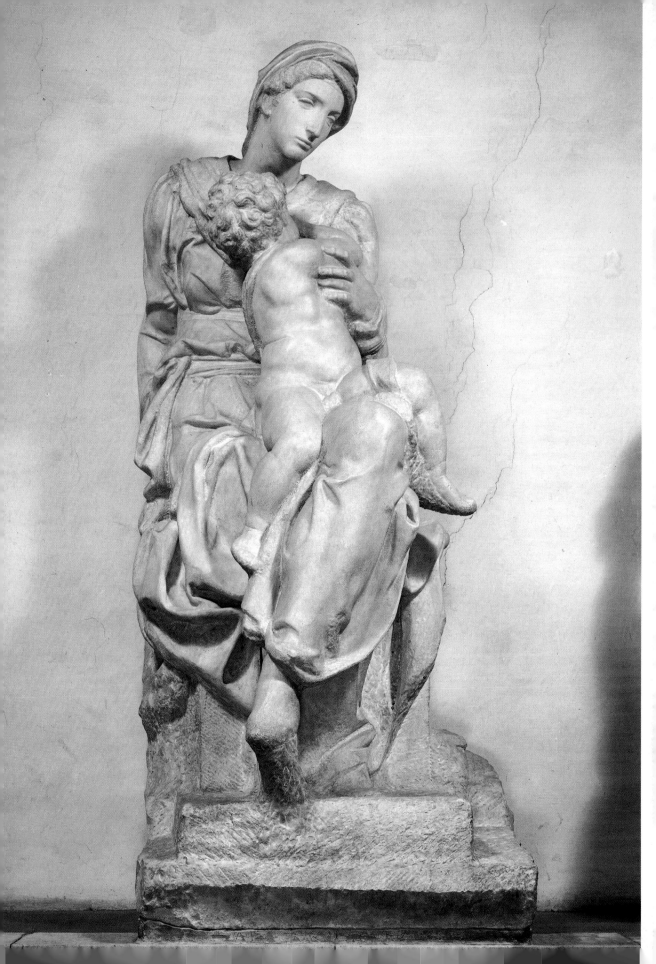

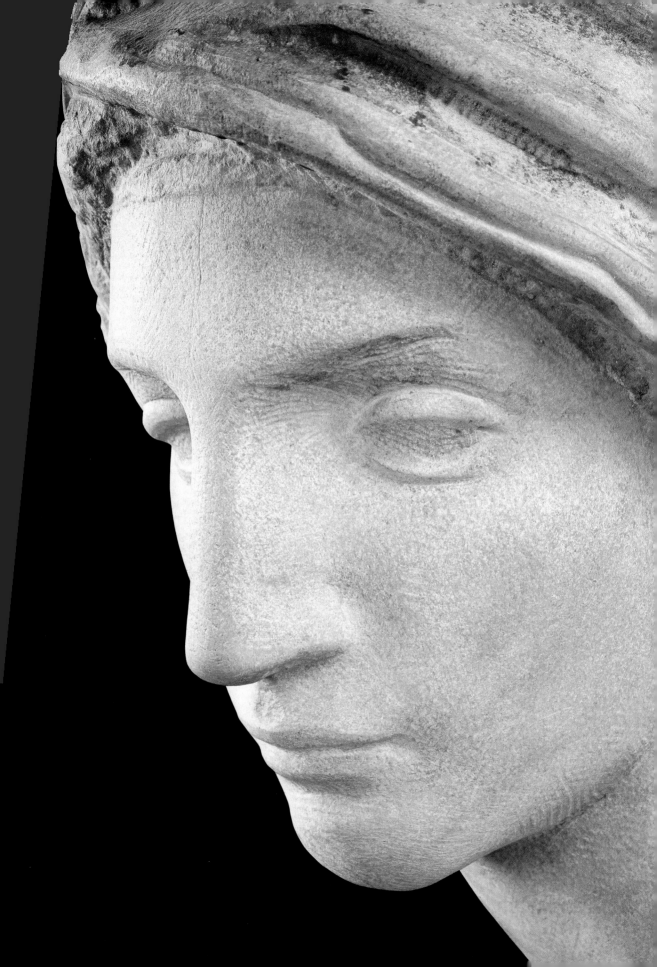

some of the marble not yet cut away beside Christ's left foot or beneath the Virgin's skirts exhibits the punctures made by the point surrounded by hollows where the surface has burst away. Series of tiny punch holes outline forms. The hair has been largely defined with the point. The base is scored by jagged parallel cuts made by driving a point at an oblique angle – a procedure especially favoured by Florentine masons. Almost all the parts that appear at first to be finished retain the traces of claw chisels (pl. 80). In his finished work these traces would remain only on such parts as the beard of the *Moses* or the rocks at the feet of the *David*. Nevertheless, the beauty of the hatched and cross-hatched textures of Michelangelo's sculpture at this stage was appreciated by his contemporaries. It imparts a melancholy beauty, a softness and distance of expression, as well as a tension to the modelling, and is reminiscent of some of his no less novel techniques of drawing.

The exhibition of the carver's tool-marks, analogous to the display of the painter's brush and palette knife, became increasingly characteristic of Italian marble sculpture in the seventeenth century. It had earlier been employed by Italian architects for the 'rusticated' masonry of palace facades and garden grottoes. Massive stones bearing the gashes and punctures of pick and point, such as had been used in Roman engineering and for traditional Tuscan fortified palaces, were now relished from an aesthetic point of view, as were the grooves of the claw chisel and the grainy texture of the *boucharde* (a

81 (above) Florentine, rusticated window surround, local sandy limestone (*pietra forte*), late sixteenth century, unmeasured, Palazzo Vecchio extension, Via de' Gondi, Florence.

84 Maurice Sterne, *Sitting Figure*, unidentified Greek island marble, 1932, 57.9 cm. high, National Gallery of Art, Washington, D.C. (gift of Lawrence H. Sterne and Marshall H. Sterne).

82 (page 88) Gianlorenzo Bernini, *Apollo and Daphne* (detail of pl. 69), Apuan (Carrara) marble.

83 (previous page) Antonio Canova, *Cupid and Psyche* (detail of pl. 71), Apuan (Carrara) marble.

hammer with pyramidal points on its striking face, favoured by French masons), which contrasted with sharp edges and smooth mouldings. All the types of tooling that may be observed in Michelangelo's unfinished marble tondo are present in the rusticated window surrounds of local brown stone made in Florence in the same period (pl. 81).

Bernini gave a grooved texture to the rocks in the base of his *Apollo and Daphne* and a similar texture to the bark, contrasting this with the eggshell finish of the drilled-out flower heads and the high polish of the delicate toes of Daphne, from which new roots already extend (pl. 82). In Canova's *Cupid and*

Psyche (pls 71 and 72) we discern an even greater interest in surface textures: the highest polish is given to the vase on the ground, which we have already noted as being carved separately. The drapery is less polished but it contrasts with the roughened ground and also with the flesh, which has been scraped with the rasp – the minute scratches can be seen flowing round Psyche's left hip and under her right arm (pl. 83). The very fine chiselling of the down on the wings is blended exquisitely with the fine striations on the skin. The hair, which is daringly perforated by the drill, has been combed with a claw chisel.

Relatively little imitation of the surfaces of the real world is involved. Rocks and bark are rough, but they are seldom grooved. The sight of these textures elicits a sympathy with the making of sculpture – the use of tools – and can also stimulate appropriate tactile sensations, awakening the recollection of touching. Such surface excitement in sculpture may be felt to be superficial in its appeal, and such virtuosity in carving did often lead to mere technical exhibitionism: Canova himself seldom repeated the surface effects he had created in his *Cupid and Psyche*. And when, in the second half of the nineteenth century, the flamboyant style of Bernini was revived, there was a strong reaction, most notably exemplified in the sculpture and the theoretical writings of Adolf von Hildebrand.

A fine example of the sort of carving that owed much to Hildebrand's purist example is Maurice Sterne's *Sitting Figure* carved near Rome in 1932 (pl. 84). The square base, with its rough-hewn upper surface, reminds us of the controlling influence of the block upon the entire form. The sculptor seems content to accept these limits, and for us to be aware of them. We can imagine clearly how the outline of the figure was inscribed upon the four faces of the block. In the figure itself variety of texture is avoided. There are neither polished nor grooved surfaces, but only a few traces of the rasp. The treatment of the surface is not designed to imitate or to recall skin but to reveal the beauty of the stone – Greek island marble, said to have been dredged from the Tiber. Use of the drill was probably avoided altogether. The hair, which had so frequently tempted sculptors to special effects with the drill, is here reduced to something like a close-fitting cap – not that any such simile is encouraged, for the surface is not meant to look like textile but like stone. The concentration and repose owe much to the study of archaic Greek statues. But the sculptors of those works were impatient with the constraints of the material that they used – anxious to emulate work in wood and clay – and their figures were bursting with vitality and brilliant in colour, quiet only when compared (as they could not be by those for whom they were made) with the dynamic movement of what came afterwards.

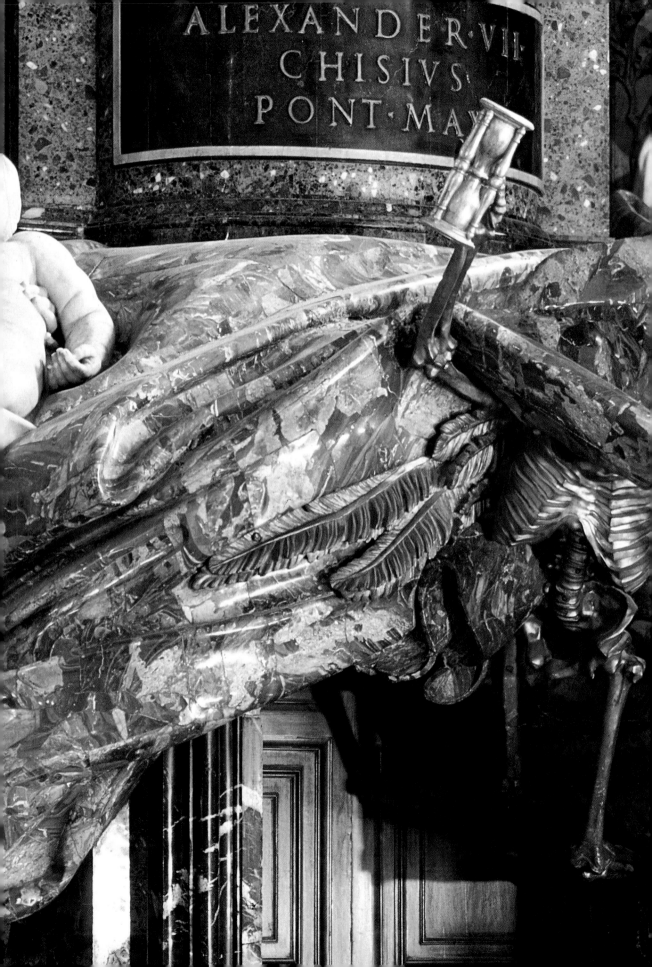

7 Coloured Marbles

THE ANCIENT ROMANS OPENED QUARRIES in all parts of their empire, not only for white statuary marble but for coloured 'marbles' (many of them, strictly speaking, limestones), calcite 'alabasters', serpentines, granites and porphyry. Such coloured stones were used chiefly for paving floors and cladding walls, and for columns and basins. But they were sometimes used also for figure sculpture. The large statues of fauns and centaurs carved out of the deep red or dark grey marble (*rosso antico* and *bigio morato*, as these stones were known to later Roman masons) from Cape Tainaron (Matapan), the south-western tip of the Peloponnese, which now adorn the Capitoline Museum in Rome, once stood in the villa of the Emperor Hadrian at Tivoli. They may originally have been ridden by cupids of gilt bronze.

Blocks of coloured marble that were large enough for such groups were very rare and must have been quarried specially. It was more usual for coloured marble to be used for smaller sculptures, often of animals. Many such sculptures were discovered at Hadrian's Villa in the late eighteenth century and restored for the Sala degli Animali in the Papal Museum at the Vatican. Often the colour of the marble, and sometimes also its place of origin, coincided with that of the creature that was carved out of it – as with the lion of orange-and-yellow breccia marble (*giallo antico brecciato*) from Chemtou in Tunisia, or the panther of golden calcite 'alabaster' with inserted spots of black marble with yellow marble centres (pl. 86).

In addition, many Roman figure sculptures were made of more than one material: porphyry was combined with gilt bronze or white marble heads set into torsoes with cloaks and breastplates of coloured marble – a development of acrolithic Greek sculpture, in which white marble extremities were added to wooden or limestone figures.

Ancient coloured ornamental stones were excavated from Roman ruins in increasing quantities from the fifteenth century onwards, and were re-employed, especially in Rome, for opulent new buildings as well as pedestals and socles for sculpture, and sometimes for sculpture itself. A rare and beautiful stone, white with undulating bands of deep russet red, branching and breaking up into densely speckled areas, was used for the draped chest of the posthumous bronze portrait bust of the scholarly poet and translator Annibal Caro, made by Antonio Calcagni in the late 1560s (pl. 87). This lump of stone had to be made up at one shoulder (presumably using a smaller

86 Roman, calcite 'alabaster' panther with insertions of black and yellow marble (*nero antico* and *giallo antico*), probably late first or early second century AD, 52.5 cm. high, Sala degli Animali, Museo Pio-Clementino, Vatican Museums, restorations of *c.*1790 perhaps by Gaspare Sibilla.

85 (facing page) Detail of tomb in pl. 89, showing Death, modelled by Lazzaro Morelli, cast in bronze by Girolamo Lucenti (1675–6), tooled and gilded by Carlo Mattei, and the shroud carved in travertine by Lazzaro Morelli and veneered with soft jasper from Sicily (*breccia di Trapani*) by Gabriele Renzi (1673).

88 Bartolommeo Ammanati and collaborators, detail of the Neptune fountain showing hippocamps pulling Neptune's chariot, white and violet-pink Apuan marble (*bianco* and *mischio di Seravezza*), 1560s, unmeasured, but size of life, Piazza della Signoria, Florence. The colour is far stronger when the marble is wet.

fragment from the same source). The folds are fairly simple and shallow and for the most part follow the pattern of the marble itself. The shape is not well adapted to the anatomy of a heroic chest such as we would expect, and betrays its origin as a fragment of a column shaft, but had the folds been deeper or less rounded much of the beauty of the stone would have been obscured. Recent discussion of this sculpture has been confined to the vivid portrait head, yet among its contemporaries the ingenious utilization of such an ancient and beautiful stone would probably have excited more comment.

Coloured stones were not only recovered from Roman ruins, but also discovered in the Italian mountains. Early in the second half of the sixteenth century a particularly splendid marble was found at Seravezza, in Tuscany where (as has been mentioned) quarries had been exploited for white marble. *Mischio di Seravezza*, deep violet with a smoky or cloudy pattern of pink, was employed in some of the new monuments erected by the Medici grand dukes in Florence – for instance, the great basin and two of the four hippocamps (finned horses) pulling Neptune's chariot in the fountain of Piazza della Signoria, the work of Ammanati and other sculptors in the 1560s (pl. 88). *Breccia di Seravezza* or *brèche violette*, a closely related stone, in which jagged fragments of white and pink and pale green are set within a matrix of deep violet, was especially prized in both Italy and France in later centuries, particularly for the tops of console tables and commodes, as also for the socles and pedestals of sculpture.

The agents of the Medici carried their search for novel varieties of stone far beyond Tuscany. In the early seventeenth century numerous agates and jaspers were found in Sicily, as well as richly coloured and lively patterned marbles

87 Antonio Calcagni, *Annibal Caro*, bronze and calcite 'alabaster' (*albastro a pecorella*), on a socle of *porta santa* marble, *c.*1570, 76.8 cm. high, Victoria and Albert Museum, London.

95

that took a very high polish and were, perhaps for this reason, called soft jaspers, *diaspri teneri*. One of these, *breccia* (or *brecciato*) *di Trapani*, in which the jagged pieces are coloured tawny orange, pale green and white, sometimes with fragmentary patterns of wavy bands, enjoyed immense popularity between the mid-seventeenth century and the late eighteenth, when either supply or demand seems to have dried up. In Rome walls and piers of whole interiors of churches were covered with it – notably, Sant'Ignazio and Santa Catarina da Siena – as well as table tops and chimneypieces in France and England. It was well suited for use as a veneer, not just because it was probably available only in small pieces, but because joins were easily concealed within its broken pattern. In this form it played a prominent part in one of the greatest tombs erected in Rome during the seventeenth century, that of Pope Alexander VII, designed by Bernini and erected in Saint Peter's in the 1670s (pls 85 and 89).

The effigy of the Pope at prayer is carved out of Carrara marble and is raised upon a pedestal that seems to float above a massive drape disrupted by a gilt bronze skeleton brandishing an hourglass. The drape was first carved out of travertine, the local limestone of Rome, and then veneered with *diaspro* by a specialist in such work, Gabriele Renzi, with great difficulty on account of the curved surfaces and still more on account of the deep hollows. In the dim light of the basilica it is the glowing white marble and the shimmering *diaspro* of which we are most aware; but the electric light with which the tomb has been flooded for the photograph illustrated here gives prominence to all the coloured marbles – the grey, green and white breccia (*verde antico*) of the Pope's plinth, the black-and-white breccia (*bianco e nero antico*) veneered in a symmetrical 'book-matched' pattern on the base and door frame, the smoky pink and grey (*africano*) of the arch, the white-veined russet (*rosso di Francia*) of the columns. Of these materials only the last mentioned, which was quarried in Languedoc, was not reworked from ancient Roman remains.

A less theatrical but no less dramatic use of coloured marble is exemplified by the sculpture that the Jesuits of Sant'Andrea al Quirinale in Rome, commissioned in 1702 from the great French sculptor Pierre Legros, to promote the veneration of the blessed Stanislas Kostka (who had died in 1568 at the age of eighteen (pl. 90)). The pious Polish novice is represented lying on his deathbed wearing a robe of black marble from Belgium (a source of larger pieces of black marble than were available from quarries in any other countries). His delicate face and hands and his pillows of white Carrara marble are strikingly contrasted with the black – so too is the mattress of *giallo antico*.

Instead of placing this figure in the church as a conspicuous shrine, the Jesuits chose to sequester it in the chamber where the youth actually died. Polychrome sculpture, especially when life-size, is often described as illusionistic, and it is possible, in certain settings and lighting conditions, to be wholly deceived by it – although not for long. The initial *frisson* on entering the hushed and darkened room – the sensation that the boy himself might be present – soon passes, but a part of the imagination cannot detach

89 Gianlorenzo Bernini and collaborators, tomb of Pope Alexander VII, marble and bronze, 1671–8, unmeasured but figures larger than life, basilica of Saint Peter, Rome.

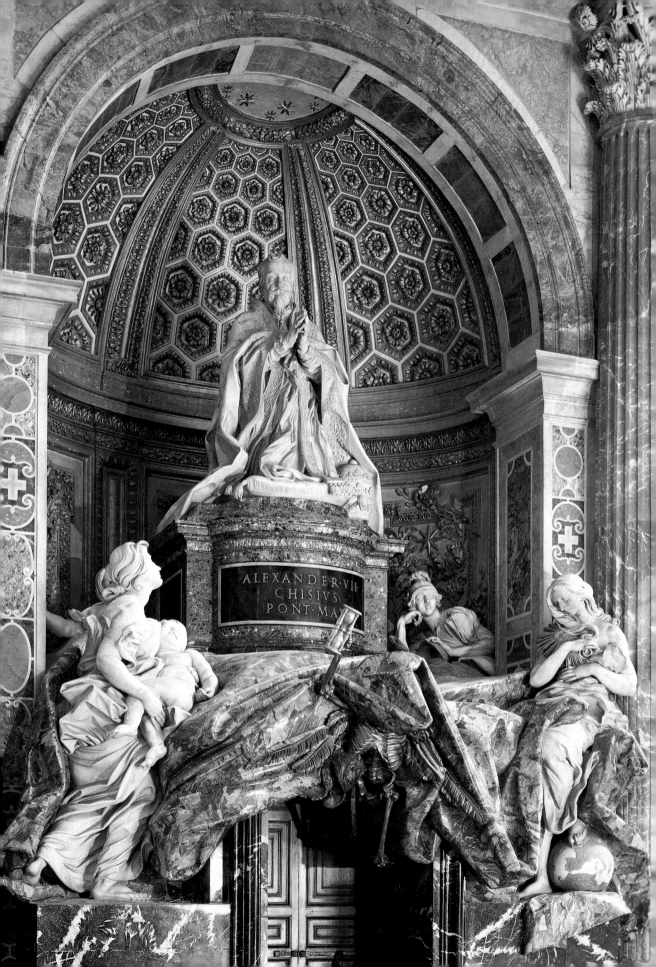

90 Pierre Legros the Younger, *The Blessed Stanislas Kostka on his deathbed*, Apuan (Carrara) marble, black Belgian marble, yellow marble (*giallo antico*) and banded calcite 'alabasters', 1702–3, unmeasured, but figure the size of life, Sant' Andrea al Quirinale, Rome. (Stanislas was canonised in 1726. See also pl. 186.)

91 Detail of pl. 90.

itself from the idea. Had such an illusion been the chief intention, coloured wax and real clothing would have created it more effectively. However, wax is repellent on close inspection, whereas polished marble is at once seductive and precious, and more durable, as befits a figure that is to be cherished and venerated.

We have already mentioned calcite 'alabaster' in this book as a translucent white stone that was used by the Egyptians, among others. It was, in fact, often banded with yellow, brown, pink and green, from the iron and other minerals that seeped into the calcarious waters by which it was deposited. Such banded 'alabaster' is often known as 'onyx' because of its superficial similarity to the gemstones onyx and sardonyx (rather as the lively Sicilian marbles were known as 'jaspers'). The polished stone used for the hanging below the mattress of Stanislas Kostka's bed, white with chestnut-brown bands suggestive of cloth with a striped weave, is a calcite 'alabaster' – *alabastro listato da Palombara*, named after the villa in Rome where it had been discovered (where the ancient Romans found it, however, is not known). The stone employed for the bust of Annibal Caro is also a calcite 'alabaster' – *alabastro a pecorella*, or fleecy alabaster, quarried by the ancient Romans

98

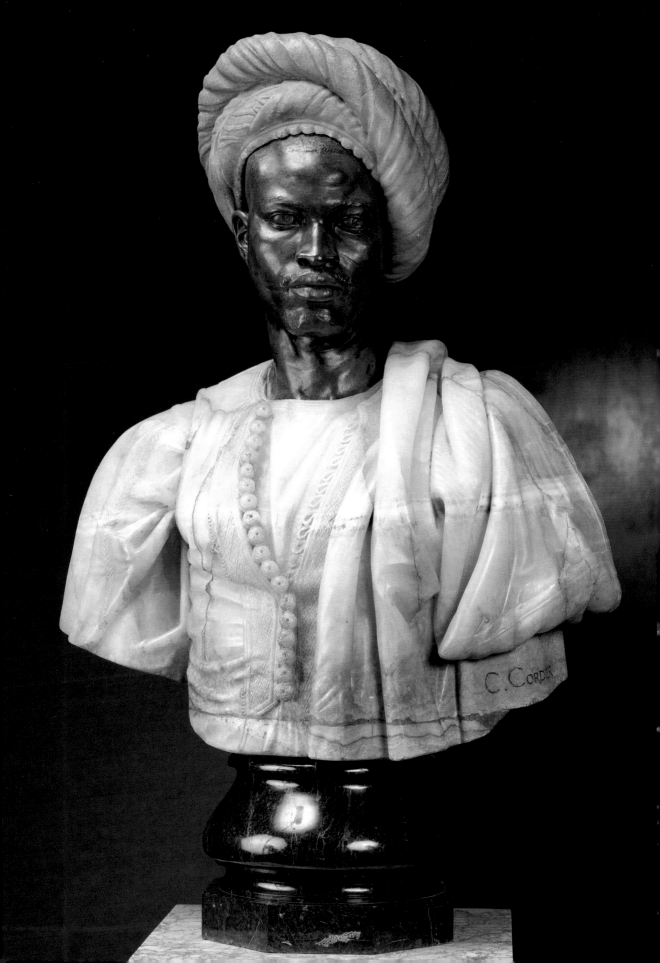

probably in Algeria. One source of Algerian 'onyx' that was known to the ancient Romans was rediscovered in 1849 near Oued-Abdallah. It was much used for sculpture, especially by the French, who had recently colonized this part of North Africa.

After the great success of his bust of a Sudanese man (also known as *Le Nègre de Tombouctou*) exhibited at the Salon in Paris in 1848 and 1850, Charles Cordier became a specialist in the sculpture of 'noble representatives' of the races of North Africa. He also developed an interest in polychrome sculpture and was attracted by the newly discovered, or rather rediscovered, Algerian 'onyx', as may be seen in the *Nègre en costume Algérien* (pl. 92) exhibited by him at the Salon of 1857, a year after his visit to Algeria on an official mission to study the racial types of that country. The subject wears a turban, cloak and tunic of 'onyx', the colour of unbleached wool and linen, but with hints of pale green and of brown. Here mineralogy, ethnography and anthropology are combined under the auspices of romantic imperialism. The attitude of the Emperor Napoleon III, who bought this piece, was not perhaps dissimilar to that of the Emperor Hadrian, who had delighted in wild pagan creatures made of exotic materials, which, in addition, reminded him of the extent of Rome's territories and of the achievements of modern technology.

92 Charles Cordier, *Nègre en costume Algérien*, bronze and Algerian calcite 'alabaster', with a socle of dark Algerian black and red marble, 1856–7, 76 cm. high (96 cm. high including socle), Musée d'Orsay, Paris.

8 Schist, Sandstone and Limestone

IN GANDHĀRA, AN AREA THAT IS NOW part of northern Pakistan, between the first and third centuries AD under the Kushan emperors whose courts were at Kabul and Peshawar, there flourished a distinctive school of sculpture, promoted by numerous prosperous Buddhist monasteries and associated with a local stone – schist, or phyllite, probably quarried in the lower Swat river valley. This stone, like marble, gneiss and slate, is metamorphic, formed under intense heat and pressure. It resembles slate in its foliate structure and colour – a dark, silvery grey, sometimes tending to blue or green, often glistening with mica – but the figure sculpture carved out of it was covered with gold leaf, sometimes applied directly on the stone, sometimes over a red priming. A Chinese pilgrim in the early sixth century described the stone statues he saw in Gandhāra as golden, and many of the figures seem to have retained their gilding until shortly after excavation – a few small patches can sometimes be found on examples in museums.

Relief sculpture of schist decorated the stupas (Buddhist reliquary mounds) and the walls of the monastic courtyards surrounding them. Within these precincts there were also large – but smaller than life-size – free-standing figures of the Buddha (probably the earliest significant representations of him) and his saintly followers, the Bodhisattvas. The art of the Roman Empire was known in Gandhāra, for much of the Mediterranean trade with Asia was channelled through its mountain passes. The stance of the figures, the style of the draperies, and even the proportions and idealized features of the heads with their straight noses, oval eyebrows and tranquil expressions owe much to Greek prototypes. There are, however, many differences, the most fundamental of which is that Gandhāran free-standing figures were not truly conceived in the round.

Statues of the Buddha (pl. 94) were placed against a wall facing the worshippers and would have been seen only from the front, but the flatness of the sculpture reflects also the fact that schist is extracted from relatively shallow beds, in the form of slabs rather than blocks, and awareness of the plane of the slab is encouraged by a plate of stone between the legs and the large halo behind the head. Vertical foliation is also often visible, as in a side view of the Buddha's face in the example illustrated here, and the tendency of the stone to split along these layers may have made carving difficult. Modest projections and a certain amount of undercutting were common, however, and

94 Gandhāran, Buddha standing in *abhaya mudra* (the attitude of benediction), dark grey schist, late second or early third century AD, 95.3 cm. high, Ashmolean Museum, Oxford. A small particle of the original gilding is visible on the chin.

93 (facing page) Detail of the sculpture in plate 102.

95 Indian (West Bengal), *Viṣṇu*, siltstone (certicised slate), *c*.1050, 89 cm. high, Ashmolean Museum, Oxford, on loan from the Pitt Rivers Museum, Oxford.

the Buddha illustrated here is not unusual in the way that his right forearm, supported by a bar of stone, is extended in the ritual gesture of benediction, while the other originally held out the hem of his monastic robe.

A metamorphic stone that is closely related to the schists of Gandhāra was used for sculpture made between the eighth and twelfth centuries in Bengal and Bihār, in north-eastern India, under the Pala and Sena rulers. This is a very dark grey-brown stone, sometimes tending to green, and very fine in grain, which is often described as slate or siltstone, or (quite wrongly) as basalt. It was quarried in the Rājmahal hills of Bihār, just south of the Ganges, by which river and its tributaries it could be transported to the coast of Bengal, where it was used for both building and sculpture. Like the schists of Gandhāra, it was quarried in relatively small blocks or slabs, and the characteristic form taken by the sculpture was that of the stele, or arched upright slab, dominated by the figure of a god about half life-size. Unlike the schist sculpture of Gandhāra, this stone was not originally gilded. Perhaps its sheen gave it sufficient allure. There is some evidence to suggest that details were coloured.

The plane of the slab, instead of being retained only in the halo and as a support for the legs, as in Gandhāran figures, here frames the whole figure, supporting projecting limbs and attributes, and accommodating attendants and small narrative reliefs. This formula was used for both Buddhist sculpture and images of the Hindu gods. A stele that came from Sagar island in the mouth of the Ganges (pl. 95) represents Viṣṇu and his consorts. In his upper two hands the god holds a mace and a discus, and in one of his lower hands he holds a conch, while in the open palm of the other there is a lotus blossom.

Both of the lower hands of Viṣṇu are nearly parallel with the front plane of the slab and they are 'webbed'. Undercutting is avoided, but the substantial presence of the god is enhanced by extensive perforation in the slab: above and below the swag that crosses the stiff, post-like legs; beside the hips; above the shoulder; and beside the neck, beneath the ear pendants. These perforations created dark shadows, rather than any lightness or transparency, for the stele, which is very roughly carved behind, would have stood against a wall. Whereas the surfaces are highly polished and some of the details – the jewellery and the wavy pattern of thin fabric running over the thighs and chest of Viṣṇu – are very precisely cut, the little relief panels to either side, representing the god's incarnations, are no more easily deciphered than hastily mumbled prayers are heard – save by those who know what to expect.

In southern India granulitic rock was commonly used for sculpture, and, in some parts of western central India, white marble. We have already discussed sculpture in both materials that takes the form of an arched high relief, yet neither of these stones needs to be quarried in the form of slabs. However, the stone that is most closely associated with the finest Indian sculpture is the sandstone from the Vindhya range which stretches across central northern India. This stone, being sedimentary, was often cut from shallow beds. It

96a and b Indian (Madhya Pradesh), addorsed *yaksi* from a gateway, sandstone, *c.*10– 25 AD, 62.2 cm. high, Los Angeles County Museum of Art (Nasli and Alice Heeramaneck Collection, Museum Associates Purchase). From Stupa I at Sāñcī.

varies in colour from cream to deep mauve, but is most commonly russet. Composed of quartz or quartzose sand, it is hard and durable, with relatively low porosity and a fine and even grain which can sometimes take a polish.

Figures carved in sandstone tend to be less stiff than those carved in schist: the sandstone *yaksi* (a female spirit of the woods and streams) illustrated here is depicted in a sinuous (*tribhaṅga*, or three bends) pose, plucking the fruits of the banyan tree, winding in and out of space with a freedom that is very rare in the figure sculpture of other civilizations (pl. 96a). Yet this figure, too, is essentially conceived of as high relief. The framing block of stone remains evident in the upper part of the figure. On the other side there is another figure of similar character (pl. 96b). This double-sided high relief in fact served as a corbel supporting a projecting beam of stone on one of the gates of the stupa at Sāñcī, carved around AD 10 under the Āndrha rulers – part of a stone structure imitating previous timber gateways, and not only their decoration but also their construction (hence the projecting tenon that can be seen on top of the block illustrated here).

106

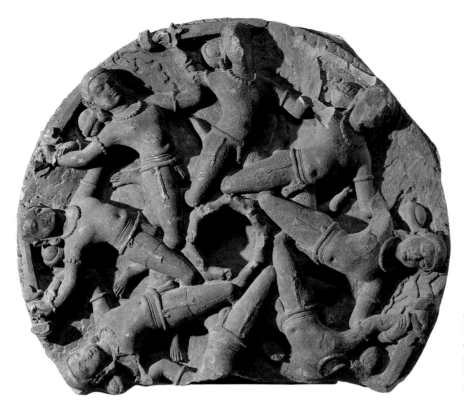

97 Indian (Gujarāt or
Rājasthān), ceiling slab of
eight flying figures,
sandstone, *c*.750, 76 cm.
in diameter, Ashmolean
Museum, Oxford.

Indian temples, frequently cut out of the 'living rock', are never light or
elegant in their structural elements, nor are they lucid in design, but they are
impressive in scale and covered with sculptural reliefs in patterns that both
engage and bewilder the intellect, embodying a mathematical theology allied
to an endeavour to epitomize the universe. The effect can be felt even in small
fragments such as the sandstone ceiling-slab, perhaps from the porch of a
temple in northern Gujarāt or southern Rājāsthan, carved in about AD 750
(pl. 97), which shows eight armed warriors – they may represent the elements,
or simply be spirits of the air – interlaced in flight, their raised swords
forming the perimeter of a wheel, their left heels the hub. The composition
possesses a dynamic complexity comparable to the most sophisticated Gothic
tracery or vaulting, which for all its symmetry and regularity seems completely
organic in character. The swelling rotundity of these living spokes owes much
to the texture of the sandstone, while the mysterious vitality owes much to
the colour, which has weathered to a grey-green, with orange, like smouldering
embers, within it.

The tactility of the most perfectly finished Indian sculpture in sandstone,
such as the lithe, twisting nude torso of the Bodhisattva Avalokiteśvara, the
Bodhisattva of Compassion, which once flanked a statue of the seated Buddha
in the stupa at Sāñcī made in about AD 900 (pl. 98), is greatly enhanced by the

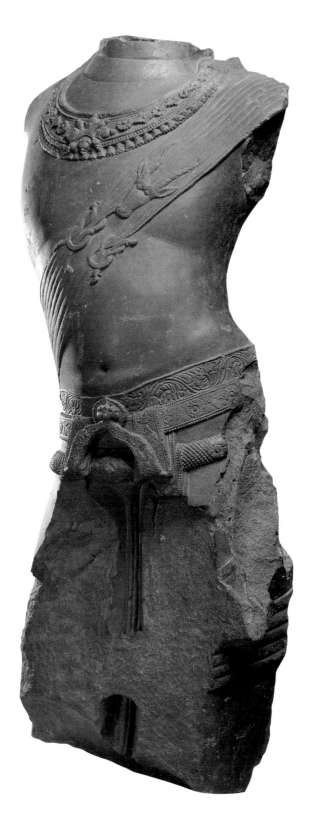

98 Indian (Madhya
Pradesh), *Bodhisattva
Avalokiteśvara*, from Sāñcī
sandstone, *c*.900, 86.4 cm.
high, Victoria and Albert
Museum.

99 Cambodian (Khmer),
Viṣṇu, sandstone, tenth
century AD, 190 cm. high,
Musée Guimet, Paris.

100　Cambodian
(Khmer), *Head of Śiva*,
sandstone, tenth century
AD, 42 cm. high,
Cleveland Museum of Art.

contrasts between smooth skin and the hard, sharp necklace which hangs upon the chest, and the stiff embroidery of the belt which bites into the belly, just as the movement of the chest owes much to the antelope skin tautly stretched across it. The figure seems free standing but is cut from a shallow slab. The grain of the purple brown sandstone is barely discernible but enough to make its smoothness more sensuous than that of a material without a grain – just as the texture of a finely woven textile is more appealing than that of an even smoother paper. The beauty of the stone in this and other examples of sandstone sculpture just discussed is remarkable, but there is good reason to suppose that it was frequently coated with whiting and coloured.

In Cambodia, under the rule of the Khmers, between the ninth and the thirteenth centuries, the worship of both Buddhist and Hindu deities associated with the divinity of the royal family was promoted by massive sculptural campaigns. This sculpture was much influenced by Indian art, but the statues assumed a new form, less closely related to the temple architecture, more architectonic in themselves, with a result that, in a modern museum detached from their original setting, they retain much of their original power. The sandstone Viṣṇu holding aloft the discus and the conch, probably carved in the late tenth century (pl. 99), exhibits the symmetry, rectitude, precision of detail and perfection of finish that must have sprung from ideals akin to those which animated the sacred art of the ancient Egyptians. The smooth surfaces are interrupted only by features inscribed, as it were, in the skin of the stone. This exquisite low relief is more clearly seen in the head of a Śiva of slightly later date (pl. 100). Only with a side light can the lines of the moustache or the *urna*, the sacred spot on the forehead, be discerned.

There is a suspense as well as a serene composure about the statues which derives partly from the way that the figures, although frontal in pose, are carved entirely in the round, with legs parted and arms held away from the torso. A halo of stone would originally have made contact with the extremities (a portion of it remains joining the conch with the tall crown of Viṣṇu (pl. 99)), and reinforcement was given to the back of the lower legs – but these supports seem calculated to be as minimal as possible and the figures were more precarious than any Indian stone sculptures or even European marble ones. It is tempting to speculate that these carvings followed metal models, although it may be coincidental that the grey-green and brown sandstones from which they are carved resemble in colour the natural patinas of bronze. Yet it is also obvious that they were cut from slabs.

* * *

In Europe, after the decline of the Roman Empire in the West, the stones the Romans had delighted in – granite, marble, serpentine – ceased to be used, or at least ceased to be used for sculpture that was polished. But such

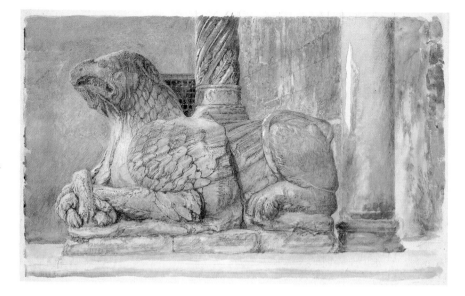

101 John Ruskin, griffin of Verona 'marble' bearing the north shaft of the twelfth-century porch of the Duomo, Verona, watercolour, 1869, 22 × 35.7 cm. (the griffins are unmeasured), Ashmolean Museum, Oxford.

stones, and the beauties of polished surfaces, were not forgotten. Some limestones are richly coloured and capable of taking a polish, which, of course, enhances the colour as surely as does water. The limestone from the valley of the Adige, north of Verona, which is mottled and varies in colour, from a pinky orange to creamy grey, is available in large quantities. Much of Venice is paved with it, and it lends colour to the walls of the Doge's Palace. No doubt because it is easily polished it is commonly described as a marble (as is the remarkably similar mottled orange limestone quarried near Esztergom in Hungary and at Salzburg in Austria, and used extensively in Vienna and as far north as Cracow).

Although brick, supplemented with coarse tufa, was the principal building material of medieval Verona, this superior local limestone was used for prestigious or ornamental features such as the twelfth-century porches of the basilica of San Zeno and the Duomo, together with some pieces of reworked Proconnesos marble. The twisted column-shafts of the Duomo's porch are supported on the backs of griffins — beasts as assured in their power as those fantastic sculptural creatures of Assyria and Egypt from which, distantly, they perhaps descend. As we have observed of animals fashioned out of jade, some of the life in such sculpture seems to belong to the stone itself — to the structure, the flaws, the patterns — as well as to the carving of beak and wing and sinewy flesh (pl. 101). But to what extent, if at all, the griffins were originally polished is not clear and, in any case, it is only incessant rubbing that keeps them dark and shining. Higher up, the stone has a dry and pale orange colour resulting from constant exposure to the elements.

In England during the twelfth century, certain varieties of dark polished limestone became popular, especially for column shafts in cathedrals. Chief among these were the 'marbles' of the Isle of Purbeck in Somerset, characterized

by densely conglomerated fossils of the shell of a freshwater snail, turning from grey to nearly black when polished, but sometime tinged russet or green, as is suggested by the names – 'red rag', 'blue', 'brassy' – given to the beds of stone by the quarrymen. Purbeck stone was not only quarried and mined in Dorset (in the village of Corfe Castle) but often finished there as well and transported thence by water. Salisbury cathedral, where it is used in abundance and in unusually large pieces, was a short distance up the River Avon. Other cathedrals, some far distant, were reached by coast.

The chief sculptural use of Purbeck stone was the carving of low-relief sepulchral effigies of the rich and powerful – abbots and bishops and kings especially – the majority of which were made in London. (At an earlier date the black limestone of Tournai had been imported for tomb slabs and fonts.) The effigies were full length and life-size; although recumbent, they were represented as if standing. Bishops like Hugh de Northwold had one hand raised in blessing (pls 93 and 102). All were framed by an architectural niche. Smaller figures – angels at the head of the effigy, saints by its side and monsters at the feet – were often mingled with the ornament of the niche. Such compositions, with their contrast between large static figures and smaller ones incorporated in a vital coiling border, as well as their colour, are reminiscent of the stele of north-east India, but these sepulchral figures remained horizontal, whereas the Indian slabs were set upright. By the mid-thirteenth century the finer sculptors in Purbeck stone demonstrated their

102 London workshop, recumbent sepulchral effigy of Bishop Hugh de Northwold, Purbeck 'marble', *c.*1250, 208 cm. long, 86 cm. wide (at head), Ely cathedral.

113

skill by undercutting this hard material, as in the shaft beside Bishop Hugh's left hand and the staff of his crozier, which has for this reason broken off (pl. 93).

Purbeck stone and similar limestones (for instance, Alwalton stone, with its distinctive oyster-shell fossils, quarried near Peterborough) were extracted in lengths of six or seven feet, but the slabs were rarely more than a foot thick, and this limited the depth of relief carvings. Bishop Hugh's hands are thus flattened against the plane of the block. When employed for column shafts the stone had to be set up at right angles to its natural bed, making it unsuitable for load-bearing and, if exposed on the outside of a building, vulnerable also to penetration by rain. Unsurprisingly, the stone seems never to have been used for sculpture on the exterior of the buildings in the way that Verona marble, for instance, was.

Most of the great Gothic cathedrals north of the Alps were built in limestone, although some (most notably Strasburg) were sandstone. Anyone regarding these sacred structures when they were newly erected was likely to have been aware of the expense and effort involved in obtaining the stone (unlike today when a building can be clad in whatever material happens to be fashionable, whether Swedish larvikite, Spanish granite or Roman travertine, at little extra cost and without attracting any surprise). According to legend, rich and poor alike helped to carry limestone from the quarry of Berchères to Chartres, fifteen kilometres away. Much of the cathedral of Troyes was built with stone transported from the Tonnerre quarries, sixty kilometres distant but along a Roman road. For the most part, stone was carried long distances by water. Westminster Abbey was built of limestone from Caen in Normandy, then part of the same kingdom and no further away than Yorkshire, which also supplied London and Westminster with stone.

Such limestone was available in fairly large blocks, although size greatly increased the cost and difficulty of transport. These blocks were not, however, comparable in size with those which could be obtained from marble quarries, and, moreover, the sedimentary structure of the stone made it far easier to extract blocks that were long rather than deep. The stones used to build a wall were bedded as they were in the quarry, and horizontal blocks were also employed for the slender vertical elements of a Gothic building – piers, buttresses, pinnacles. But when large upright blocks were required for column shafts or for the columnar figures adorning or guarding the great portals of the twelfth-century cathedrals they had to be turned, and this often proved fatal, for the reason already mentioned in connection with Purbeck stone. Such blocks were perforce of exceptional size when compared with the others used for the building, and their prestige as such is not lost, for the figures, however lively, declare themselves to be single stones, monoliths. Carved together with a column shaft behind, each figure has closed legs and arms pressed tightly against the body, permitting no projections that would diminish the columnar character of the form (pl. 103).

103 'Chief Master of the Portail Royal', a queen, a prophet and another Old Testament figure, Parisian limestone, 1140s, Portail Royal, west front, Chartres cathedral. The Queen is 38 cm. wide and the block used for her statue is approximately 266 cm. high. The limestone is probably from the quarry at Conflans-Sainte-Honorine or that of Carrières-sur-Seine. Each block extends from just above the halo to just below the corbel. Each figure is carved together with a column shaft and overlaps narrower monolithic shafts densely carved with interlaced ornament.

The virtuoso undercutting of the tight forms (for instance, in the raised hands, now broken, and between hair and neck) and the fine engraving of drapery folds in the figures from the Portail Royal at Chartres required a finer limestone than the relatively coarse local stone from Berchères. Any whiting on these figures must have been lightly applied so as not to clog the carving, and it was surely always clear that no joins interrupted the streaming verticals. But such sculpture was painted, and we were not expected to admire the golden or silvery stone with its minutely granular or shelly textures.

115

104 Charles Sluter,
*Philip the Bold, Duke of
Burgundy at prayer supported
by Saint John the Baptist*,
limestone (probably from
Tonnerre) with traces of
whiting, 1391–3, 134 cm.
high (the duke), 170 cm.
high (the saint), portal of
the Charterhouse of
Champmol, near Dijon.

Statues on the outside of gothic buildings have long been denuded of their
original surface, but clues do sometimes remain. In the effigy of Philip the
Bold, Duke of Burgundy (pl. 104) represented at prayer before the Virgin and
Child in the great portal of the Charterhouse at Champmol near Dijon and
carved out of limestone probably from Tonnerre in the 1390s, there are
indentations in the collar (pl. 105), presumably for inserting separately

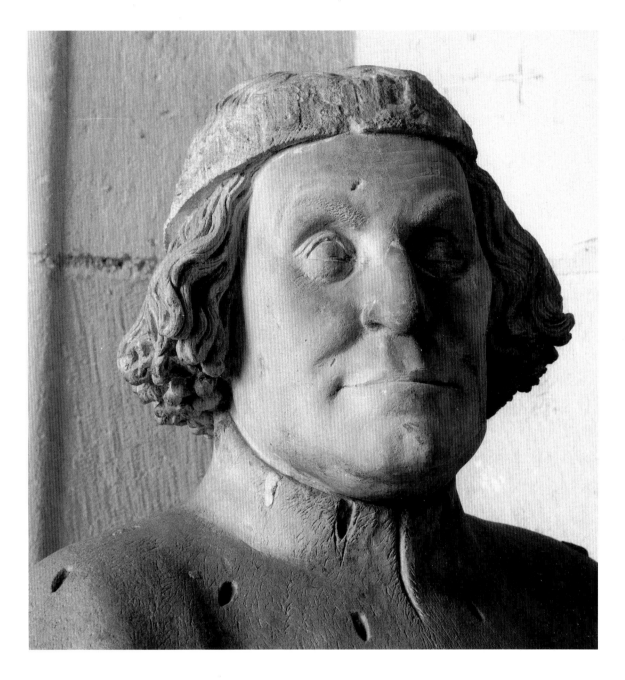

fashioned ermine tails (perhaps made out of off-cuts of black marble), and
there are rectangular holes around the neck of the companion statue of his
duchess, presumably for the coloured glass or gilt metal of a necklace. These
statues were the work of Claus Sluter, whose alabaster tomb for the same
Duke of Burgundy originally in this same abbey has been examined in an
earlier chapter.

105 Detail of the Duke
of Burgundy in pl. 104.

117

106 English, screen wall of Bishop Alcock's chapel, limestone, c.1490, unmeasured, Ely cathedral.

The statues of the Duke and Duchess of Burgundy are far less architectural than the figures designed for Gothic portals two centuries previously. Indeed, they are imperfectly integrated with the architecture, for their bases do not fit the corbel supports. Moreover, the sculptor no longer seems constrained by the block of stone and the sculpture no longer seems contained within it: there is nothing columnar about the kneeling effigies, nor about the saints

behind them. Sculptors at this date did not hesitate to piece their sculptures: Sluter in some of his other work added separately carved stone wings to his angels, for example. Iron was increasingly used for the dowels and pins and props in sculpture, just as it was by masons, to provide extra support for the more fragile pinnacles, parapets and flèches of late Gothic architecture. It may be that the sculptor borrowed from the new technology of stonemasons even as his art became, in appearance, emancipated from architecture. Or might it be, rather, that both sculptors and masons were learning from, or seeking to emulate, woodworkers who were not only carvers but (the term is significant) joiners. If so, it would not have been the first time that work in wood inspired a new direction in stone carving.

The carvings that decorated the interiors of Gothic churches were often in the same stone as those of the exterior, but softer and lighter limestones were sometimes favoured. An example of this is the white chalk or clunch of Cambridgeshire that was used in Ely cathedral for the mid-fourteenth-century Lady Chapel and the late fifteenth-century chapel of Bishop Alcock. This stone 'could be worked with such facility that it offered an almost irresistible temptation to the carvers to be over-elaborate and finicky': this is the stern verdict of Alec Clifton-Taylor, the finest writer on English building stones. But the real problem, at least with Alcock's chapel, is not the intricacy of the screen walls but a certain monotony and congestion (pl. 106). The stone, which is remarkably light – as light as wood – was carved on the ground before being fitted into position. Such prefabrication must have encouraged repetition and made it easy to miscalculate the completed effect. The open-work pinnacles were made in four sections, with the crockets masking the joints, capped by finials of one or two parts (pls 107a and b). They were then pegged together with wooden dowels. The brittle stiffness of the screen inspired by the work of wood carvers and joiners is deceptive, for on close examination the soft stone has been cut so that it seems to have been modelled – each face of the rigid finials looks as if a tongue of clay with a rippling edge has been pressed on to it. In the earlier Lady Chapel at Ely traces of colouring survive on the stone – blue, red, green and gold for the leaves (pl. 108). The gabled caps of the Purbeck shafts here seem to have been painted in imitation of this stone. In Alcock's chapel the architecture seems not to have been coloured, but variety and focus would have been provided by numerous statues of saints and prophets, with pink flesh and vivid red, blue and gold drapery. To judge from the niches (pl. 106) they would have been of three sizes: four feet, two feet and one foot high.

* * *

Of all the sandstones available in Europe none is more beautiful than the very fine-grained grey sandstone of Fiesole, known as *pietra serena* when pale, and *pietra bigia* when darker and browner. It seems never to have concealed

107a and b Finial from a pinnacle in Bishop Alcock's Chapel (pl. 107) in two sections, the upper 41 cm. high, the lower 25.9 cm. high.

108 English, detail of wall arcade, limestone with a column shaft of Purbeck 'marble', *c.*1335–50, unmeasured, Lady Chapel, Ely cathedral.

with paint although it was sometimes gilded in part. Its most memorable use is perhaps to be seen in the vestibule of Michelangelo's Laurentian Library in Florence, where columns, consoles, tabernacles, stairs and balusters of *pietra bigia* contrast with white plaster. Vasari likened the stone here to silver on account of the value of the craftsmanship, and perhaps also because of its closeness to the colour of that metal when it is tarnished. This sandstone was available in very large blocks, large enough to supply monoliths for the columns in the naves of Brunelleschi's fifteenth-century Florentine churches of San Lorenzo and Santo Spirito – monoliths as large as those of granite or marble favoured (as Brunelleschi knew) by the Romans – and it could be crisply carved with elaborate detail, as in the fifteenth-century corbel illustrated here (pl. 110), and as in some of the most important sculpture by Donatello and Desiderio da Settignano.

In later centuries a corbel of this quality would more commonly be carved out of white marble, especially in Italy, but the same sandstone or limestone that was used for the masonry of buildings continued to be used for the ornament of both inside and outside. For some purposes a rougher stone than marble might indeed be preferred. Bernini, for instance, chose to use travertine for the fountain that he carved in 1642–3 for Piazza Barberini in Rome (pl. 109).

Travertine, a limestone formed by the direct precipitation of the calcium carbonate found in spring water upon exposure to the air, abounds in the Tiber Valley and became the preferred material for dressed masonry in Rome

109 Gianlorenzo Bernini, Triton fountain, limestone (travertine, perhaps from Cave delle Fosse, Tivoli), 1642–3, unmeasured, but the figurative elements larger than life-size, Piazza Barberini, Rome.

110 Francesco di Simone Ferrucci, corbel, probably for a Eucharistic tabernacle, with angels, the head of Christ, emblems of the City of Florence, the people of Florence and the Guild of Silkworkers (Arte della Setta) between cherubim, sandstone (*pietra serena*), *c.*1480, 91.5 cm. wide, Museo Nazionale, Bargello, Florence.

111 Henry Moore, *Reclining Woman*, Hornton limestone, 1929, 83.9 cm. long, Leeds City Art Gallery.

and its environs. Its small, irregular cavities, caused by the organic life that has decayed within it, gives it the appearance of petrified sponge. Among its advantages are its availability in large pieces, its resistance to water and frost, its lightness and the ease with which it can be cut, especially when newly quarried. For his Triton fountain Bernini used over a dozen blocks of it, each laid in its natural bed. In other Roman fountains he and his followers carved the figures in white marble and the rocks, animals and vegetation in travertine, but in this case the organic unity of the whole conception – a giant clam carried upon the tails of dolphin-like fish, opening to reveal a triton blasting water from a conch – is essential: curling lips, coiled tail, ridged shell, rippling muscle are all part of a continuous movement. Moreover, the spouted water falls back upon the triton's body, and the resulting brown stains and green algae suit rough grey travertine better than they would white marble.

By the early twentieth century in Europe limestone might be preferred to white marble for less practical reasons. Henry Moore's *Reclining Woman* of 1929 (pl. 111) is intended to represent not simply a woman, but something more abstract – though not conventionally idealized. It owes much to the 'primitive' Mexican carvings of gods. And it has a primeval character, too, which owes much to the stone from which it is carved – Hornton limestone, an ironstone from north-west Oxfordshire, rusty brown and rich yellow with hints of greyish green, which, with the veins and fossils embedded in it, seems more essentially rocky, more part of the ancient body of the earth, than does white statuary marble.

9 The Structure and Decoration of Larger Wooden Sculpture

WOOD HAS BEEN THE MATERIAL MOST UNIVERSALLY and commonly favoured for sculpture. But it is vulnerable to both fire and damp and is easily damaged or destroyed by infestation, so it has survived less well than sculpture in stone. Among the ancient Greeks it was very highly esteemed, and (as has been argued in an earlier chapter) there is good reason to suppose that it played an important part in the development of their marble sculpture. But we can only guess at what it looked like. Likewise, very little ancient wooden sculpture has survived in India, although (as has been observed in the previous chapter) some highly important stone sculpture looks as if it may have derived from it.

The earliest sculptors in wood perhaps embellished a long log or a whole tree trunk, cutting it out into intricately pierced forms similar to the ancestor figures of New Ireland in the West Pacific, or, more frequently, carving it in relief, as with the so-called 'totem poles' – heraldic displays sometimes as high as ninety feet – made by the Tlingit people of Alaska. Certain trees were commonly held to be sacred, in many parts of the world, especially in the early phases of civilization and the spirit that supposedly dwelt within them informed the sculptures made out of them. The way in which African carvers confined their figures to the form of the log may well have been conditioned by veneration for such a spirit as much as it was by ignorance, or distrust, of glues, dowels and joints.

However, as it happens, by far the oldest surviving sculpture in wood – that of ancient Egypt – was assembled out of several pieces. For those sculptors the log was not at all analogous to the block of stone. And when the finest large wooden sculptures of the world are reviewed it will be found that most of them were built up out of different pieces in a manner that no one working in stone would dare to imitate. This is hardly surprising. A people who had graduated from the log roller to the spoked wheel, or from the hollowed canoe to the timber hull, would have seen no special advantage in rejecting new technology when creating images.

The largest wooden sculpture made by the ancient Egyptians were portraits of their deified kings, such as the pair of statues of Tutankhamun that stood in the antechamber of his tomb (pl. 113). They were life-size: indeed, it seems, exactly the size of Tutankhamun himself. The royal head-cloth, the

112 Detail of pl. 129.

123

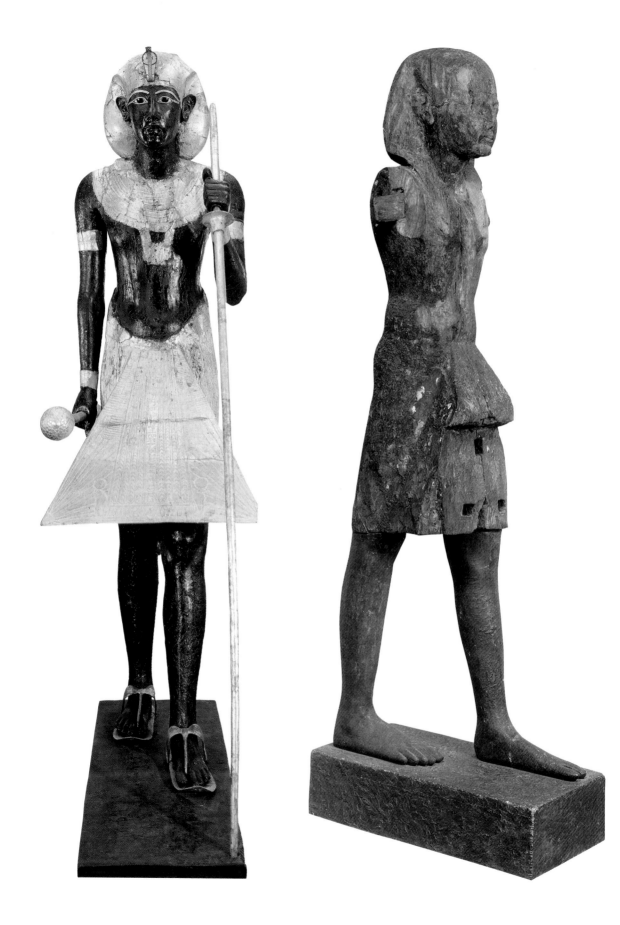

115 Egyptian, detail of a tomb effigy of Ramesses I, sycamore fig with traces of resin, c.1320 BC, British Museum, London. This sculpture, which must have been made in a different workshop from the similar figure in plate 114, shows clearly a join in the neck. Nose and ears were separately carved and dowelled. Eyes and brows would have been inserted.

113 (facing page left) Egyptian, tomb effigy of Tutankhamun, wood (probably sycamore fig) with gold leaf, resin, gesso and some bronze or copper attachments, c.1340 BC, 190 cm. high (excluding plinth), Cairo Museum.

pectoral ornament, the kilt and the bracelets are gilded, the gold leaf being applied on top of a layer of gesso, which covers linen glued to the surface of the wood. The ungilded flesh is coated with black resin, most of it applied directly onto the wood.

Because wood, however well seasoned, shrinks as it ages, some of these joins have become evident. Each limb – as well, obviously, as staff and mace – was made separately, and in the figure illustrated here the bent arm is composed of two pieces. Most of the kilt has also been added. Some of the attachments are of different materials: the head of the royal cobra emerging from the headdress is of bronze, partly gilt; the sandals, the eyelids and the kohl marks projecting sideways from the eye were also made of gilded bronze; and the white of the eye was fashioned out of calcite 'alabaster', with an obsidian pupil.

Similar figures of slightly more recent date that were found in royal tombs at Thebes are in a ruined condition which reveals more of the wood – which

114 (facing page right) Egyptian, tomb effigy of Ramesses II, sycamore fig with traces of resin, c.1230 BC, 195.5 cm. (including plinth), British Museum, London. The tenons for attaching the arms and the slots for dowels attaching the front of the kilt are clearly visible, as is the join in the left foot.

has recently been identified as sycamore fig, one of the common trees of Egypt – and more of the manner in which such sculptures were pieced together (pls 114 and 115). The head could be carved separately, with slots for the ears and small holes for pegs which fixed them, as well as similar holes for inserting and fixing the eyes. We can see also how the projecting portion of the kilt and the front of the feet were made of separate pieces.

Convenience and economy may have been among the factors that encouraged such assembly. Less wood and effort was wasted if projections could be attached in the manner described. But, as we shall see, there are other advantages to this type of construction.

In northern Europe the wood favoured for sculpture, as also for building, carpentry and joinery, comes from the oak-tree which, with its longevity, great girth, considerable height and heroic spread, is likely to be familiar to most readers of this book. In some areas of Europe during the fifteenth century the woodcarvers' guilds permitted no other wood to be used for sculpture – a regulation devised not so much to protect local suppliers (there was plenty of demand for oak for other purposes), but to guarantee that the work would be made of what was believed to be the best material. Oak is available in large logs and is immensely strong and very resistant to damp. However, when it shrinks it tends not only to split (as all wood does) but often to warp as well. Moreover, it is difficult to carve across the grain – although very intricate work has been done in carefully selected pieces of oak.

Some of the properties of oak are well illustrated by a statue of the angel Gabriel made in northern France in the first half of the fifteenth century, as part of a group depicting the Annunciation (pls 116a and b). Although carved in the round, the angel is not intended to be seen from all sides, and it must have been set against a back panel. From behind, its structure is very clear: a single log nearly one and a half feet in diameter was used for most of the figure, including the right hand. The wood was probably part of a curved branch, for its grain follows the bend of the angel's back. The wing was carved out of a separate plank, perhaps cut from the same log, slotted into the back and secured with a peg; the other wing was added in the same way, though it has been broken off. A short but thick piece of wood was added for the tail of drapery which conceals the angel's right foot.

The sculpture has suffered considerable damage, chiefly from 'woodworm' (in fact, the larvae of a beetle): most notably, the cope which fell from the angel's raised right hand has disintegrated. Where its broken edge passes over the angel's left forearm, an uncarved portion of that arm near the elbow is revealed which enables us to see that this arm was carved from a separate piece of wood, slotted and pegged behind the cope.

Of the four additions, this last, the angel's left arm, is the most significant. The sculptor probably chose not to carve it out of the main log in order to avoid carving against the grain: instead, the grain of the added arm runs in the direction of the arm itself. The grain of oak is clearly evident on the

reverse side of the remaining wing, where again it runs vertically. Some of the smaller wing feathers, as also the angel's curls and some of the folds of drapery, were carved against the grain, in relatively shallow relief, but the longer of the separated plumes are cut with the grain and would have been harder to manage in any other way.

European figurative sculpture of this period was usually made from one large log, with smaller additions, but frequently in a figure of this size (about half the size of life) and usually when the figure was of larger size the log was hollowed out from behind to remove the heartwood. The shrinkage of the heartwood at a slower rate than the rest of the log, creates tensions which may cause the wood to split. In the relatively rare cases when the statue would be seen from all sides the hollow would be covered with a separately carved lid.

Much of the sculpture on altarpieces in northern Europe was carved in relief, sometimes with dense compositions incorporating numerous figures. These might be made of separately carved and superimposed planks. A relief of the *Entombment of Christ* made for a church in Westphalia or the Lower Rhine around 1500 (pls 117 and 118) has been detached from its framework

116a and b Northern French, *Angel Gabriel*, from an Annunciation group, oak with traces of gilding and paint, 1415–50, 74 cm. high, Victoria and Albert Museum, London.

and so can be inspected from the side. This enables us to see, in the bearded figure in the foreground (representing Nicodemus or Joseph of Arimathea), a join, partly concealed by a fold of his cloak, but obvious enough above and below that. The farther side of his body is united with that of Mary Magdalene and is carved out of the second plank. Another female figure is carved on the third plank, as is much of the rocky hillside with the trees and soldiers on it.

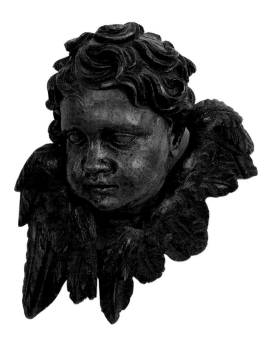

119a and b Northern
European, perhaps
Flemish, *Cherub*, walnut,
c.1700, 32 cm. high,
Private Collection, London.
One of a pair of cherubim.

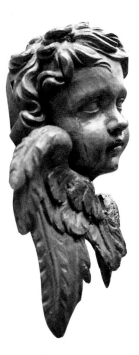

A short plank was added for the uppermost objects on the hill. The space is compressed, and the intervals between the figures and even parts of the figures' bodies (for example, the farther side of Joseph's head or most of the back of the figure behind the Magdalene) have been eliminated in a manner that is directly related to this method of layered construction.

The advantage of such a method was that it allowed the carving of certain details – for instance, the breast and hands of the woman behind the Magdalene – which would have been very difficult to achieve, if not impossible, had a single block been used. Moreover, a single thick block of wood is far more likely to split or warp than a laminated block of similar size.

Although in the case of such reliefs the separate oak planks were carved before assembly, a block can also be assembled and then carved. Such would have been the case with the head of a cherub, probably a Flemish carving of about 1700 – although obviously the wings were carved separately and then attached (pls 119a and b). The join that runs down the cherub's right cheek has opened, but the other join, towards the back of the head, is almost invisible. The sculptor's confidence that the joins would remain tight is indicated by the fact that he placed one of them in so obvious a surface.

Whereas all the other sculpture examined so far in this chapter has been coloured and gilded, this cherub, which is carved of walnut and would have been attached to an ornamental frame of scrolls and foliage, was only polished. In this case, not unusually, the wax polish used was tinted. In the hollows, where the polish was thickest and has mingled with dirt, it is darkest, thus enhancing the effect of the shadows there. In some of the salient areas the wood may also have been bleached by sunlight.

117 (facing page left)
Westphalian or Lower
Rhine, *Entombment of
Christ*, oak, silvered,
gilded and painted – with
some of the colours on top
of the gilding – *c*.1500,
65.5 cm. high, Victoria
and Albert Museum,
London.

118 (facing page right)
Side view of the *Entombment*
(pl. 117).

In southern Europe oak was seldom used for sculpture. Poplar, pine and, less commonly, chestnut were preferred for large figure sculpture in Spain and Italy. Walnut, however, was popular both north and south of the Alps. It has a finer texture than oak and a more uniform colour, which can resemble both the rich golden brown or the near black patinas often given to bronze – and, like bronze, it was often gilded in parts.

The cherub would have been designed for a setting where bold forms were required – or at least where fine detail would have been wasted – and therefore it does not exhibit any of the minute carving that is possible in walnut but instead a deep cutting of the hair and rough faceting in the cheeks. These facets are shallow concavities left by the chisels used for wood carving – gouges with curved blades – while the V-sectioned divisions of the hair and wings were made with burins which were handled with remarkable assurance and a freedom impossible in oak.

Together with oak and walnut, the tree most frequently employed for large wooden sculpture in Europe has been the lime-tree. It is chiefly associated with the sculptors working for the exuberant Gothic or Baroque churches in Austria, Bavaria, Franconia, Swabia and the Upper Rhine. Lime (or lindenwood) is relatively soft and elastic and pale – often described as white, but really a very pale, creamy brown. It can be cut more easily than walnut and far more easily than oak, but it is less durable than either and much more vulnerable to damp. A candle-bearing angel, one of a pair of altar ornaments carved by one of the greatest of these sculptors, Tilman Riemenschneider, who worked in Würzburg between 1485 and 1520 (he died in 1527), has been stripped of its original colouring, making both its construction and the character of the chiselling easier to study.

The angel (pl. 120) is cut out of a single block to which one large and one small addition were made at the back, in the lower part of the figure. The main vertical join is partly concealed in a pleat of drapery. The joints have remained tight and the heads of the hand-forged nails that secured them are still visible. A pair of wings would also have been attached. Curved incisions of an easy decisiveness represent the eyelids and the fur borders of his clothes, but these have an abrupt harshness which was designed to be softened by the whiting. The curls of the hair are not only deeply cut, against the grain as well as with it, but are also pierced, as was conventional in limewood carving of this period. Where limewood was not familiar as a material for sculpture – as for example in Florence – such effects were regarded as amazing. The versatility of the material has often encouraged virtuosity, as in the decorative carving made in England by Grinling Gibbons in the late seventeenth century which included sheaves of corn and peas in open pods.

The earliest large figure carvings in limewood which were not painted and gilded seem to have been those made for German altarpieces of the very late fifteenth century – including some by Riemenschneider – in which the wood was tinted a slightly darker brown, while the lips were coloured with red

120 Tilman Riemenschneider, altar candlestand in the form of a kneeling angel wearing amice and chasuble, lime (linden) wood, *c.*1490– 1500, 63.5 cm. high, Victoria and Albert Museum, London. From the church at Tauberbischofsheim. One of a pair of figures.

121 Michel Erhart, detail of an altar statue of Saint John the Evangelist, lime (linden) wood, painted and gilded, *c.*1493–4, 171 cm. (height of whole figure), high altar of Klosterkirche, Blaubeuren, Swabia.

pigment and the eyes with black. However, most limewood figurative carving was painted and gilded, and this practice continued in the eighteenth century, when, however, the figures were sometimes given the colour of pale stone rather than naturalistically painted.

Both paint and gilding were applied on top of coats of gesso or chalk whiting, which in turn were sometimes applied on fine linen or other textile,

132

especially over joints or knots. The textile reduced the effect of any movement in the wood on the hard, easily cracked layers above. In essence the method was the same as that employed in the large figure sculptures of ancient Egypt. The gesso or chalk softens the carving, giving it a pleasing, rounded finish. If sharp detailing and a crisp texture in low relief were required, the gesso or chalk itself was sometimes carved. A good example of this technique is provided by Michel Erhart's sculpture of Saint John the Evangelist, made in the 1490s for an elaborate architectural setting on the high altar of the Klosterkirche, Blaubeuren, in Swabia (pl. 121). The creases in the saint's neck and knuckles, also the network of veins over his hand, are all cut in the chalk.

Two methods of gilding were generally employed in such sculpture. Gold was sometimes applied in an oil medium, as for the hair of Erhart's Saint John and the back of the niche, which is carved in a low-relief damask pattern. More commonly, gold leaf was laid over a thin layer of clay, or bole, which was moistened to make it sticky (hence this method is known as water gilding), and then burnished with a tooth or agate. The colour of the gold was partly determined by that of the bole beneath, usually a red or pink. The degree of burnishing could be varied as well: in the border of the open sleeve of Erhart's Saint John it is particularly brilliant. Such brilliance is possible only with water gilding.

Water-gilded gesso could be punched and incised to create patterns and textures, as in the border of scrolling foliage in Saint John's mantle. In addition, silver leaf was used, often to represent armour or weaponry, and it was sometimes coated with yellow varnish to supply a cooler gold (or a cheaper substitute for it), though the silver has almost always tarnished. Glazes of colour, especially red and green, were also laid over the gilding. So, too, was opaque paint, which could then be scratched through in a decorative pattern (a technique known as sgraffito). These techniques were also used on the paintings that were sometimes combined with sculpture on altarpieces, chiefly on the shutters that concealed the saints for most of the time. The sculpture was often also decorated by the same artists who made the paintings.

The gilded surface was also made to resemble embossed gold, either by building it up using controlled dripping onto the whiting – a technique known as pastiglia – or by pressing a strip of stiffened whiting into a mould prior to applying it as a low relief. Extensive remnants may be seen in the oak figure of the seated Virgin Mary, probably carved in Liège in 1330–50 and once part of a group of the Coronation of the Virgin (pls 122 and 123). On the gilded border of Mary's mantle, the collar of her gown and the rim of her crown there is a low-relief pattern embedded with some green-and-blue cabochon stones (presumably glass paste). Traces of pink remain on the Virgin's cheeks, of white on her veil, and of blue in the lining of her gilded mantle, and some of the red glaze on top of the gilded plinth also survives.

The varied types of gold and the degrees of burnishing, the contrasting textures and the low relief of the gilded surfaces were all calculated to respond

122 Northern French, *Virgin Mary seated*, from a group of the Coronation of the Virgin, oak, painted and gilded, *c.*1330–60, 57 cm. high, Victoria and Albert Museum, London.

133

123 Detail of pl. 122. The figure is intended to be viewed from the left, which explains the lopsided treatment of the crown.

to changes in light – natural light, which usually entered from the side, or flickering candlelight, mostly from below – subtleties that are ill served by the overhead electric lighting of the modern museum. However, the original

134

124a and b English,
wyvern with a scroll and
tendril of flowers, pine,
water gilded, *c.*1740,
35 cm. (from tip of wing
to end of tail), Ashmolean
Museum, Oxford. From
the rococo frame made for
The Choice of Hercules by
Paolo de Matteis.

finish of such sculpture has seldom survived, for the pious, eager that their images should look bright and fresh, have repeatedly repainted or regilded them, blunting detail with additional coats of whiting, covering water gilding with oil-gilding, and so on. In many cases, too, dealers and collectors have stripped sculptures down to the wood, supposing that their artistic character consists only in the carving.

A wyvern – or long-tailed, two-legged dragon – perched on a scroll from which a swag of flowers is suspended, and part of a rococo picture frame of the mid-eighteenth century (detached when undergoing restoration) is a good example of fairly crude and hasty carving in wood which has been given a seductive finish (pls 124a and b). Its seemingly molten surface comes from a softening coat of whiting, and its vitality from the grooves of feather, fur and petal cut in this coating after it had become 'leather hard'.

This wyvern was carved out of pine, the usual material for gilded orna-mental carving in England during this period. The distinctive straight lines of its grain are visible behind, where some of the gesso has fallen off. The nails fixing one of the legs are also visible, as is some fabric in the gesso concealing the join of one of the wings. The lightness of pine facilitates this sort of loose, open structure, which is found also in the limewood figure sculptures made for the Baroque churches of southern Germany during the eighteenth century, in which spread fingers, outflung arms, fluttering wings and tails of drapery, sweeping beards and extravagant corkscrewing locks of hair all demanded the piecing of numerous large and small blocks of wood. Because wood is a 'fibrous, compact and comparatively light substance' out-stretched arms do not 'run the risk of breaking with their own weight'. The

126 Reverse of the sculpture in plate 125b, showing crude carving but complete painting.

demonstrative style of such sculpture owed much to this fact. The style is also found in stucco sculpture in the same part of Europe but, as we shall see, this sculpture was built over an armature of wood or iron. The angels by Christian Jorhan the Elder illustrated here have joins in the arms, and the wings are, of course, attached: the one with a raised hand is composed of eight pieces (pls 125a and b). These angels are carved in the round with hooks in their backs so they could seem to hover in the air above an altar or perhaps a pulpit (pl. 126) while in fact perching upon, or dangling from the architecture. For this purpose, the relative lightness of the wood was obviously an advantage.

Such complex and composite structures are also typical of the wooden sculptures made for Buddhist temples in the northern part of China, especially in the province of Shansi, during the twelfth and thirteenth centuries under the Chin dynasty (the alien Jurchen rulers who preceded the Mongols). A sculpture of the Bodhisattva Guanyin, illustrated here, exemplifies such work at its most accomplished and exuberant (pl. 127). Guanyin, associated with the Buddha Amitābha, had come to be increasingly worshipped independently in China and had achieved a status there akin to that of the Virgin Mary in Christian Europe. Although possessed of the qualities of both sexes, Guanyin was more and more commonly depicted in feminine guise, as here, seated in the attitude of 'royal ease' in the caves of the island Potalaka, one foot resting

125a and b (facing page top) Christian Jorhan the Elder, pair of angels, lime (linden) wood, painted and gilded, *c.*1760–70, 39.4 and 41.3 cm. high, Metropolitan Museum of Art, New York (Bequest of Emma A. Sheafer, The Lesley and Emma Sheafer Collection, 1974).

127 Chinese, *Guanyin*, unidentified wood, painted, eleventh or early twelfth century, 241.3 cm. high, Nelson Gallery of Art and Atkins Museum, Kansas City.

upon the lotus flower, one arm gracefully extended, as if ready, by the slightest movement of the hand, to calm the agitated souls of mortal supplicants. Such an open pose could not easily be achieved in stone, while the rocks are intricately pierced in a manner perhaps influenced by work in clay.

The larger forms of the sculpture are elaborated by – and the tranquil composure of the figure contrasted with – sashes, belts, locks of hair, weeds and waves. The body and rocks were carved out of relatively large blocks dowelled (probably with bamboo) and glued together, over which separately

carved plates of wood were then attached. The way that the broad basic forms are elaborated by smaller, linear additions may owe something to the techniques of clay sculpture, but the brittle, sharp-edged and somewhat flat character of these additions is entirely characteristic of woodcarving.

This statue of Guanyin is most unusual in having retained its grotto throne. Such a complicated, weedy, anfractuous structure sometimes surrounded the whole figure, and on the walls of the temple behind there were paintings of more rocks, among them clouds and blessed souls. Between this type of sculpture and its setting, in which the painting of both figure and wall was carried out by the same artists, there is the same sort of continuity that can be found in many fifteenth-century sculptured altarpieces in Europe. Moreover, the long, sinuous lines and the calligraphic flourishes of the sashes and belts; the weightless scarf or the cloud half obscuring a monumental structure; and the witty echoes of one shape, such as a fluttering hem, in another, such as a breaking wave, are all characteristic of Chinese painting. As is often the case in the history of sculpture, the remarkable exploitation of the possibilities of one material — in this case wood — was stimulated by zealous emulation of effects achieved more easily in another.

There has been very little detailed investigation of either the structure or the surface of Chinese sculptures of this type. Samples taken from three related sculptures have revealed that one was made from the wood of the fig-tree, one from that of the princess-tree and one from that of the foxglove-tree. There is no surviving example of a sculpture on which the gilding and painting has survived intact. However, it has been ascertained that the ground was not a gypsum or lime composition, as in European whiting, but china clay (kaolin) bound with glue. Pigments were mixed with the clay to obtain some of the paints — the range used was limited but included azurite blue or indigo blue, copper green and vermilion (sometimes in a lacquer varnish). As in European sculpture, rock crystal played an important role. The hollow cut in the chest of the fourteenth-century Virgin from the coronation group that has already been discussed would originally have contained a relic protected by rock crystal, while the sacred spot, the *urna*, in the centre of the forehead of this Guanyin once contained a cabochon of the same material.

In Japan, where there is no native stone suitable for either statues or buildings, wooden sculpture, like wooden architecture, has a special place. Magnificent trees abound, the value of which were acknowledged in both religious tradition and practical husbandry. Moreover, the extremes of temperature and humidity made it imperative that timber be selected and seasoned with the utmost care, and construction methods ingeniously made allowance for its inevitable expansion and contraction. By the Nara period (710–94) figure sculptures in wood, which were introduced into the country with Buddhism in the sixth century, had become common. These were generally made of cypress, which continued to be the wood preferred for sculpture.

Cypress, different species of which flourish in Mexico, the Himalayas,

China and southern Europe, has often been favoured for sculpture. Pliny records an ancient Greek statue of Jupiter made out of it which had lasted in excellent condition for eight hundred years, and it is believed that the carved cypress doors of old Saint Peter's in Rome survived for a similar length of time. The Japanese cypress (*Cupressus obtusa*), no less admired for its beauty than the shining, dark green, flame-shaped trees of the Mediterranean (*Cupressus sempervirens*), grows to still greater heights (100 feet as against 70–90), and its wood has an even smoother texture, is softer to cut and is also remarkably pale in colour.

During the Heian period (794–1185), when wood had become the chief material for Japanese sculpture, there were important innovations in the way it was used. By the end of this period the technique of *yosegi zukuri* had been perfected, whereby figures were built up out of separate components, each of which had been split, hollowed out and reunited. This technique of making wood sculpture prevailed in the Kamakura period (1185–1333), when Japan was ruled by *samurai* warrior clans, and new – or renewed – Buddhist temples were filled with sculpture, much of it astonishingly novel in style. Some of the statues were portraits of priests in attitudes of disciplined repose, others represented the Buddha in his numerous manifestations, for the most part hieratic. However, the statues of attendant or supplementary mythological figures were often highly dynamic.

The snake divinity Mi Shin, for instance, snarls with rage as he twists his body round to menace a victim at his feet (but unseen by us). This statue (pl. 128) represents one of the twelve heavenly generals (corresponding to the twelve creatures of the zodiac) who guard true worshippers of the Buddha of healing (Yakushi Nyorai). Probably from a temple on the outskirts of Nara they were made in the early thirteenth century by a member of one of the great dynastic families of wood sculptors there, known as the Kei School. As with Chinese sculpture of the same period, which was familiar in Japan (the *samurai* government had reopened communications with China), much use is made of thinly carved extensions or additions of drapery – scalloped cuffs, the scarf winding over the upper arms, and the floating tail of drapery.

The lower part of the body of Mi Shin – as distinct from the drapery – is static, and the figure is designed to be seen from more than one viewpoint – though not entirely in the round. This is true, too, of the colossal statues of muscular warrior gods in threatening postures who guard the gates of Japanese temples built in this period. But some figures are wholly animated and demand that we move round them to appreciate this. The fourteenth-century statue of Daikoku Ten, a guardian deity in Buddhist temples, also associated with good luck, shows him rushing to the rescue, arms outstretched and originally with a mallet in one hand and a sack in the other, his flapping clothes forming bold, curvaceous, hollowed shapes, like shells or mudguards, which spin round both limbs and chest (pl. 129).

Little of the original colouring of the statue of Daikoku Ten survives and

128 (following page) Japanese, Kei School, *Mi Shin*, cypress with paint and gilding, early thirteenth century, 69.2 cm. high, Tokyo National Museum: Important Cultural Properties.

129 (previous page) Japanese, *Daikoku Ten*, cypress with traces of paint, early fourteenth century, 56.3 cm. high, Nara National Museum.

much of the surface of the cypress wood is now exposed, its grain clearly flowing in different directions in different parts of the body, though few of the joins are easily found. In fact, the skirts, chest (together with part of the raised right arm), head, left arm, right forearm and both legs are all separately hollowed components.

The hollowing of wooden sculpture was not unique to Japan: we have observed the practice in medieval Europe. Many wooden statues of horses made by the Greeks are described in ancient literature, and one must assume that the bodies of these would have been hollowed to reduce the weight supported by the legs – indeed, the idea that men could be concealed within a large statue of this kind, as in Homer's *Iliad*, is not absurd. What distinguishes Japanese sculpture of this kind is the systematic splitting and hollowing which reduced the wood to a membrane. Hence, perhaps, the complete absence in the statue of Daikoku Ten of any sense of the log from which the forms were carved – the figure looks rather as if it had been inflated from within. There are two factors that may have encouraged Japanese craftsmen to think in such terms: one was the importance of wooden masks in their theatre, the other the technique of *kanshitsu*, perfected during the Nara period in the eighth century, whereby coats of lacquer reinforced with hemp were built up over a clay core which was then removed, leaving a hollow shell.

In the case of the sculpture of Mi Shin, not only have some of the colours survived surprisingly well – these were painted over a thin ground of clay – but also the leaf gilding applied over lacquer and then burnished and meticulously incised with intricate floral and geometric patterns. This type of surface decoration, as with European painted and gilded sculpture, was designed for relatively dim interiors with artificial light, which was not intended – as is 'correct' or 'good' lighting today – to supply uniform, informative illumination, but rather to add animation and mystery.

The original colours of Japanese Kamakura sculpture have usually darkened, where they have not flaked off, as in the statue of Daikoku Ten. But in that case the rock crystal eyes have remained. These were secured with bamboo pins projecting from inside the hollow head. White silk or paper was stretched behind them and painted to represent the pupils, iris and veins. It seems possible that knowledge of this technique was carried back to Europe by Jesuit missionaries, for the glass eyes found in Spanish wooden sculpture of the seventeenth and eighteenth centuries were also often inserted from within. This must have been the case with a statue illustrating the miraculous posthumous appearance of Saint Francis of Assisi, probably made in Castile in the late seventeenth century by a follower of Pedro de Mena. The front of the face was separately carved and inserted as a mask (pl. 130). When lit by candles the eyes would have glowed within the dark hood. And the open mouth where the mask is in fact completely perforated would have supplied very impressive shadows.

130 Follower or associate of Pedro de Mena, detail from a statuette of the miraculously preserved body of Saint Francis of Assisi, unidentified wood (perhaps walnut) painted, *c*.1680–1700, 50.5 cm. high, Victoria and Albert Museum, London.

142

10 Varieties of Smaller Wooden Sculpture

THE ANCIENT EGYPTIANS, as mentioned in the previous chapter, made their larger royal sculpture out of sycamore fig, but the wood was concealed beneath gold and gesso and resin. However, they clearly did appreciate the beauty of certain types of wood, as can be seen in smaller tomb effigies such as that of a high official named Tjeti, made about 2250 BC (pl. 131). This is made of cedar, a superior wood, strong but easy to work, fragrant and beautifully coloured, imported from Lebanon and Syria. The polished surface enhances our awareness of the stripes of the grain, which flow over the chest, dramatizing its modelling. The golden red colour contrasts strikingly with the wig, which is stained black, and with the calcite 'alabaster' and obsidian eyes. The nipples, represented by inserted studs (only one survives), were perhaps also originally different in colour, and slots in the buttocks suggest that the figure may once have worn some clothes. But most of the surface of this figure was certainly intended to be visible, and because it is not covered with gilding any joins would have been more apparent. Hence the sculptor endeavoured to reduce them to a minimum: only the arms are added (and in at least one similar figure there are no joins at all).

An ointment container in the form of a young girl supporting a jar against her hip (pls 132a and b) and probably made in the early fourteenth century BC, illustrates still more clearly the degree to which beautiful woods were esteemed in ancient Egypt, for this is precisely the sort of luxury utensil that was so often fashioned out of precious metal. Gold is used for the girl's belt, and ivory on the lid of the jar; and these, together with the black pigment used for her minute garment, necklace, and eyes, enhance the warm brown colour of the flesh. Figure and jar are carved from one piece of wood, although originally a small black braided lock of hair was inserted in the side of the head. Clearly the owners must have appreciated the skill involved in overcoming the difficulties of cutting around the arms and between body and vessel. It is remarkable that the delight in undercutting and in a composition with numerous points of view flowing into each other have no parallel in the larger stone sculpture of the Egyptians nor in their small metal sculpture. It has been conjectured that exquisite statuettes of this kind served as royal gifts. This particular piece seems to have been famous: certainly it was frequently copied.

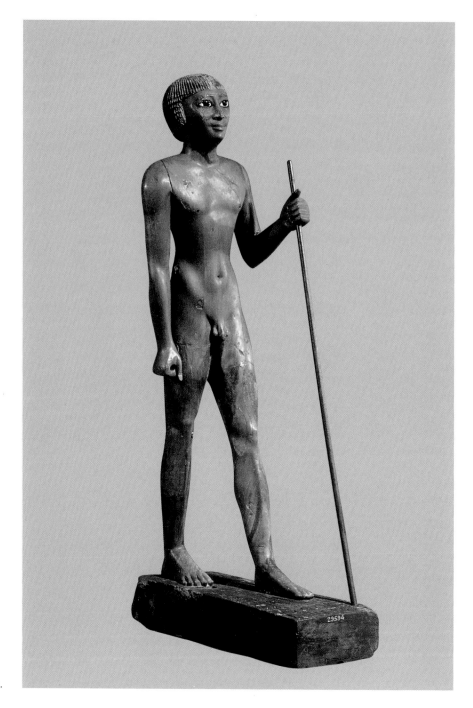

131 Egyptian, tomb effigy of the high official Tjeti, cedar, *c.*2250 BC, 75.5 cm. high, British Museum, London. The staff is a modern addition.

It has been supposed that the wood employed for this figure in box, but that in a similar figure has been identified as the heartwood of the juniper-tree, which is excellent for intricate carving. As a timber, juniper resembles cedar, and the Greeks and Romans knew these woods by the same name. The Egyptians imported box, juniper and yew from the north. From Ethiopia in

144

the south they imported ebony, together with ivory – and the palace servants such as the one represented in the carving. Ebony is the very heavy, fine-grained black or nearly black wood – with pale streaks occurring in some species (known as coromandel or calamander) – which comes from the heart of the tree of the genus *Diospyros* found in Africa, Madagascar, India and Ceylon. Because it can be combined so effectively with ivory, ebony has always enjoyed some of the prestige accorded to that material. The majority of cult statues made in archaic Greece were of cedar (or juniper) or cypress, but some of the smaller figures were of box or olive or ebony, and those of ebony are likely to have been the most prestigious.

Although the Romans valued the use of exotic wood for their furniture (especially citrus from North Africa which enjoyed almost as much glamour as porphyry), there is no evidence that they valued it for sculpture. And yet it was during the fifteenth century, when bronze statuettes and medallions were revived as an art form in Europe (partly stimulated by a new awareness of ancient Roman art), that small sculptures in hardwood became popular again. The woods favoured for this purpose were native to Europe: fruitwoods, especially pear, and box (now most familiar as a hedge shrub but growing as a tree to a height of ten metres). For the most part, these woods were available only in logs of small diameter, which encouraged their use for statuettes.

132a and b Egyptian, servant girl carrying a jar, unidentified wood (probably box or juniper), *c.*1350 BC, 13.3 cm. high, Durham University Oriental Museum.

145

133 Christoph Weiditz, boxwood medal of Margarethe Gysel, aged twenty-nine, in a turned frame of fruitwood (perhaps pear), *c*.1530, 5.3 cm. diameter (7 cm. including the frame), Victoria and Albert Museum, London.

134a and b Style of Franz Anton Bustelli, *Saint Sebastian awaiting martyrdom*, boxwood, 51.6 cm. high, *c*.1760, Ashmolean Museum, Oxford.

They served other purposes too: toilet items and musical instruments were made of them, as they had been by the ancient Egyptians, who used box for combs and flutes.

The popularity of hard wood for carving in northern Europe is in fact closely connected with metal work. Medallic portraits for example were cast in brass, bronze and lead in Germany soon after 1500 from wooden prototypes. The latter were not only preserved and valued after use but some seem also to have been made as substitutes for metal medals (pl. 133). Statuettes in copper alloys or silver in Northern Europe were also cast from, or at least modelled upon, carvings in boxwood or fruitwood. In these cases too the wooden prototypes were preserved.

Box and pear are blond in colour, sometimes ruddy, sometimes pale gold. An exceptionally fine grain makes them suitable for the most miniature detail, detail that could be executed, or fully appreciated, only with a magnifying glass. Box has the additional advantage of being repellent to the 'woodworm' beetle. It was not uncommon for the arms of small figures in box or pear to be added on to the torso, but usually the statuettes were made out of one piece, often with passages of virtuoso undercutting not dissimilar to those on the little Egyptian ointment container. In a boxwood statuette of Saint Sebastian, tied to a tree, awaiting martyrdom (pls 134a and b) – a work very close in style to the figures made at the Nymphenburg porcelain factory after models by Franz Anton Bustelli in the 1750s and early 1760s (e.g. pl. 167) – it is the rope that the sculptor could not resist undercutting and that, unsurprisingly, has broken off.

The wood used for this sculpture opened slightly whilst being seasoned, and these splits were carefully filled before carving commenced: they appear as stripes of slightly different colour in the saint's chest, belly and loincloth. A

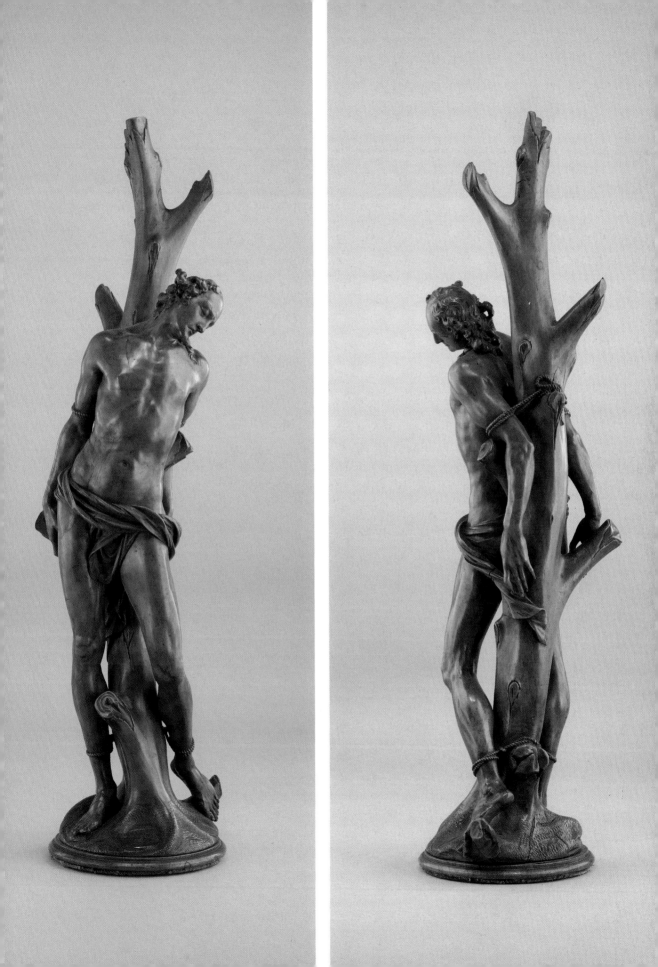

few more splits have developed since the sculpture was completed. It may be that the subject, or at least the elongation and torsion of the pose, was suggested by the form of the wood. The sculpture is also in part a sculpture of a tree, and indeed the upper part of the tree trunk behind the saint appears to correspond with a branch that actually grew out of the piece of wood used (at least, the flow of grain suggests as much).

It was unusual for European sculptors before the twentieth century to adapt their designs to the shape of the wood in this way. In China on the other hand, where, as we have seen, the shapes and colours of jade pebbles could suggest the subject matter into which they were worked, great delight was taken in contorted but natural plant forms. Sedentary senior males of the Qing dynasty (1700–1850) used flywhisks or backscratchers (*ruyi*: literally, 'what you will') fashioned out of bamboo to add emphasis to their conversation. In the example illustrated (pl. 135) the shape of the bamboo root is preserved so that it resembles an ornamental tree upon which beetles, bats, nuts and leaves are carved. Upon the scholar's table there would be pots (for caligraphic brushes) made out of sections of the curiously distorted trunks of streaky red and purple-brown rosewood. There was even a fashion for making furniture out of the natural forms of branches.

The paler hardwoods are sometimes combined with darker woods such as ebony, and with ivory or, less commonly, with stones such as turquoise or obsidian. Perhaps the most ambitious sculptures of this kind are the series of large black slaves with ebony flesh, ivory eyes and boxwood garments and chains carved in Venice in the early eighteenth century by Brustolon. The most refined may be the miniature sculptures of nineteenth-century Japan.

Patterns and pictures were created by inlaying differently coloured and figured woods – with the occasional addition of ivory or bone. This craft, known as *lavoro di intarsio* in Italy (and now simply intarsia), flourished in ancient Egypt and in Mesopotamia and then again in Italy, especially in the second half of the fifteenth and the first half of the sixteenth century. Whereas elsewhere in Europe this technique developed into marquetry (or parquetry when the pattern was geometric) and consisted of thin veneers placed side by side rather than one inlaid into another, the craftsmen of Egerland in Bohemia developed a form of *lavoro di intarsio* in relief. This was taken further in the nineteenth century by the French cabinet-maker Henri-Auguste Fourdinois (1830–1907).

Like his father, Alexandre-Georges Fourdinois (1799–1877), Henri-Auguste was an accomplished imitator of the most elaborate French cabinets of the past – chiefly those of the sixteenth century which were of walnut, with many panels in low relief, free-standing figures and a few contrasting panels of coloured marble or semi-precious stones; but also those of the mid-seventeenth century, which were of ebony imported from Madagascar, much of it veneer. Such historic French furniture was not always imitated: sometimes elements from different periods were combined, as in the great showpiece cabinet that

135 Chinese, bamboo-root *ruyi* carved with finger citrons, 52.8 cm. long, *c*.1760, Victoria and Albert Museum, London. Reproduced without its blue-silk tasselled attachment.

Henri-Auguste and his collaborators made for the International Exhibition of 1867. The techniques employed here were, however, derived not from earlier French cabinet-making but from the relief work of Egerland.

One detail – a medallion of Neptune (pl. 136) – shows the varieties of wood involved. The oval frame is of walnut, the background is of lime, the flesh of the figure is of box, the drapery probably of pear. A similar range of woods can be seen in the very low-relief foliage, contrasted against the ebony. The cabinet incorporates personifications of the four continents, two of which (America and Africa) are visible here. The colour of their flesh, however, for reasons of symmetry, are not distinguished. In addition to the woods already mentioned, holly and mahogany are said to have been employed in this piece. The hardstone tablets are of heliotrope or Bohemian jasper. The cabinet exhibits simultaneously the unprecedented technical skills and the full range of materials that were available in France and from her tropical colonies. In like manner, the ancient Egyptians delighted in their carvings of cedar and box. The materials were received as tribute from exotic lands but were worked with a skill beyond the power of any alien people.

For centuries in Europe exotic subjects had been represented in exotic materials – ebony and ivory especially. Sculpture by exotic peoples, on the other hand, was little known and exerted little if any artistic influence until the late nineteenth century, when Gauguin attempted to recapture the magical power of 'primitive' carvings, treating terrible or mysterious subjects with coarse vigour and in unfamiliar compositions which often owed much to the confinement of the figure to the shape of the log. He initiated a reaction against the sort of technical virtuosity represented by the Fourdinois cabinet. During the first decades of the twentieth century the leading sculptors in France, Italy and Britain, where wood had long been neglected as a material for high art (as distinct from exquisite craftsmanship), were attracted by the idea of making sculpture of this type.

John Skeaping's *Pampas cat* of 1932 (pl. 137) gains in savage menace from the compression into cylindrical form, stalking with short legs and lowered head. The slight twist in the wood and the streaks of colour suggest the flow

137 John Skeaping,
Pampas cat, snakewood
with opal inserts, 50.8 cm.
long, 17.8 cm. high,
1933, The Fine Art
Society, London.

of muscles, and the opal eyes suggest the hunter's nocturnal vision. The material is snakewood, a new import into Europe but similar to other exotic hardwoods such as rosewood, tulip wood, zebra wood, long used as veneers in European furniture. Such woods had, in fact, seldom been favoured for sculpture in the areas where they were locally available. African and Oceanic sculptors whose work inspired modern artists never attached such importance to natural colour but rather stained and painted their sculpture. Nor did they value polish, which is typical of sculpture made to be caressed by the hand of the connoisseur rather than of statues made to be raised upon an altar or to guard a shrine. On the other hand, by confining themselves to simple tools and avoiding undercutting (for instance, of the cat's tail) or intricacy (for instance, in the treatment of the paws), Skeaping and other sculptors like him, did effectively return to the fundamentals of their art.

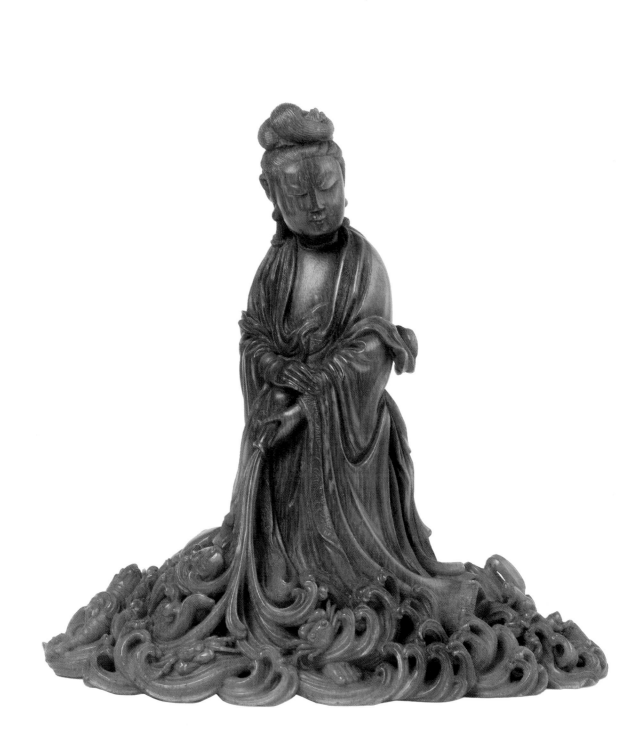

11 Ivory and Horn

No material has been more widely and continuously employed for sculpture of high quality than ivory. Wherever luxury artefacts have been made it has almost always been in demand, and until recently it was almost always available (although at a high price) from both Africa and Asia, and also from the polar regions. It has often been worked by craftsmen who have never seen the animals from which it was removed, just as carvers of exotic woods have often never seen the trees from which they were cut.

The chief sources of ivory are the tusks of the elephant and the teeth of the hippopotamus, though other sources have enjoyed some popularity: the tusks of the mammoth and the walrus (the latter much favoured in northern Europe during the early Middle Ages), the teeth of the boar and the crocodile, the tusk of the narwhal, the teeth of the sperm whale. Other materials have served as a substitute: bone, especially whalebone, and antler. The horn of the rhinoceros is a special case. A different material, more akin to nails than to teeth, it has in its own right been as highly valued as elephant ivory. When cut and polished it is a pale yellow and grey, though the Chinese stained it to a rich golden brown.

The colour of ivory varies from a rusty brown to a snow white. The whitest ivory comes from the hippopotamus, whose larger lower teeth are especially uniform in tone. The tusks of the Indian elephant are whiter than those of the African; those from New Guinea whiten with age. The rings in African ivory are a blue grey and purple brown; those of the harder African varieties resemble onion skin. But such distinctions are distorted by the numerous other factors conditioning the appearance of ivory of any antiquity.

Ivory comes in many shapes. The lower teeth of the hippopotamus are curled into half-circles. Most other teeth are short and straight. The tusks of the elephants of the grasslands of East Africa are longer, fatter and more curved than those with which the elephants of the Congo clear their path through the forest. The tusk always has a rind, and removal of this is not easy. On an elephant tusk it is present only towards the base, while the hippopotamus tooth is covered with an enamel that is said to be harder than jade. Once the rind has been removed, ivory can be scratched with an iron nail, and the tools generally employed to work it are those of the woodworker – saws, chisels, gouges, gravers, files. Indeed, many sculptors who have specialized in working hardwoods have also used ivory. Once prepared for the

138 Chinese, *Guanyin pouring balm*, rhinoceros horn, *c*.1600, 15.3 cm. high, Victoria and Albert Museum, London.

153

139a and b Tokoku of
Asakusa, netsuke of a
tennin bearing a lotus in
the clouds, stag horn,
*c.*1870–80, 4.2 cm.
diameter, Ashmolean
Museum, Oxford.

sculptor, ivory should have little tendency to crack, crumble or splinter, but, like wood, it splits with the grain when it dries. Such splits are common in elephant-ivory sculpture, but walrus ivory has survived far better.

Sometimes a whole elephant tusk was used for a single carving, as in the 'oliphants', or ornamental horns, of the Middle Ages, but more commonly the tusk was divided. The hollow base was adapted for *situlae*, or holy-water buckets, that were used in medieval Europe, for the bracelets worn on the arms of Benin rulers in sixteenth-century Africa, or for the tankards made for art collectors in seventeenth- and eighteenth-century Europe. The hollow base was also sawn into sheets for veneer, or into thicker, somewhat curved plaques for relief carvings. Figures were carved out of the solid upper parts of a tusk.

No material used in sculpture is more seductive than ivory or the finer horns. Its appeal to the touch is at once familiar and compelling, perhaps because it is anticipated, inadequately, in the feel of our own teeth to the tip of the tongue. Partly for this reason it has been much used for the handles of both daggers and hairbrushes – and for keyboards. Many of the most beautiful sculptures in ivory are indeed made to be touched: Chinese seals, German powder horns, Mughal chess pieces and, above all, Japanese netsukes.

Netsukes, which became fashionable in Japan during the eighteenth century, are toggle buttons used to suspend a cord (for medicine, pipe, tobacco, brush and ink and suchlike items) from a sash at the waist. They were usually carved out of elephant ivory, which was imported at great expense from China (whence it had been imported from both India and Africa), though many were made of fine woods or horn. The *manju* – that is, a beancake-shaped netsuke – illustrated here is carved out of stag's horn (pl. 139a). It represents a *tennin*, a maiden of the Buddhist paradise, bearing a lotus flower as she floats through the clouds – clouds that are continued on the reverse of the netsuke (pl. 139b), where we see a rectangular tablet engraved with the name and origin of the artist, Tokoku of Asakusa (1846–1913), and the *himotoshi*, the holes for the cord. Such holes had to be incorporated into all netsukes, and in *katabori* (netsukes of rounded form) the poses of the figures were designed to accommodate or conceal these, as in a late eighteenth-century carving of a seated woman suckling her son – a charming, compact group in elephant ivory, partly engraved with fine lines that were coloured, providing an exquisite contrast in texture with the smooth rotundities of the flesh (pl. 140).

The *manju* was carved from a slice of stag's horn the diameter of which suggests that little must have been wasted, whereas the *katabori* reflects the pyramidal shape into which the solid ends of the elephant tusk were cut to make suitable blocks. When a larger figure was cut out of the solid tusk or horn it was, of course, more likely to reflect the original form. We have observed the interest Chinese carvers took in the shape of jade pebbles, apparently discovering the subject of their sculpture within them; it was in China also that most delight was taken in ingeniously utilizing the curvature of the elephant tusk or the spreading form of the rhinoceros horn. This latter

material was being imported by the Chinese from Java, India and Africa by the thirteenth century. It was made into small ornaments but also into statuettes and, above all, cups which were used originally as sacrificial vessels, a few of which may date before the sixteenth century. These incorporate the shape of the horn, though, of course, reversed, adorning it with a fluent but complex design of leaves and stems. Sometimes the horn remained the right way up, as in an exquisite statuette of Guanyin, the compassionate Bodhisattva, of the seventeenth century. Sweetly smiling, she pours balm on the ocean coiling around her feet in which the crabs dance. The waves are carved out of the spreading base which glows, because the horn here is hollow and thus translucent (pl. 138).

The most interesting use of the curvature of the elephant tusk can be found in the statuettes of the Virgin and Child made in thirteenth-century Paris. One of the largest of these, and one of the finest of all European sculptures of this period, is the group made in about 1250 for the Sainte-Chapelle in Paris; it shows the Virgin leaning backwards to hold out a fruit for her child (pl. 141). This device of the elegantly swaying pose which makes it possible for both her raised arm and the Child to be cut from the curving tusk, became popular in wooden and stone sculpture, and indeed in paintings. The composition was also cunningly calculated so that the 'nerve' or pulpy core of the tusk corresponds with the hollows between the figures. The high regard with which this and other ivory sculptures were held may have encouraged the use of white marble for tomb effigies (pl. 53) and, just as ivory was cut from a tusk, such effigies, as has been suggested, might be cut from a column.

In an ivory group of the seated Virgin and Child of about fifty years later, also made in Paris, she leans even farther to one side. In this case, neither the tilt of her head nor the pose of the Christ Child are so effectively contrasted with the long, tight curve (pl. 142). There is another difference, too: the front of the group seems compressed, as is most apparent in the limited projection of the Virgin's right knee, in the disappearance of her left knee and in the strange bend in the wrist of her right hand, in which she holds the stem of a flower. The group is free-standing, but it was probably intended for a tabernacle: in any case, the back view was surely not important. It is, nevertheless, carefully finished (pl. 143), and in it we can discern the rotundity of the tusk, which is so absent from the front. From this we may conclude that the sculptor was employing the end of a tusk which had been cut vertically.

The sculpture is very little damaged. There are the usual splits as well as a few losses – most notably the points of the Virgin's crown and the rest of her flower, which was probably made of gilded copper. In the Virgin and Child from the Sainte-Chapelle the crown is missing, as are the ornaments originally set in the base, but much of the gilding on the borders of the garments has survived. No doubt there was originally gilding and colouring on the later

140 Japanese, netsuke of a woman suckling her son, elephant ivory, late eighteenth century, 4 cm. high, Museum of the History of Science, Oxford.

155

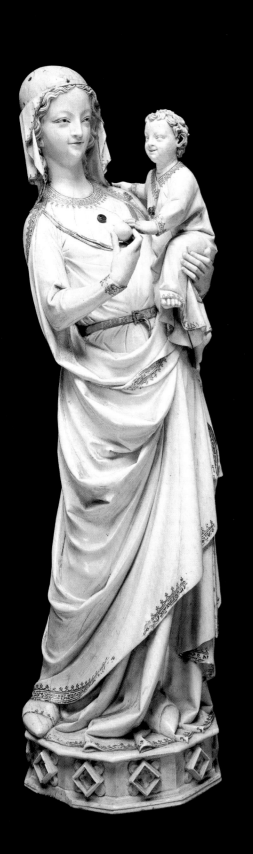
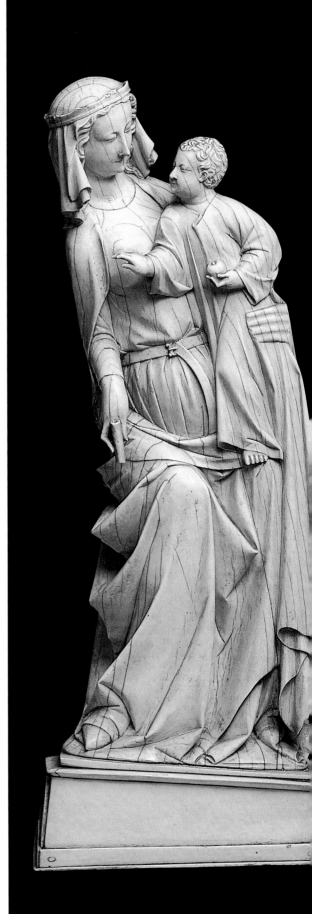

group as well; indeed, it is necessary for understanding some of the forms, since at present there is no distinction between the garment of the Christ Child and the Virgin's cloak. Presumably the cloak was stretched up beside Christ's leg to the Virgin's left hand, which is carefully carved to show that it is underneath the fabric. The cloak may well have been painted blue, which would have much enhanced both the gilding and the colour of the ivory.

There are some periods in which ivory seems not to have been available, or perhaps not to have been in demand. No Byzantine carving in ivory has been dated to the period between the mid-sixth century and the early tenth, when iconoclasm prevented the fabrication of religious images and the rise of a hostile Islamic power in the east cut off the usual sources of supply. A similar disruption of trade routes may have occurred during the fifteenth and sixteenth centuries, for the popularity of bone as a material for inlay in furniture suggests that, had ivory been available, it would have been appreciated. By the early seventeenth century ivory was again available and was being used by leading European sculptors such as Georg Petel, who enjoyed a high reputation for work in wood and metal as well.

Petel's *Venus and Cupid* (pls 144a and b), an early work probably of the 1620s, perhaps made on his visit to Italy or in Antwerp soon after he returned, would have been a surprising subject three centuries earlier when the groups of Virgin and Child that we have been examining were carved. Anatomical accuracy, the weight and articulation of the body, the soft plumpness of flesh have become major concerns of the artist. The figure, although approximately the same size as the Gothic Virgins, does not lean with the curvature of the tusk (which was to her right, as is not hard to discern). Petel's sculpture is full of ingenious undercutting achieved with minute pointed and curved files (known in English as rifflers). The drapery, the dressing of Venus's hair (especially the looped plaits at the back), the fingers of the hand over her genitals, and the open mouth of Cupid (in which tongue and teeth are distinguishable) all demand close scrutiny by the connoisseur who turns the ivory in his hands. Such handling, of course, precluded the colouring and gilding found in medieval ivories, and it necessitated making the group interesting from every point of view.

The elbow of Petel's Cupid is made of a separate piece of ivory fixed by an ivory peg. There is another small attachment to the fold of drapery over the goddess's arm and also a slot in Cupid's back where a separately carved wing was inserted. It is not known whether any one of these additions is original. Petel certainly did make small additions to some of his other works in ivory – the wings of the Cupids in his great salt-holder, executed to the design of Rubens and now in the Royal Castle in Stockholm, for example – but he preferred to carve entire compositions out of the same tusk as is clear from his great Crucifixion of 1629, in which Christ is represented with his arms stretched above his head and nailed to the bar of the cross at points unusually

143 Rear view of *Virgin and Child* in pl. 142.

141 (facing page left) French (Île-de-France), *Virgin and Child of Saint-Chapelle*, elephant ivory with gilding, *c.*1250, 41 cm. high, Musée du Louvre, Paris. The crown is missing. The gilding has in many parts been rubbed off to reveal red underpaint. Traces of blue pigment remain in the Virgin's eyes.

142 (facing page right) French (Île-de-France), *Virgin and Child*, elephant ivory, early fourteenth century, 40.6 cm. high, Victoria and Albert Museum, London.

144a and b Georg Petel, *Venus and Cupid*, elephant ivory, c.1622, 40.5 cm. high, Ashmolean Museum, Oxford.

near the post – a daring innovation which enabled him to carve the whole body out of one tusk.

The Crucifixion, together with the Virgin and Child, were the chief subjects for the European ivory carver. Since in Crucifixions Christ is naked, it

158

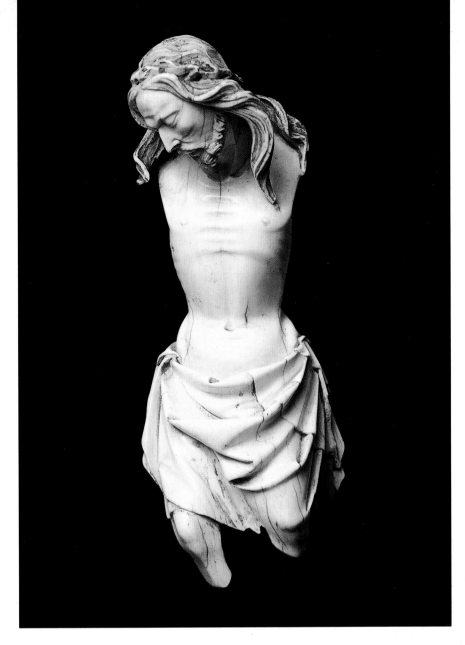

145 Giovanni Pisano, *Crucified Christ*, elephant ivory, *c*.1300, 15.2 cm. high, Victoria and Albert Museum, London.

was not easy to conceal the joins when his outstretched arms were made of separate pieces of ivory, and such joins, however finely executed, become more apparent – and often loosen – when the ivory shrinks or when dirt enters the division. Petel's solution was an unusual one. It was also extravagant, for he wasted much of what must have been an exceptional tusk, and thus it is not surprising that this formula was not widely adopted. Another solution is exemplified by a powerful fragment of a Crucifixion made in Italy almost certainly by Giovanni Pisano in about 1300 (pl. 145) in which Christ is given long hair which covers his shoulders at the point where the arms were joined. The head of Christ here projects forward not only because he is dead (as was

146a and b (facing page)
Perhaps Georg Kriebel,
Virgin Mary, from a
Crucifixion group,
elephant ivory, early
seventeenth century,
16.25 cm. high,
Ashmolean Museum,
Oxford.

usual in Crucifixions of this period), but probably because the figure was to have been raised above an altar and hence seen from below. Since the arms were carved separately, an additional fixture would have seemed prudent – hence a projection in the loincloth at the back.

Whereas Christ's right leg has been shattered across the flesh, the break on the other leg corresponds with the edge of the drapery, and examination of the underside of the ivory at this point suggests that the left leg would have been separately carved and inserted, with the loincloth concealing the join. The sort of tortured pose that Pisano was interested in could not easily be confined within a single tusk of ivory, and the most notable stylistic characteristics of this sculpture, the contrasts between the bold mass of the hair and the richly folded loincloth, on the one hand, and the taut and emaciated body on the other, are related to technical problems of piecing.

A remarkable possibility in sculpture of ivory or horn which was not fully exploited by the figure sculptures in ivory that we have been examining, but which is found in the rhinoceros-horn statuette of Guanyin, is that of translucency. A small figure of the Virgin Mary from a Crucifixion group (pls 146a and b), certainly dating from the early seventeenth century and probably German, is unusual in the imaginative use it makes of this quality. There are passages of extraordinary undercutting in the drapery, where the ivory resembles crumpled, brittle, paper. When lit from behind these seem to glow, imparting a supernatural intensity to the figures and enhancing our sense of the fragile material.

This ivory also differs from those so far examined in colour – a dark golden brown in some areas – and because it was carved from the point of the tusk. The resulting curvature seems to have stimulated the angular torsion of the figures. The outer curve of the tusk is evident on the Virgin's left-hand side, and it is interrupted by an arm which has been separately carved. This arm is fixed at the shoulder and the cuff, her hand having been carved together with her body.

As was observed earlier, at the other end of the tusk, which is hollow and thicker, plaques could be cut for relief carvings. Ivory reliefs, combined to form diptychs or triptychs, or multiplied to form an altar frontal or to cover a throne, were especially popular in the Byzantine Empire. In Byzantium, indeed, ivory seems very rarely to have been employed for carving free-standing figures. A novel way of employing their plaques in low relief was in the form of book covers, generally for the gospels. They were displayed in processions and at the altar, and kissed by the priest. Because such reliefs were pinned to wooden under-covers they could safely be pierced, as in an early twelfth-century plaque of Saint John the Baptist surrounded by Saints Philip, Stephen, Andrew and Thomas (pl. 147) which, however, may have served as the lid of a reliquary or had some other, similar purpose. A brilliant fabric or gilding would have shone through the interstices. The drilled eyes may have been filled with glass, and the drilled holes in the foliage with gilt pinheads.

The piercing increases our awareness of the thinness of the plaque and so contributes to the almost spectral character of the floating half-figures of the saints. The four smaller disks are firmly enough attached to both the border and the central disk, but the fine, rounded moulding which unifies the design

147 Byzantine, *Saint John the Baptist surrounded by Saint Philip and Saint Stephen {above} and Saint Andrew and Saint Thomas {below}*, elephant ivory, twelfth century, 23.5 cm. high, 13.5 cm. wide, Victoria and Albert Museum, London. The flat frame would originally have been concealed, presumably with pliable gilt metal.

also lightens it to the point of precarious delicacy, for it seems as if it is a pliable wire which holds the five disks together.

More amazing objects were made out of ivory, especially by virtuoso craftsmen in eighteenth-century Dieppe or Canton. In the workshops of the latter, whole years were devoted to fashioning concentric sequences of hollow balls – 'laborious orient ivory sphere in sphere'. During the previous century the turning of the most complicated forms of cup and cover with twisted stem was established as a form of therapy for European princes. But the imagination of the beholder is seldom engaged by such exhibitions of ingenuity and virtuosity – indeed, they can depress the spirits in precisely the way that art does not.

12 Stamped and Moulded Clay

CLAY IS SOFT, YET IT IS COMPOSED of the particles of some of the hardest igneous rocks, such as granite and gneiss, eroded by ice and water and wind. Primary clay, or kaolin, is not easy to model. Secondary clays, which have been washed away and deposited, have finer particles, bonded with other materials and thus have greater plasticity. However, modelling will be treated separately, in the following chapter, and our concern here is with stamping, moulding and, of course, firing. In a hot climate clay can be hardened by baking it in the sun, but more generally it is fired in a kiln, after preliminary drying, to form earthenware, or terracotta (meaning, literally, 'baked earth').

Clay has been universally and abundantly used for sculpture but, as with wood, this has never been its chief purpose, which has, rather, been the manufacture of bricks and tiles and jars and jugs. For many centuries clay was also of great importance as a surface for writing. Cuneiform script, the earliest-known form of writing, developed in about 3000 BC among the civilizations of Mesopotamia. It consisted of wedge-shaped letters made by jabbing a split reed into a half-dried clay slab or wax tablet (pl. 149). Clay from the valleys of the rivers Tigris and Euphrates was used for the bricks of which Mesopotamian cities were built – and these also served as a writing-surface.

Once it had been established, cuneiform script could be inscribed on other materials, and we find it carved across the relief sculptures of gypsum alabaster made by the Assyrians (pl. 35). It is conjectured that the script was first drawn onto the face of the alabaster by scribes and then carved by craftsmen who did not understand it. Likewise, as has been mentioned in an earlier chapter, the figures were perhaps drawn with a brush by the artist who would also have painted the murals higher up on the same palace walls. Some such division of labour may, in fact, be deduced from oddities in these carvings. For instance, in one of the famous reliefs of ritual lion slaughter, where King Ashurbanipal's left arm meets the neck of his horse, the clipped mane is interrupted, as if the carver was confused as to whether the arm was intended to pass in front of or behind it (pl. 150).

However, even if painted outlines were followed, the prototypes for such carved lettering were those impressed in clay. Likewise, the carved figures

149 Sumerian (probably Fara), tablet with cuneiform inscription, unbaked clay, c.2400 BC, 8.5 cm. high, British Museum, London. The inscription records a variety of deliveries of silver to the governor, some verified, others not.

148 Detail of pl. 157.

151(facing page top) Assyrian, detail of a fragment of a relief depicting a king slaughtering lions, unbaked clay, *c.*650 BC, 15 cm. high, British Museum, London.

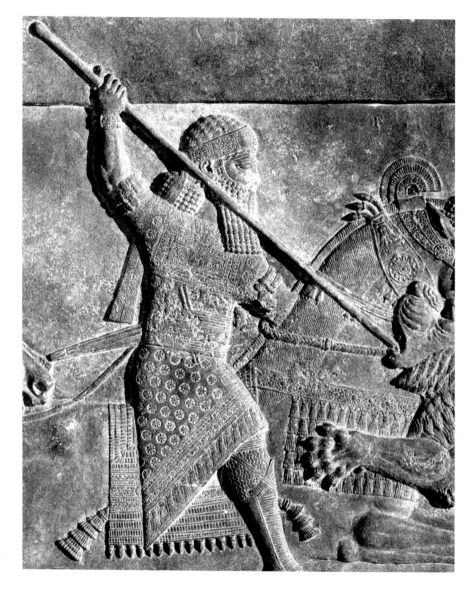

150 Assyrian, detail of *King Ashurbanipal slaughtering lions*, (pl. 35), gypsum alabaster.

were surely modelled on figures that had been incised and stamped in clay. It would be hard to devise a pattern more tedious to carve in stone than a raised star within a recessed circle separated at regular intervals and on a minute scale, such as we find adorning King Ashurbanipal's kilt. But it would be a comparatively easy matter to stamp this pattern into a soft surface, using a small hollow-carved punch or seal. It should be borne in mind that little cylinders of hardstone with designs in intaglio — or 'hollowed out' — are among the most important works of art to survive from Mesopotamian civilizations. The pressing of such seals into clay or wax, as a sign of owner-ship or approval, was then a familiar process, so the use of similar devices to

decorate larger surfaces is not surprising. Clay plaques have, in fact, been discovered which are supposed to have been models made for the carvers in gypsum alabaster. But they are surely more likely to be rare survivors of the relatively fragile art that these alabaster carvings replaced, for, although stamping and incising accounts for much of the detail, the background has been laboriously cut back around each figure (pl. 151).

Instead of pressing a stamp or seal into a slab of clay, a lump of clay could be pressed into a larger, hollow-carved piece of wood or stone, or (more probably) into a hollow mould of earthenware or plaster. Much relief sculpture of the Babylonian and Persian Empires which succeeded the Assyrian Empire was made in this way. Each of the sacred dragons and bulls of the Ishtar gate of Babylon, built in 575 BC, is compiled out of bricks pressed into moulds and coloured with blue, white and yellow tin glazes (pl. 152). The lack of deep relief and the repetition of each creature many times renders these effective ornaments for a building: the former quality makes them seem a part of the wall; the latter gives them the regimented monumentality of architectural units. The ridge-like divisions of the relief kept the glazes from flowing into each other. Independent sculptures mass-produced out of simple moulds by early civilizations are seldom precise or detailed. Notable exceptions are the press-moulded clay plaques made in about 200 BC which have been discovered in many parts of northern India. The first to be excavated, and one of the finest, is the so-called 'Oxford Plaque' found near Calcutta

152 Babylonian, a bull from the Ishtar Gate, glazed bricks, 575 BC, unmeasured, Staatliche Museum, Berlin. Considerably reconstructed.

153 Indian (West
Bengal), a *yaksi* or lesser
goddess, earthenware,
c.200–100 BC, 21.3 cm.
high, Ashmolean Museum,
Oxford.

154 Indian (West
Bengal), a mould for a
yaksi with a mortal
attendant, earthenware, *c*.
200–100 BC, 23 cm.
high, Ashmolean Museum,
Oxford.

(pl. 153). Like many of its kind, it represents a lesser goddess, or *yaksi* – or just possibly a mother goddess. The post-like legs, fat cheeks, bulbous headdress and bracelets, and bolster-shaped ear pendant have no more subtlety than a pastry or jelly formed by one of today's kitchen moulds. But the surface has been animated, with the utmost patience and delicacy, with tiny incised lines representing the threads of hair and creases of silk, and with numerous tiny studs and rosettes. One might suppose that the clay figure was carefully worked over after it emerged from the mould but clay moulds for figures of this type have been discovered which prove that pins and punches were pressed into the inside of the mould before firing, which is why the studs and rosettes are raised on the cast figures (pl. 154). This way of working within the hollow mould was a technique perhaps suggested by the fashioning of seals in intaglio.

Figures in the round could be made by pressing clay into a pair of moulds joined like the two shells of a clam. The figurines found in Chinese tombs of

168

the Han dynasty (206 BC – AD 220), such as the servant illustrated here (pl. 155), are of a very simple shape broken only by a few shallow incisions for folds or fingers, with soft and indistinct features perhaps suggestive of an appropriate anonymity and meekness. A thin raised line is sometimes apparent down the sides of the skirt, where the clay was forced into the join between the moulds. The Oxford Plaque is warm orange in colour, while this Chinese figure is pale grey. The former is closer to the colour that most people associate with terracotta – the earthy red colour of flowerpots – but earthenware can be dark brown, pale pink, grey, buff or orange, according to the iron content of the clay, the reactions of other minerals within it, the temperature of the kiln, and the amount of oxygen admitted during firing. The Chinese figure was also coated with a pale slip, that is, a liquid mixture of especially fine clay such as kaolin, traces of which remain. This would have been applied after firing, to provide a surface suitable for painting and perhaps to conceal cracks and seams – the same material was, as mentioned in a previous chapter, employed as a ground for the decoration of later wooden sculpture in China. The figure would also have been given a thin staff, presumably of wood.

The shape of this tomb figure is simple and rounded, with no projections or undercutting. The operation of casting it would have been easy and there would have been little risk of anything being caught in the mould and broken off or pulled out of shape in the process. Although such clay figures were carefully dried before firing, they still contained residual moisture, and, when this was driven off as steam in the kiln, were reduced by a fraction – anything between a twelfth and a twentieth. Moreover, differences in the thickness of the clay lead to differences in the rate of shrinkage and therefore to cracks. For this reason, the figure was cast hollow, with a wall of clay, more or less equal in thickness, pressed into both sides of the mould. Each foot would have been cast in a pair of moulds as well. The two sides of the body and of each foot would have been united in the moulds as soon as they were filled, and the clay would have been pressed across the join within the hollow interior. The attachment of the feet to the body would have been achieved when both had been removed from the moulds and had started to dry, using liquid clay (slip) as a cement – a technique known to the potter as 'luting'. The same basic procedure was used for the earthenware nymphs and cupids and the graceful slaves made in Greece, Sicily and Asia Minor in the fourth, third and second centuries BC, except that they seem to have more frequently favoured separately moulded heads and also modelled adjuncts – wings, sunhats and so on. The example illustrated here (pl. 156), which retains much of the pale slip, is more complex in form than the Chinese figure, because it is modelled on a marble sculpture that had deeply cut drapery folds. The folds of the drapery, also the divisions between the fingers, have been made more distinct with a tool after casting. The lively cuts and jabs that mark the hair were also made at this stage.

The practice in China of making earthenware animals, servants and enter-

tainers to exhibit at the funerals, and to populate the tombs, of the wealthy seems to have been revived and to have increased during the T'ang dynasty in the eighth century. Exotic camels and horses were especially popular, but these were, of course, more difficult to construct than demure domestic servants. The ferocious Bactrian camel illustrated here (pl. 157) is not unusual except in its high quality and excellent preservation. Each leg, the body and the head (with neck) would have been made of clay pressed into a pair of moulds. A single mould would have served for each hump, for each of the masked cushions between them, and for the plinth, making a total of seventeen parts. In this case, as always with animals of this type, there is an aperture below the belly of the animal, large enough for a hand to reach in so as to ensure that the parts have been properly assembled. This was needed because the use of an internal armature of metal or wood to hold all the parts together was impracticable, for in the heat of the kiln the metal would expand and buckle and the wood would burn. Such apertures also served as vents for steam to escape from within the hollow of the interior of the model when it was fired.

Many of these T'ang tomb animals were coated with slip and painted (as with the Han servant); in numerous cases, too, the pale buff earthenware was enlivened with a *san cai*, or three-colour glaze of rich green, amber and straw yellow, or (more rarely) with a blue glaze. The glazes were allowed to run, gather and mix. Translucent lead glazes were first invented by Chinese potters. When iron was mingled with the powder of lead oxide and scattered over the earthenware, an orange or yellow glaze was achieved; copper would be added to make a green one, and cobalt (which was imported, and more unusual) to make blue. The delight in the accidental patterns of these glazes is reminiscent of the delight taken in the natural colouring of jade – perhaps the excitement of the unpredictable, or apparently unpredictable, is also attractive to craftsmen who are in perfect control of their technique. Certainly it guaranteed that each animal, although essentially mass-produced, would have a unique appearance.

Of course, the moulds from which such figures were made were taken from prototypes that could be modelled in clay or carved in wood (to mention only the most probable materials). The angular treatment of the heads strongly suggests a form that has been cut out of a hard material, and is a notable feature of the jade horse (pls 4 and 6), an earlier tomb animal of the most superior kind.

Chinese tomb figures were viewed at the funeral and then buried forever, but other moulded earthenware sculptures were intended to provide permanent inspiration for the living. The most notable of these known to us today are perhaps the statues of seated Buddhist and Taoist sages known as Lohans, made between the tenth and thirteenth centuries and discovered earlier in this century, south of Beijing (pl. 158). They are slightly larger than life-size and were fired in a single piece – a remarkable achievement, for the larger the kiln

155 (facing page left) Chinese, a tomb figure of a servant, earthenware with traces of slip, second century BC, 76.2 cm. high, Ashmolean Museum, Oxford.

156 (facing page right) Boetian, a female figure, earthenware with traces of slip, *c*.330–200 BC, 19.7 cm. high, British Museum, London.

157 Chinese, a tomb figure of a Bactrian camel, earthenware with three-colour glaze, eighth or ninth century AD, 84 cm. high, British Museum, London.

the more difficult it is to heat and to control the temperature. Whether or not these Lohans are portraits cannot be established, but they do impress us as individuals and, although they are all seated cross-legged on a similar rocky plinth and are clothed in the same type of robe falling in the same rhythms, their faces and expressions are different from each other, as are the positions of their hands. It is likely that the heads and hands were modelled, while the rest of the figure was moulded and then partly modelled, which not only enabled the drapery to be varied but also meant that the edges of the drapery could be made sharper and the folds cut more deeply than we would expect in moulded work.

172

158 Chinese, *Lohan*,
earthenware with three-
colour glaze, tenth to
thirteenth century AD,
105 cm. high,
Metropolitan Museum of
Art, New York (Hewitt
Fund).

The ceramic traditions of China are more continuous and impressive than
are those of any other civilization. Yet, in the field of ceramic sculpture, most
of what was achieved there has some sort of parallel in the work of ancient
civilizations of the Mediterranean, where some remarkably large (as well as
thousands of small) piece-cast figures were made in earthenware. One of the
more remarkable large figures to have survived (at least in part) is a life-size
cult statue made in Italy in the late fourth or early third century BC out of a
pale yellow clay flecked with feldspar (pl. 159). The head and hair were
inserted, as a separately moulded 'mask', into a slot formed by the veil. The
large fold of drapery passing across the belly would have concealed a join, and

159 Italic, Votive or cult
figure, earthenware, late
fourth to early third
century BC, 74.8 cm.
high, Metropolitan
Museum of Art, New York
(Rogers Fund, 1916).

there was another at the elbow, where the statue has broken. The bracelet and numerous pendants on neck and chest seem to have been cast from moulds taken from real jewellery of gold and precious stones. They would have been stuck on top of the larger forms. Both the folds of the drapery and the details of the jewellery have the dull, rounded quality characteristic of casts, but after casting the head was tooled, and thus there is an unusual sharpness in definition of the eyes and hair.

174

160 Gandhāran, *Bodhisattva*, unbaked clay, sixth century AD, 51 cm. high, Musée Guimet, Paris.

A similar technique was used for the large clay figures found in a Buddhist monastery of the seventh century AD at Fondukistan, 117 kilometres north-west of Kabul. The most notable of these figures is a Bodhisattva more than two feet in height, seated in a lively swaying pose (pl. 160). It retains some of the whiting and original colour which would have made it seem to grow out of the two-dimensional paintings on the niche to which it was attached. The figure was not cast but modelled over an armature of wood with unbaked clay,

with which much horsehair and chopped hay had been mixed. However, all the ornaments – ringlets, curls, flowers, pendants, hair ornaments – which conceal or compensate for the boneless quality of the body, have been separately moulded or stamped and then applied. This method would have facilitated repetition, but it may also have been difficult to model the clay in much detail.

By the fifteenth century large earthenware figures were again being made in Italy, but these were modelled and will therefore be discussed in another chapter. Moulding was, however, also introduced, especially for architectural ornament – a development probably pioneered by Brunelleschi – and for sculpture of a devotional character and intended for the popular market. The workshops of leading Florentine sculptors of the fifteenth century reproduced bronze and marble relief sculptures in stucco, *cartapesta* (papier mâché) and earthenware, passing them on to painters, who would add colour and precision to the blunted details and smudged expressions that the casting process all too commonly yielded. In Bavaria and the Middle Rhine whole figures were cast in clay. In Cologne and Utrecht statuettes were cast in pipeclay – a very pure secondary clay which cannot be thrown on the wheel or modelled by hand – with a sharpness seldom equalled in Florentine work.

One of the leading Florentine sculptors of the second half of the fifteenth century, Luca della Robbia, realized that earthenware could be made more attractive and durable by means of a tin glaze. This sort of glaze was a development of the type of lead glaze that had been invented in China. In Persia, probably in the ninth century AD, tin and silicate of potash were added to the oxides of lead to form an opaque and smooth, white, porous coating which was applied after a preliminary firing of the earthenware. This coating could then be painted with pigments derived from metallic oxides and refired in order to fix the glaze to the earthenware and vitrify it (an additional transparent lead glaze could be added to make it more glossy). Tin-glazed earthenware, introduced into western Europe from Islamic Spain, was first imitated in fifteenth-century Italy (where it was known as *maiolica*) and then elsewhere (as faience and Delft). Among its advantages for Luca della Robbia was the white surface, which could compete with, or at least appeal to, a taste formed by the fashion for expensive white marble, while the colours that were employed could be returned to their original brightness with a duster or a wash. The brilliant colours that could be achieved also enabled these sculptures to attract attention even when placed high in a room. Moreover, because of the glaze protecting the porous earthenware body, they could serve as exterior architectural ornament. Earthenware had been made hard enough for this purpose elsewhere in Europe without glazing, and perhaps it was the colour of the glazing that was the chief attraction. No coat of arms or tabernacle of the Virgin and Child carved out of any of the stones available in Florence could survive so well; certainly no painted surface would remain

161 Andrea della
Robbia, *Virgin and Child
with angels* (*Tondo dei
Cappuccini*), glazed
earthenware, *c.* 1470–5,
100 cm. diameter, Museo
Nazionale del Bargello,
Florence.

as bright. The colours, however, are far from subtle, and refinements of modelling were lost under the thickness of the glaze.

Although Luca della Robbia and the members of his family who continued the business into the sixteenth century modelled their most important works in earthenware – both large free-standing figures and small table-ornaments – some of their work was moulded. A good example is the *Tondo dei Cappuccini*, a relief roundel of the Virgin and Child with angels (pl. 161), probably of about 1470 and by Andrea della Robia. Three colours are used: blue for the sky, the eyes and the ribbon in the garland frame; green for the leaves in the garland; yellow for the flowers and haloes. It might have been possible (judging from other works) for this piece to be fired as one, but the risk of kiln damage would have been great, and it was, in fact, fired in eleven pieces. These are clearly visible. The garland frame was made in six equal parts, each cast from the same mould and with a design that is not continuous. Both the Virgin and Child and the angels look as though they could be repeated in other reliefs – the Virgin and Child alone, the angels in other compositions.

Luca della Robbia, if asked to model or carve a group of this kind, would probably have devised a happier composition than this one, which looks as if it was an ingenious combination of standard moulded components. The angel on the right is uncomfortably close to Christ's halo (which was cast with it rather than with Christ), and both angels appear to be gazing at the back of the Virgin and Child.

* * *

The Italians who had recently learnt to imitate Islamic tin-glazed earthenware also had knowledge of wares made in the Orient which were finer and harder. By the fourth century the Chinese had invented stoneware, in which clay is mixed with a fusible stone, usually feldspar, and fired at a high temperature so that the stone vitrifies; and by the seventh or eighth century they had perfected porcelain, in which, by using quartz and sericite rock or felspathic rock combined with purest kaolin, the whole ceramic body is fused into a hard, translucent white body, generally given a high glaze. At first figures were not made by this method, but by the thirteenth century there were some sculptures made at the porcelain kilns at Ching-te Chen, Kiangsi, in southern China, which had grown up under the southern Sung dynasty and continued to prosper under the Mongols. The porcelain produced there was characterized by a very subtle hint of blue green in the glaze. The seated Guanyin, more than a foot and a half in height (pl. 162) is an ambitious example. That it was a novel and even experimental work is suggested by the firing cracks and speckling in the glaze. The garment, where unglazed, was perhaps gilded.

The torso and legs of this figure were probably moulded as one unit, while the head and forearms were moulded separately. The relatively simple body then assembled was 'dressed' in thin sheets of pleated clay for the drapery (we can see that it did not fall over the left arm quite as gracefully as intended); with tiny rolls and strips and balls of clay for locks of hair, ribbons and beads; and with curled wafers of clay for the garland on the head, in a process not so different from the decoration of a pie crust. The result is an odd mixture of moulded forms of a static, slightly inflated monumentality, with fussy miniature ornament that has obviously been applied.

The numerous statuettes of Guanyin made for domestic shrines in the seventeenth and eighteenth centuries under the late Ming and early Ch'ing dynasties at Tê Hua, in Fukien province in south-east China, must have been made in the same way, yet the result is entirely unified in conception. These figures are generally smaller, influenced less by monumental earthenware or wooden sculpture than by small carvings in jade and ivory, which could be rotated in the hand. The figures turn, their hair coils, their silk sleeves flow, in a continuous movement. Details are often minute, as is, for example, in the statuette illustrated (pls 163 and 164), the tiny basket containing a fish (the carp into which the son of the dragon-king has been turned and which

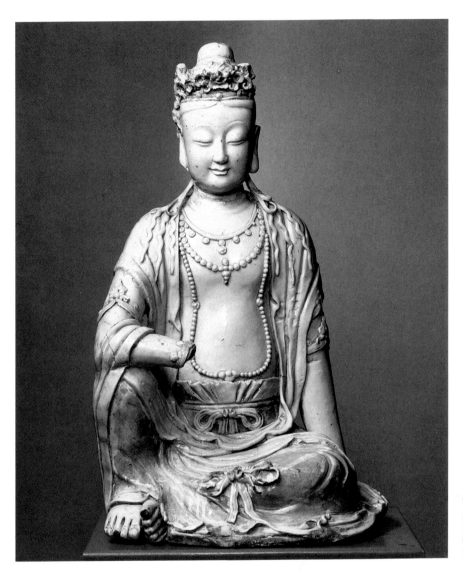

162 Chinese (Ching-te
Chen factory), *Guanyin*,
porcelain, 1298 or 1299,
51.4 cm. high, Nelson
Gallery and Atkins
Museum, Kansas City.

Guanyin bought in the fish market). Heads and hands were not only separately
moulded, but were often detachable (perhaps for safety in transit). Whereas in
the earlier and larger Sung Guanyin the applied elements could be easily
distinguished from the principal press-moulded form, here such elements as
the separate strands of hair (three on either side) which fall over but are not
combined with the drapery are integrated into a harmonious whole. In fact, it
is difficult to be sure whether some elements were applied or were part of the
moulded body. The scarf, for example, where it falls beside Guanyin's left
foot, is completely, but finely, undercut. Like the strands of hair, but at an
earlier stage, this must have been applied. The actual undercutting looks
tooled and may have been cut out when the clay was leather hard.

179

163 (facing page)
Chinese (Tê Hua factory),
Guanyin, porcelain,
probably late seventeenth
century, 30.5 cm. high,
Ashmolean Museum,
Oxford. The figure is
impressed with the mark of
a double gourd and with
an illegible inscription.

164 Detail of the
sculpture in plate 163.

The white porcelain figures made in this factory, with their distinctive
ivory-tinted glaze (slightly brown where 'gathered') known in Europe as *blanc
de Chine*, were among the works of Chinese art and technology that were most
prized in Europe in the early eighteenth century, when true porcelain was first
created at the Royal Saxon porcelain factory at Meissen, near Dresden. Among
the earliest works marketed there from 1713 were copies of such statuettes of
Guanyin.

165 Johann Joachim
Kändler, *Stork*, porcelain,
1732, 63.5 cm. high,
Porzellansammlung,
Dresden.

Johann Joachim Kändler, who became chief modeller at the Meissen factory
in 1733 two years after he commenced working there and retained that
position for over thirty years, had been trained as a sculptor. He conceived the
ambition of creating works of monumental size in porcelain, despite the
extreme difficulty of doing so: a group of animals made after his models for

the first floor of the Japanese palace of Augustus the Strong (the ground floor was filled with oriental porcelain) are a stupendous demonstration of the potential of this novel medium, though on closer examination they also reveal some of its limitations. The stork (pl. 165), for instance, made in 1732, would have been moulded in parts and assembled before firing. Cracks at the top and bottom of the neck reveal two of the joins, though the construction is not obvious. Kändler knew that it would be impossible to support the bird on its two slender legs alone, hence the reeds in which it stands, which mask a hollow pillar supporting the hollow body. Various smaller parts – two of the separate claws of the bird's feet, the rounded water-leaf curling over the stem of the bulrush, the projecting reeds and end of the bulrush itself – are separately moulded and give extra depth to the relief while also blending with the details on the main moulded element. Knowing that it would be impracticable, if not impossible, to fire a porcelain stork with its head lifted – for it was likely to sag when the body of the clay became molten (if it hadn't already) – Kändler devised a pose in which the head bends downward, very ingeniously pressing it into the side of the body, thus diverting our attention from the fact that it must have been separately moulded.

Such creatures, like the altar figures that Kändler also made in the 1730s, were special commissions, and for the general market the factory confined itself to smaller figures, mostly intended as diverting ornaments for the dining table (where previously sugar statuettes had been the fashion) and derived from comedy and romance. Turks and Chinamen, harlequins and columbines, gallants and shepherdesses, picturesque street-vendors and the like were also made by the rival porcelain factories such as Capodimonte, the Royal Neapolitan factory, where Giuseppe Gricci was chief modeller from 1743, and Nymphenburg, the Elector of Bavaria's factory near Munich, where Franz Anton Bustelli was *modellmeister* from 1754.

Bustelli's mincing, pouting, strutting, gesticulating, figurines (pl. 166) possess an exquisite grace – 'no sculptor and, indeed, no medium less delicate than porcelain has ever succeeded in catching the fleeting movements of the human figure with greater sensitivity'. This master of comic ballet also created some of the most tragic sculptures of the eighteenth century – works made for the candlelit altar rather than the candlelit dining table. His crucified Christ of 1755 (pl. 167), with outstretched arms and fingers, paper-thin loincloth and minutely intricate crown of thorns (separately worked), is an astonishing technical feat, yet it is not designed to draw attention to itself. The extreme formal attenuation responds to the cruel stretching of Christ and the fragility of his body.

The smaller porcelain figurines made at Nymphenburg, like those at Meissen and other factories, were decorated with enamel colours – metallic oxides mixed with powdered glass – first developed in China. These were applied after an initial firing, and the figures were then refired at a lower temperature. Kändler's larger animals are now almost all white, but most of them were

166 Nymphenburg factory, after Franz Anton Bustelli, *Nymph*, porcelain with enamel colours, *c.*1762, 20.2 cm. high, British Museum, London (Eckstein Bequest). The nymph, sometimes known as Leda, is companion with a statuette of the importunate Capitano Spavento.

originally decorated in 'cold' colours – that is, with unfired pigments which tend to flake and to discolour and so have been removed. Indeed, the point of these animals was that they were true to life in colouring as well as size. The paint also concealed the firing cracks, which were filled with resin, sawdust and gypsum plaster. On the other hand, Bustelli's altar sculpture was undecorated. This was because, like the Guanyin in *blanc de Chine*, it invited comparison with work in ivory or, rather, vied with it, for such a crucified

167 Nymphenburg
factory, after Franz Anton
Bustelli, *Crucified Christ*,
porcelain, 1755, the
body of Christ 35.5 cm.
high, Bayerische
Nationalmuseum, Munich.

Christ could not, of course, have been carved out of a single piece of ivory. In this connection, it is worth noting that the crisp and brittle quality that distinguishes German eighteenth-century porcelain figures in general and those of Bustelli, with their sharp ridges and gouged hollows, in particular, from those of Italian, French, English and Belgian factories reveals that the moulds were often made from prototypes carved in lime and other woods rather than modelled ones. Moreover artists who carved in wood on this scale often also worked in ivory. And this is true of some who were employed as *modellmeister*.

All the porcelain figures thus far considered were glazed by the addition of powdered feldspar before firing, and thus enlivened by flickering highlights on their highly reflective surfaces. Soft-paste porcelain, an imitation of true porcelain, but not so hard, not translucent and even more difficult to prepare and to work, has to be fired twice if it is to be glazed and the unglazed state is known as biscuit porcelain – confusingly, since *biscuit* means twice-fired. It may have been so named because it resembled a type of sugared biscuit popular in Paris in the mid-eighteenth century, when such porcelain first became fashionable. Its texture closely resembles that of smoothed but unpolished marble, and a very popular variant of this material, which was manufactured in the mid-nineteenth century, was known as parian ware, after Parian marble. The biscuit porcelain introduced in the mid-eighteenth century at the Royal French porcelain factory of Sèvres by Jean-Jacques Bachelier was made of the fine sand of Fontainebleau, plaster of Paris, sea salt, saltpetre, soda and alum – a more synthetic substance than any so far considered in this chapter, for it was not even based on a natural clay. The great sculptor Étienne Falconet, who was chief modeller to the factory between 1757 and 1766, used it to make statuettes, many of which were reductions of much larger marble groups.

By the end of the century miniature biscuit-ware versions of antique statues were being produced all over Europe, in reaction to the light comedy and pastoral romance that had characterized earlier enamel-painted porcelain figures. In France edifying marble statues of great French warriors, statesmen and writers, commissioned for the Royal Palace of the Louvre, were reproduced in biscuit by the Sèvres factory – again by order of the state. Augustin Pajou's statue of Blaise Pascal, modelled in 1783 and produced in 1784, was one of the first (pl. 168). The extraordinary complexity of the moulds required to reproduce a figure of this kind from the small clay model that Pajou made after his large marble testifies to the very highly developed skills of the factory's various specialists. It is not difficult to comprehend how small, discrete elements such as the book on the plinth were separately cast and then attached before firing (an inkwell and plume on the other side of the plinth have fallen off); but it is very hard to comprehend how the limbs of Pascal and the very deeply undercut folds of his cloak, furled around the tablet upon which he meditates, were cast. The drapery cannot have been formed by

168 Sèvres factory, after Augustin Pajou, *Blaise Pascal*, soft-paste biscuit porcelain, 1784 (after a model of 1783 reduced from a plaster cast of a large model of 1781), 32.1 cm. high, Ashmolean Museum, Oxford.

folding thin sheets of porcelain over a moulded body, as in some Chinese figures, for it has far more plasticity and reproduces what was modelled out of a clay which, unlike porcelain, can be freely manipulated.

European porcelain figures were made not only by pressing clay into moulds but also, and, indeed, after 1750 more usually, by pouring a liquid clay – a slip – into absorbent moulds which sucked out the water. The moulds were rotated to ensure that an even and thin wall was created. This made possible the use of far more complex moulds into which clay could not easily have been pressed. The absorbent moulds were made of gesso (gypsum plaster) and seem not to have been employed in the ceramic technology of East Asia before the late nineteenth century.

The competitive experiments of the European ceramic industry led in England to the invention of a type of stoneware known as 'artificial stone', or 'Coade stone', so named because it was first manufactured to a consistently high standard and successfully marketed by Eleanor Coade, who in 1770 took over a factory producing it at Lambeth, in south London. She described her product as 'lithodipyra', a Greek word meaning 'twice-fired stone' – no doubt because it consisted of much grog, or pre-fired clay, ground up with flint and quartz sand to form a paste that accounted for about thirty per cent of the body. Sixty per cent was clay and ten per cent, consisting of ground glass, acted as a vitrifying agent. The grog, flint and sand helped to keep the shrinkage in drying below ten per cent. This stoneware was hard enough to survive frost better than most British building stones, and the chief source of Mrs Coade's success lay probably in her ability to maintain an efficient supply of rock-hard but exquisitely modelled fashionable architectural ornament – capitals for columns, urns for cornices, friezes for entablatures, tablets for walls.

She also supplied garden sculpture, including a river god and a water nymph designed by John Bacon, the chief modeller and director of the factory. These large figures, fired in her largest kilns (said to have been nine feet in diameter) over four days and nights, were designed to be placed in damp grottoes, where most stone carvings would be particularly vulnerable, and thus they acted as double advertisements for the factory. Some of the statues, about half the size of life, were designed so that they could be adapted to serve as useful and imposing ornaments in fashionable interiors. These were first made shortly after the discovery of a group of ancient Roman terracotta figures of similar size and technique. The head of the figure illustrated here (pl. 169) was modelled by Bacon in imitation of one of these classical examples. The crispness of the ringlets and the sharp edge of the eyelid reveal that the surface was carefully tooled after casting, as is indeed the case with all Coade's products. Hairline cracks and slight colour changes in the body of the clay nonetheless betray mould junctions accross the neck, at the shoulder and along the figure's left arm.

The colour of Coade stone is buff or dull cream, not very attractive in itself

169 Coade factory, Lambeth, after John Bacon the elder, detail of a statue of Clio, this example dated 1800 (after a model of *c*.1775), tip of nose to hair line 6 cm., Clifton Little Venice, London.

and disagreeable in combination with white or grey Portland stone, but often pleasing with richer yellow limestones and sandstones. Many of the Coade factory moulds were still in use in the mid-nineteenth century. The material was by then extensively imitated and the 'terracotta' embellishments that came to play such an important part in European architecture of the late nineteenth century – more often deep red in colour but sometimes still buff – were made to a similar formula. Coade-stone plaques and statues used indoors were often coloured to resemble white plaster or dark bronze, and Mrs Coade also offered, for sale at a lower price, plaster casts made from the same models.

189

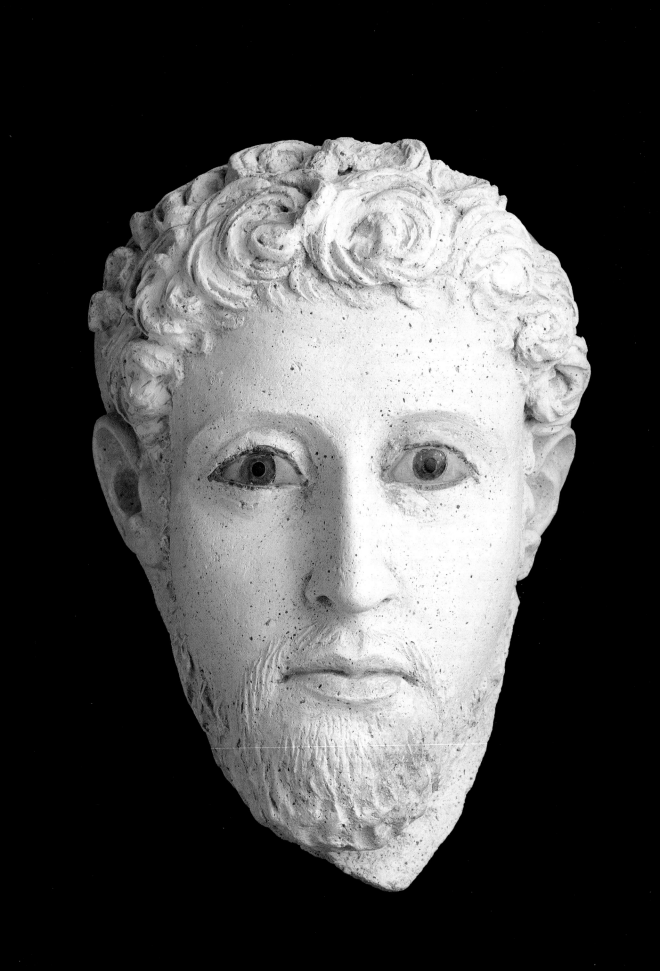

13 Stucco and Gesso

CLAY IS NOT THE ONLY MATERIAL SUITABLE for casting. Wax and plaster may also be used for this purpose. Both set much faster than clay and are hard when they emerge from the mould.

Plaster is generally composed of lime, in the form of powder made by roasting limestone, which is then chopped and slaked (that is, soaked at length to reduce its caustic qualities). It varies greatly in appearance, plasticity and durability, according to the proportion and quality of the fine sand and other ingredients, such as grog and animal glue, that are added to it. Animal hair or hemp have often been used as binding agents, while other materials can be used to counteract the tendency to set rapidly. Stucco, the finest, whitest plaster available to the European sculptor, as well as one of the hardest, is made by burning marble or Roman travertine and combining the lime thus obtained with pulverized marble and other ingredients. Used extensively by the ancient Romans, it was rediscovered in Rome in the early sixteenth century when artists were becoming increasingly aware of the beauties of the low relief decoration found on the walls and vaults of ancient Roman palaces and tombs. (It is striking that the expansion of the marble industry had made large quantities of waste available at that same period.)

Ancient Roman ornamental stucco, usually in low relief, was not, it seems, cast. Framing mouldings were stamped. Tendrils, scrolls and figures were worked with spatulas and incising tools, evidently with considerable speed and before the plaster dried. The lines cut easily into a yielding surface which is raised to either side. In the hardened plaster such fluency would have been impossible, and there was probably a risk of splintering. The spontaneity of execution (concealing, as poetic improvisation does, a dependence upon formulae) makes the dancing nymphs and flying monsters such as those on the vault of the Tomb of the Valerii (in Via Latina, Rome) seem like fantasies tossed out by a capricious imagination, and the linear low relief would have flickered beguilingly in the unsteady light of torch or lamp (pl. 171).

When revived by Giovanni da Udine, who was sponsored by Raphael, hard white stucco of this type also incorporated reliefs that were more elaborate in composition and careful in finish. These were cast. The stiff stucco was driven into moulds (some of them of boxwood) and then transferred, before they were dry, to the designated patch of wall or vault (roughened to form a key). This was the system employed for the reliefs set against a gold ground in the roundels of the Villa Madama, made in Rome in the 1520s (pl. 172). The

170 Roman (Alexandrian), funeral mask, gesso, c.200 AD, 29.4 cm. high, Kimbell Art Museum, Fort Worth, Texas.

191

171 Roman, vault of the Tomb of the Valerii, stucco, unmeasured, c. 150–75 AD, Via Latina, Rome.

fact that Italian sculptors had been making casts of plaster, as well as of clay and *cartapesta* (papier mâché), for over a century no doubt encouraged this development. By the 1520s plaster casts of whole large antique statues were also being made. One of the Italian artists most involved in this was Primaticcio, and it cannot be a coincidence that he also pioneered the use of life-size figures and other high-relief elements in stucco for the King François Premier at Fontainebleau (pl. 173). However, the stuccoists working at Fontainebleau seem not to have used moulds. Numerous wrought iron cramps and keys were first attached to the masonry, and a pink cement of lime and coarse sand with pulverized brick and limestone was built up over this, and

192

172 Giovanni da Udine and associates, vault of the Villa Madama, stucco, unmeasured, *c.*1523, Rome.

then successive coats of a stucco made of lime, fine sand and powdered white limestone (instead of marble dust) were applied and modelled, more iron supports being used for projecting limbs and heads. From technical analysis and archival documents it is clear that much which is now off-white was originally gilded.

High-relief stucco was greatly developed as an art in the following century, chiefly by Italians, and in the eighteenth century by artists in Austria and southern Germany. It was modelled over an armature (and sometimes over clay) and then combined with many separately moulded elements, but, because

173 After Primaticcio and Rosso, clustered caryatid figures, stucco, unmeasured, 1530s, centre of south wall of Gallery of François Premier, Palace of Fontainebleau, France.

it is hard enough to be tooled and smoothed, it is very difficult to distinguish, in the finished work, what was modelled from what was moulded. The subtlety of modelling that is necessary to impart life to the nude human body is very hard to achieve in a material that dries relatively quickly; drapery, however, can be simulated far more efficiently.

Stucco is often confused with gesso, which, being white and smooth also, was often substituted for it, and in some recipes mixed with it. For instance, the stucco employed by Giacomo Serpotta in Sicily in the eighteenth century, which was famous for its brilliant white polished surface, was said to have been made with gesso as well as marble dust and lime. The main constituent of gesso is gypsum rather than lime, and it is often called plaster of Paris because of the vast deposits of gypsum that were found in the hill of the Parisian suburb Montmartre. It was, as has already been mentioned, an ingredient in the biscuit porcelain of Sèvres. When newly mixed, gesso is sufficiently liquid to flow into the furthest interstices of a mould – to 'épouser' the smallest details. On the other hand, it is usually difficult to tool (being easily splintered), is not very hard (unless made with glue) and is highly absorbent and thus easily soiled. It had been available in ancient Egypt and throughout the eastern Mediterranean world, no doubt sometimes obtained from the mines that supplied gypsum alabaster. In Italy large quantities of gypsum were available, from Volterra for instance (which was celebrated for its gypsum alabaster).

One of the chief purposes for which gesso was employed was as a coating for sculptures of stone and wood, and as a ground for painting and gilding, in which cases it was bound with animal glue. In contemporary usage gesso is usually confined to a 'whiting' of this kind, and there is a frequent confusion between whiting made of gypsum and glue, and whiting made of lime or chalk and glue. While gesso was used in Italy as whiting, a lime composition – made with soft chalk – seems generally to have been favoured north of the Alps. The coating on Hellenistic earthenware sculptures, often described as gesso, is sometimes a lime plaster but more commonly it is a pale-coloured clay slip such as is also found on Chinese earthenware tomb figures.

Gypsum needs to be heated to about 100° centigrade to form a powder, which, when recombined with water, sets hard, whereas far higher temperatures are required to roast limestone. The ancient Egyptians had abundant limestone and gypsum but little fuel, and so it is unsurprising that their plaster was made from the latter. They used it for casting-purposes at an early date. A group of gesso heads made in about 1340 BC and discovered in the studio of the chief sculptor of King Akenhaten are presumed to have served as artists' models. Many are cast, but whether from masks made of dead or living heads or from realistic models made in clay or wax is disputed. Gesso was also favoured for the masks covering the skulls of mummified corpses, and when Egypt was absorbed into the Roman Empire these masks were more

idiosyncratic in character, and may even be regarded as portraits. The example here (pl. 170), doubtless from Alexandria, is of gesso cast in a clay mould, and it retains some of its original colouring: pink on the lips, some gold leaf in the beard and some brown pigment, probably a ground for the gold, in the hair. The eyes have been inserted – either pressed into the gesso before it set, or lodged in the mould in such a way that the gesso could be poured around them. They are of a creamy pink substance which has not been identified – it 'might be a fired clay or glass paste' – and the irises are of translucent green glass paste with black pupils, possibly of obsidian. The framing lines of black for the lashes are separately inserted. The hair looks modelled rather than moulded, and it seems likely that the cast mask was given a cap of fresh plaster which was then hastily stirred into curls with a spatula before it set. A similar method may have been employed for the beard, for the downward strokes of the tool are relatively soft, as if the plaster, when manipulated, had only half set – lines cut into hard plaster would have a more scratchy appearance. The holes in the surface are frequent in gesso and are caused by the bubbles of air.

The technique of working with plaster is supposed to have spread east from Egypt to Gandhāra, where in the fourth and fifth century AD much Buddhist sculpture was made, mostly of lime (but occasionally of gypsum) composition. However, this sculpture seems seldom, if ever, to have been made in moulds but rather modelled in fine plaster over a coarse plaster core with wooden supports. The numerous heads of Bodhisattvas that have survived are simple in shape, with the smooth, sometimes polished, surfaces and clean lines of lips and eyes and brows, apparently made with a metal tool – there are also often single sharply cut lines defining the side of the nostril or a crease in the neck. But the hair is more softly and freely modelled, again perhaps in the undried plaster applied separately (pl. 174). Colouring with a black or ruddy brown and, more rarely, with a blue pigment seems to have been designed to enhance the modelling and to emphasize eyes and lips.

174 Gandhāran, attendant figure from a Buddhist shrine, stucco, first century AD, 24.8 cm. high, Ashmolean Museum, Oxford.

Plaster, like clay, can be cast in moulds of wood or clay as well as plaster. Archaeological evidence suggests that, for the earthenware items in the Hellenistic eastern Mediterranean, plaster moulds began to replace earthenware ones in about 200 BC. The former do not shrink as fired ones do (indeed, plaster expands slightly as it sets) and, if an exact reproduction of a model is required, plaster is obviously more effective. It is, moreover, even more absorbent than earthenware, which is an advantage if a wet clay or slip is being used. Although models made for European porcelain figures were generally of earthenware – some of which, including that for Pajou's *Pascal* (pl. 168), survive – or of wood, the moulds were of gesso. Thus any full account of the casting of clay sculpture must involve some consideration of plaster. So too must any account of casting in metal, for the moulds employed were often of plaster. The so-called *stein guss* – cast stone – statues made in

195

Salzburg in the early fifteenth century are in fact of gypsum plaster with a small amount – about three per cent – of other minerals, and it is tempting to suppose that the idea came from making trial proofs for metal casting.

Before the mid-nineteenth century, when flexible moulds (made of gelatine) were more generally employed, a form with intricate hollows – the human ear or a cloak with deep folds – had to be moulded in parts; for a really complex work the mould might consist of more than a hundred pieces. Each of these, having been pressed into the hollows and allowed to harden, was then removed, neatly shaped, keyed to the others, and given a divider, a number and a little handle. Finally, the whole assembly was bound by an outer 'mother' mould. Molten wax (if the mould was small), liquid slip or creamy gesso would then be poured in. Alternatively, clay or stucco or papier mâché could be pressed in, though these would require a larger aperture.

Piece moulds can be reused – some in use today have been in service for more than 150 years – and they can be used for casting in more than one material, although the mould may require different treatment. When gesso is cast in a gesso mould the inner surface of the mould must be greased so that the two can be separated. (Goethe was astonished to find his landlady's cat in Rome licking a newly made cast from an ancient head of Jupiter: it had, in fact, sniffed the residue of grease.) Such treatment makes the mould useless for casting clay slip because it is no longer absorbent.

The cast, when revealed, is covered with a network of thin raised lines corresponding to the divisions of the piece mould. In the ceramic factories a specialist was employed to 'repair' the cast clay before firing. This involved 'fettling' and 'towing' – correcting distortions, sharpening detail and, above all, eradicating such relief lines, using tools or textiles. In addition, the ceramic repairer would add separately cast components – heads, legs, books, etc. – before firing. Separately cast components were commonly added to plaster casts when these were solid or very thick-walled, and joins could be safely made. The surface of a plaster cast would be carefully rubbed down with fish skin or some other fine abrasive. But during the nineteenth century the lines of the piece mould were often left, their fineness being proof of the precision of the cast as a reproduction (dishonest craftsmen sometimes rubbed down the thick lines and added threads dipped in gesso). The example illustrated here (pl. 175) is a cast of the 'Dresden boy' (a Roman copy of a late fifth-century BC Greek work) made for the cast collection in Oxford in the late nineteenth century. The lines are evident across the brow, the nose and the upper lip.

The technique of complex piece moulding such as has just been described was probably perfected in the fourth century BC by Greek sculptors. Pliny the Elder records that Lysistratos, brother of the celebrated sculptor Lysippus, was the first artist who made gesso moulds from the human face and used them to make wax casts, on which he then worked. He was especially noted for the accuracy of his portraits. The popularity of the new art of portraiture

175 German, detail of a cast of the 'Dresden boy', piece-moulded gesso, late nineteenth century, size of life, Ashmolean Museum, Oxford. (The statue reproduced is considered a Roman marble copy of a bronze of the school of Polykleitos, dating from the late fifth century BC.)

in the fourth century BC may well have stimulated the taking of casts, as perhaps did the custom, in some Mediterranean civilizations, of making death masks. The portraits by Lysistratos were presumably of bronze. If more than one cast is to be made of a bronze sculpture of any complexity, it is essential to use the technique of piece moulding. In addition, by the fourth century BC certain sculptures in marble and bronze were acknowledged as master-pieces which should be copied as models for students and as reminders for connoisseurs. A precondition for producing an accurate copy was the taking of a cast, and for this purpose gesso was by far the best material. Pliny's discussion of Lysistratos and his moulds is followed by a reference to the invention of a method of making a cast of a whole statue.

The claims made by Pliny for Lysistratos were also made by Vasari for Andrea Verrocchio, who seems to have been a pioneer in making accurate gesso casts from life, who did much to promote the fashion for taking death masks, and who was also much involved in bronze casting. The coincidence of a new interest in portraiture and of a developing technology for bronze casting in fifteenth-century Florence must have been crucial to the rediscovery of piece moulding, and an additional stimulus was provided by the demand for replicas of the ancient Roman marble statues that were coming to be revered –

176 Alexander Munro,
Profile portrait of John
Everett Millais, gesso,
1853, 56 cm. high,
Ashmolean Museum,
Oxford.

again – as the most perfect models for modern artists. The *Apollo Belvedere* (pl. 68), excavated in the fifteenth century, was a marble copy of a bronze, doubtless made in ancient Rome with the use of a gesso cast. Its fame was spread by further casts now taken in Renaissance Rome from the marble, and some of these in turn facilitated the making of copies in marble and bronze.

Some of the disadvantages of plaster have been mentioned. It is fragile, highly absorbent and easily soiled. A common way of rendering its surface impermeable was to coat it with a shellac varnish, but this soon darkens. Other methods involve the application of wax or successive coats of milk. Work on a small scale can be protected by glass, and the plaster profile portraits made by Alexander Munro in the mid-nineteenth century, which have been preserved when protected in this way, have retained all the delicacy and perfection of white biscuit porcelain (pl. 176). For the most part, however, plaster casts have not been regarded as works of art. They were, above all, aids to study, an essential feature of the artists' academy and they also became as valuable to archaeologists as photographic collections were for students of the history of painting. In addition, they played a crucial role in the making of sculpture.

177 Edouard Dantan,
Casting from Life, oil on
canvas, 165 × 131.5 cm.,
1887, Konstmuseum
Göteborgs.

Casts from life – ears or whole legs – which sculptors have often found to
be valuable models, were also made in gesso. Edouard Dantan's painting of
1886 (pl. 177) shows a young sculptor in a smock and an older bearded
craftsman – the *formatore*, or specialist plaster-cast maker – wearing an apron
and beret. They are carefully removing a mould from a young woman's leg.
Casts of famous masterpieces mingle with the trowel, spatula, sponge, rag,
sieve, sack, mortar and pail. A cast of a bosom, perhaps also taken from warm
living flesh, hangs on a hook. The sculptor's dependence on such aids was
sometimes cited so as to diminish his inventive powers. Casting was, however,
no less important for preserving the rough clay model in which the sculptor's
imagination was most evident. Such models could not safely be preserved by
firing. And the full-size finished clay model also needed to be preserved in
gesso, for it was too large to be fired. Moreover, from a gesso cast of the
finished model additional marbles could be carved after the first had left the
studio. It is to the sculptor's models, preliminary and finished, in clay and
wax, that we must turn in the next chapters.

14 Modelled Clay

WHEREAS MOST SURVIVING ANCIENT STATUETTES were cast in moulds, many were certainly modelled freely out of solid clay. In China, in Chekiang province, for instance, tomb figures were made in 'greenware' (Yüeh-ware), a stoneware with a high-fired green glaze, during the third and fourth centuries. The seated harpist illustrated here (pl. 179) is typical of the style of modelling found in these pieces – with separate balls of clay inserted for the eyes and short cuts made in the clay for the brows. The survival of a solid model of this character in a kiln would depend on the temperature of the firing and on the nature of the clay. Most early potters would have regarded it as an experiment not worth conducting because of the shrinkage in the kiln, which led to cracks – cracks that are very obvious in the figure illustrated here – especially when some parts of the body were thicker than others. Instead, figures were built up out of thrown pots or on flat sheets of clay which were then bent round and joined. But neither of these methods left the sculptor with much freedom to manipulate the material.

Most large earthenware sculpture has been moulded rather than modelled, although, as we have seen, some of the finest examples, such as the larger Etruscan or Chinese figures, were modelled after moulding, or moulded and then fitted, before firing, with modelled heads and hands. But in Italy during the fifteenth century there seems to have been a determined attempt to find ways of firing large modelled figures. A life-size group of the *Virgin and Child* (pl. 180), modelled in the early fifteenth century in the workshop of Michele da Firenze, a Florentine sculptor who worked with both Ghiberti and Donatello, illustrates one solution: the group was modelled solid and then dug out from behind. This was possible only because it was to be placed in a niche or against a wall, as were many wooden statues (also, but for a different reason, hollow behind). A free-standing Apostle of similar size, made in Mantua later in the century (pl. 181) by an artist much influenced by Mantegna, was evidently modelled in solid clay and then cut in sections, hollowed and reassembled. In this case the divisions are clearly visible, and reassembly must have taken place after firing: the size of kiln available would doubtless have been a conditioning factor. Both of these statues were originally coated with gesso and both would have been painted and gilded, which would have concealed the obvious divisions in the *Apostle*. There were other methods of making the figures hollow, the use of a core which could be drawn out before firing or would burn out during firing being the most obvious. But there are always difficulties.

179 Chinese, tomb figure of a harpist, stoneware with a crazed green glaze, probably late third century AD, 14.6 cm. high, Ashmolean Museum, Oxford.

178 Detail of pl. 184. The smooth, hard surface or 'firing skin' of the clay is preserved in the forehead and hair where tiny particles of original colouring are also detectable.

201

180 Michele da Firenze, *Virgin and Child*, earthenware, c.1420, size of life, Museo Nazionale del Bargello, Florence. Originally coloured.

181 (far right) Italian (Mantuan), *Apostle*, earthenware, c.1480, 180 cm. high (approx.), Palazzo Ducale, Mantua. Originally coloured.

The sculptors of these two earthenware statues, so very different in style, were both concerned to avoid projections – although the gesture made by the Christ Child in Michele da Firenze's group would be greatly enhanced if his arm were not sunk into the general mass. In stone-carving such a constrained character would be determined by the need to confine the figure within the block, or to avoid difficulties of carving; but clay is built up and can be easily cut out, and in these cases the concern was rather that a projection would

182 Niccolò dell'Arca,
Mary Magadalene,
earthenware, *c*.1465,
151 cm. high, Pinacotcea,
Bologna. Originally
coloured.

need an armature for support – a clay figure weighs fifty per cent more than a living one of equal size. However, such an armature would have been difficult to extract before firing and would, if left inside, create other problems.

In a few Italian cities, most notably Bologna, where earthenware was in great demand (and good clay in abundant supply), superior techniques for the hollowing and firing of such large sculptures were devised. The *Lamentation* consisting of six life-size earthenware figures grouped around the body of Christ and made by Niccolò dell'Arca for the Bolognese church of Santa Maria della Vita in the 1460s, exhibits none of the limitations that have been observed (pl. 182). The sculptor found some less obvious way to hollow the figures and was able to represent the figures in active poses, not only with outflung limbs but with billowing draperies, as in the violently demonstrative figure of Mary Magdalene. The statues must have been modelled, cut into sections, hollowed, and reassembled. The projecting draperies would then have been added. This is conjecture, but documents inform us of the necessity of enlarging the kiln employed by Niccolò, and it is clear that the figures were fired in two pieces (Christ in three). Having been reassembled, the figures would have been cut again – in the case of Mary Magdalen, through her belly and both wrists. The joins, as well as the inevitable cracks (and probable breaks), would have been concealed beneath the gesso and painting.

Large modelled earthenware figures were relatively rare but such sculpture in unbaked clay was common: indeed, by the fifteenth century most sculpture in stone and marble made in Europe required a preliminary model, often full-size, in clay. The columnar stone figures of the Gothic portals or the blockier, frontally posed figures of archaic Greece may have been carved without reference to models, but they were essential for the carving of any complex form. The clay model enabled the sculptor to work out ideas in a form that could easily be altered and was relatively cheap. Once the model was completed it could be shown to the patron for approval. Measurements would then be taken from it which enabled masons to reduce the block of stone to the appropriate dimensions before the sculptor began work, consulting the model but at this stage not always following it exactly. Such models could be built on an armature. For this purpose, wood was commonly employed (although the damp clay tended to make it swell) or sometimes iron (although it rusted, and could discolour the clay); lead piping came to be especially favoured for its pliability and resistance to damp. Tow or hay would be tied to the armature to help it to bond with the clay, which was often applied with strips of cloth and with hair mixed into it.

As it dried, the clay model tended to crumble, but baked flour and other materials would be added to retard drying, and it could also be kept damp, although this was tedious over a long period. By the eighteenth century the usual practice among European sculptors was to work from a gesso cast of the clay model. In a few cases, however, large unbaked clay models have survived – that for Giambologna's group of *Florence triumphant over Pisa* is an example.

Coated with gesso, which concealed the original modelled surface, it was for long supposed to be merely a gesso cast. The unbaked clay figures of Fondukistan (e.g. pl. 160), mentioned in an earlier chapter, are a reminder that sculptures of this kind are able to survive.

It was not difficult to salvage, hollow and fire a part of an original large clay model, but it is not clear how often this was attempted. The head from the model of Saint Paul made by Bandinelli in the late 1530s (pl. 183) for one of the two statues flanking the tomb of Pope Leo X in Santa Maria sopra Minerva in Rome is an example of this practice. Because the head was dug out from within, its walls are thick but irregular. It cracked somewhat during firing and was reinforced with plaster inside, and the cracks were blocked with wax. It is obvious why the head was preserved, for the freedom of handling both with a tool – the way the hair was clawed back, for instance – and with the fingers – which left impressions on the beard – give it a ferocious vitality for which there is no equivalent in the marble carving.

A fragment of an earthenware statue – probably a tomb effigy made in about 200 BC – found on the Esquiline Hill in Rome (pl. 184) has hair that has been no less roughly tooled. Such handling has no equivalent in Greek or Roman sculpture carved in marble or cast in bronze, but the bold massing and the dynamic plasticity of such work in clay surely did affect the character of sculpture in other materials.

Before the sculptor made a full-size clay model, a smaller model would be made. Unless it is very open in composition, small work in clay has no need of an armature. For this reason, and also because of their size, such sketches were more easily fired. Many have been preserved, for they came to be valued by collectors, together with the drawings made as preparatory studies for paintings. The group of the *Virgin with the Laughing Child* (pl. 185), almost certainly modelled by Antonio Rosellino in Florence in about 1465, must have been such a sketch model. Although the flesh areas, especially those of the Virgin's face, have been carefully sponged, the Christ Child's tiny fingers and toes, the fringes of the Virgin's dress and the scapular round her neck are only roughly indicated, and her hair merges imperceptibly with her veil. In addition, had the sculpture been intended as a finished work of art in its own right it would, at that date, have been coloured, yet no trace of gesso or of colour is to be found on it. Had this sculpture been made as a prototype to be moulded, it would have been simpler, without the deep hollows behind Christ's back on either side of the Virgin's neck and by her right sleeve, the deep folds of the cloak across her knees, and the undercutting of the end of the swaddling which the Child is pulling with his left hand. This must have been made as the model for a carving in marble (perhaps larger in size) which, if it was ever executed, has not survived. Again, it is not hard to understand why the sculptor could wish to preserve such a work, for the solemn but affectionate solicitude of Mary's smiling face and the joyful laughter of her child are fleeting expressions such as had perhaps never previously been

183 (following page) Baccio Bandinelli, head from a full-size clay model for a statue of Saint Paul, earthenware, *c.*1536, 39.7 cm. high, Ashmolean Museum, Oxford.

184 (page 207) Italic, *Head of a youth*, earthenware, *c.*200 BC, 28 cm. high, Ashmolean Museum, Oxford.

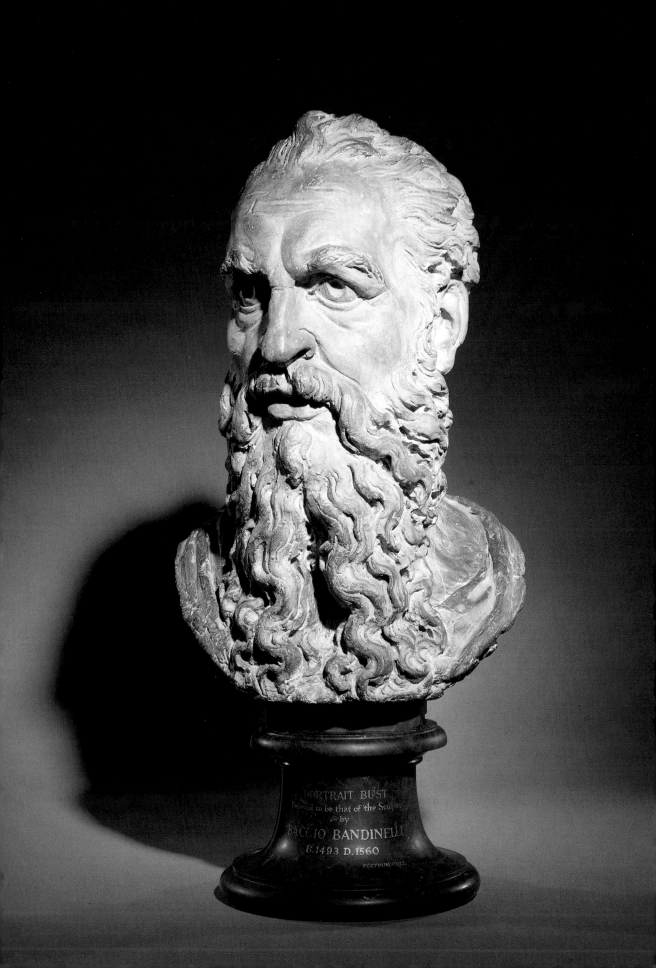

PORTRAIT BUST
Believed to be that of the Sculptor
by
BACCIO BANDINELLI
B.1493 D.1560
FORTNUM COLL.

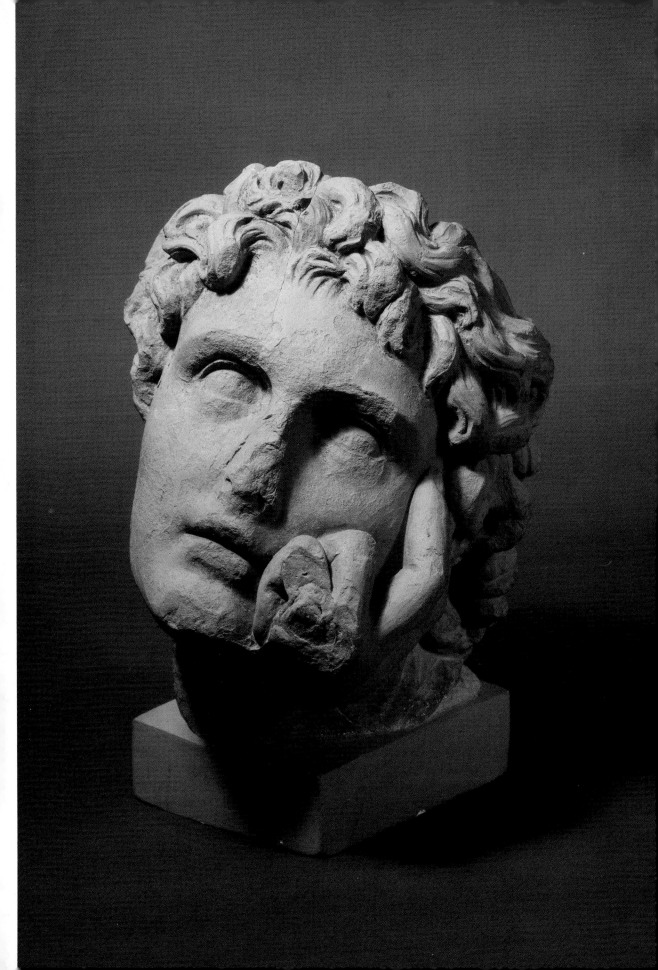

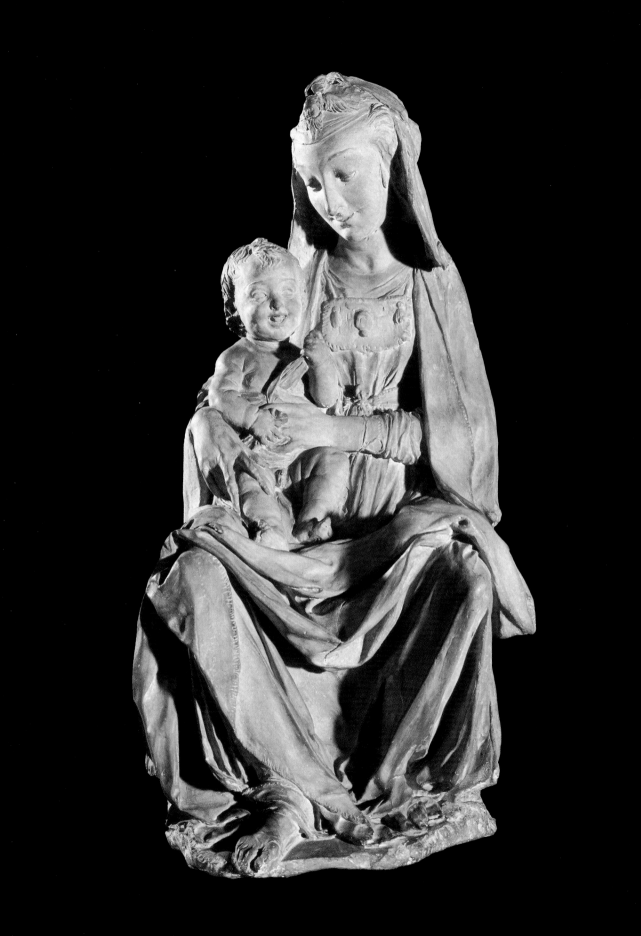

depicted in sculpture. These are far more easily captured in clay or wax, which are responsive to the softest touch and instantly adjustable, than in any harder material.

The subtlety and refinement of these faces is reminiscent of the paintings and drawings made by the young Leonardo da Vinci, who also made models in clay and wax. Moreover, the drapery is reminiscent of the studies he made from pieces of linen that had been soaked in diluted gesso or slip and then thrown into beautiful arrangements. It is perhaps significant that this practice of drawing from drapery was particularly associated with the workshop of Verrocchio, who was a sculptor as well as a painter, and relates to the practice of dressing clay models in stiffened drapery after they had been fired. Relatively few examples of earthenware sculpture finished in this way have survived – and the best examples are considerably later in date. A model made in 1763 by Antonio Calegari of Brescia for a marble statue of the youthful Jesuit Saint Stanislas Kostka on the altar of the parish church of Chiari has a tremulous delicacy which could not be matched in another medium (pl. 186). Generally the drapery treated in this way took the form of a robe, cloak or toga gathered round the figure, but Calegari also gave sleeves to this saint and even made the arms separately to facilitate dressing them. He may have been influenced by crib figures made both in wood and terracotta and given real clothes.

Rossellino's statue is only slightly hollowed out, behind the Virgin's seat. It must have been fired at a comparatively low temperature, but even so there are considerable cracks, now carefully filled and coloured. Most clay models of a later date than this were more obviously designed to avoid the dangers of different rates of shrinkage. A figure of Fortitude seated on a lion (pl. 187), which was probably made by a Bolognese sculptor in the last decades of the eighteenth century, must have been modelled in one piece and then divided with a knife or wire just above the heavy drapery passing over the legs and through the right wrist and left hand. The two parts of the body were hollowed and the group was then reassembled for firing. The sculptor would have known that joins of this sort tend to open up as the steam seeks an outlet, and perhaps for this reason there is a small aperture, hidden by the fold of drapery.

This group was almost certainly made as a preparatory model for a monumental sculpture – hence the very broad treatment of the drapery – and, furthermore for a sculpture designed to be placed on the projecting corner of a plinth – hence the concern with visibility from several points of view. However, once fired, it was preserved, to be enjoyed as a work of art in its own right. It seems, indeed, to have been gessoed and gilded, for traces of this remain in the hollows.

Appreciation of sculptors' preparatory models, including models far sketchier than this, was widespread among European connoisseurs by the eighteenth century, and such collectors appreciated also the natural colours of earthenware –

185 Antonio Rossellino, sketch model for a statue of the Virgin and Child, earthenware, *c.*1465, 48.3 cm. high, Victoria and Albert Museum, London.

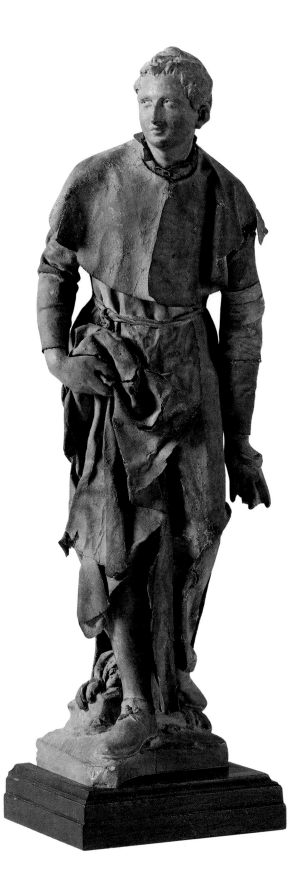

186　Antonio Calegari,
sketch model for a statue of
Saint Stanislas Kostka,
earthenware with cotton
dipped in clay slip,
1762–3, 39.5 cm. high,
Pinacoteca Tosio
Martinengo, Brescia.

187 (facing page)
Possibly Gaetano Gandolfi,
sketch model for a statue of
Fortitude, earthenware,
probably 1760s, 43.4 cm.
high, Ashmolean Museum,
Oxford.

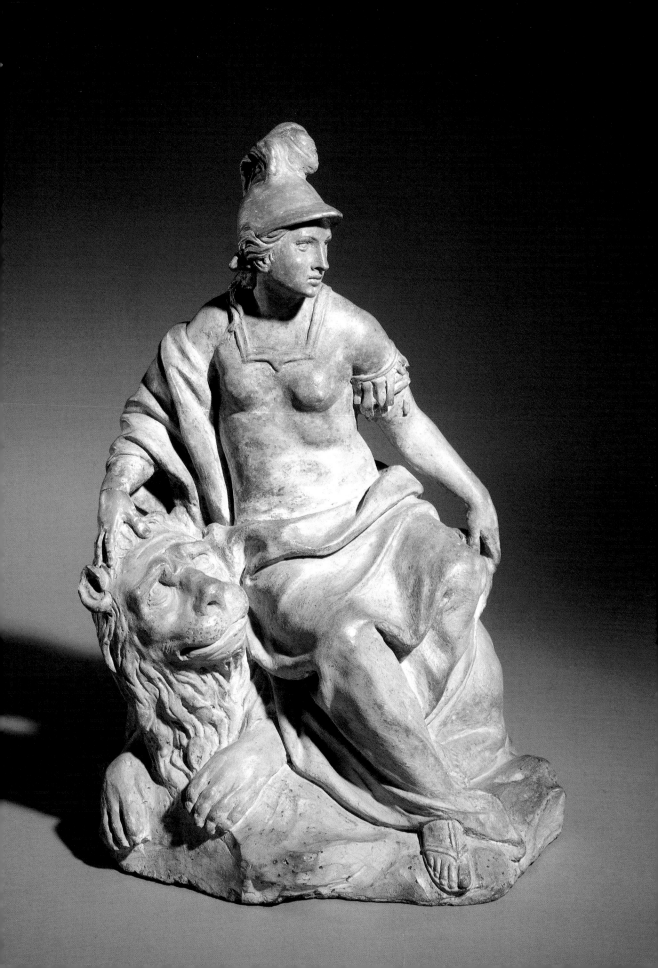

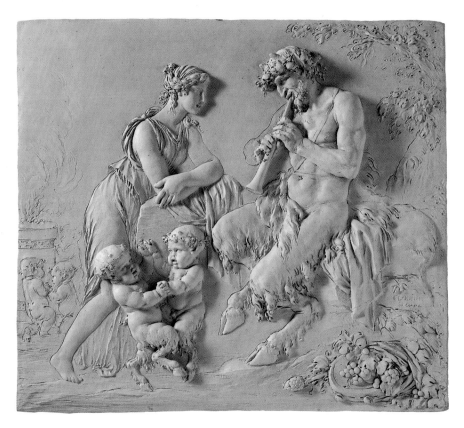

188 Claude Michel (Clodion), *Satyr piping to a nymph*, earthenware, 1773, 33 cm. high, 36 cm. wide, 2 cm. deep, Los Angeles County Museum of Art.

189 Detail of pl. 188.

grey, buff or pink. For the first time there arose a demand for earthenware sculptures that were left without any coating. These were small in size and often freely executed but were not made as preparatory models. Of the sculptors who obtained a special reputation for such works the most famous was the French sculptor Claude Michel, known as Clodion. He did also obtain commissions for important large carved works, but, even when in Carrara selecting blocks of marble, he worked in clay, signing an exquisite relief of a satyr family 'in Carare 1773' (pls 188 and 189).

The pleasure derived from such a sculpture is similar to that derived from an oil sketch or a free drawing – a delight in the artist's fluent, bold, nervous or spirited touch. Much of this sculpture is indeed 'drawn': the faintly indicated smoke and the distant putti; the more deeply incised curls representing the leaves of the tree or the hair of the heads and legs. A ridge of displaced clay to either side of such incisions catches the light. Surfaces of flesh or background which have been sponged smooth are contrasted with almost imperceptible vertical grooving made by wire scrapers or with tiny folds of drapery modelled with a spatula. A comparable delicacy may be found in some of the reliefs made in the Greek colonies of southern Italy, where clay was the principal material of sculpture, although such pictorial effects were never pursued in low relief. But Clodion, whose subject matter is often taken

CLODION
in Corra
1773.

from ancient Roman poetry and paintings, is more likely to have studied the rapid, improvisatory handling of Roman stucco work (pl. 171).

Within the immensely subtle and refined schemes of interior decoration that became fashionable in eighteenth-century France, burnished fire gilding on bronze mounts and water gilding on carved wood and the sheen of blue or pink silk fabric were played off against the matt surfaces of sculpture in earthenware or biscuit porcelain. The latter sculpture is now segregated in the category of ceramics in public collections, salerooms and textbooks. But contemporaries would have thought of earthenware and biscuit porcelain together. Moreover, the absence of cracks or flaws of any kind and the very high firing of the earthenware sculpture by artists such as Clodion must reflect the superlative techniques that had been developed in the French ceramic factories.

The technical achievements of Clodion are easy to underestimate in the twentieth century, when clays are subjected to chemical analysis and kilns are controlled by gas or electricity. It becomes more obvious when sculpture made elsewhere in eighteenth-century Europe is examined. In England the leading sculptors such as Michael Rysbrack who executed much of their work in clay seem to have considered some damage in firing to be a high probability. Their work was therefore often mended with plaster (sometimes reinforced with mutton bones) and given a surface coating, usually of a red paint (sometimes containing clay), although stone-coloured and dark bronze paints were also employed, especially for bust portraiture, which was more highly prized – and, of course, more highly priced – when carved in marble or cast in metal.

15 Modelled Wax

AS A SOFT MATERIAL FOR MODELLING, wax has many advantages. It hardens naturally without the shrinkage that is inevitable, or the cracking that is common, when clay is fired. It is also cleaner to use and easier to prepare and to preserve. Indeed, it was an adage that 'wax is always ready' – at least, in a warm climate the heat of the modeller's hand can rapidly render it malleable. Nor is there the problem of an adverse reaction between wax and an iron or wooden armature, and such an armature can remain in the model, since it has not been fired. There are, however, disadvantages to wax. It is almost as easily obtained as clay – wherever honey is harvested wax is available – but not in large quantities, and it is far more expensive than clay. Thus it has generally been used only for small models. Hard wax is very brittle, and when broken it is hard to repair. It is also easily damaged by heat. Turpentine and other resins that are commonly added to wax to make it tougher can cause cracking when they evaporate, whilst a surface efflorescence, often of a repellent character, can be caused by the fats and oils that are added to it to make it more supple. Although wax was extensively used for both preparatory sketches and finished statuettes and reliefs, far fewer wax sculptures have survived than earthenware ones, and those that have survived in good condition are almost always framed reliefs kept under glass.

During the sixteenth century some of the most minutely finished preparatory models made in wax were those from which moulds were taken in order to make cast metal models or in order to make dies. Such models were often beautiful, and, moreover, it was prudent as well as relatively easy to preserve them in case moulds were damaged. Perhaps significantly, it seems to have been a medallist, working in Milan for the Holy Roman Emperors, Antonio Abondio the younger (1538–91), who was one of the pioneers of a new form of miniature portraiture using a wide range of coloured waxes – red for the lips, pink for the flesh, brown for the hair, and so on. The wax was not only coloured but sometimes impressed with the textures of real textiles for the clothes. On occasion textiles themselves were incorporated, as well as gold wire, seed pearls and minute gemstones. Such portraits (pl. 190) were being made at several European courts, and it is difficult to attribute them to specific artists. They were always protected by glass and were probably among the first wax sculptures to be made as finished works of art in their own right.

Coloured waxes were used, during the seventeenth and eighteenth centuries,

190 Perhaps Antonio Abondio the younger, portrait of a woman (perhaps Elizabeth of France, d.1568, third wife of King Philip II of Spain), coloured wax on glass with seed pearls, 1560s, 11.4 cm. high, Victoria and Albert Museum, London. Illustrated together with its finely engraved fire-gilt copper frame and locket.

for full-size effigies of martyred saints and dissected corpses, serving as stimulants to piety and as aids to the secular study of anatomy. The manufacture of large sheets of clear glass made this development possible, or at least practical, and has helped preserve these sculptures: the royal funeral effigies favoured at an earlier date have for the most part perished, as have all of the masks of ancestors that were kept in shrines within the homes of the ancient Romans. By the eighteenth century coloured wax models with real clothes and painted backgrounds were providing less edifying forms of popular entertainment, not only in full-size tableaux but, in miniature, on small glazed box stages. In consequence, the more accomplished, or at least self-consciously artistic, miniature-portraitists reacted against realism, preferring to set the profile head or bust in pink or white wax against a black or brown ground.

This remained the usual formula for more than a century and is well exemplified in a medallion portrait of the diplomat Sir Henry Rawlinson (pl. 180), signed by Henry Cockle Lucas, the leading wax modeller in Britain in the mid-nineteenth century. In the background there is impressed a cuneiform text, with a translation ('I crossed the Euphrates') finely scratched below. The very forms of the letters – no less than the area of wrinkling caused by accidental contact with heat – is a reminder of the softness of the material, but the choice of colours (white on brown), the low relief and the oval shape are intended to recall cameo portraits cut in sardonyx.

Wax is a translucent yellow when removed from the beehive. It is bleached by exposure to sunlight and can be whitened also by adding white-lead powder to the molten wax or coloured by adding other pigments in the same way. Red, orange or green, made with common pigments – red lead, vermilion or verdigris, were the colours that seem to have been generally preferred for models made by European sculptors from the sixteenth century onwards, perhaps because they resembled the colours of the metal sculpture for which these models were often preparatory.

Giambologna no doubt made numerous wax models in the 1580s for his great three-figure group of the *Rape of a Sabine Woman*, and most of these must have been rough sketches. One carefully finished model has survived and is typical of the sort of sculpture that, although primarily made as a preparatory aid, was then preserved for its own sake (pl. 191). However, unlike the portraits just mentioned, this little model has not always been protected, and all three heads and other extremities have been broken off and lost. Radiography has revealed a wire armature inside the figures, and also the fact that the body of the woman carried aloft is hollow. Wax is easily cast, and this figure must have been taken from an earlier model where the sculptor no doubt felt the figure had been perfected. He may also have wished to keep the uppermost figure of the group relatively light.

By the mid-nineteenth century wax could be obtained from both paraffin and stearin, but sculptors generally preferred the more traditional and

191 Giambologna, sketch model for the marble group of the Rape of a Sabine Woman, wax, *c*.1580, 47 cm. high (including base), 30.8 cm. (without base), Victoria and Albert Museum, London.

192 Henry Cockle Lucas, profile portrait of Sir Henry Rawlinson, wax of two colours, *c.*1850, 19.5 cm. high, Ashmolean Museum, Oxford.

expensive beeswax, sometimes mixing it with the new waxes, or with flour. For models, red wax remained popular, but a dark brown (often obtained by mixing vermilion and organic black pigments) was more usual, as it also was for the patination of bronze sculpture.

The new attention to movement among nineteenth-century European artists – especially evident in the sculptures of animals made in France – gave the wax model a new importance. Just as the fleeting expression on the faces on the figures of Rossellino's *Virgin and Child* owes much to the clay in which it was modelled, so too the bristling fur and quivering muscles of Barye's jungle

217

193 Pierre-Jules Mène, sketch model for a group of a stablelad feeding champagne to a victorious racehorse held by its jockey, wax with metal armature and supports, *c.*1863, 22.3 cm. high (including plinth), Ashmolean Museum, Oxford.

creatures, the twitching flesh and jerking heads of Mène's racehorses, and the straining torsion and tortuous balance of Degas's ballerinas required for their initial study, if not their final realization, the even more responsive and malleable material of wax.

A brown-wax sketch model by Pierre-Jules Mène (pl. 192) of a stable boy pouring champagne into the mouth of a victorious racehorse held by its jockey retains, in addition to the internal armature, external supports – vertical rods for the stable lad and the belly of the horse – of a kind that were sometimes removed when the model was completed. Whereas sculptors usually built up the wax in rolls or balls, Mène applied his in thin sheets and in drips as well, using his fingers more than any scraper or spatula. There is some white efflorescence on the surface of the wax and there are also cracks. Moreover, some of the wax has fallen off the thin wire used for the tail and reins. This sculpture is thus an apt illustration of the fragility of wax, but it is no less an example of the unique merit of wax as a material, for the thin legs of a horse of this scale, to say nothing of the reins and tail, could be modelled in no other traditional material. And once modelled in fragile wax, they could easily be translated into durable metal.

Important though wax may be, especially in comparatively recent European art, as a material in its own right, its great contribution to sculpture has been one of continual sacrifice, flowing out of the moulds into which the molten metal entered. The casting of bronze and other metals by the 'lost-wax' process is discussed in the following chapter.

16 *Bronze and Other Copper Alloys: Part 1*

ARCHAEOLOGISTS WORKING IN THE NEAR EAST estimate that by the seventh millennium BC copper was being hammered and rolled, that by the second half of the fifth millennium it was being annealed (heated and cooled in water to reduce the tendency to brittleness caused by hammering), that by the late fourth millennium it was being melted and poured into open moulds of stone or earthenware, and that by the early third millennium bivalve moulds were being used as well. Copper was found to be stronger and more malleable if mixed with arsenic, which is often attached to copper ore, and by the third millennium alloys containing significant percentages of either arsenic or tin were being used.

Bronze, the alloy of copper containing more than one or two per cent of tin, became the most widely used metal for weaponry, tools and armour – and for sculpture – in many parts of the world; but the term has often been used very loosely, even on the labels of the greatest museums or in the captions of the most scholarly books. There are many other copper alloys, most notably brass, and bronze can include other ingredients in addition to tin and copper, most notably lead. Whenever possible, in this chapter and the next, an accurate account of the alloy in question has been attempted. At the same time, it is important to recall that neither the distinctions of modern metallurgy, nor indeed the terms in common use today, correspond to those used in previous centuries, let alone those used by ancient metalworkers. However, a distinction between pure copper, or alloys containing a very high percentage of copper, which are pinky orange, and copper alloys, which are yellow, has always been important.

Among the earliest known ornamental works in metal are those from graves in the Zagros mountains of Iran, known as 'Luristan bronzes'. Some of these can be identified as horse tackle, while others, more distinctive and mysterious, were designed to be mounted vertically on shafts, and it seems likely that they would have served as standard finials. In the example illustrated (pl. 194), which has been dated to between 850 and 650 BC, a symmetrical pair of rampant goats with beards and backswept horns face each other, each with a smaller beast attached to its back. There is a ring which is level with the goats' necks, and another just below the level of their feet.

The design, though linear, is not flat, and it is too complex to have been

194 Iranian, standard finial of confronted rampant goats, bronze, *c.*850–650 BC, 18.6 cm. high, Ashmolean Museum, Oxford. A solid lost-wax cast.

made in an open or even a bivalve mould. Thus the casting method must have been that of 'lost wax'. The figures would have been modelled in wax and then 'invested' in a clay mould. When this was heated the wax ran out, leaving a hollow into which molten alloy could be poured. The clay mould would then be broken open to reveal the solid cast. After cleaning, the colour of the metal would have been an orange brown: today it has corroded to a dusty green. The alloy has in this case been analysed: it is 96.1 per cent copper with 3.7 per cent tin and some other accidental components (notably lead and nickel), neither amounting to as much as 1 per cent.

The forms of this bronze finial seem to have been partly determined by the material out of which the model was made – the stylized representation of the goats suggests that they were constructed out of rolls of wax, sometimes twisted and pinched, with pellets added for the corrugations of the horns, the eyes and the curls of the mane. No tool – no stylus or spatula – would have been required to model such forms, and no tool – no chisel or file – seems to have been used to smooth or cut the metal. Many small bronzes, of less fanciful subjects, such as warriors with raised spears or teams of horses, cast in Italy and Greece and other Mediterranean countries during the same centuries, are similarly lean and open in structure, although less waxy, and sometimes ornamented with patterns cut into the metal with a sharply pointed tool of a harder alloy. In the case of the fifth-century Etruscan warrior illustrated here (pl. 195), all the decoration, which is confined to the armour and clothes, is made with a bird's-eye punch, or with a smaller pointed punch tracing a waving line. In this case there are prongs attached to the soles of the feet – such projections (often known as 'tangs') are intended to fix the figure to its base, but probably originated as channels through which the metal was poured into the mould.

Not all civilizations developed the technology of metal casting. It has, for instance, been little used in Africa, although the Igbo-Ukwu in Nigeria were casting bronze probably as early as the tenth century AD. While it is known that copper was being transported by Arab traders across the Sahara from at least the eleventh century, it has been noted that deposits of lead and copper do exist near the site where the Igbo-Ukwu bronzes were discovered, and, moreover, it is known that in ancient times tin was extracted on the Jos Plateau, so it is probable that the alloy used was made locally and possible that the technology was not imported. Most of the sculpture made by the Yoruba at Ife between the twelfth and fifteenth centuries and then by the Bini at Benin (also in what is now Nigeria) between the fifteenth and nineteenth centuries, was of brass, a different alloy consisting of copper and zinc, which had been introduced into western Europe from Asia by the Romans in the first century AD, most notably in the new coinage of the Emperor Augustus, and towards the end of the Roman Empire it had replaced bronze as the usual copper elloy throughout the western world. The metal employed was certainly imported, often already in the form of brass, by Portuguese and other European coastal traders. The roof of the royal palace of Benin City was clad in flattened European cooking pans and crowned with wooden carvings of Portuguese soldiers sheathed in brass. The use of brass was entirely controlled by the Oba, the Benin king, and the material itself as well as the rituals in which the sculpture served were associated with divine – and regal – power. Its status as an alien product no doubt played a part in this.

The standing figure (pl. 196) of a man wearing a cross on his chest, a type of statue known to have been placed on ancestral Benin altars, perhaps representing a court official, perhaps the servant of a god, was cast probably in the sixteenth or seventeenth century. It reflects a style of modelling that immediately suggests wax – applied in thin strips and flattened rolls for the network of the collar and for the raised cheek scars and eyelids. The linear pattern on the kilt was also cut in the wax and has been almost perfectly reproduced. No attempt was made, after casting, to sharpen any of this ornament where it is smudged, nor were the casting cracks in the elbows repaired, nor was the 'flashing' – the fins of metal that have leaked from the mould – cut off from the insides of the arms. The casting, whereby a figure modelled in a soft material was first destroyed and then replicated by a hard one, may well have been regarded as a magical process, the results of which should not be meddled with. And yet it would have been necessary to cut various extruding elements from the brass figure after it was freshly cast.

The figure is a hollow cast. The wax was modelled around a clay core for the torso and both arms and legs were modelled in solid wax and attached. The clay core was supported on an iron rod. The wax figure was then fitted with wax 'branches' and invested with the clay mould. These 'branches' formed the 'runners' and 'risers', or 'gates' and 'vents' – the passages through which wax and gas flow out and metal is poured in. When the mould is

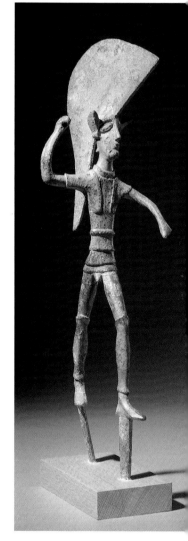

195 Etruscan, *Warrior in a threatening pose*, bronze, *c*.500 BC, 26.7 cm. high (from soles of feet, excluding tangs), Ashmolean Museum, Oxford. A solid lost-wax cast.

broken open such branches remain – though now, of course, of metal – forming 'sprues', the above-mentioned extruding elements. To keep the core in position when the wax layer between it and the mould had melted, chaplets, or core pins, were often employed: after casting these either fell out, leaving holes, or remained as additional extrusions to be sawn off and filed down. In the case of this Benin figure the chaplets seem to have been of a similar alloy to the brass used in the figure so they cannot easily be discerned.

There were four possible reasons for casting figures hollow. The less metal used, the less costly the sculpture. It would also be lighter and, if the figure was to be transported or paraded, weight was likely to be an important consideration. The hollow inside the figure could also serve as a container (brass heads made for the Oba held carved elephant tusks on the ancestral altars of Benin, and their brass leopards were used to hold water). Finally, a hollow cast circumvented a difficult technical problem, for metals contract as they cool and, as the rate of contraction differs according to thickness, this may cause cracks (a similar problem has been noted of earthenware sculpture).

A similar debate to that concerning the origin of lost-wax metal casting in Africa centres on the use of copper alloys under the first identifiable dynasty of great rulers in China, that of the Shang. The vessels associated with sacrificial rituals and ancestor worship, which have been discovered in Shang tombs of the second millennium BC, were made of an alloy of copper, tin and lead. Lead may have been introduced to make an alloy with a lower melting-point, which would run more easily into the intricacies of a mould. It might also be supposed that it was introduced to make a cheaper alloy, but the patrons of these ritual vessels seem to have had abundant supplies of ore and a great disdain for frugality.

These ancient vessels not only are decorated with ornament derived from both real and fabulous animals, but are themselves sometimes partly conceived of as such. The lid of the *guang*, or ritual wine jug of the twelfth century BC, illustrated here (pl. 197), takes the form of a dragon's head; the hinged end of the lid represents – in stylized form – a fantastic mask with flattened horns and beak; at the top of the handle there is the head of another horned animal which is consuming a bird at the feet of which is another little dragon; the neck of the jug is decorated with *k'uei*, stylized dragons, and the belly and top of the lid with the stylized monstrous masks known as *t'ao-t'ieh*. The creatures are half abstracted into – or rather concealed within – the patterns. And the patterns themselves possess an organic vitality that springs from a dynamic relation between negative and positive spaces, swelling bosses and deep incisions, rounded and angular shapes.

The form of this vessel, like those of Shang bronze vessels generally, is unique to China, and so is the manner of both its decoration and manufacture. It does not incorporate forms that are typical of hand-modelled wax, as do the bronze ornaments of Luristan or the brass figures of Benin,

196 Nigerian (Benin), *Court official or servant of god*, brass, sixteenth or seventeenth century, 65.4 cm. high, Metropolitan Museum of Art, New York (gift of Mr and Mrs Klaus G. Perls, 1991). A lost-wax cast, hollow only in the torso.

197 Chinese, ritual wine server (*guang*), bronze, twelfth century BC, 18.1 cm. high, Arthur M. Sackler Gallery (Smithsonian Institute), Washington, D.C. Cast in a ceramic piece mould.

198 Chinese, ornament of interlaced chimeras, bronze, *c.*500 BC, 10.2 cm. (diameter), Ashmolean Museum, Oxford. A solid lost-wax cast.

rather it reproduces something has been cut and incised. However, the sculpture of the model was not carried out in a hard material: the cutting is deep, but with edges that are not always sharp, hollows that are not of a V section and do not taper, and that twist and wriggle, as a cut made by a burin in metal or by a gouge in wood cannot. This sort of movement is seen most clearly in the *lei-wen* (or thunder-spiral) ornament of squared whorls with tremulously thin walls found on so many of these bronzes, and also incised on the sides of some ancient Chinese clay vessels.

The model for this jug must have been made in clay, and from this in turn clay piece moulds would have been taken. Fragments of such moulds have been discovered and turn out to have been made from loess, the wind-blown rock dust deposited across the great plane of north China, selected for its fine grain which enabled it to take precise impressions, for its stability which meant that it shrank relatively little when dried or fired, and for its porosity which enabled gases (formed when the molten metal was poured into it) to escape. Moreover, this type of clay could be cut neatly after firing both to correct distortions in the negative pattern and to form neat edges and keys for assembly. The advanced ceramic technology of the Chinese is obviously reflected in this method of casting.

A core would be inserted in the assembled mould. It perhaps consisted of the clay model shaved down. The core would be held in place by bronze spacers. Projections such as horns could be pre-cast and fitted into the mould before the molten bronze was poured in. 'Casting on' was also practised. In the case of the jug illustrated here, the body was cast with a pair of projecting tenons: the moulds for the handle were clamped over these and the bronze

224

poured in. After casting, little work seems to have been done on the metal beyond cleaning and polishing with abrasives. Evidence of tooling cannot be found (which is not to say that files were not employed).

The Shang foundries did not employ lost-wax casting for these vessels, which need not mean that they were ignorant of it. At a later period, around 500 BC, fantastic ornament came into fashion for application to solid vessels and furnishings in China (pl. 198). Its intricacy – an ostentatious demonstration of a quality unique to the lost-wax method – is equivalent to the vermiculate designs of some twelfth-century northern European candlestands, or to the knotted ropes cast by the Igbo-Ukwu.

The type of bronze vessels made under the Shang dynasty continued to be made under the Chou dynasty, and in the Warring States period, often with sharper projections and more exaggerated undercutting. Inlay decoration was also introduced: fine wire or sheets of gold, silver or copper were beaten into hollows made in the smooth surface of a bronze, to form swirling patterns. The edges of the hollows had been undercut, forming a lip which could be hammered down on to the inlay. The hollows themselves seem also to have been cut out. This type of bronze technology, unlike that of the Shang ritual vessells, entailed considerable tooling of the metal.

The use of inlay in bronze appears to have enjoyed similar favour in Egypt at about the same date. The small bronze figure of Ptah, god of the city of Memphis and patron of craftsmen, probably cast in Egypt in the Twenty-Sixth Dynasty (664–525 BC), illustrated here (pl. 199), is one of the most perfectly preserved of all ancient bronze sculptures, and one of the most exquisite in quality. The sculptor has adopted the traditional form in which the god was represented, whatever the material: the body swathed in cloth, 'mummiform', with feet concealed and hands emerging only at the wrists. The beard is attached to the neck and chest, just as we would expect, had it been carved in granite, but the sceptre is half detached from the body. It was cast in three separate parts and threaded through the hands. The shape of the figure is so simple that one supposes it would have been far easier to use a bivalve mould; but the sculptor seems to have wished to make a perfect cast, avoiding any tooling of the metal (such as would have been needed to remove the seams of a mould). Areas of the surface have been carefully and minutely worked in relief – in particular the softly undulating parallel lines of the beard, parted where the sceptre presses against it – but these were incised in the wax model, as were the hollows for the eyes, and the broad collar and bracelets. Traces of silver remain in the whites of the eyes and gold remains where it was inserted into the bracelets, but the rings of gold in the collar and almost all of the petal-shaped pendant ornaments have been prised out. For the most part the bronze is a rich chestnut colour with only a few patches of green corrosion, a natural patina for a bronze with an alloy such as this (the percentage of tin is 11.4 per cent with less than 1 per cent lead), and it contrasts with the black artificial patination of the wig, beard and sceptre,

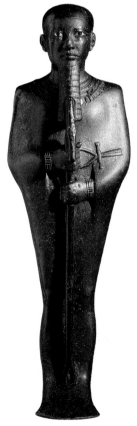

199 Egyptian, *Ptah*, bronze with gold inlay, *c*.600 BC, 17.8 cm. high, Ashmolean Museum, Oxford. A solid lost-wax cast.

225

perhaps obtained with sulphides. This black was sometimes favoured as the principal colour of Egyptian bronze sculpture, especially in pieces that were highly prized.

Ptah was cast solid. Perhaps any suggestion of economizing was considered improper in a votive offering of the very highest quality such as this was likely to have been, but other ancient Egyptian bronze sculptures were certainly cast hollow, and it was not uncommon for them to have separately cast arms that were attached by tenons, in a manner reminiscent of traditional Egyptian wooden sculpture. Hollow bronze figure sculpture may well have been made elsewhere, but the Egyptian work was certainly very familiar on the Greek island of Samos in the seventh and sixth centuries BC, and it was there and during that period that the casting of large bronze sculpture seems first to have taken place.

Life-size bronze casts rapidly replaced in prestige large wooden sculptures plated with sheets of copper, of which only a few fragments have survived. Very few ancient Greek life-size bronzes have been discovered, and the method of their manufacture is much debated. However, investigations undertaken during the conservation of the pair of bronze warriors fished out of the Ionian Sea near Riace in 1972 provided precise evidence on matters that had long been the subject of speculation. The 'Riace bronzes', which some scholars assign to the fifth and others to the fourth century BC – and some even to a more recent date – are certainly among the finest examples of bronze casting in existence and represent a technical standard that has never been surpassed.

Statue A, the better preserved of the pair (pl. 200), lacks spear and shield as well as a separately wrought garland that would have been attached to the fillet in the hair, but otherwise it is complete. The thickness of the bronze is remarkably uniform – more so than would be likely had the wax been built up over a core. A core survived within the bronze, which incorporated straw, animal hair and grog, fully baked only on the outside, and this contained an iron armature. In the case of Statue B, which was made in the same way, the armature had strayed from the centre of the core, which would not have been likely had the core been the sculptor's starting point. Such evidence suggests that the sculptor made a complete clay model first and then took moulds from it, into which soft wax was carefully pressed or molten wax was poured and swirled. The hollow wax mould was then filled with a core into which an armature was inserted. When this core began to dry the wax mould was carefully tooled to remove all seams, and additional detail may also have been added – indeed, it may have been at this point that the model was given hair and beard, or even ears and genitals, which would have been troublesome to mould in the original model. The wax model, filled with core, was then invested and the mould was heated so that the wax ran out and the core was baked, or rather partly baked.

To simplify the casting of so complex a form, the statue was made in parts:

200 Greek, *Warrior*, bronze with glass paste, silver and copper inlay, probably fourth century BC, 200 cm. high, Museo Nazionale, Reggio Calabria. A hollow lost-wax cast. Large parts (e.g. the arms) and small (e.g. the locks of hair) separately cast and attached.

226

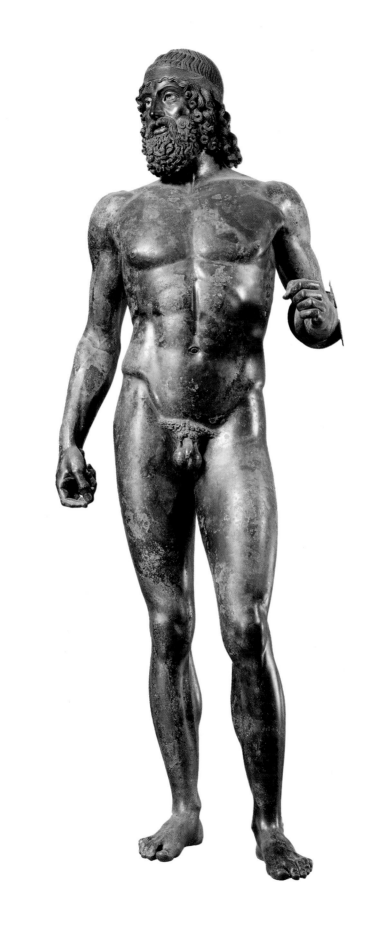

head, arms and front of the feet were cast separately, as were some even smaller parts – the middle toes, the scrotum the penis, much of the beard and many of the hanging locks of hair (nipples, lips, eyes and teeth were also fashioned separately but in different materials). Assembling the separate bronze casts would have been particularly difficult: they were heated, and molten bronze was poured into the narrow space between them – in some cases a shallow hollow was cut in the wall of the bronze on either side of the join so that the new bronze would spread into both. Some of the joins cannot be seen now, and none of them can have been obvious originally. The separately cast portions of hair and beard must have been attached to the cast wax model and then detached from it for solid casting.

The composition of the alloy does not vary in the separate castings alone. Within the torso and legs, for instance, the tin content ranges between nine per cent and twelve per cent. In some cases the alloy seems to have been deliberately varied: the copper content of the separately cast locks of hair seems to be especially high, rendering them softer and more easily chiselled. The nipples were cast in more or less pure copper and then inserted into holes, the bronze being carefully hammered around to secure them – they could not themselves be hammered without their shape being altered. The lips were cut out of the wax model, cast in copper and reinserted before it was invested – fitting tightly between core and mould so that the bronze would flow around them. The eyeballs of ivory (marble in the companion statue), with pupils and irises that do not survive (but were perhaps made of glass paste), were encased in copper, the projections of which were cut into lashes, and inserted into the hollow sockets, projecting deeper than the walls of the bronze itself. A strip of silver teeth was inserted below the upper lip (pl. 201).

No trace remains, on the statue, of the dozens of 'sprues' – the 'runners' and 'risers' that would have extended from it – nor of the flashing, which would be inevitable in a cast of this size. Some chaplet pins (made of bronze, though iron was sometimes preferred by the Greeks) have been discovered, embodied in the surface of the bronze, and so have numerous rectangular patches hammered into prepared hollows cut around defects in the surface caused by gas bubbles or other casting problems. Whatever tools and abrasives were used to sharpen and clean and smooth the surface, no trace remains except for the very delicately chiselled details of the highest, finest hair of pubes and beard.

A patch of perfectly preserved smooth black surface beneath the crust that covered the bronze during its long stay under the sea suggests that the sculpture originally had a black patina, not unlike the blackened portions of the statuette of Ptah. In any case, we can assume that the colour of the metal was sufficiently dark to contrast with the copper of the lips and nipples. Like Egyptian bronze sculptures, these Greek statues would have resembled in colour and finish polished hardstones such as basanite and basalt, but they were now as large as life – or larger – and seemed to possess the supple

201 Detail of pl. 200.

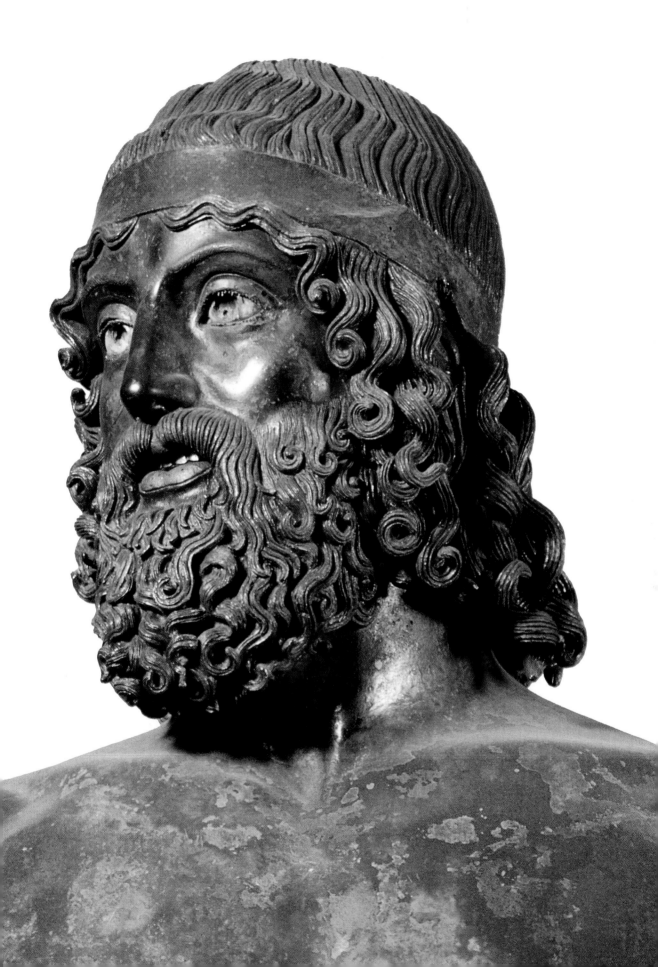

elasticity of living athletes, with a freedom from any kind of support that would be impossible to achieve in stone. Realism is an inadequate word for the sculptor's aim, when we consider the calculations behind the physical proportions of these beings. But ideal seems too anodyne a term for creations of so alarming a particularity, their impressive, but menacing, power as warriors – that is, killers – enhanced by the gleam of their teeth and eyes.

The astonishing technical skills involved in casting and finishing a metal figure of this size survived during the Roman Empire. The network of international trade which brought tin from Spain or Cornwall to join copper from Cyprus was strengthened. Lead (which constitutes less than one per cent of the alloy used for the Riace bronzes) tended to replace tin in many Roman metal sculptures, both because it was more readily available and because it made casting easier. (Lead, already noted as present in Chinese alloys, had been favoured by the Etruscans, and the statuette illustrated as plate 195 here contains eighteen per cent lead as against sixteen per cent tin.) The joining of separate parts such as arms and genitals in the manner we have examined continued, as did the practice of inserting separately fashioned eyes and teeth, also the casting of separate locks of hair (which may be observed in many of the bronzes from Herculaneum and Pompeii in the Archaeological Museum in Naples). It is unclear exactly when the technical skills were lost, but by the fourth century AD no large figure sculptures were being cast in the Roman Empire of the West, although some were in the Byzantine Empire in subsequent centuries. A few large Roman bronze sculptures – the horses of Saint Mark's, for instance, and the bronze equestrian statue of the Emperor Marcus Aurelius – survived destruction by barbarism and bigotry to serve as reminders of the skills of a lost age.

Small bronze figure sculptures also ceased to be made in Europe: the technology survived, but the desire to possess such figures, most of which represented pagan gods or were offerings to them, declined, as did the interest in representing the youthful nude figure. The Roman statuette illustrated here (pl. 202) is not unusual in its subject – Mercury, protector of traders and travellers, presumably belonging to a domestic shrine; but its quality is outstanding. As its first British owner, the connoisseur Richard Payne Knight observed, even 'the veins are strongly but delicately marked', the hair seems 'moveable by every breeze, and the countenance absolutely speaking, with a beauty and sweetness of character more than human'. The sculpture, which was found in 1732 in a cave in France where a pious heathen had probably concealed it, is likely to date from the first half of the second century AD. Gold was used for the cloak brooch, copper for the nipples, and both niello (a black alloy of sulphur and silver or lead) and silver for the palmette decoration inlaid in the pedestal; and the original colour of the bronze – most likely a rich brown – must have contrasted effectively with the other metals.

The literary sources, and especially the *Historia Naturalis* written in the first century AD by Pliny the Elder, indicate that Roman connoisseurs of sculpture

202 Roman, *Mercury*, bronze with copper, silver and niello inlay and gold accessory, probably early second century AD, 20.3 cm. high (including pedestal), British Museum, London. The pedestal is original. A hollow lost-wax cast.

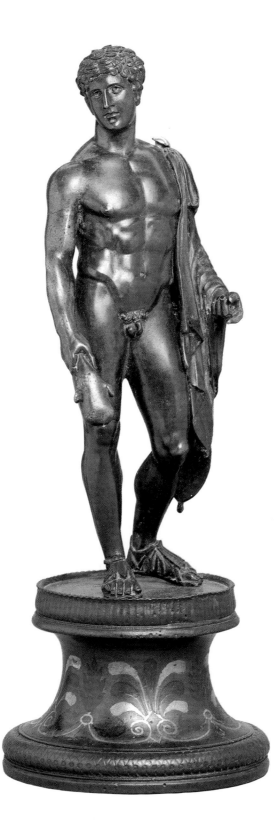

were fascinated with the alloys and patinas of the finest Greek bronzes. Plutarch, writing at the same period, claims that Silanion of Athens, working in about 325 BC, created a sculpture of the dying Jocasta with silver in the alloy employed for the head which gave her a pallid appearance. Pliny claimed that Aristonidas made a statue of Athamas whose fury was giving way to shame, the latter emotion conveyed by rusty colour in the copper, achieved by adding iron to the alloy. The descriptions of famous Greek statues by Callistratus, written much later but in a traditional mode, frequently commend bronzes that seem to blush. Most modern scholars dismiss these descriptions as poetic nonsense, but there is nothing impossible about Silanion's use of silvery bronze and Pliny's account of the varieties of colours available is reminiscent of the virtuosity practised in much more recent centuries by craftsmen in Japan where connoisseurs, as well as foundries, distinguish between numerous types of bronze, two main types of brass and copper alloys made both with gold (shakudo) and silver (shibuichi).

On the other hand, the literature concerning bronze alloys has often been influenced by the magical ideas of the alchemists. Ancient sacred texts, for instance, have encouraged the belief that some north Indian metal sculpture was made of an alloy containing eight metals (including iron, gold and silver) but that has been found to have no correspondence with foundry practice, although precious metal was, it seems, sometimes mingled with the brass or copper as an offering. Some element of magic, or at least superstitious veneration, is also attached to patinas.

When small Roman sculptures were rediscovered in Europe, or when ancient ritual vessels were rediscovered in China, part of their attraction was the colour of the corroded bronze – the green and blue of malachite and azurite (carbonates of copper) and the red of cuprite (oxide of copper), which were regarded not only as beautiful in themselves, but as proof that the sculpture was also a messenger from a superior, buried civilization. Connoisseurs in thirteenth- and fourteenth-century China also believed that bronze vessels that had been buried in soil for a thousand years and were as green as the kingfisher's feathers were impregnated with the essence of earth, and would repel evil spirits and keep cut flowers alive. Because of the prestige of such patinas forgers learned to imitate them. The small green nodules speckling the olive brown metal of the Shang *Guang* (pl. 197) consist of powdered malachite mixed with an organic binder and attached to the ancient vessel to conceal modern patches.

17 Bronze and Other Copper Alloys: Part 2

AS HAS BEEN POINTED OUT IN EARLIER CHAPTERS, the ambitious bronze sculpture of the Greeks determined the character of sculpture in stone under the Roman Empire. In like manner, in Cambodia and Thailand under the Khmer kings, between the ninth and twelfth centuries AD, sculptures of the gods that were carved in dark stone emulate the open poses that are more easily achieved in bronze. Formulas for representations of gods in bronze do, however, seem in all parts of Asia to have originated with stone sculpture. Thus the Cambodian Buddha found in Chaiyaphun province (pl. 203) is enthroned below an arch that reflects in its overall shape the back plate of stone against which images of the gods were conventionally set and out of which they were originally carved in high relief. Exceptionally large for a bronze sculpture – altogether nearly six feet tall – it is generally dated to the late twelfth or early thirteenth century, when the execution of such an ambitious and complex structure would have been beyond the technical ability of any foundry in Europe.

The ashen green colour of the bronze is a consequence of its long burial in the earth. Originally it would perhaps have been a dark, lustrous grey, reflecting a high percentage of tin and the addition of precious metals, including silver, characteristic of a copper alloy known as *samrit* which was used in south-east Asia – although the metal of this Buddha has not been analysed. Its colour would have contrasted with the gems (or paste imitations of gems) originally set in the diadem and necklace, and the rock crystal of the *urna*, the spot of sanctity, in the forehead. Polished flesh would have contrasted with dense, bristling detail – the petals clustered in the pillars or organized into lozenges on the upper and lower friezes of the throne plinth; the bustling guardian dragons whose tails merge with the scrolled arch; the twenty-four tiny mortal Buddhas, each seated cross-legged within a nimbus projecting like a fin from pillars and arch; the stylized branches and leaves of the Bodhi tree (beneath which the fasting Buddha achieved enlightenment) crowned with the emblem of the trident. Surface corrosion makes it difficult to assess the original finish of such details, but it is not apparent that a chisel was employed even to sharpen them.

The sculpture was cast in eighteen separate pieces; however, the joins are not concealed by careful tooling, as in Greek or Roman work, but are

203 (following page) Cambodian (Khmer), *Enthroned Buddha*, copper alloy, twelfth or thirteenth century, 175.5 cm. high, Kimbell Art Museum, Fort Worth, Texas. A hollow lost-wax cast. Assembled from separately cast sections.

233

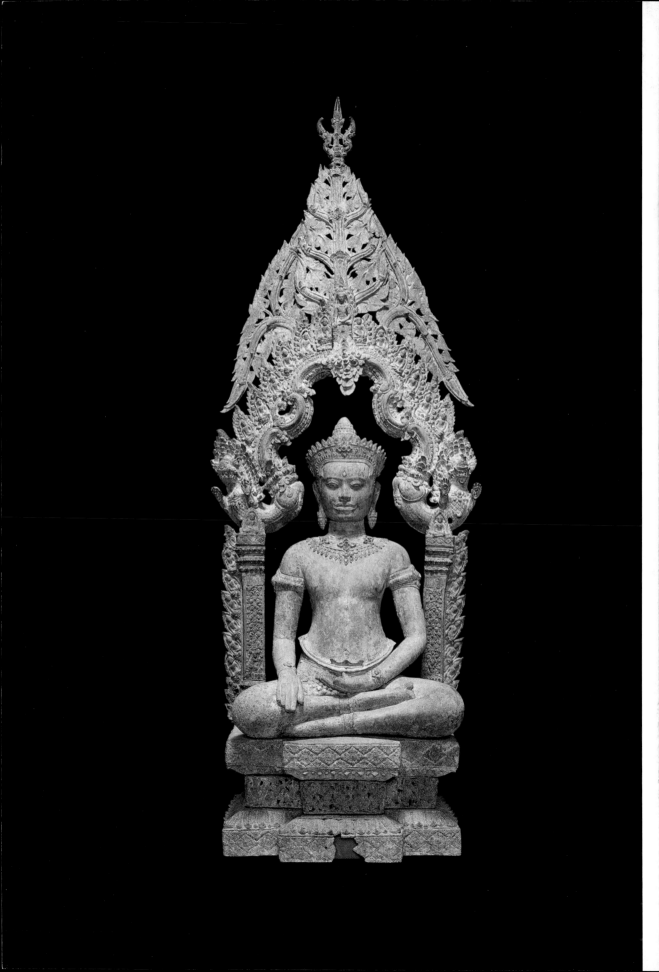

incorporated in the design – thus in the figure the joins at the bottom of the neck and at the tops of the arms correspond with the necklace and bracelets, and the junction of legs with belly coincides with the top of the loincloth.

The metal sculptures produced under the Chola dynasty which ruled southern India between 880 and 1279 are among the largest known to have been made in India, but they are smaller than this Cambodian bronze and quite different in character, having been cast for the most part in one or two pieces and being often solid. The most remarkable of these depict the god Śiva as Nataraja, Lord of the Dance (pl. 204) – a popular subject because Śiva was the patron deity of the Chola family. In form they follow a pattern first established in stone sculptures of the early tenth century, in which there is a halo of flames around the edge of a stone slab, cut in low relief, whilst one of the god's two pairs of arms and one of his legs, supported by struts, project in very high relief.

The sculpture illustrated here, which dates from about 950, is typical in its design, although of exceptionally high quality. It recalls the carved images above all in its frontality, although it was made to be carried in procession during festivals (hence the square holes in the lotus base, through which a pole would be passed), as stone images of this size could not have been. Only in metal would it be possible to achieve such open forms, such freedom of action, such a fine balance, such brittle extensions. Whatever the alloy employed in this particular figure, many of the metal sculptures of southern India are cast in almost pure copper. This sculpture was cast as a single piece, with the exception of the flying hair, which is soldered to the god's back (in one or two casts even this is integral). The halo of fire serves as a support: the figure, which seems to move within it, was, in fact, cast with it. This framework is likely also to have played an important role in the casting process, incorporating some of the channels through which the metal could enter the main body of the sculpture.

The necklaces, anklets, bracelets, scarves, belts, pelt and snake that entwine the god's lithe body, and the skull and crescent moon (proper to the conqueror of death, with his all-seeing powers) amid the ornament of his crown, are all softly rounded in a way that reflects the wax model – though this softness has been exaggerated by centuries of temple rituals, when it would have been bathed, anointed (with milk, curds, clarified butter, honey and sugar), perfumed (with sandalwood paste), and attired with silks and garlands and jewels. The only part of the sculpture that was certainly chiselled is the outline of the eyes and brows. Some scholars believe that these were reinforced in bronze sculpture when the features had been rubbed down with handling, but in later periods, at least, the eyes were chiselled when the newly cast sculptures were consecrated in the temple for which they had been made, in the ceremony of 'opening the eyes', whereby the god 'awoke' within his image. Had it been conventional to chisel other parts of the sculpture after

204 (previous page) Southern Indian (Tamil Nadu), *Śiva Nataraja*, probably copper, *c*.950, 76.2 cm. high, Los Angeles County Museum of Art. Lost-wax cast, probably solid. The flying hair separately cast and soldered.

casting, the magical nature of such an intervention would have been much diminished.

Some of the Chinese Buddhist sculptures made in metal have light and open forms of greater intricacy, but this was achieved by assembling numerous separate casts. In these cases the skill consists more in the design and assembly than in the casting, for most of the parts were simple in shape and cast solid. The shrine illustrated here (pl. 205) made in about 525 in Hopei province, represents the Maitreya Buddha, the Buddha of the Future, standing before a lotus halo incorporated into a leaf-shaped mandorla such as would have been solid in the great stone shrines, but here is pierced. The Buddha was cast with three hooks in his back. These poke through the mandorla and are pegged into place. Attached in similar fashion to the borders of the mandorla are swooping *apsarases* with streaming drapery (pl. 206). The attendant Bodhisattvas were cast with pedestals on branches hooked into the structure that supports the Buddha, while the two monks are cast with prongs enabling them to be slotted into place. It is not size that determined the preference for this method of assembly but the complexity of the design and possibly in this case the portability of the shrine (which could be dismantled for packing), as well as the pursuit of forms as light and animated as rustling reeds or dancing flames. The copper alloy (probably bronze) was gilded, and in this case enough gilding survives to help us imagine the original effect of light flickering on the surfaces of these bristling shapes. The mandorla is tilted forward, perhaps to catch more light from the lamps below. The sculpture has been extensively tooled. Both the broad folds of the Buddha's robes and the tiny creases of his palms were sharpened with a chisel – though not with great skill. However, the lack of fluency in the cutting matches the broken, angular character of the sculpture as a whole.

Some ancient Egyptian bronzes were gilded, with gold foil hammered into grooves or hollows, or with gold leaf applied to a gesso ground such as was also used on stone or wood. Fire gilding, mercury gilding, or ormolu, as it is also known, seems first to have been employed in China during the Warring States Period (481–221 BC), and by the second century AD it had spread to the Mediterranean. In this process milled gold (or *moulu*, hence ormolu) was mixed with mercury to form a paste that was spread over the surface of the metal and was then heated until the gold fused with the surface and the mercury was burnt off. The gold could then be burnished. The resulting surface was highly durable, even out of doors, and, in addition, it protected the metal from corrosion. But the method was both difficult (the heating of a large bronze especially so) and dangerous (mercury is highly toxic and now the process is permitted in Europe only with special licence; at the time of writing it is not practised anywhere in Britain). This type of gilding is also more easily applied to some copper alloys than others, and is most successful when the alloy has a high copper content – the ancient Chinese and the ancient

205 (facing page) Chinese, shrine of *The Buddha teaching, flanked by Bodhisattvas and monks*, copper alloy, fire-gilt, *c.*AD 525, 59 cm. high, Metropolitan Museum of Art, New York. The Buddha is a hollow (probably lost-wax) cast. The other parts are solid (probably lost-wax) casts.

206 Back view of the shrine in plate 205.

Romans seem usually to have avoided lead alloys when fire-gilding; the majority of fire-gilt statuettes made in Nepal and Tibet from the ninth century seem to have been of copper.

The fire-gilt statuette of a Bodhisattva that is illustrated here (pls 207a and b) was made in China perhaps in the thirteenth century under the Sung dynasty. The Buddha in the shrine which we have just been examining is a heavy cast with a simple hollow in the body (the other elements in the shrine are solid).

207a and b Chinese, *Bodhisattva seated in attitude of royal ease*, copper alloy, fire-gilt, thirteenth century, 19 cm. high, Ashmolean Museum, Oxford. Heavy-walled, hollow lost-wax cast.

208 Chinese, *Guanyin*, copper alloy partially coated in lacquer, seventeenth century, 25.5 cm. high, Ashmolean Museum, Oxford (Sir Francis Oppenheimer Bequest). Heavy-walled, hollow lost-wax cast.

There are similar hollows in this statuette – one in the torso and one in the raised leg – but arms and head are solid. The fluent pose is elaborated with locks of hair which retain traces of additional colouring, probably a dark blue, and cords and sashes, both in relief and detached, which have in some parts cracked or broken because they cooled much faster than the larger body. Further elaboration is supplied by the chiselled pattern on the hems and scarves, the lines of which fail to flow easily because of the effort with which they were cut as a series of contiguous curved gouges.

In addition to fire-gilding bronzes, the Chinese applied gilded lacquer to them. Lacquer is a varnish made from the sap of *rhus vernicifera*, a tree indigenous to China, which can be applied in numerous coats. The statuette of Guanyin illustrated here (pl. 208) which dates from the seventeenth century retains a brilliant red lacquer on its base, a translucent lacquer (incorporating gold leaf) on top of red lacquer in the drapery, and a darkened colour of lacquer (perhaps blue) on the veil. We might suppose that these finishes were intended to contrast with the colour of the bronze in the face and hands, but the metal surface has been tooled to provide a key for lacquer there and some traces remain in the hollows of the face, so originally no metal surface would have been left exposed. The grooved or roughened surfaces of ancient Egyptian bronzes intended for gesso which would then have been gilded are very similar and remind us that bronze, although often valued for its beautiful colour, is not a precious material.

240

By the thirteenth century, when the bronze statuette of a Bodhisattva was cast and chiselled and gilded in China, the demand for cast metal – especially for small objects – was growing in Europe. Candlestands and *aquamanile* (vessels for pouring water over the hands at table), often in the shape of lions or mounted knights, most of them in brass rather than bronze, were made in the Meuse and Rhine valleys in the twelfth century. Altar fittings and liturgical objects were made in copper from the twelfth to the fourteenth centuries at Limoges. The head of a crozier, or bishop's staff, of the late twelfth or early thirteenth century (pl. 209) is a good example of Limoges casting. It takes the form of a coiling serpent-like dragon, within which the archangel Michael spears another dragon – whilst other dragons form the knop and are stretched along the shaft. The copper was fire-gilt, though in some places it has worn away to reveal the warm chocolate colour of the metal, and was also extensively tooled, with a variety of tiny punches for the scales of the smaller dragons, as well as a small chisel or burin for the folds of Michael's robes and the feathers of his (separately cast) wings. Much of the surface is enamelled, mostly with blue, but also with red, yellow and green in the flower heads on the shaft. In this process the metal had to be cut into neat hollow compartments within which the coloured glass could be fired. Copper, being relatively soft, was easily cut and was, moreover, both easily fire-gilt and fused with the enamels.

The most notable monumental purpose for which bronze was employed in Europe during these centuries was for the doors of great churches. In the second decade of the fourteenth century the Florentine Guild of Wool Merchants, following the example of Verona, Pisa and other Italian cities, resolved to commission a pair of bronze doors for the Baptistery. They employed a Pisan sculptor, Andrea Pisano, both to make the models and to tool the metal of the twenty-eight relief panels; to cast them they employed Leonardo d'Avanzo from Venice (where a strong tradition of metal work owed something to the example of Constantinople, and much to the armaments industry). Such a division of labour is not surprising, but the extent to which it existed in earlier periods and in other civilizations is not at all clear.

In 1401 a competition was held for the second pair of doors, and the commission was given to Lorenzo Ghiberti, a Florentine goldsmith. His work, completed in 1424, was much acclaimed, and in 1425 a third pair, which came to be known as the 'Gates of Paradise', was given to him as well. Ghiberti had assistants who were employed as both specialist bronze chisellers and founders, but it is certain that he finished much of the work himself and actively supervised the casting. The alloy he employed in the 'Gates of Paradise' has a very high copper content – 93.7 per cent with 2.2 per cent tin, 1.8 per cent zinc and 1.3 per cent lead. The earlier doors are probably composed of a very similar alloy, which is, indeed, characteristic of Florentine bronzes of the fifteenth and sixteenth centuries. Besides being relatively easy to tool, such an alloy is suitable for fire gilding. Although it was only in 1423

209 French (Limoges), crozier with Saint Michael spearing the dragon, copper, fire-gilt, with champlevé enamels, *c*.1200, 32.9 cm. high, Metropolitan Museum of Art, New York (Bequest of Michael Friedsam, 1931). Solid lost-wax cast.

that the guild resolved to have Ghiberti's first set of reliefs gilded, it seems unlikely that this had not always been the plan.

The group of Christ as a child disputing among the Doctors of the Temple, a relief panel in the right half of the second pair (Ghiberti's first set) of doors, is typical in its technique (pl. 211). The cast was not perfect, and a crack is now visible running down from the cornice to the edge of the shell niche. This is joined by another, beside the hand of Christ, which extends to the pier on the left. Two insertions were made in the cornice, no doubt to conceal casting flaws. In the hollows and subordinate areas there is plenty of evidence that the cast must have been very rough, and much chiselling and filing were required to clean up deep drapery folds and the narrow spaces between the overlapping figures (which in some of the reliefs were separately cast). The tooling is especially evident in the fine hatching and cross-hatching in the borders of the drapery and in the spandrels of the arches, but also in the features of the figures – especially the eyes. Such work did not necessarily sharpen what had been present in the model but was, rather, adding something entirely new. The tight curves and tapered points of the cuts made in metal by a burin or small chisel, and the sharp edges of the forms, are essential to the style of Ghiberti's reliefs – essential to the linear elegance of the seated figure and curving mantle which echo the quatrefoils of the frame, and essential to both the contrasting rectilinearity of the architecture, and the angular movements and alert expressions of the figures cramped within it. The cutting of bronze and brass in this way was a skill that had been much developed in parts of northern Europe during the previous century and is especially evident in the tomb slabs of brass cut with effigies and in the strips of brass cut with letters which run along the top of tomb chests in England (pls 210 and 53). The existence of such skills were of course also a precondition for the development in the fifteenth century of printmaking.

In northern Europe some royal tomb effigies had been cast in metal as early as the thirteenth century, and the free-standing archangel Michael on the facade of Orvieto cathedral was cast in bronze in the mid-fourteenth century. The Florentine guilds commissioned an unprecedented series of large bronze statues of saints from Ghiberti early in the fifteenth century, and before the end of the century two other Florentines, Donatello and Verrocchio, had created the first large bronze equestrian statues since those of the ancient Romans – employing, in both cases, the foundry technology of Venice or the Veneto. Admiration for the art of ancient Rome also led to the revival of bronze statuettes, often of pagan subjects, the casting of which was greatly facilitated by the rediscovery of the technique of making a hollow wax cast

211 (facing page) Lorenzo Ghiberti, *Christ disputing with the Doctors in the Temple*, bronze, fire-gilt, modelled before 1415, cast *c.*1420, 45 × 38 cm., Baptistry, Florence (North Door). Solid lost-wax cast.

210 London workshop, chiselled brass inscription strip from the tomb of Lord and Lady Cobham (pl. 57). The name 'Cobham' is followed by a wyvern, the heraldic beast of Lady Cobham's family.

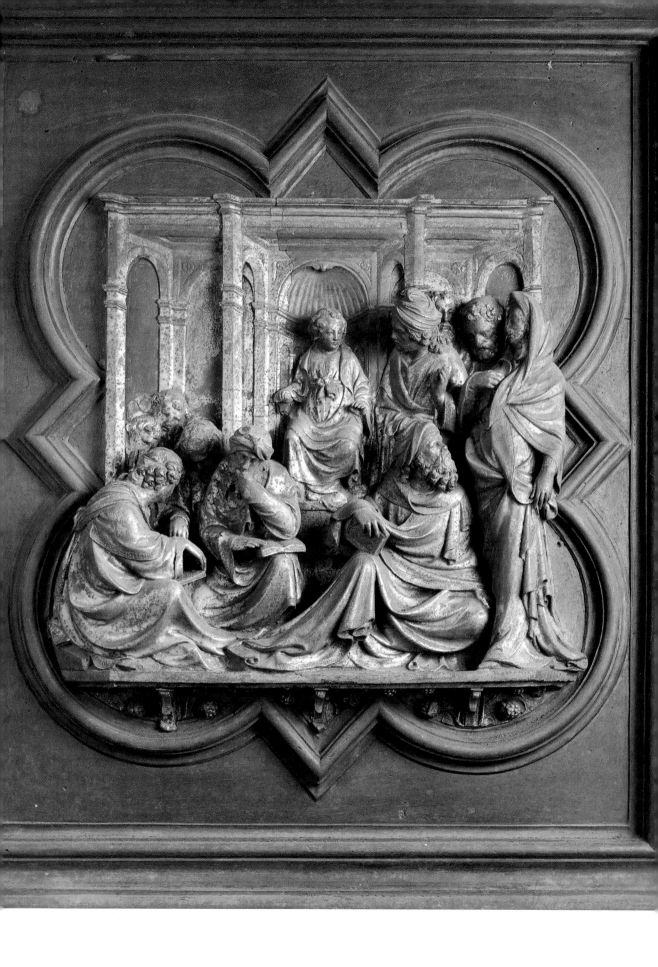

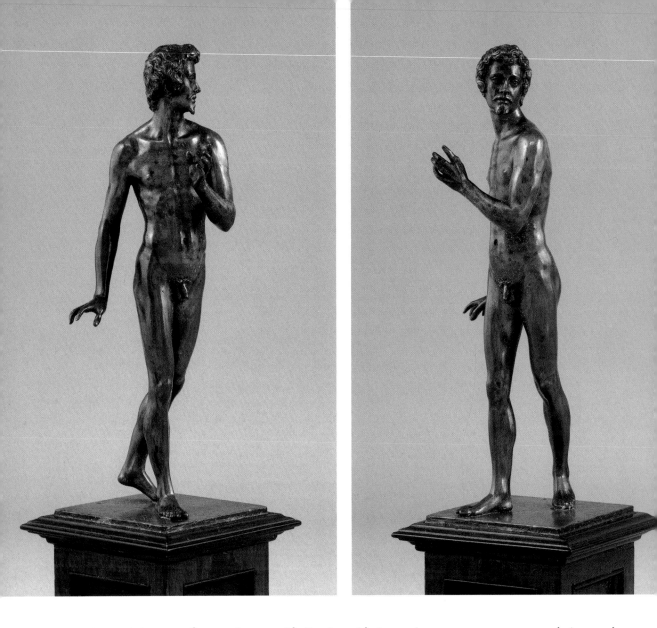

212a and b Probably after Pierino da Vinci, male nude probably intended for an Adam Tempted, probably copper or high copper alloy, fire gilt, 1547, 17 cm. high, Ashmolean Museum, Oxford. Hollow lost-wax cast.

from a piece mould. By the mid-sixteenth century statuettes were being made with a precision equal to that of the best Roman examples – although often different in spirit and finish.

The small figure of a nude man cast after a model perhaps made by Pierino da Vinci in the 1540s has a complexity of movement and a lightness and alertness of pose that are hard to match in any earlier sculpture of this type (pls 212a and b). Probably intended to represent Adam, he must certainly have been companion with another figure – probably an Eve holding an apple. Narratives composed of separately cast statues were known in ancient Greek and Roman art, though they were rare in miniature sculpture. Clearly, for narrative purposes there must have been a principal view of the *Adam*, but it is also evident that this is a figure to be turned in the light as it is handled, for the pose is expressive, and the composition elegant, from numerous points

246

of view. Again, whereas Roman statuettes such as the *Mercury* (pl. 202) were carefully finished in the round, they seldom invite this type of rotation, being for the most part sculptures of divinities before which prayers were made or to which tribute was brought. This is also the case with the bronze sculptures made in Asia. Even when the figure is depicted in action and was designed to be moved, as with the sculptures of Śiva Nataraja, and even when the figure is small and easily turned in the hands, as with the seated Chinese Bodhisattva, the figure is composed for frontal viewing – although there are some Chinese bronzes that, like jade, were certainly made to be handled.

The small bronze of *Adam* is not a perfect cast. There is a tiny firing crack in his left bicep, and there may have been a worse crack in the other arm, which necessitated the reattachment, perhaps even the recasting, of the forearm. The bronze is finished with minute scratches, perhaps made with a wire brush, which imparts to the flesh a quivering vitality. The colour has darkened to a green or grey-brown in some parts, but when the metal was a bright yellow-brown it was covered with a warm golden lacquer varnish to preserve and enhance its natural colour, and this varnish, unusually, has survived in parts. Many varnishes on sixteenth-century and later European bronzes were a translucent red, through which the golden metal would shine, but in the hollows where the varnish was applied most thickly it has generally darkened, and in salient areas it has worn off, thus exposing the metal, which has itself darkened. Other colours were certainly appreciated: Vasari mentions green and black, obtained with oils, pickles and varnishes. The bronze sculptures in paintings of the period are either orange or green in colour.

Although many bronze sculptures of the fifteenth and sixteenth centuries were extensively tooled, a cast which needed no such attention was regarded as marvellous, and on occasion – in Germany as well as in Italy – sculptures were cast that seem to reproduce perfectly the qualities of a wax model. Most of Giambologna's bronzes cast in Florence towards the end of the sixteenth century were meticulously polished and finished, often by goldsmith-founders, but the bronze animals that he made for the Medici villa of Castello are very different, with all the textures of feather and fur reproduced from the wax. It has been suggested that their roughness was considered appropriate for the rustic setting of a grotto, but such an explanation could not be applied to the relief of the *Descent from the Cross* of about 1560 by another sculptor, at the Florentine court, Vincenzo Danti. The portions in lowest relief reproduce what is little more than drawing on a wax tablet – the lines, pushing the soft material aside with ease, at once fluent and nervous, are the very opposite in character to lines cut in metal (pls 213 and 214). Virtuoso casting of this type continued to be practised, and was revived in Naples in the late nineteenth century by the great Italian sculptor and founder Vincenzo Gemito, whose casts reproduce his own fingerprints in the wax. The reproduction of the texture of real flesh or real cloth and casts made from actual objects, such as shells or reptiles, are, of course, most effective if they are not tooled. Such

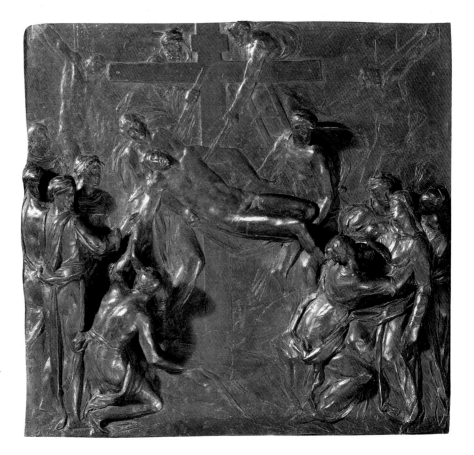

213 Vincenzo Danti,
Descent from the Cross,
copper alloy (probably
bronze), *c.*1560, 44.5 cm.
high, 47.1 cm. wide,
National Gallery of Art,
Washington, D.C.
(Widener Collection).
Lost-wax cast.

214 Detail of pl. 213.
The seam to the left was
probably caused by a slight
crack in the investment
mould. In the top left
corner the granular and
broken surface is minor
casting damage, and some
unintended extrusions also
seem to have been chiselled
off.

reproductions were often attempted. Nevertheless, the major tradition in European metal sculpture consists rather in casts that were tooled with exceptional care.

If a sculpture is complex in form and is cast in one piece, it is obviously difficult to tool. Had the bronze Juno seated on the clouds, holding her sceptre in one hand and resting the other on a peacock – a group probably invented by the Florentine sculptor Giuseppe Piamontini in the late seventeenth or early eighteenth century – been cast in one piece, it would have been exceedingly difficult to work the areas under her left arm and behind her left heel with files, chisels and abrasives (pls 215 and 216). In fact, the sculpture was cast in numerous pieces and assembled after much of the tooling was complete. The bare portions of both arms were cast separately, the join in one case corresponding with the drapery, in the other just beneath it. Most of the lower part of the body was cast with the clouds, but not the lower part of the goddess's right foot, which again must have been a separate cast, although no join is apparent. The Florentine founders responsible for this work were particularly ingenious at piecing casts and were skilled in the tooling of bronze. The use of the punch in the hair, plumage and clouds, with a

248

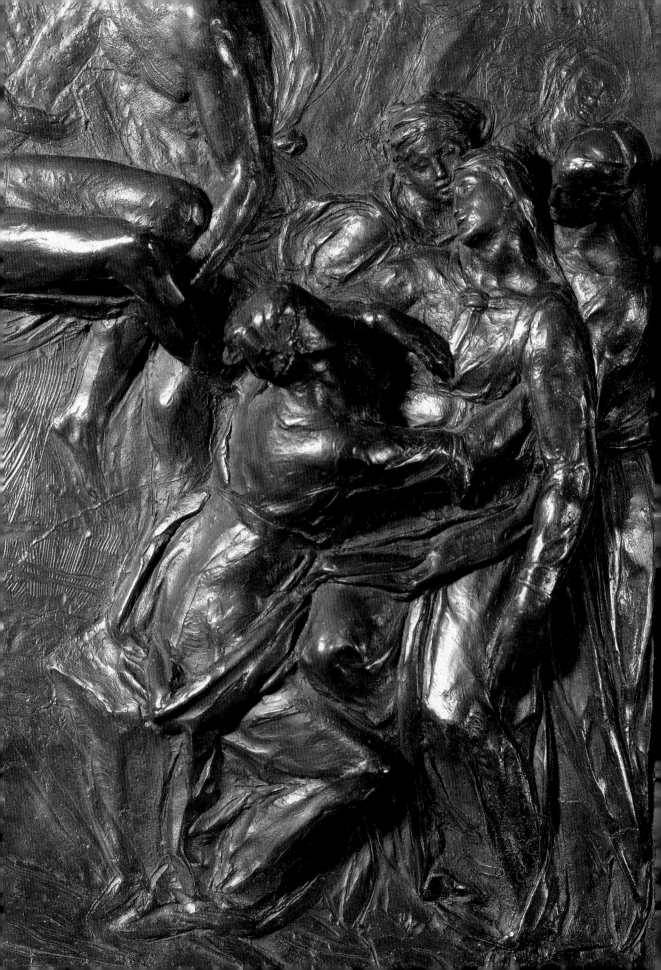

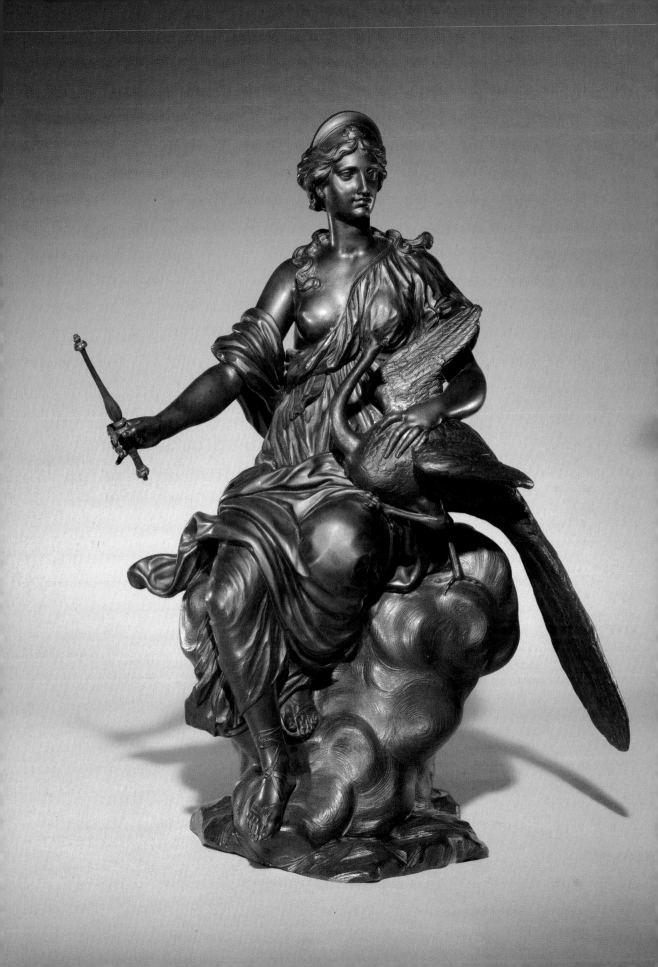

215 (left) Probably
Giuseppe Piamontini,
andiron ornament of Juno
enthroned among clouds,
copper alloy (probably
bronze), *c.*1700–20,
46.5 cm. high, Ashmolean
Museum, Oxford. Hollow
lost-wax cast in several
parts and joined.
Companion for a Jupiter.

216 (right) Detail of pl.
215. Enlarged to show
work with matting tools,
punches, and ciselets, also
the translucent red varnish.
Both neck and tail of the
peacock are joined. The
arm is cast, separately from
the body but together with
much of the peacock.

different effect in each case, is particularly noteworthy here. Such textures on the bronze, as well as the polish and colour – now a rich chestnut brown but originally, no doubt, more golden – would have been calculated with its original situation in mind, as the ornament for an andiron (companion with a Jupiter) in the grate of a palace fireplace, and thus intermittently lit by a wood fire.

Historians of European sculpture almost always assume that sculptors were responsible for the casting and finishing of their models, but the evidence, when it exists, suggests that the casting was rarely performed by the modeller – even if it was done under his direction (as was the case with Ghiberti) – nor, often, were the finishing and the gilding. One sculptor who was involved in all these processes was Benvenuto Cellini. No reader of his vivid autobiography will fail to recognize that he was an unusual artist, but it is all too easily assumed that the range of his activities was not as exceptional as it was. In eighteenth-century France the different skills involved in this type of sculpture were clearly demarcated, and the separate functions of *fondeurs*, *ciseleurs*, and *doreurs* were protected by the guilds.

Throughout the eighteenth century the finest French furniture was ornamented not with carvings in the wood but with gilt mounts of bronze or, more commonly, brass. Handles, masks, keyhole escutcheons, feet – all exquisitely textured, fire-gilt and burnished – were combined with glossy lacquers or figured veneers of exotic tortoise shell, kingwood, tulipwood, rosewood, satinwood. Gilt metal was also combined with vases of porcelain, hardstones and marble, not merely supporting the feet but embracing the bodies, as in the pure white Carrara marble vases made in the 1760s which have fine mounts almost certainly worked by Pierre Gouthière (pls 217 and 218). The masks were cast separately and fixed tightly on top of the swags

217 Detail of pl. 218, the mask 8.5 cm. from chin to crown. Enlarged to show punching and scraping.

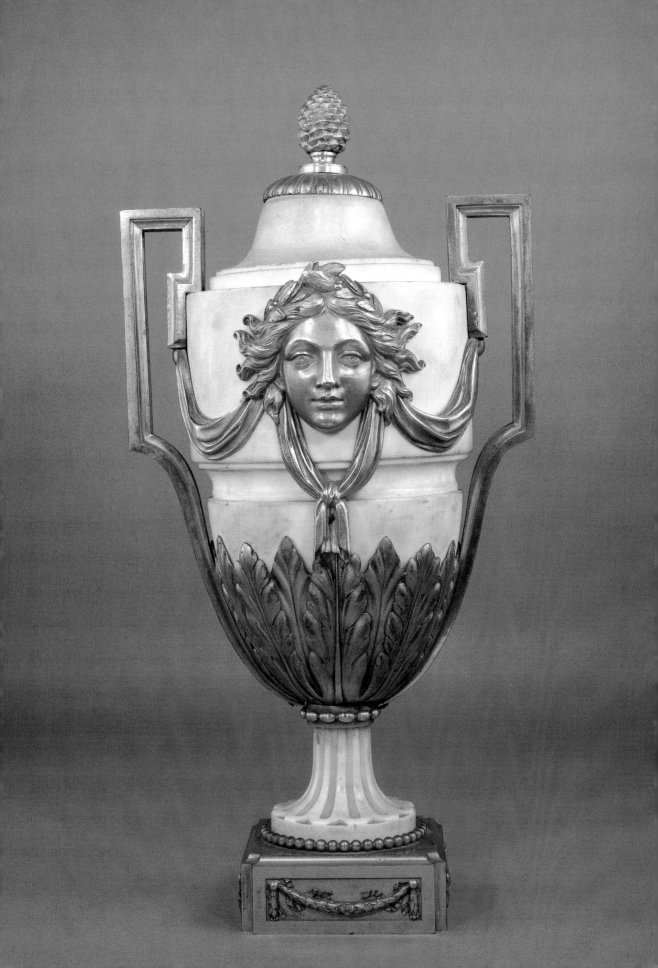

which link them with the angular handles and with the leaves below. These mounts may have been cast, not by the lost-wax process, but in moulds of fine and densely packed sand. In the eighteenth century this method became increasingly common for bronze and brass, and in the nineteenth century the most common method of all. Only relatively simple forms can be made with a sand cast, hence this method encouraged assemblies such as were favoured, as we have already seen, for Florentine sculpture (cast, however, by the lost-wax process). Parisian craftsmen in the eighteenth and nineteenth centuries emulated the superlative skills of the earlier Florentine workshops in both concealing joins and tooling metal. Indeed, extensive tooling was essential, because a sand-cast bronze has a dull surface. The miniature texture of the leaves, in Gouthière's work, the varied rippling of their edges, the silky flesh of the radiant faces enhanced by almost imperceptible hatching, the softness and flow of the hair blown back into flame-like points, reflect laborious work with *ciseaux*, *ciselets* and punches.

Such tooling was, of course, less laborious when the metal was soft, and some of the most exquisite and expressive tooling of metal sculpture is to be seen on the lead statues made in the eighteenth century by Georg Raphael Donner, Franz Xavier Messerschmidt and Johann Baptist Hagenauer in Austria (which had some of the largest lead mines in Europe). Elsewhere in Europe in the eighteenth century lead was also employed, but usually as a cheap substitute for bronze, in locations where the difference could not easily be discerned or was felt not to matter – statues for the skylines of great houses or for their gardens. Lead has been employed at least since the sixteenth century for fine medals, but only in Austria, it seems, was the sombre beauty of the metal widely appreciated for its own sake. Lead employed for sculpture generally contained a high percentage of tin (often between twenty-five and thirty per cent) and a certain amount of antimony, copper or zinc to improve its strength. Lead alloys were easily made and there were many attempts to improve them throughout the eighteenth and nineteenth centuries.

During the first half of the nineteenth century there were numerous experiments with the action of electrolysis on metals, and by 1840 a process of electrodeposit was patented in both Britain and France. The chief commercial consequence of this was that tableware could be made of base metal plated with silver, but it also meant that gilding could be achieved without the hazards of mercury fumes – indeed, the pursuit of an alternative to fire gilding had been a major stimulant to the experiments. Casting was revolutionized with the discovery of the electrotype, or 'galvanoplastic', whereby a cast could be coated or a mould lined with copper (gold or silver) within a plating vat.

In some foundries, above all the Royal Iron Foundry of Berlin, iron was sand-cast with a precision which made possible the making of statuettes which are easily mistaken for bronze ones. Zinc (or spelter) also became popular as a substitute for bronze in ornamental statuettes, its blue-grey colour concealed by varnishes. Aluminium, first available towards the end of

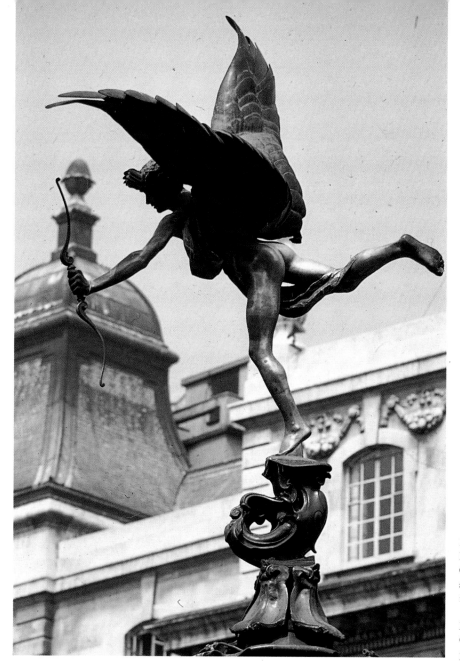

219 Foundry of George Broad and Sons, Alfred Gilbert, *Eros*, aluminium and bronze, 1886–93, figure height approx. 188 cm. The Shaftesbury Memorial, Piccadilly Circus, London. Hollow, probably sand cast.

the nineteenth century, was also used to cast some fine sculpture, notably the flying *Eros* by Alfred Gilbert in Piccadilly Circus (pl. 219), its dark silvery grey contrasting with the golden brown of the fountain basin and the lustrous greens of the writhing fish and playful children lodged within the swelling and contracting mouldings of the bronze fountain stem upon which it perches. In the twentieth century, however, few of the innovations of the nineteenth century have had much following. Cast-metal sculpture has generally been of bronze, and the method of casting has been that of lost wax.

18 Embossed and Chased Metal

GOLD AND SILVER, often found together in the form of electrum, are the most precious of all metals – gold generally regarded as the more precious because of its incorruptibility. They are precious on account of not only their beauty and rarity but their extraordinary ductility and malleability. Pure gold and silver are too soft to be used for sculptural purposes and must be alloyed with other metals, generally copper. In this form they can be cast, exactly as copper or copper alloys are, into solid or hollow sculpture. However, it has always been a temptation to melt such sculptures down, and therefore few have survived.

Consideration of the high value of gold and silver and their softness prompted an alternative to casting. A sheet of gold or silver can be embossed, that is, hammered from behind (repoussé), to form a relief – a method well illustrated by a gold cup decorated with gazelles, made in north-west Iran in about 1000 BC (pls 221 and 222). A gold sheet was laboriously hammered, probably over a lump of pitch, to form the cup. Then, from the inside of the cup the bodies of the gazelles were hammered out into low relief. The heads in high relief, were separately worked, however, and soldered to the bodies. Soldering entails the joining of two metals by means of another with a lower melting-point, and when working with silver or gold this metal will simply be a different alloy of one or the other, indistinguishable in colour. Previous to the soldering of the heads to the bodies, ears and horns had been soldered to the heads. The metal was not only worked in reverse from behind: all the fine details of fur and features were chased from the front, as was the guilloche, or interlaced ornament, just below the rim.

In the process of chasing, as distinct from engraving, there is no loss of metal, for it is indented rather than cut. The French distinguish between *ciseaux* – cutting-tools such as chisels and burins – hammered or pushed at an angle into the metal, and *ciselets* – blunter instruments used for indenting, some of which are known in English as tracers, generally struck perpendicularly into the metal. Both were mentioned in the last chapter, in connection with the work of Gouthière, but chisels are more important for work in bronze than *ciselets*, and the conventional description of tooled bronzes as 'chased' is misleading.

Some of the most beautiful surviving examples of ancient craftmanship in precious metal are the ceremonial drinking horns, or *rhytons*, made in the ancient Near East, in the Hellenistic kingdoms of Asia Minor and in the

220 Detail of pl. 226.

257

221 North-western Iranian, cup adorned with four gazelles, gold, *c.*1000 BC, 6.3 cm. high, 8.5 cm. diameter at rim, Metropolitan Museum of Art, New York (Rogers Fund, 1962). Repoussé with soldering.

222 View of the cup in plate 221 from the opposite side and a higher point.

223 Iranian, *rhyton* in the form of a running stag, silver gilt, *c.*50 BC–*c.*AD 50, 46 cm. long, 12.7 cm. diameter at the rim, J. Paul Getty Museum, Malibu. Solid lost-wax cast, extremities soldered to a repoussé body.

kingdoms of the Seleucid and Parthian rulers. Wine poured into the open rim of the horn would have issued as a fine stream through a spout at the end. The gilt-silver *rhyton* illustrated here, engraved in Aramaic with a dedication to Artemis, the goddess of the hunt, is thought to have been made some time between 50 BC and AD 50 (pl. 223). The end of the horn takes the form of a running stag whose terrified, wide-open eyes are inset with glass paste. From the spout between the forelegs red wine would have poured out, like blood

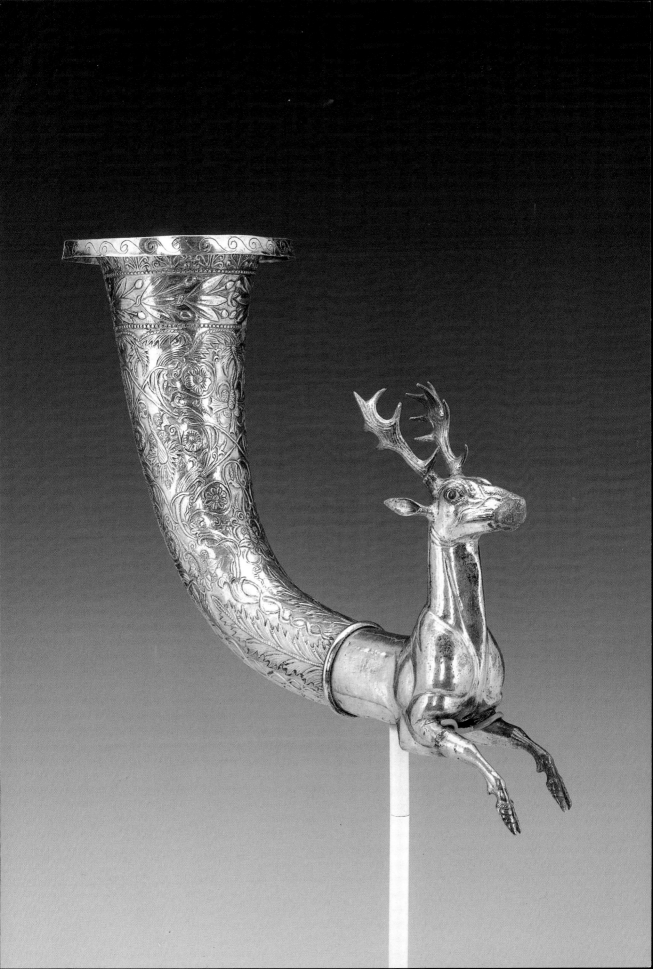

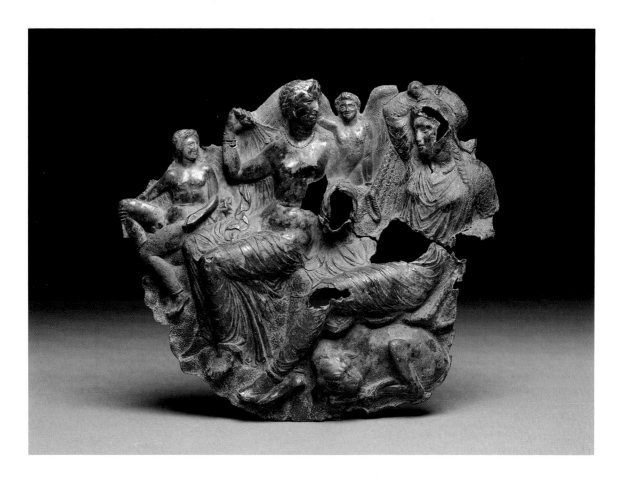

224 Greek, mirror back, furniture ornament or votive plaque decorated with an unknown subject, copper alloy, c.200 BC, 15.2 cm. high, British Museum, London. Repoussé, the soldered extremities missing.

spurting from a wound. The stag's six extremities (antlers, ears and legs) were solid cast in silver and soldered on. The principal portion of the horn and the body of the stag were formed by raising and repoussé, while the fine ornament of acanthus and olive and honeysuckle, as well as the veins on the snout and the wrinkles in the antlers, were chased. The difficulty in work of this sort is to achieve an impression of ease and fluency in lines that are fashioned so laboriously, but here the difficulty is not apparent.

Copper, and the softer copper alloys, can also be embossed, and a fragmentary relief, perhaps of Venus on Mount Ida with her earthly lover Anchises, originally part of a mirror back and made in Hellenistic Asia Minor in about 200 BC, illustrates the busy patterns and dense textures – and the uncertainty of plane – that are associated with this technique (pls 224 and 225). The figures are contrasted with a punched background, and different punches, including a bird's-eye punch, have been used to indicate the patterns of the silk fabrics. Some of the finest lines – most notably those on the wings – were probably engraved rather than chased. The most remarkable feature, from a technical and artistic point of view, is the drapery with its minute folds, and it is here that it is most difficult to assess what is due to work from behind and what to work from the front, which is always the case with the finest embossed work. Whereas the ancient Egyptians and, later, Byzantine

260

craftsmen were content with low relief, it was typical of Greek and Hellenistic sculptors to attempt some elements in high relief, as here, with the left hands of Venus and Paris which, having no doubt been soldered, have broken off.

Sculpture made of sheet metal can also be fashioned in the round. Sometimes it was beaten over and pinned to a core of pitch or wood. Sometimes it was simply assembled out of separate embossed elements, not uncommonly with some small cast elements attached. The silver and silver-gilt statuette, nearly two feet in height, of Saint Christopher carrying the infant Christ (pls 220 and 226), with a slot in the plinth for the preservation and exhibition (behind a crystal window) of a relic, was made in about 1400 in Toulouse (the marks of the city are stamped into base and cloak), at a time when few metal sculptures of that size were being cast (and casting – even hollow casting – such a statuette in silver would have been immensely costly). The drapery,

225 Detail of pl. 224. Enlarged to show minute chasing.

261

227 J.F. Canzler, reliquary bust of Saint Joseph, silver partially gilt, 1768, the figure is the size of life (made after a wooden model attributed to Ignaz Günther), Bürgersaal, Munich. Hollow, lost-wax cast, head and hands rivetted to repoussé drapery.

which is thin and has deep but narrow hollows, looks stiff, indeed metallic, which, of course, it is. The legs resemble boots and are, naturally, hollow. The figure seems dislocated, as if there were no torso beneath the drapery – and, indeed, there isn't. The sculpture, for all its charm, has neither the solidity nor the coherence nor the subtlety of modelling that we would expect in contemporary carved sculpture in wood or stone, but whether such a judgement was likely to have been made in 1400 we may doubt, for the importance attached to the material, in this case precious silver, probably outweighed the evident limitations implicit in this method of manipulating it.

Much European silver sculpture made in more recent centuries has a similar thinness, but sometimes this is confined to the drapery, which is arranged in brittle folds and contrasted with cast silver for the flesh, as in the bust made in Munich in 1768 of Saint Joseph rapturously contemplating the miraculously flowering lily that he holds with tremulous hands (pl. 227). The goldsmith Joseph Friedrich Canzlers made this bust using a carved wooden model (perhaps the work of Ignaz Günther). Even here, however, the sculpture loses coherence by the evidence of its assembly: the rivets in the collar are apparent and the embossed ornaments are obviously attached to the frame from which they should look as if they grow.

226 French (Toulouse), reliquary statuette of Saint Christopher, silver partially gilt, c.1400, 60 cm. high, Metropolitan Museum of Art, New York (gift of J. Pierpont Morgan, 1917). Repoussé, assembled from separately worked parts.

263

228 Nepalese, *White Tārā*, copper fire gilt, set with semi-precious stones, *c*.1750, 54.6 cm. high, Asian Art Museum, Avery Brundage Collection, San Francisco. Repoussé with hollow lost-wax cast hands.

229 Tibetan (Central Regions), *White Tārā*, silver, gilt in part, set with semi-precious stones, seventeenth century, 17.1 cm. high, Asia Society, New York, Mr. and Mrs. John D. Rockefeller 3rd Collection. Heavy-walled, hollow lost-wax cast.

At approximately the same date that the silver bust of Saint Joseph was made in Munich, the figure illustrated here (pl. 228) was made in Nepal out of repoussé copper – fire-gilded and set with jewels. It represents the White Tārā, one of the most popular manifestations of this female Boddhisattva, a 'saviour' who brings peace and prosperity, health and longevity. She has eyes in her palms and forehead, to detect the suffering in all corners of the world, and with her right hand she makes the gesture with which prayers are answered, whilst holding in the other the white lotus with one bud, one full bloom and one closed flower (for the Buddhas of the Past, the Present and the Future) – an attribute that is now missing.

The creation of such repoussé metal figures entirely in the round was a technical achievement apparently perfected by Nepalese metalworkers in the seventeenth century. The body was divided into units – head, torso, upper arm, lower arm, legs and lotus base – each of which were made in two parts and then welded together. The joins between these units were more difficult to achieve because they could not be fixed by reaching inside the hollow metal. A system of lap joints were thus devised which were fixed with rivets – conspicuous in this case at the joins between arms and torso. Elsewhere the rivets are concealed by jewelery. The hands, on account of their complex form, seem always to have been cast rather than repoussé. Over a dozen separate pieces of hammered metal would often serve to make such a figure – many more when the bracelets, necklaces, crown and other adjuncts are counted. The method of assembly is in some respects similar to that of moulded ceramics.

The figure of White Tārā is not large, but part of the appeal of this technique, in Tibet and Mongolia as well as Nepal, was the relative ease with which large items of metal sculpture could be constructed in repoussé brass. Sculpture as large, or larger, than life had rarely if ever been cast in metal in these regions. Metal cladding had, in fact, long been used for large sculptures in other civilizations but generally over a core of pitch or wood, as with some of the great lions of ancient Assyria or some of the tomb effigies of medieval Europe. Moreover, the most famous colossal statue of modern times, the great *Liberty* by Bartholdi which greets all who arrive at New York harbour, gateway to the New World, is made of huge sheets of copper wrapped around an iron scaffold. The index finger alone is eight feet long. By 1886 when this was completed, 'ironclads' steamed by beneath it, and, before long, metal-cased vehicles were common on land and in air as well.

It is instructive to compare the *White Tārā* of repoussé copper with a statue of the same subject cast in silver by the lost-wax method probably at a slightly earlier date in the central regions of Tibet (pl. 229). In this statue the thick metal has been engraved, not only to outline lips and eyelids, the creases of fingers and the floral pattern of the drapery, but to emphasize the raised sashes, necklaces, bracelets and cords, fire-gilt and set with turquoises, rubies and jade which so enhance our sense of the softness and solidity of the

body that they clasp. By comparison, the accessories of the repoussé *Tārā* seem flat, and the simplified rotundities of her body, with its cylindrical arms, hemispherical breasts and balloon face, reflect the fact that it was hammered out in the same manner as jugs and basins. In this case, however, as with the finest suits of plate armour or with the mote stylish motorcars, there is a unity and controlled energy – a tautness – in the smooth surfaces.

The metal of the *White Tārā* is beaten thin, more thin than the wall of a cast figure would be, but it does not look weak like foil, as does the silver used for the Saint Christopher reliquary figure or the drapery of the Saint Joseph. The inevitable thinness of most sculpture of embossed or stamped metal is also characteristic of much of the hand-made European coinage before the introduction of mechanized minting machinery in the sixteenth century, but this was not true of the earliest coinage in the European tradition, that of ancient Greek city-states, which retained the look and feel of the nugget of precious metal – the form of money from which such coinage evolved.

The silver tetradrachm, that is, the four-drachma piece, weighing approximately seventeen grammes, was a standard coin throughout the Greek world and represented, it seems, an average weekly wage for many citizens. The example illustrated here (pls 230a and b) was minted in the proud and wealthy Greek city of Syracuse in Sicily in about 415 BC – the year in which it triumphantly defeated an Athenian invasion. To make such a coin, a blank of silver of the correct weight was heated and placed upon a die set in an anvil and then stuck with an upper die, or trussel. Both dies would be made of tough bronze or (as we know to have been the case at Syracuse) of iron. The head of the nymph Arethusa, sacred to the city, was on the upper die, and an imperfect ring of metal was formed where the blank bulged upwards at the edges of the die as it was hammered down. This raised edge and the inevitable irregularity of a coin made in this manner stimulate awareness of the process of its creation and of the moment when hard metal struck soft.

The designs were engraved in the hard metal of the dies, but only occasionally is the difficulty of such work apparent – in this particular case, only in the lettering. Without any loss of immediate clarity and strength of

230a and b Euainetos,
silver tetradrachm of Greek
Syracuse, 415 BC,
17.29 gm., 2.7 cm.
diameter, British Museum,
London (Richard Payne
Knight bequest).
Enlarged.

design, the die engraver included minute details such as tiny dolphins adorning Arethusa's headband and the folds of the floating garment of Victory who flies to crown the charioteer on the reverse. The engraver also animated with incident what had been a conventional emblem, giving the furthest horse in the quadriga a broken rein to show that it is about to break loose. Much of the detail can be appreciated fully only under magnification, and it is only when such a coin is turned in the light that the thundering hooves of the horses and the coiling locks of the nymph seem almost bewilderingly in movement. That the gratifications of the connoisseur were thus made available by the munificence of the city's tyrant to every citizen has always been marvelled at, and the prestige of the artist in this society is made clear from the fact that his name is written on the tablet carried aloft by Victory and also inscribed minutely on the flank of a dolphin by the head of Arethusa, whereas the name of his patron is not recorded on the coin.

When we examine a bronze statuette we need to think of two materials — the soft material out of which the model was made and the hard material in which it has been cast and tooled. So, likewise, in looking at this coin we are aware of two materials, the relatively soft silver and the engraved dies that have left their impression upon it. These dies were engraved in much the same way that seals were — with tiny wheels and drills working abrasives. Such seals were engraved on stones that were often harder than bronze or iron: thus behind the whole tradition of the European metal coin there lies that of the seal in the early civilizations of the eastern Mediterranean, Mesopotamia and Egypt, and the methods of working with the hardest stones early perfected in the ancient world and discussed in the first chapter of this book.

Conclusion

IN THE COURSE OF THIS SURVEY the doctrine of 'Truth to Material' has been mentioned several times. It was eloquently expounded by John Ruskin and other advocates of the merits of medieval architecture in the middle of the nineteenth century, later elaborated by the crafts revival in Britain, and then adopted by avant-garde sculptors all over Europe after the First World War. Architects ceased to favour uniform monochrome ashlar preferring walls that exhibited the contrasting colours and textures of the stones of which they were composed; craftsmen replaced cast iron with wrought iron – that is, iron twisted, beaten, cut and curled at the forge – for gates and railings, and, rather than smoothing the surfaces of raised silver or embossed copper, preserved the little dents left by the hammer; and sculptors working in stone retained in their compositions the massy character of the quarried block and even deferred to – or mimicked – the shapes and finish of rugged boulders or smooth pebbles.

The doctrine of 'Truth to Material' did much to encourage appreciation of Romanesque stone carving and African woodcarving which had been ignored or dismissed as barbaric or primitive. But it also inhibited recognition of the evidence that ancient sculptures had been painted and gilded, and licensed the stripping of medieval carvings to reveal bare oak or stone. It promoted – indeed still promotes – appreciation of the qualities that are peculiar to the various materials employed. But it has hindered acknowledgement of the many great achievements in sculpture that have sprung from a determination to transcend the limitations, or even to disguise the identity, of the material employed. And it has discouraged awareness of the fact that the creation of much great sculpture was not guided by the idea that the method or the material should be revealed.

Those who believe that a work of art must display the essential properties of its material are likely to distrust versatile materials such as marble or limewood, and are still more likely to be embarrassed by casting, which frequently involves the reproduction in one material of a model made in another. And certainly, when the cast is an imitation of something that was carved or modelled, it is likely to look shoddy or, if well done, to seem a cheat. However, the survival in Chinese earthenware tomb animals or in Nymphenburg porcelain figurines of the style of woodcarving employed for the models from which they were moulded cannot offend in this way. And the comparison that the makers of porcelain figures in both southern China and

southern Germany sometimes invited between their work and that of ivory carvers in fact stimulates awareness of the differences as well as the similarities between these materials. Moreover, a translation from one material into another can seem marvellous, and it is easy to believe that the replication in hard metal of a model in wax must once have seemed magical.

Cast metal is not the only hard material that can recall a soft one. The craftsmen who carved Byzantine marble screens and capitals or late medieval tracery and pinnacles were attracted by the technical and imaginative challenge of making stone appear to resemble a pliable or malleable substance. When the carver was following a model in clay or wax, the imitation of a soft material – flesh, hair, fabric – was, of course, encouraged. And it is striking that the periods of the most remarkable innovations in sculpture – sixth- and fifth-century Greece and fifteenth-century Florence – were ones in which sculptors worked in more than one material. They were also periods in which techniques of modelling, carving and casting were all developing in response to each other. In transcending the limitations or extending the possibilities of one material, the sculptor has sought to emulate, if not imitate, effects familiar, or at least more easily achieved, in another – a process frequently described in this book. Perhaps the greatest sculpture has been created by artists thinking not only about the materials they were employing, but about those which they were not employing.

Notes

SOME OF THESE NOTES will help readers to find more general literature on the works of art discussed. Others will be of interest only to specialists. They are arranged in the order in which topics are discussed in each chapter and there is a reference for every sculpture discussed in any detail.

A preliminary note is required concerning *La Sculpture: Méthode et Vocabulaire*, 'réalisé par M.-T. Baudry', with the collaboration of D. Bozo, under the editorial supervision of A. Chastel and J. Thirion and published in 1978 by the French Ministère de la Culture, which is of special value for its detailed and well-illustrated accounts of complicated processes, such as the use of the pointing machine, the making of piece moulds, and the methods of sand casting. On many matters of technique it supplies much more information than is provided here. However, its approach is different, and so is its scope: the sculpture discussed is all European (and, when not actually French, is preserved in French museums). It is abbreviated as *La Sculpture* in the notes that follow.

On numerous occasions in these notes reference is made to the introduction to materials and techniques that Vasari placed at the start of his *Le Vite de' più eccellenti pittori, scultori ed architettori*. These references are both to the nineteenth-century edition by G. Milanesi, reprinted in Florence, 1981, and to the admirable translation of this part of Vasari by L.S. Maclehose, published as *Vasari on Technique*, London 1907 (reprinted New York 1960), which has useful notes and commentary by G. Baldwin Brown.

With these exceptions, abbreviations have been avoided and the use of *op. cit.* is confined to works referred to within the notes for a single chapter.

Introduction

For jet, see H. Muller, *Jet Jewellery and Ornaments* (Shire Album No. 54), Aylesbury 1991 (1980); H. Muller, *Jet*, London 1987.

The jet group of Saint James the Greater with a pilgrim is catalogued in N.B. Penny, *Catalogue of European Sculpture in the Ashmolean Museum, 1540 to the Present Day*, 3 vols, Oxford 1992, II, pp. 160–1, no. 368.

An excellent account of how marble was obtained from the Polvaccio quarries at Carrara during the seventeenth century is provided in J. Montagu, *Roman Baroque Sculpture: The Industry of Art*, New Haven and London 1989, pp. 23–9. Much information on quarry technology may also be obtained from L. and T. Mannoni, *Il Marmo – Materia e cultura*, Genoa 1985. See especially pp. 108–33, for transporting blocks down the mountainside.

1 The Hardest Stones

For the working of jade, see S.H. Hansford, *Chinese Jade Carving*, London 1950, and *idem*, *Chinese Jades*, London 1968 (the latter does not replace the former); also C. Hardinge, *Jade: Fact and Fable*, London 1961. A recent brief introduction is J. Hartman-Goldsmith, *Chinese Jade*, Oxford 1986.

The jade pendant is catalogued in *Chinese Art of the Warring States Period*, Freer Gallery of Art, Smithsonian Institution, Washington, D.C., 1982, no. 90.

The jade horse discussed here has sometimes been suspected as a forgery, but see *Fake? The Art of Deception*, catalogue of the exhibition at the British Museum, London, 1990, p. 34, no. 5.

For the jade mask from Mexico, see *Palazzo Vecchio: Committenza e collezionismo Medicei*, catalogue of the exhibition at Palazzo Pitti, Florence, 1980, p. 170, no. 314.

The jade goose is catalogued by T. Lawton in *Asian Art in the Arthur M. Sackler Gallery: The Inaugural Gift*, Smithsonian Institution, Washington, D.C., 1987, p. 123, no. 78.

The jade cup of Shah Jahan is fully discussed by R. Skelton in *The Shah Jahan Cup*, London 1969 (reprinted from *The Bulletin of the Victoria and Albert Museum*, II, no. 3, 1966).

For the rock-crystal vessel, see *L'Arte di Corte nella Firenze dei Granduchi*, catalogue of the exhibition at Palazzo Pitti, Florence, 1988–9, pp. 78–9, no. 3.

For gemstones, see H.M. Westropp, *A Manual of Precious Stones and Antique Gems*, London 1874. Westropp discusses the distinction between sardonyx and onyx on pp. 94–104 and chalcedony on pp. 106–8. See also G.F. Herbert Smith, *Gemstones*, 10th (revised) edition, 1950, pp. 401–2 (for chalcedony), 402–3 (for agate, sardonyx and onyx).

For the chalcedony seal of a standing heron, see G.M.A. Richter, *Engraved Gems of the Greeks, Etruscans and Romans*, London 1968, no. 466, and M. Robertson, *A History of Greek Art*, 2 vols, Cambridge 1975, I, pp. 344 and 362. The design is similar to the work signed by Dexamanos, but the technique much less so.

For the cameos carved with a dancing satyr and centaur, see *Il Tesoro di Lorenzo il Magnifico*, I (*Le Gemme*), catalogue of the exhibition held at Palazzo Medici, Florence, 1972, p. 46, no. 9 and pp. 62–3, no. 35 (entries by A. Giuliano).

The work of Tommaso Saulini is surveyed by M. Carr in an article on him and his son Luigi in *Connoisseur*, November 1975, pp. 171–3. The shell cameo by Saulini is catalogued in H. Tait (ed.), *The Art of the Jeweller. A Catalogue of the Hull Grundy Gift to the British Museum: Jewellery, Engraved Gems and Goldsmith's work*, London 1984, no. 912 (the subject is identified in error as *Aurora*). The shells most commonly employed for cameos are those of univalve shell molluscs: the *Cassidae* – *Cassis rufa* (commonly known as Bull's Mouth or Bulmouth) – seems to have been especially favoured; also the Black Helmet, Yellow Helmet and Queen's Conch. There is little of value published on shell cameos generally, but see O.E. Paget, 'Mollusken im Gebrauch der Völker', *Jahrbuch der Kunsthistorischen Sammlungen in Wien*, LXXVIII, 1981, pp. 155–62. For the shell cameos of the Renaissance, see M.C. Guadagni, *Cammei in conchiglia del Rinascimento* (*Lo Specchio del Bargello*, no. 46), Florence 1988, and, above all, M.A. McCrory, 'Renaissance shell cameos from the Carrand Collection of the Museo Nazionale del Bargello', *Burlington Magazine*, June 1988, pp. 412–26. For the carving of shells (with gravers and burins etc.), see L.B. Thompson, 'On the Working of Shell Cameos', *Art Journal*, 1898, pp. 277–80; also the set of demonstration pieces by James Ronca of 1874 in the Victoria and Albert Museum, London.

The small glass cameo fragment from Dunbarton Oaks is catalogued in G.M.A. Richter, *Catalogue of Greek and Roman antiquities in the Dunbarton Oaks Collection*, Cambridge (Mass.) 1956, p. 65, no. 45. A recent study of cameo glass in ancient Rome will be found in D. Harden, *Glass of the Caesars*, catalogue of the exhibition at the Corning Museum of Glass, the British Museum and the Römisch-Germanisches Museum, Cologne, 1987, pp. 53–7, preceding catalogue entries for the most celebrated examples of cased glass: the panels and amphora in the Archaeological Museum in Naples, the Morgan Cup, the Getty Cup and Bottle and the Portland Vase. This should be supplemented by D. Whitehouse, 'Cameo glass', in M. Newby and K. Painter (eds), *Roman Glass: Two Centuries of Art and Invention*, London 1988, pp. 19–32.

For Northwood and other carvers of cased glass, see G.W. Beard, *Nineteenth-Century Cameo Glass*, Newport (Monmouth) 1956. For Solon, see G. Godden, *Victorian Porcelain*, London 1970, and for him and his rivals, see *Pâte-sur-Pâte: The Art of Ceramic Relief Decoration 1849–1992*, London 1992.

2 Granite and Porphyry

For the methods of cutting and polishing hard rocks in ancient Egypt, see A. Lucas, *Ancient Egyptian Materials and Industries* (1926), revised and enlarged edition by J.R. Harris, London 1989, pp. 65–74 (also pp. 57–9, 407–12, 416–19 for the rocks themselves), and A. Zuber, 'Techniques du travail des pierres dures dans l'ancienne Egypt', *Techniques et Civilisations*, V, 1956, pp. 161–80. Zuber's article is distinguished not only by a careful examination both of Egyptian paintings and of the actual sculptures but also by practical experiments of his own. For quarrying, see the same article, pp. 195–215.

For the seated statue of Amenhotep III from Thebes, see E.A. Wallis Budge, *Egyptian Sculpture in the British Museum*, London 1914, pl. XXII; also T.G.H. James and W.V. Davies, *Egyptian Sculpture*, Cambridge (Mass.) 1983, p. 18, fig. 16, and for a discussion of royal and divine statuary under Amenhotep, the entry by B.M. Bryan, chapter 5 in A.P. Kozloff and B.M. Bryan, *Egypt's Dazzling Sun: Amenhotep and his World*, catalogue of the exhibition at the Cleveland Museum of Art and elsewhere, 1982–3, pp. 125–53.

The granite lion is discussed, with its pair (of inferior condition) in I.E.S. Edwards, 'The Prudhoe Lions', *Athens Annals of Archaeology*, XXVI, 1939, pp. 3–9. See also the entry by B.M. Bryan in *Egypt's Dazzling Sun* (cited above), pp. 219–20, no. 30.

The granodiorite head of Amenhotep III is catalogued by B.M. Bryan in *ibid.*, pp. 164–5, no. 10. See also the entry for the head in Cleveland, which retains pigmented resin (*ibid.*, pp. 166–7, no. 11).

The hard rocks of southern India are fully described in R. Newman, *The Stone Sculpture of India: A Study of the Materials used by Indian Sculptors from the 2nd Century BC to the 16th Century*, Cambridge (Mass.) 1984.

The Nandī is catalogued in J.C. Harle and A. Topsfield, *Indian Art in the Ashmolean Museum*, Oxford 1987, pp. 52–3, no. 64. (entry by Harle). The material is there described as granite, but Andrew Topsfield kindly arranged for it to be inspected by Dr Keith Cox of the Department of Earth Sciences in the University of Oxford whose identification was made from a surface inspection. Prophyritic basalt (feldspar phenocrysts set in fine-grained ground mass) is discussed in Newman, *op. cit.*, p. 23.

The Sapta-Matrka is discussed by M.C. Beach in *Asian Art in the Arthur M. Sackler Gallery: The Inaugural Gift*, Smithsonian

Institution, Washington, D.C., 1987, p. 64, no. 28. It is there described as of granite. Greenstone is discussed on p. 29 of Newman, *op. cit.*, where this figure is fig. 11, p. 23. For the Hindu rock sculpture in Tamil Nadu and southern India, see J.C. Harle, *The Art and Architecture of the Indian Subcontinent*, Harmondsworth 1987, pp. 269–354 (this particular statue is discussed on p. 291), and also S.E. Lee, *A History of Far Eastern Art*, London 1988 (1964), pp. 178–88.

Daniel Chester French is the subject of a monographic catalogue, M. Richman, *Daniel Chester French: An American Sculptor*, serving as the catalogue for the exhibition at the Metropolitan Museum of Art, New York, and other locations, in 1977. The statues of Manhattan and Brooklyn are fully documented on pp. 143–50. For American granites, see J.C. Rich, *The Materials and Methods of Sculpture*, New York 1947, pp. 215–16.

The work of early twentieth-century Scandinavian sculptors in granite is the subject of a book by A. Brenna, *Form og Komposiðjon i nordisk granittskulptur 1909–1926* (Viegland Museum Bulletin), Oslo 1953. It includes a summary in English. Nielsen's Rasmussen statue is discussed on pp. 56–60, and his Blaagaardsplads groups on pp. 65–81. There is a splendid appreciation of Carl Milles's use of granite by Stanley Casson in his *XXth Century Sculptors*, Oxford 1930, pp. 32–4; the passage on Swedish hills and islands is taken from this. Milles employed basalt as well as granite. I am doubtful that a mineralogist would now describe the black stone employed by Nielsen as a granite, although it is always so described in literature on the artist.

The Alexandrian basanite head seems never to have been properly published. It is comparable in some respects with the basanite Mark Antony and the male head in diorite, both in the Brooklyn Museum and catalogued in the exhibition held there and elsewhere 1988–9, *Cleopatra's Egypt*, by R.S. Bianchi, pp. 139 and 192, nos 43 and 80. There is a full account of basanite in R. Gnoli, *Marmora Romana*, Rome 1971, pp. 87–93. I have been unable to discover how hard basanite is to carve. Stephen Cox, who has worked in the notoriously hard puddingstone, *breccia verde*, from the same mountain, does not consider the matrix of this material, as distinct from the fragments within it, to be especially hard: this matrix is clearly a close relative of basanite.

There is a full account of porphyry in Gnoli, *op. cit.*, pp. 98–118. An interesting recent discussion of the high relief groups – the so-called *Tetrachs* – of Saint Mark's is M. Cagiano de Azevedo, 'Nota sui "Tetrarchi di Venezia"', *Rendiconti della Pontificia Accademia Romana*, XXXIX, 1966–7, pp. 153–9.

The rediscovery of porphyry-cutting is discussed in detail in a forthcoming I Tatti monograph, *The Triumph of Vulcan*, by S.B. Butters. A succinct account of the rediscovery of the art of working porphyry and other hardstones in Florence is provided in A. Giusti, 'Origine e sviluppi della manifattura granducale', in *Splendori di pietre dure: l'arte di corte nella Firenze dei Granduchi*, catalogue of the exhibition at Palazzo Pitti, Florence, 1988–9, pp. 10–23. See also Vasari-Milanesi, I, pp. 108–13 (*Vasari on Technique*, pp. 26–34, 110–15). The inscription on the step of Santa Maria Novella is discussed in *Vasari on Technique*, pp. 30–1, and footnote.

The great porphyry vase in the National Gallery of Art in Washington was for years in store: it was put on display in 1991. It has never been properly published.

3 White Marbles and Alabasters: Part 1

The use of calcite 'alabaster' in ancient Egypt is discussed in A. Lucas, *Ancient Egyptian Materials and Industries* (1926), revised and enlarged by J.R. Harris, London 1989, p. 60.

The stopper for the canopic chest in the form of a bust portrait of Tutankhamun is catalogued by I.E.S. Edwards in *Treasures of Tutankhamun*, catalogue of the exhibition at the British Museum, London, 1972, no. 8.

For the Assyrian hunting reliefs, see J.E. Reade, *Assyrian Sculpture*, British Museum, London 1983, pp. 53–60. A fuller investigation of technique and style in these works is provided by the same author's 'Assyrian Architectural Decoration: techniques and subject matter' and 'Narrative Composition in Assyrian sculpture', *Baghdader Mitteilungen*, X, 1979, pp. 17–49, 52–110.

The Egyptian limestone pair statue is discussed briefly in C. Aldred, *New Kingdom Art*, London 1961, p. 93, no. 175.

A useful introduction to Cycladic art is J.L. Fitton, *Cycladic Art*, British Museum, London 1989.

A crucial discussion of the importance of iron for the Greek sculptor is provided by H.J. Etienne, *The Chisel in Greek Sculpture*, Leiden 1968. C. Blümel's *Griechische Bildhauer an der Arbeit*, Berlin 1927 (translated from the 1940 edition as *Greek Sculptors at Work* in 1955), was long the major text on the technique of Greek sculpture but has been largely supplanted by S. Adams, *The Technique of Greek Sculpture in the Archaic and Classical Periods*, London 1966.

The literature on the *Peplos Kore* is very large: there is a discussion of it in relation to sculpture of the same period in J. Boardman, *Greek Sculpture: The Archaic Period*, London (1978) 1991, pp. 63–81. The statue has thirty-five attachment holes in two rows encircling the head, some retaining lead pins. What exactly was attached is not certain. On the metal accessories in such sculpture, see B.S. Ridgeway, 'Metal attachments in Greek Marble Sculpture', in *Marble: Art Historical and Scientific Perspectives on Ancient Sculpture*,

papers from a symposium at the J. Paul Getty Museum, April 1988, Malibu 1990, pp. 185–206.

For the Erectheum, see L.D. Caskey, J.M. Paton and G.P. Stevens, *The Erectheum*, 2 vols, Cambridge (Mass.) 1927, especially I, pp. 84, 85, 89, 221–2. T.L. Donaldson's drawing of the glass beads was published in *Transactions of the Royal Institute of British Architects*, I, 2, 1842, p. 107. His note that the base of the columns was 'ornamented in the same manner' was incorrect. The beads cannot now be traced.

There is a full discussion of the evidence for the colouring of ancient Greek marble sculpture in P. Dimitriou, *The Polychromy of Greek Sculpture* (Ph.D. dissertation, Columbia University, New York, 1947), Ann Arbor 1989. See also the interesting recent discussion of the colouring of ancient Greek architectural sculpture in I.D. Jenkins and A.P. Middleton, 'Paint on the Parthenon Marbles', *The Annual of the British School of Archaeology at Athens*, LXXIII, 1988, pp. 183–207; also C. Gratziu, I.D. Jenkins, A.P. Middleton, 'Further research on surface treatments of architectural sculpture in London', in the proceedings of the symposium, *Superfici dell'Architettura: le Finiture*, Padua 1990, pp. 217–40. There is a fascinating account of the discovery of the extensive use of colouring in ancient Greek marble architecture (and its sculpture) and the debates concerning this in M.-F. Billot, 'Recherches aux XVIII^e et XIX^e siècles sur la polychromie de l'architecture grecque', in the catalogue of the exhibition *Paris-Rome-Athens* held in the Ecole Nationale Supérieure des Beaux-Arts in Paris, 1982, pp. 61–129. I.D. Jenkins, *Archaeologists and Aesthetes in the Sculpture Galleries of the British Museum 1800–1939*, London 1992, pp. 48 ff, supplies a valuable supplement to this.

A summary and assessment of the evidence concerning the sculptural innovations by Kallimachos is supplied in M. Roberston, *A History of Greek Art*, 2 vols, Cambridge 1975, I, pp. 405–7.

Jerry Podany, Conservator of Antiquities at the J. Paul Getty Museum, informs me (letter of 17 November 1992) that the acrolithic cult statue 'did in fact have traces of colour on the limestone segments: blue (identified as Egyptian blue), pink (identified as cinnabar mixed with calcium carbonate), and red. There were two reds identified, one was cinnabar and the other, a deeper red, was identified as hematite, both mixed with calcium carbonate . . . There was no indication of pattern since the pigment traces were extraordinarily small and dispersed. The colours were not found in immediate conjunction with one another and there was no evidence of a preparation layer.'

Greek acrolithic sculpture is discussed briefly in Robertson, *op. cit.*, I, pp. 202, 385.

The distinctions between the major types of white marble known to the ancient Greeks and Romans were established in

G.R. Lepsius, *Griechische Marmorstudien*, Berlin 1890, but have not generally been noted in museum labels (those in the Fitzwilliam Museum, Cambridge, are exceptions) or even in catalogues. These marbles are not easily illustrated in a helpful way, but see G. Borghini (ed.), *Marmi Antichi*, Rome 1992, pp. 247–53, nos 94–100 (entries by M.C. Marchei). Types of marble have recently become the subject of intense scientific research; see, for example, N. Herz, 'Stable Isotope analysis of Greek and Roman marble: provenance, association, and authenticity', and other contributions to the Getty Museum symposium papers cited above, pp. 101–22; also, P. Pensabene (ed.), *Marmi antichi, Problemi di impiego di restauro e di identificazione* (Studi Miscellanei, Rome 1985). A notable publication on the quarry technology and trade in marble under the Romans is J.C. Fant (ed.), *Ancient Marble Quarrying and Trade*, papers given at a colloquium at San Antonio, Texas, 1986, Oxford 1988. More generally, see J.B. Ward-Perkins, *Marble in Antiquity*, London 1992.

The orgin of marble quarrying at Luni is discussed in M. Franzini, 'I marmi da La Spezia a Pisa', in E. Castelnuovo (ed.), *Niveo de Marmore: l'uso artistico del Marmo di Carrara dall' XI al XV secolo*, catalogue of an exhibition at La Cittadella, Sarzana, 1992, p. 38. He observes that the earliest quarries were porbably at Punta Bianca, where there are visible outcrops on the coast. The earliest Roman monument certainly made of Carrara marble is the Ara Pacis of Augustus of 13-9 BC. In the early second century its popularity in Rome began to wane: see Ward-Perkins, *op. cit.*, pp. 21–2, no. 30.

The passage on the shadow stealing back from the column shafts of Saint Mark's comes from the remarkable evocation of the basilica's façade in the fourteenth paragraph of chapter 4 of volume 2 of Ruskin's *The Stones of Venice*, first published in 1853. Although Ruskin had a far greater knowledge of mineralogy and geology than most writers on architecture or sculpture, he nowhere identifies the type of marble to which he here refers. I suspect that he did not like to acknowledge to himself that the discovery of this material was owing to the pagan Romans. Elsewhere he specifically describes this marble as alabaster (*ibid.*, para. XXXVI). Proconnesos (Marmara) marble, with its undulating grey-blue bands, is often misdescribed today as *cipollino*, which is green and white – a few shafts of this also adorn the façade of Saint Mark's.

The streaked grey marble head in the Getty Museum, Malibu, has never been published. A date of AD 240–50 is now preferred by scholars, but other work of similar quality executed in this material at that date is hard to find, which perhaps explains why a date in the fifth century has also been seriously entertained.

For the great marble Buddha in the British Museum, see B. Gray and W. Watson, 'A great Sui Dynasty Amitābha', *British Museum Quarterly*, XVI, 1951–2, pp. 81–4. The

traces of colouring on the seated marble Buddha of 550–75 AD in the Victoria and Albert Museum (A. 36-1950) are given on a museum label.

Marble and stone Buddhist sculpture in China is discussed in relation with other arts in the fifth chapter of M. Tregear, *Chinese Art*, London 1987, pp. 70–89.

The Da-Li marble briefly mentioned in the text (sometimes referred to as Ta-Li marble) comes from Mount Diancang in Yunnan province. See W. Shixiang, *Connoisseurship of Chinese Furniture*, 2 vols, Hong Kong 1990, I, pp. 153–4.

4 White Marbles and Alabasters: Part 2

For the goddess Sarasvati, see P. Pal, *Indian Sculpture in the Los Angeles County Museum of Art*, II, Los Angeles 1988, pp. 142–3, no. 63. The catalogue entry does not mention the remains of colour, the existence of which has, however, been confirmed for me by Mr Pal. A figure very closely related in style to the Sarasvati has recently been acquired by the Virginia Museum of Fine Arts, Richmond. It may represent a donor and is 121.4 cm. high.

For the marble of India, see R. Newman, *The Stone Sculpture of India: A Study of the Materials used by Indian Sculptors from the 2nd Century BC to the 16th Century*, Cambridge (Mass.) 1984, pp. 45–53. The highly mannered marble carving of Mount Abu is discussed in J.C. Harle, *The Art and Architecture of the Indian Subcontinent*, Harmondsworth 1987, chapter 16, pp. 219–44, and in S.E. Lee, *A History of Far Eastern Art*, London 1988 (1964), pp. 213–14.

A general introduction to Mughal architecture in an Islamic context is provided in B. Brend, *Islamic Art*, London 1991, pp. 203–10; see also E. Koch, *Mughal Architecture*, Munich 1991. For a screen somewhat similar in character to the one illustrated here, see S.C. Welch, *India: Art and Culture 1300–1900*, catalogue of an exhibition at the Metropolitan Museum of Art, New York, 1986, pp. 250–1, no. 164.

The screen at Ravenna is illustrated in D. Talbot Rice, *Byzantine Art*, Harmondsworth 1968, p. 396, together with other examples. His chapter 9 (pp. 389 ff) provides a general discussion of Byzantine sculpture of this period.

The re-use of ancient Roman marble during the Middle Ages is discussed in C. Klapisch-Zuber, *Les Maîtres du Marbre: Carrare 1300–1600*, Paris (S.E.V.P.E.N.) 1969, pp. 23–32; in G.T. Grisant, 'Il reimpiego di marmi antichi a Pisa nell' XI secolo', in E. Castelnuovo (ed.), *Niveo de Marmore: l'uso artistico del Marmo di Carrara dall' XI al XV secolo*, catalogue of the exhibition at La Cittadella, Sarzana, 1992, pp. 76–8; and in A. Dagnino, '"Spoglia" e frammenti antichi', *ibid.*, pp. 92–5.

For the use of marble in medieval Pisa, Lucca and Siena, see *Niveo de Marmore*, cited above, *passim*; also F. Rodolico, *Le Pietre delle Città d'Italia*, Florence 1953, pp. 270–83, 287–92. For white marble and contrasting red and green stones used in Florence, see *ibid.*, pp. 246–7. The inscription regarding snow-white marble on the cathedral of Pisa – 'Non habet exemplum niveo de marmore templum' – is part of the epitaph of the architect Busketus (Buscheto) published by G. Scalia in 'Ancora intorno all'epigrafe sulla fondazione del duomo pisano', in *Studi in Onore di Giuseppe Ermini*, Spoleto 1970, pp. 513–19. The epitaph is also of interest for its reference to Buscheto's transportation of Roman monoliths of Elban granite.

For the history of the quarries at Carrara and its region, see Klapisch-Zuber, *op. cit.* See also the fourth chapter of L. and T. Mannoni, *Il marmo–materia e cultura*, Genoa 1985 (the translation of which, published without date in New York and Oxford, is inadequate), and M. Franzini, 'I Marmi da La Spezia a Pisa', in *Niveo de Marmore*, cited above, pp. 29–42. Franzini proposes that the white-marble quarries of Monti Pisani were in fact opened before those of Carrara in the early twelfth century (p. 40) and points out how hard it is to tell whether the medieval masons using Carrara marble were using blocks that had been newly quarried.

For the hexagonal reliefs on the bell-tower in Florence see M. Burresi (ed.), *Andrea, Nino e Tommaso scultori pisani*, catalogue of an exhibition at Pontedera, 1983, pp. 174–5 (entry by Maria Cataldi).

The white marbles of Milan, Bergamo and the neighbourhood are described in Rodolico, *op. cit.*, pp. 101–6, 134–41.

Giovanni Pisano's *Prophet Haggai* is the subject of a remarkable essay by J. Pope-Hennessy, 'New Works by Giovanni Pisano – I', in his *Essays on Italian Sculpture*, London 1968, pp. 1–5. The evolution of the gothic façade in Tuscany is succinctly described in M.G. Burresi and A. Caleca, 'La decorazione delle facciate', in *Niveo de Marmore*, cited above, pp. 212–15.

Donatello's statue of Saint John Evangelist is catalogued in H.W. Janson, *The Sculpture of Donatello*, Princeton 1963, pp. 12–16.

Michelangelo's *David* is catalogued in J. Pope-Hennessy, *Italian High Renaissance and Baroque Sculpture*, London 1970 (1963), pp. 308–10

For excitement about large blocks of marble, see Vasari-Milanesi, I, pp. 118–20 (*Vasari on Technique*, pp. 43–9).

For the effigy of Queen Isabella, see A. Erlande-Brandenburg, *Le Roi est Mort*, Geneva 1975, pp. 168–9. There has, it seems, been no scholarly exploration of the earliest uses of Italian marble for tomb sculpture north of the

Alps. The suggestion that this effigy has been cut from a column has not, I think, been made before. There may well have been marble columns at Saint-Denis – the Abbot Suger had been very anxious to obtain such. The beautiful ivory colour of Isabella's, effigy distinguishes it from later marble effigies in the basilica, as does the quality and style of carving. My point about the unusual flatness is confirmed by comparing the effigy with those of Hermentrude and Constance of Castille (now both at the West end of the nave) carved out of limestone more than a decade earlier which are 32 cm. high, i.e. more than twice as high. Even the very flat bronze effigy of an unidentified princess similar in style and date to Isabella's effigy is 22 cm. high.

Carrara under Elisa Baciocchi is discussed in G. Hubert, *La Sculpture dans L'Italie Napoléonienne*, Paris (Centre Nationale de la Recherche Scientifique), Paris 1964, pp. 327–81.

For Seravezza and Tuscan quarries generally, see *Vasari on Technique*, pp. 119–28.

Daniel Chester French is the subject of a monograph, M. Richman, *Daniel Chester French: An American Sculptor*, which served as the catalogue for the exhibition at the Metropolitan Museum of Art, New York, and other locations, in 1977. The colossal statue of Lincoln is fully documented there on pp. 171–86.

For the Lamberti and the cresting of Saint Mark's, see G. Fiocco, 'I Lamberti a Venezia', *Dedalo*, VII, 1927–8, pp. 287–314, 343–76; G.R. Goldner, 'Niccolò Lamberti and the Gothic Sculpture of San Marco in Venice', *Gazette des Beaux-Arts*, series 6, LXXXIX, February 1977, pp. 41–50; A.M. Schulz, 'Revising the History of Venetian Renaissance Sculpture: Niccolò and Pietro Lamberti', *Saggi e Memorie*, XV, 1986, pp. 7–61, 137–222.

Istrian stone is discussed in Vasari-Milanesi, I, pp. 124–5 (*Vasari on Technique*, pp. 56–7); see also Rodolico, *op. cit.*, pp. 198–207. The claim that this stone takes a polish is often made, but sculptors did not deliberately polish it because of the change of colour. Francesco Sansovino's claim, 'le quali polite col feltro a guisa del marmo, poiché sono pomiciate, hanno sembianza di marmo', is odd (*Venetia città nobilissima et singolare*, Venice 1581, p. 141r).

The passage on the cresting of Saint Mark's comes from the description of the façade by Ruskin already cited in the notes to chapter 4 (*The Stones of Venice*, II, chapter 4, para. XIV). It is not surprising that Ruskin did not discern the use of Istrian stone high up in Saint Mark's, but it is surprising that he describes as of marble the sculpture on the vine corner of the Doge's Palace (*ibid.*, II, chapter 8, para. XXVI).

For the Botticino 'marble' of Brescia, see Rodolico, *op. cit.*, pp. 106–13.

For English alabaster, see F. Cheetham, *English Medieval Alabasters*, Oxford 1984, and A. Gardner, *Alabaster Tombs of the Pre-Reformation Period in England*, Cambridge 1940.

The Cobham tomb has never been published. 'A tomb of alabaster' is mentioned in Lord Cobham's will. It is likely to have been completed before his widow's death in 1453.

Sluter's tomb of Philip the Bold is fully discussed and catalogued in K. Morand, *Claus Sluter: Artist at the Court of Burgundy*, London 1991, pp. 121–32 and 350–69. In one respect, this account is misleading: the author assumes that the 'white stone' of Tonnerre mentioned in accounts for the tomb was alabaster, but the stone in question is a pale limestone and this stone is also documented as the stone employed for the portal sculpture and great Calvary at the Charterhouse of Champmol – where alabaster could not have been employed. In connection with my hypothesis that Sluter, in approaching a Genoese dealer, may have been looking for marble, it should be noted that northern European documents of the late Middle Ages use the terms alabaster and marble interchangeably (see J. Gardner, *The Tomb and the Tiara*, Oxford 1992, pp. 144 and 162).

The alabaster sculpture by Widman was published by F. Souchal as perhaps corresponding with a marble group by Simon Hurtrelle (1648–1724) exhibited at the Salon of 1699 (*French Sculptors of the 17th and 18th Centuries: The Reign of Louis XIV*, II, Oxford 1981, p. 158). The identity of the sculptor was discovered by Peter Fusco – see *La Chronique des Arts*, supplement to the *Gazette des Beaux-Arts*, March 1981, p. 35, no.190. For Widman in general, see E.O. Blažíček, *Baroque Art in Bohemia*, Prague 1968, p. 123, and J. Neumann, *Das Böhmische Barock*, Prague 1970, pp. 141, 189–90.

The fullest account of Parian ware is P. Atterbury (ed.), *The Parian Phenomenon*, London 1989.

5 The Versatility of Marble

For the earlier Egyptian limestone sculptures notable for perforation and undercutting, see C. Aldred, *Egyptian Art*, London 1980, pls 56 and 57 (legs) and 58 and 62 (arms).

Egyptian trial pieces of the type illustrated here are discussed by T. Liepsner in *Lexikon der Ägyptologie* (ed. W. Melk and others), IV (1982), cols 168–80. More recently R.S. Bianchi in *Cleopatra's Egypt*, catalogue of the exhibition held at the Brooklyn Museum, New York 1989, pp. 242–3, no.131, follows Bothmer's suggestion that they are double-sided ex-voto plaques. Many of them may be, but the character of the carving on the Ashmolean's example is hard to reconcile with its simply being an unfinished example of such an ex-voto.

Most recent surveys of the origins of Greek marble carving make no mention of the tradition of wooden sculpture which preceded and intermingled with the work in marble and do not speculate on the significance of sculptors working in both materials. But for the extensive use of wood by Greek sculptors, see R. Meiggs, *Trees and Timber in the Ancient Mediterranean World*, Oxford 1982, pp. 300–11, and, for acrolithic sculpture, *ibid.*, pp. 314–15. Of particular importance is Pausanias's reference in his *Description of Greece* to a gilded wood Athena with extremities of Pentelic marble at Plataea (9, iv, 1). Among other images of wood and marble which he mentions were the Three Graces at Petra (6, xxiv, 6) and the statues in the sanctuary of Demeter at Onceium (6, xxv, 6).

For the *Peplos Kore* see the notes to chapter 3.

The techniques of piecing ancient Greek and Roman marble sculpture are surveyed in A. Claridge, 'Ancient Techniques of making joins in Marble Statuary', in *Marble: Art-Historical and Scientific Perspectives on Ancient Sculpture*, papers from a symposium at the J. Paul Getty Museum, April 1988, Malibu 1990, pp. 135–62.

For the head of an athlete discussed here, see A. Furtwängler, *Masterpieces of Greek Sculpture*, London 1895, pp. 161–5, and *The Arrogant Connoisseur: Richard Payne Knight*, catalogue of an exhibition at the Whitworth Art Gallery, Manchester 1982, pp. 137–8, no.49 (entry by N. Penny).

For the origins of the Corinthian capital, see the note on Kallimachos in those for chapter 3.

The elaborate Roman Corinthian capital illustrated here is catalogued as no. 56 in A. Guiliano (ed.), *Museo Nazionale Romano: Le Sculture*, I, 2 (catalogo delle sculture esposte nelle ali del chiostro), Rome 1981, pp. 267–8 (entry by L. Lupi).

For the *Apollo Belvedere* and its influence, see F. Haskell and N. Penny, *Taste and the Antique*, New Haven and London 1981, pp. 148–51, no. 8.

Bernini's *Apollo and Daphne* is catalogued in R. Wittkower, *Gian Lorenzo Bernini* (1951), Oxford 1981, pp. 183–4. For Finelli, see J. Montagu, *Roman Baroque Sculpture*, London and New Haven 1989, pp. 104–7.

For Nollekens's *Diana*, see N. Penny, 'Lord Rockingham's sculpture collection and *The Judgement of Paris* by Nollekens', *The J. Paul Getty Museum Journal*, XIX, 1991, pp. 5–34. The small bronze by which the figure is influenced is a Cupid attributed to Fanelli.

For Canova's group of Cupid and Psyche see *Antonio Canova*, catalogue of the exhibition in Venice, 1992, pp. 234–41, no.122 (entry by G. Pavanello).

6 The Traces of the Tool

For the use of the drill in ancient Greek sculpture, see S. Adam, *The Technique of Greek sculpture in the Archaic and Classical Periods*, Oxford 1966, pp. 40–73; for the running drill, see pp. 61–73.

The bust of Commodus is catalogued in H. Stuart Jones, *A Catalogue of the Ancient Sculptures Preserved in the Municipal Collections of Rome: The Sculpture of the Palazzo dei Conservatori*, Oxford 1926, pp. 139–42, no.20.

The sarcophagus discussed here was displayed beside the western door of the Baptistery in Florence until the end of the thirteenth century and then moved to the front of the bell-tower. It is decorated with the Dioscuri and scenes of sacrifice and clemency as well as the central nuptial scene which is perhaps intended to symbolise concord. See G. Koch and H. Sichtermann, *Römische Sarkophage*, Munich 1982, pp. 78–9, 104–5, 507, pl. 99. For Phrygian sarcophagi and their transport, see J.B. Ward-Perkins, *Marble in Antiquity*, London 1992, pp. 65–8; also M. Waelkens, 'Marmi e Sarcophagi frigi', *Annali della Scuola Normale Superiore di Pisa*, XVI (1986), pp. 59–76.

A succinct account of the evolution of the Corinthian capital in Byzantine architecture is provided in D. Talbot Rice, *Byzantine Art*, Harmondsworth 1968, pp. 70–2.

For Pisano's *Haggai*, see the notes to chapter 4.

Bernini's bust of Thomas Baker is catalogued in R. Wittkower, *Gian Lorenzo Bernini* (1951), Oxford 1981, p. 208, and in J. Pope-Hennessy with R. Lightbown, *Catalogue of Italian Renaissance Sculpture in the Victoria and Albert Museum*, London 1964, 3 vols, II, pp. 600–6, no. 638.

For the tools employed in carving marble and stone, see *La Sculpture*, pp. 194–207 and 594–8, also more generally R. Wittkower, *Sculpture: Processes and Principles*, Harmondsworth 1977, chapter 1.

The use of the claw or tooth chisel and other technical aspects of ancient Roman marble carving are discussed in P. Rockwell, 'Some reflections on tools and faking', in the Getty Museum symposium papers cited in the notes to chapter 5, pp. 207–22. Cf. Adam, *op. cit.* pp. 18–22.

Michelangelo's *Virgin and Child* in the Medici Chapel is catalogued in J. Pope-Hennessy, *Italian High Renaissance and Baroque Sculpture* (1963), London 1970, pp. 334–5. There is a valuable discussion of Michelangelo's use of the claw chisel in Wittkower, *op. cit.*, chapter 5, pp. 99–126.

For Bernini's *Apollo and Daphne*, see notes to chapter 3.

For Canvoa's *Cupid and Psyche*, see notes to chapter 5.

The importance of Adolf von Hildebrand is very well discussed in Wittkower, *op. cit.*, pp. 244–9. Hildebrand's *Das Problem der Form in der bildenden Kunst* was first published in 1893. A translation by M. Meyer and R.M. Ogden was published in 1907. Wölfflin's essay on Hildebrand and Hildebrand's essay on Rodin are translated into English for the first time in *Viewpoints: European Sculpture 1875–1925*, catalogue of an exhibition held at The Shepherd Gallery, New York, October-November 1991. A collected edition of Hildebrand's writing (*Gesammelte Schriften*) was published in Cologne in 1969.

For Maurice Sterne, who was a painter as well as a sculptor, see M. Sterne, *Shadow and Light*, ed. C.L. Meyerson, New York, 1965. The note that the sculpture was made of Greek marble found in the Tiber comes from a review of the artist's work exhibited at the Museum of Modern Art, New York, 1933, by Stark Young in *The New Republic*, quoted in Sterne, *op. cit.*, p. 215.

7 Coloured Marbles

Two books are indispensable for the serious student of the coloured marbles used in ancient Rome and since reused: R. Gnoli, *Marmora Romana*, Rome 1971, and G. Borghini (ed.), *Marmi Antichi*, Rome 1992. There are two important collections of marble samples available for consultation in Britain. One is in the Sedgwick Museum of Geology in Cambridge University which was created in the late nineteenth century and can be viewed by appointment. Its range is extraordinary, but it is less strong on the marbles used in antiquity than is the collection formed by Faustino Corsi in Rome in the early nineteenth century. The Corsi collection is now in the University Museum in Oxford; part of it is on display and the parts in store can be viewed by appointment. Corsi's own *Catalogo ragionato d'una collezione di pietre di decorazione* was published in Rome in 1825. Handy books with useful introductory sections and numerous photographs of specimens of ancient marbles are H. Mielsch, *Buntmarmore aus Rom im Antikenmuseum Berlin*, Berlin 1985, and E. Dolci and L. Nista (eds), *Marmi antichi da Collezione: La raccolta Grassi del Museo Nazionale Romano*, catalogue of an exhibition at Carrara 1992.

For the centaurs of black marble, see F. Haskell and N. Penny, *Taste and the Antique*, New Haven and London 1981, pp. 178–9, and for the coloured marble panther in the Sala degli Animali, see W. Amelung, *Die Sculpturen des Vaticanischen Museums*, II, 2, Berlin 1908, p. 357, no.154. Coloured marble inserts of this type are unusual but are described by Pliny the Elder in his *Historia Naturalis*, XXXV, I, 3. There is a bronze panther in the Metropolitan Museum, New York, with copper spots which is in some respects comparable.

'Antonio Calcagni's Bust of Annibale Caro' is the title of a fine paper by J. Pope-Hennessy republished in *Essays on Italian Sculpture*, London 1968, pp. 158–61. It should, however, be entitled 'Antonio Calcagni's Head of Annibale Caro', for it pays no attention to the bust except to describe it wrongly as a 'crimson breccia stained with white'.

For the marbles of Seravezza, see the notes to chapter 4.

Ammanati's Neptune fountain is catalogued in J. Pope-Hennessy, *Italian High Renaissance and Baroque Sculpture* (1963), London 1970, pp. 374–6.

There can be few decorative materials extensively employed in Europe with more obscure origins than *breccia di Trapani*. For the quarrying initiatives in Sicily sponsored by Grand-Duke Ferdinand, see L. Orlandini, *Breve discorso del Castagno di Mongibello e delle Lodi di Sicilia*, Palermo 1614, p. 7, but this may refer only to hard stones. A rare catalogue of the hard stones of Sicily is D. Tata, *Catalogo di una raccolta di pietre dure native di Sicilia*, Naples 1772. Corsi in his great catalogue of marbles (cited above) has eighteen specimens of soft 'jasper' (now numbered 161–78), of which the sixth and fourteenth (nos.166 and 174) are closest to the material so popular in the seventeenth and eighteenth centuries, but he describes them as 'non comune' and 'raro'.

Bernini's tomb of Pope Alexander VII is catalogued by R. Wittkower in *Gian Lorenzo Bernini*, Oxford 1981 (1955), pp. 259–60.

An account of the art of Pierre Legros the Younger (1666–1719) will be found in R. Enggass, *Early Eighteenth-Century Sculpture in Rome*, 2 vols, Pennsylvania State University 1976, I, pp. 124–48. The effigy of Stanislas is catalogued on pp. 138–9. F. Haskell, 'Pierre Legros and a Statue of the Blessed Stanislas Kostka', *Burlington Magazine*, XCVII, 1955, pp. 287–91, published the fascinating documents concerning the dispute over where the sculpture should be placed so most to strike and move the novices and others who beheld it.

Cordier's *Negro in African Costume* is catalogued in *The Second Empire 1852–1870*, catalogue of the exhibition held at Philadelphia Museum of Art, 1978, at Detroit Institute of Art and the Grand Palais, Paris, 1979, V-16, p. 225 (entry by A. Pingeot). For polychrome marble sculpture in nineteenth-century France in general, see A. LeNormand-Romain and J.-L. Olivié, 'La polychromie', in *La Sculpture Française au XIXᵉ Siècle*, catalogue of the exhibition at the Grand Palais, Paris, 1986, pp. 148–59.

8 Schist, Sandstone and Limestone

For stone carving generally, A. Miller, *Stone and Marble Carving*, London 1948, will be found useful.

For the stones used in Indian sculpture, see R. Newman, *The Stone Sculptures of India: A Study of the Materials used by Indian Sculptors from the 2nd Century BC to the 16th Century*, Cambridge (Mass.) 1984.

For Gandhāran sculpture generally, see W. Zwalf, *The Shrines of Ghandhāra*, London 1979, and J.C. Harle, *The Art and Architecture of the Indian Subcontinent*, Harmondsworth 1987, pp. 71–85.

For the gilding of Gandhāran sculpture, see D. Faccenna, 'Colour and gilding on stucco modelling and schist sculpture', *Butkara I (Swāt, Pakistan) 1956–1962*, Rome 1980, Part 3, pp. 719–22; also T. Proudfoot, K. Garland and J. Larson, 'The Examination and Conservation of a collection of Gandharan sculptures from Antony House, Cornwall', in the Preprinted Contributions to the Congress on the Conservation of Far Eastern Art at Kyoto, International Institute of Conservation, September 1988, pp. 113–19. Dr Zwalf (to whom these references are owing) points out to me that a Buddha retaining an unusual quantity of gilt ornament, apparently original, is illustrated in I. Kurita, *Gandharan Art II: The World of the Buddha*, Tokyo 1990, fig. 193.

The statue of the Buddha discussed here is most recently published in the catalogue of the exhibition *Crossroads of Asia* at the Fitzwilliam Museum, Cambridge, no. 201 (entry by C.F.); see also J.C. Harle and A. Topsfield, *Indian Art in the Ashmolean Museum*, Oxford 1987, p. 13, no. 15 (entry by Harle).

The dark siltstone sculpture of the Pāla and Sena dynasties in eastern India and Bangladesh is surveyed in Harle, *op. cit.*, pp. 199–217.

The stele of Viṣṇu is catalogued in Harle and Topsfield, *op. cit.*, pp. 39–40, no. 48 (entry by Harle). This stele was acquired 1686–7 by the Ashmolean Museum, Oxford, as a gift from Sir William Hedges, governor of the East India Company in Bengal, who recorded his exploration of the temples on Saugor in 1683. It was the first major Indian sculpture to be dcquired by a museum in the west.

The addorsed *yakṣis* are catalogued in P. Pal, *Indian Sculpture. A Catalogue of the Los Angeles County Museum of Art Collection*, I, Berkeley 1968, pp. 149–50, no. S.29.

The circular ceiling slab is catalogued in Harle and Topsfield, *op. cit.*, pp. 24–5, no. 32 (entry by Harle).

For the sandstone Bodhisattva, see J. Irwin, 'The Sanchi Torso', in *The Victoria and Albert Museum Yearbook*, 1972, pp. 7–28, and the summary of this article published as one of a series of leaflets by the museum without date (but, in fact, in 1976).

For the practice of colouring stone carving in India, see Krishna Kumar, 'The Evidence of white-wash, plaster and pigment on North Indian sculpture with special reference to Sarnath', *Artibus Asiae*, XLV, 2/3, 1984, pp. 199–206.

The sandstone carving of Cambodia is discussed in chapter 11 of S.E. Lee, *A History of Far Eastern Art*, London 1988 (1964), pp. 231–44, where the head of Śiva in Cleveland is described (on p. 237).

The so-called marble of Verona is discussed in F. Rodolico, *Le Pietre delle Città d'Italia*, Florence 1953, pp. 375–92. For Ruskin's drawing, see N. Penny, *Ruskin's Drawings in the Ashmolean Museum*, Oxford 1988, pp. 74–5, no. 29. Ruskin discussed the animal in *Modern Painters*, III, 1856, chapter eight, paragraphs 11–20. The mottled red 'marble' of Hungary, Salzburg and other quarries by the Danube or its tributaries was favoured chiefly for great tomb slabs during the Middle Ages. Its use was extended to palace doorways and chimneypieces during the Renaissance–indeed, a whole interior was made of Hungarian 'marble' by Andrea Ferrucci in 1506–20 (the Bakócz chapel at Esztergom, near the marble quarries). The prestige of this 'marble' persisted, and it is remarkable that epitaphs to powerful officers of state erected in churches in Vienna and elsewhere in central Europe were carved out of it in the eighteenth century, when Carrara marble would have been used for such a purpose in Italy, Spain, France, Great Britain, Belgium, Holland, Denmark, Sweden and, indeed, India and North America.

For Purbeck 'marble', see C.H. Vellacott, 'Quarrying', in *The Victoria History of Dorset*, II, 1908, pp. 331–44; G.D. Drury, 'The Use of Purbeck Marble in Medieval Times', in *Proceedings of the Natural History and Archaeological Society*, LXX, 1948, pp. 74–97; D. Purcell, *Cambridge Stone*, Cambridge 1967, pp. 88–93; R. Leach, *An Investigation into the Use of Purbeck Marble in Medieval England*, Hartlepool 1975; H.A. Tummers, *Early Secular Effigies in England: The Thirteenth Century*, Leiden 1980, pp. 12–13.

The stone used for French cathedrals is discussed in P. du Colombier, *Les Chantiers des Cathédrales*, Paris 1973.

Accounts differ as to the need to ensure that all limestone is base bedded. Nick Durnan who has personal experience as a mason informs me that the bedding of many very good limestones such as Caen stone is not apparent. From my own observation it is apparent that the drums of which Portland stone columns are composed are frequently not base bedded.

A recent discussion of the sculpture of the Portail Royal at Chartres is contained in G. Henderson, *Chartres*, Harmondsworth 1968, pp. 39–61. See also the thoughtful analysis of these sculptures in R. Wittkower, *Sculpture: Processes and Principles*, Harmondsworth 1977, pp. 52–4. For the stones

used in the cathedral, see A. Blanc, 'La pierre, matériau des Grands Edifices', in J.-M. Pérouse de Montclos (ed.), *Le Guide du Patrimoine: Centre Val de Loire*, Paris 1992, p. 95.

For Sluter's portal at the charterhouse of Champmol, see K. Morand, *Claus Sluter: Artist at the Court of Burgundy*, London 1991, pp. 79–90, 314–320.

For clunch and similar stones, see A. Clifton-Taylor, *The Pattern of English Building*, London 1972, pp. 61–5. The passage quoted on Bishop Alcock's Chapel and the Lady Chapel in Ely cathedral will be found on pp. 62–3.

For *pietra serena* and *pietra bigia* and other stones of Florence, see F. Rodolico, *Le Pietre delle Città d'Italia*, Florence 1953, pp. 239–54. *Pietra serena* is discussed also by Vasari (Vasari-Milanesi, pp. 125–6 (*Vasari on Technique*, pp. 57–60)). Vasari distinguishes from *pietra serena* the *pietra del fossato* which is from a deeper quarry and has an especially fine grain. He believed it to be more durable, but Donatello's *Dovizia*, which he claimed had been made from it, fell to pieces in 1721. He notes that this was the stone used by Michelangelo and also for his own architecture in the Uffizi. It is dark grey and slightly brown.

The corbel illustrated here was first attributed to Francesco di Simone Ferrucci by Bode. I am obliged to Andrea De Marchi for informing me that Giancarlo Gentilini supports this attribution. It is catalogued in I.B. Supino, *Catalogo del R. Museo Nazionale di Firenze*, Rome 1898, pp. 451–2.

For travertine and other stones of Rome, see Rodolico, *op. cit.*, and *Vasari on Technique*, pp. 51–4.

Bernini's Triton fountain is catalogued in R. Wittkower, *Gian Lorenzo Bernini* (1955), Oxford 1981, p. 200. It is interesting that Bernini marks the join across the Triton's chest very faintly in his preparatory drawing for the fountain, as observed in J. Montagu, 'Disegni, bozzetti, legnetti and modelli in Roman Seicento sculpture', in P. Volk (ed.), *Entwurf und Ausführung in der europäischen Barockplastik*, Munich 1986. There is a join across each of the Triton's 'thighs'. Each shell is formed of two pieces joined in the middle at right angles to the Triton's body, but with separate pieces added for the portions curling over in front of and behind the Triton. The structure of the lower part is not entirely clear. Front and back are constructed differently. At the back, fish and cartouche are made together out of two blocks joined horizontally. In front, each fish seems to be made of a separate block, and the cartouche is made out of two blocks. In the report on the cleaning of the fountain made to the third international congress on the deterioration of stone, it is proposed that the three blocks of travertine were from the Cave delle Fosse in Tivoli, noted for its durability and slightly pink colour.

Henry Moore's *Reclining Woman* and related works are discussed in chapter 5 of H. Read, *Henry Moore, A Study of his Life and Work*, London 1965, especially pp. 71–2. For brown Hornton limestone, see Clifton-Taylor, *op. cit.*, pp. 91–2.

9 The Structure and Decoration of Larger Wooden Sculpture

For wood carving generally, see *La Sculpture*, pp. 159–67, 191–3 (methods of attaching), 208–10 (tools), 226–31 (a table of woods and their qualities), 598–601 (tools), 613–16. Also J.C. Rich, *Sculpture in Wood*, New York 1970 – an admirable manual for the student carver.

For the woods available to the Egyptians in general, see R. Meiggs, *Trees and Timber in the Ancient Mediterranean World*, Oxford 1982. Acacia and sycamore fig are discussed on p. 300.

The wooden statue of Tutankhamun and the three similar statues from the tombs of Ramesses I and (probably) Ramesses II are discussed by I.E.S. Edwards in *Treasures of Tutankhamun*, catalogue of the exhibition held at the British Museum, London, 1972, no. 1.

The effigies of Ramesses I were identified as of sycamore fig (*Ficus sycomorus*) by Caroline Cartwright of the Department of Conservation in the British Museum (BMRL nos 42286X, 42285Z, 42398X; RL file no. 6260) in April 1992. I am most grateful to Dr Vivian Davies for arranging for this.

Although large Egyptian wooden effigies are in general assembled, there are exceptions, the famous effigy of Chancellor Nakhti in the Louvre (E 11937) is carved from a single log (identified as acacia on the museum label).

The oak angel of the annunciation is catalogued in P. Williamson, *Northern Gothic Sculpture 1200–1450*, Victoria and Albert Museum, London 1988, pp. 182–6, no. 53.

The relief of the *Entombment* is unpublished.

Carving in limewood (lindenwood) in the fifteenth and early sixteenth centuries is the subject of a stimulating study by M. Baxandall, *The Limewood Sculptors of Renaissance Germany*, New Haven and London 1980. An interesting reference to the impression made in Florence by a carving of Saint Roche in the alien material of limewood by the foreign sculptor 'Maestro Janni Franzese' will be found in Vasari-Milanesi, I, pp. 167–8 (*Vasari on Technique*, pp. 174–6). This statue is still to be seen in SS. Annunziata. It was painted in the nineteenth century but was not, it seems, originally polychrome.

For Riemenschneider see Baxandall, *op. cit.*, pp. 259–65; also J. Bier, *Tilman Riemenschneider, Die späten Werke in Holz*, Vienna 1978. The angel by Riemenschneider is catalogued in

M. Baxandall, *South German Sculpture 1480–1530*, Victoria and Albert Museum, London 1974, no. 9.

For Erhart's altarpiece at Blaubeuren, see Baxandall (1980), *op. cit.*, pp. 101, 255–88.

For water gilding and silvering and for oil gilding, see *La Sculpture*, pp. 345–8.

The use of textured surfaces in Gothic wood carving is discussed in E. Oellermann, 'Zur Imitation textiler Strukturen in der spätgotischen Fass – und Flach Malerei', in J. Taubert (ed.), *Farbige Skulpturen*, Munich 1978, pp. 51–9.

The seated virgin from a coronation group is catalogued in Williamson, *op. cit.*, pp. 96–101, no. 24.

The wyvern is part of the exceptionally elaborate rococo frame made for the painting of the *Choice of Hercules*, commissioned by the 1st Earl of Shaftesbury in Naples from Paolo de' Matteis. The frame must date from the 1740s and was part of a rococo scheme of redecoration at the Shaftesbury seat of Wimborne St Giles in Dorset.

For Christian Jorhan, see F. Markmiller, 'Christian Jorhan', in H. Bleibrunner (ed.), *Grosse Niederbayern, zwölf Lebensbilder*, Landshut 1971, pp. 83–92. For south German sculpture of this period in general, see P. Volk, *Rokokoplastik in Altbayern, Bayrisch-Swaben und im Allgäu*, Munich 1981.

Jack Soultanian of the Objects Conservation Department at the Metropolitan Museum of Art, New York, kindly had X-radiographs made of the two Jorhan angels. The one with lowered arms (1974.356.799) is made of one piece with only the wings and the lower parts of the arms added. The joints of the arms are sloped. The other figure (1974.356.800) has a join on the top of the head, two joins in the raised arm and one in the other arm. There is a repair in the proper left leg which is likely also to have been an original join. Analysis of the surface coating revealed that it 'appears to be, not unexpectedly, of the dolomitic carbonate variety'. The angels are unpublished. They were acquired in Munich with an attribution to Jorhan which has been endorsed by Peter Volk.

The decoration of south German rococo sculpture in wood is discussed in J. Taubert, 'Fassungen süddeutscher Rokoko-figuren', in *Farbige Skulpturen*, cited above, pp. 109–23.

The quotation on the opportunities for projection provided by wood comes from E. Lanteri, *Modelling. A Guide for Teachers and Students*, 3 vols, London 1902–11, II, pp. 143–4.

Wooden Buddhist sculpture in China of the twelfth to fourteenth centuries is discussed in relation with sculpture in other media in chapter 14 of L. Sickman and A. Soper, *The Art and Architecture of China*, Harmondsworth 1971, pp. 187–202.

The construction and decoration of a carved wooden figure of Guanyin of the twelfth or thirteenth century in the Victoria and Albert Museum, London, has been thoroughly analysed by J. Larson and R. Kerr in *Guanyin: A Masterpiece Revealed*, London 1985.

A large (172.7 cm. high) seated Bodhisattva Avolokitesvara (Guide to Souls) or Guanyin of *c.*1300 in the Ashmolean Museum, Oxford, has been analysed as made of fig (*ficus*), of eleven parts of which one is now missing. Bruce Christman, Chief Conservator of the Cleveland Museum of Art, kindly informs me that a sample from the Guanyin in that museum (1984.70) was analysed at the USDA forest products laboratory and identified as 'probably Paulownia Sp, commonly known as the Princess tree' – a close relative of the foxglove-tree. John Larson informs me that a Chinese wooden sculpture in the Victoria and Albert Museum, London, of later date has been identified as made of magnolia wood.

Buddhist wood sculpture in Japan before and during the Kamakura period is discussed in relation with other arts in chapters 13 and 14 of S.E. Lee, *A History of Far Eastern Art*, London 1988 (1964), pp. 288–342.

A good introduction to Kamakura sculpture is supplied by V. Harris and K. Matsushima in *Kamakura: The Renaissance of Japanese Sculpture 1185–1333*, catalogue of the exhibition held at the British Museum, London, 1991, in which the two figures discussed here are nos 6 and 37.

The painted wood figure of Saint Francis of Assisi will be included in Marjorie Trusted's forthcoming catalogue of the Spanish sculpture in the Victoria and Albert Museum, London. It derives from a famous statue in the Treasury of Toledo cathedral, probably of about 1663, by Pedro de Mena which is nearly twice as large. Other variants are known, including one made of walnut recently acquired by the Louvre (*Musée du Louvre: Nouvelles Acquisitions du Département des Sculptures 1988–1991*, Paris 1992, pp. 50–3). The X-radiographs of this version show that the mask was inserted into the cowl, as with the Victoria and Albert Museum's example. I am grateful to Mrs Trusted for examining this sculpture with me. A thin strip of paper fed into the mouth penetrated 2.2 cms. When fed over the top of the head it penetrated 6.5 cms. Superficial observation suggests to me that constructing the front of the face as a separated mask was common in Spanish sculpture of the seventeenth and eighteenth centuries. Another striking example in the Victoria and Albert Museum is the statuette of Saint Francis Xavier made in Seville in the late seventeenth century (107–1864). Here the join at the edge of the mask has opened slightly.

10 Varieties of Small Wooden Sculpture

For the effigy of Tjeti, see W. Seipel, *Gott, Mensch, Pharao*, catalogue of an exhibition at the Künstlerhaus, Vienna, 1992,

pp. 142–3, no. 36. The sculpture was identified as of cedar (*Cedrus sp.*) by Caroline Cartwright of the Department of Conservation in the British Museum (BMRL no. 42399V, RL file no. 6260) in April 1992. I am grateful to Dr Vivian Davies for arranging for this.

For the *Girl carrying a jar*, see the entry by A.P. Kozloff in A.P. Kozloff and B.M. Bryan, *Egypt's Dazzling Sun: Amenhotep III and His World*, catalogue of his exhibition held at Cleveland Museum of Art and elsewhere, 1992–3, pp. 361–2, no. 87. I am grateful to John Ruffle for the information that there is no proof that wood employed in this figure is box. It is remarkable that this, the most beautiful miniature Egyptian sculpture in Britain, was acquired by Lord Prudhoe (later 3rd Duke of Northumberland) who also presented to the British Museum the most majestic of all large Egyptian sculptures, the lion discussed in chapter 2 of this book.

One exquisite figure in the British Museum's collection (EA 32743, 12 cm. high of about 1350 BC) looks very like boxwood but turned out to be juniper (*Juniperus sp.*) when examined (BMRL no. 42401P, RL file no. 6260) in April 1992. The ointment container of about 1400 BC in the form of a nude servant girl with undercutting and numerous views (EA 32767), comparable to the figure discussed here, also turned out to be juniper (BMRL no. 42400R, RL file no. 6260). The Egyptian import of box is discussed in R. Meiggs, *Trees and Timber in the Ancient Mediterranean World*, Oxford 1982, p. 280. The same book discusses ebony and cedar in Egyptian art (pp. 282 ff).

For the Roman passion for citrus wood from North Africa, see Meiggs, *op. cit.*, p. 286.

For Christoph Weiditz, see A. Schädler, 'Zur Kleinplastik von Christoph Weiditz', *Münchner Jahrbuch der bildenden Kunst*, XXXVIII, 1987, pp. 161–84, and for his boxwood medal of Margarethe Gysel, see M. Trusted, *German Renaissance Medals: A Catalogue of the Collections in the Victoria and Albert Museum*, London 1990, p. 118, no. 181. For the question of wooden medals made as models and for their own sake, see *ibid.*, pp. 6–7 and G. Habich, *Die Deutschen Schaumünzen des XVI Jahrhunderts*, I, i, Munich 1929, pp. 24 ff. For wooden models used for statuettes in bronze and silver, see J. Bier, 'Riemenschneider as a goldsmith's model maker', *Art Bulletin*, 1955, pp. 103–12.

The *Saint Sebastian* is catalogued in N.B. Penny, *Catalogue of European Sculpture in the Ashmolean Museum, 1540 to the Present Day*, 3 vols, Oxford 1992, II, pp. 124–5, no. 348.

The Chinese bamboo-root *ruyi* is discussed by C. Clunas in *Chinese Carving*, Victoria and Albert Museum Far Eastern Series (forthcoming). See also I. Yee and L. Tam, *Chinese Bamboo Carving*, catalogue of an exhibition at the Hong Kong Museum of Art, 1978, 2 vols, I, p. 371, no. 118. For a brief discussion of the carving techniques, see *ibid.*, pp. 23–4.

Root furniture is discussed and illustrated in M. Beurdeley, *Chinese Furniture*, Tokyo, New York and San Francisco 1979, pp. 46–51. Jessica Rawson points out to me that the Chinese seem to have been using the natural forms of tree roots for sculpture at an early date – a chimera fashioned out of a root and lacquered red, 69.5 cms long, was recently discovered in a tomb in Hubei, probably dating from the fourth century.

For sculpture by Brustolon, see G. Biasuz, and M.G. Buttignon, *A. Brustolon*, Padua 1969.

For *lavoro di intarsio*, see F. Arcangelo, *Tarsie*, Rome 1942, and P. Thornton, *The Italian Renaissance Interior, 1400–1600*, London 1991.

The cabinet by Fourdinois was described as the 'best work of its class that has been produced in modern times, by any manufacturer' (*The Art Journal's Illustrated Catalogue of the Universal Exhibition*, 1867, p. 141). A full description of the imagery and of the way in which the woods are 'woven together in the solid' is attempted by J.H. Pollen in *Ancient and Modern Furniture and Woodwork*, London 1874, pp. 61–4. Pollen claimed that 'Messrs. Hilaire and Pasti were the principal designers of the figure portions, and Neviller was the artist of the arabesques and other subordinate decorations', but I have not found any other references to artists with these names active at that date, and Sarah Medlam kindly informs me that they are not known to Marc Bascou of the Musée d'Orsay or Sylvain Bellenger of the Château de Blois, which suggests that the information was garbled.

Little has been written about John Skeaping (1901–80) whose work in the 1930s was of exceptional interest – obscured by the more orthodox character of his later work and by the eminence of his wife, Barbara Hepworth. The *Pampas cat* was exhibited by him in his one-man exhibition at Arthur Tooth and Son in January 1934.

11 Ivory and Horn

For ivory and ivory carving in general, see C.I.A. Ritchie, *Ivory Carving*, London 1969, and *La Sculpture*, pp. 168–70, 223–5 and 609; also C. Chesney, N. Barley and others, *Ivory: A History and Collector's Guide*, London 1987. A. MacGregor, *Bone, Antler, Ivory and Horn: The Technology of Skeletal Materials since the Roman Period*, London and Sydney 1985, although devoted to artefacts as well as art and confined to northern Europe, provides an account of the properties of these materials which is of more general interest.

Both the Japanese netsuke discussed here are catalogued by O.R. Impey in *Japanese Netsuke in Oxford*, Oxford 1987, as nos 9 and 49, pp. 15 and 38. For netsuke in general, see R. Barker and L. Smith, *Netsuke: The Miniature Sculpture of Japan*, British Museum, London 1976, and, a shorter intro-

duction, J. Earle, *An Introduction to Netsuke*, Victoria and Albert Museum, London 1980.

For rhinoceros horn, see R. Soame Jenyns (with W. Watson), *Chinese Art: The Minor Arts*, II, London 1965, pp. 189–232. The figure of Guanyin illustrated here is close in style to a figure of Guanyin seated on a rock inscribed as dedicated in a Buddhist temple in 1599 in the Fogg Art Museum, Harvard University (*ibid.*, pl. 144).

For Chinese ivory carvings, see W. Watson (ed.), *Chinese Ivories from the Shang to the Qing*, catalogue of an exhibition organised by the Oriental Ceramic Society and the British Museum, 1984.

The standard scholarly survey of Gothic ivory carvings is R. Koechlin, *Les Ivoires Gothiques Français*, 3 vols, Paris 1924.

For an important discussion of the colouring of ancient European walrus ivories, see P. Williamson and L. Webster, 'The Coloured Decoration of Anglo-Saxon Ivory Carvings', in the proceedings of a symposium held at the Courtauld Institute of Art, February 1985, S. Cather, D. Park, P. Williamson (eds.), *Early Medieval Wall Painting and Painted Sculpture in England*, 1990, pp. 177–93. Some of the splendid thirteenth-century ivories in the Louvre give an idea of the original colouring of French Gothic ivories – the frequent gilding, blue drapery and occasional pink flesh, using the white surface much as it was used in eighteenth-century porcelain.

Petel's *Venus with Cupid* is catalogued in N.B. Penny, *Catalogue of European Sculpture in the Ashmolean Museum, 1540 to the Present Day*, 3 vols, Oxford 1992, II, pp. 145–8, no. 361.

The case for Giovanni Pisano as the sculptor of the *Crucified Christ* was made in an exceptional article in the *Burlington Magazine* by J. Pope-Hennessy, republished in his *Essays on Italian Sculpture*, London 1968, pp. 6–10.

The lamenting Virgin, perhaps by Kriebel, together with its companion Saint John, is catalogued in Penny, *op. cit.*, II, pp. 137–40, nos 355 and 356.

For Byzantine medieval European ivory carvings, see P. Williamson, *An Introduction to Medieval Ivory Carvings*, London 1988, illustrated with works in the Victoria and Albert Museum, London, including the Pisano Crucifixion, the Gothic Virgin and Child and the Byzantine low-relief bust of Saint John the Baptist surrounded by four other saints, as nos 30, 29 and 10. These are also catalogued in M. Longhurst, *Catalogue of Carvings in Ivory, Victoria and Albert Museum*, 2 vols, London 1927 and 1929.

The standard scholarly survey of Byzantine ivories is A. Goldschmidt and K. Weitzmann, *Byzantinische Elfen-*beinskulpturen, 2 vols, Berlin 1930 and 1934. For a discussion of 'minor' Byzantine sculpture which supplies some sort of context for the low-relief bust of Saint John the Baptist, see D. Talbot Rice, *Byzantine Art*, Harmondsworth 1968, pp. 419–56.

'Laborious orient ivory sphere in sphere' is line 20 of the Prologue to Tennyson's *The Princess*, first published 1847. It comes from the description of the curiosities displayed in the entrance hall of Vivian-place.

12 Stamped and Moulded Clay

By far the best brief and general introduction to sculpture in terracotta (moulded and modelled) is that by J. Larson in four pages of the catalogue of French sculpture 1780–1940, published in 1981 by the Bruton Gallery in Bruton, Somerset.

A succinct account of press moulding and slip casting in clay as practised today is supplied in J. Mills, *The Encyclopedia of Sculpture Techniques*, London 1990, pp. 37–8; see also J.C. Rich, *The Materials and Methods of Sculpture*, New York 1947, pp. 39–44.

The Sumerian tablet inscribed with a notice of quantities of silver, possibly from Fara, is reproduced and briefly catalogued in E. Sollberger, *Cuneiform Texts from the Babylonian Tablets in the British Museum*, L, Pre Sargonic and Sargonic Economic texts, London 1972, pl. 3, no. 5 (15826).

On the question of the Assyrian clay reliefs, see J.E. Reade in *Baghdader Mitteilungen*, cited in notes to chapter 3, pp. 25–6. In a letter of 30 September 1992 Dr Reade informed me that he was 'not fully convinced that these things were sculptor's models'. The extent of the detail would surely be surprising in a model. Dr Reade notes that he knows of 'no evidence for this variety of clay modelling before 700 BC whereas carved stone wall-panelling starts before 860'. The clay, however, is more vulnerable than stone.

The technique of the Ishtar Gate was not new: earlier instances of impressed and glazed bricks in Mesopotamia are discussed in A. Caubet, 'Achaemid Brick Decoration', in *The Royal City of Suza*, catalogue of the exhibition at the Metropolitan Museum of Art, New York, 1912–3, pp. 223–5.

The Oxford plaque is catalogued in J.C. Harle and A. Topsfield, *Indian Art in the Ashmolean Museum*, Oxford 1987, pp. 6–7, no. 7 (entry by Harle). For the traditions of terracotta sculpture in India generally which are not covered in this book, see A.G. Poster, *From Indian Earth: 4,000 Years of Terracotta Art*, Brooklyn 1986 (where this plaque is discussed on pages 22 to 23).

The Chinese tomb figure of a standing servant is illustrated and discussed in relation with other tomb furnishings of the

Han period by M. Tregear in the fourth chapter of her *Chinese Art*, London 1980, pp. 50–69.

For Greek and Hellenistic terracotta figurines, see R.A. Higgins, *Greek Terracottas*, London 1967. The example illustrated here is his plate 43D and is discussed on pages 101 to 103. A discussion of technique is given in the opening pages. See also S. Mollard-Besques, *Les Terres Cuites Grecques*, Paris 1963. The whiting on these figures is identified on pages 26 to 27 as being 'usually' slip. The dating of the introduction of plaster moulds (some as early as the fourth century) is given on page 23. Higgins, however, considers that such moulds were 'not common' until the Imperial Roman period. For plaster moulds in Egypt, see C.C. Edgar, *Greek Moulds* (Catalogue général des antiquités Égyptiennes du Musée du Caire), Cairo 1903, Introduction.

For Tang tomb figures generally, see W. Watson, *Tang and Liao Ceramics*, London 1984, pp. 174–216. For the methods of moulding camels and other ancient Chinese tomb animals, see D.K. Strahan and A. Boulton, 'Chinese ceramic quadrupeds: construction and restoration', in the Preprinted Contributions to the Congress on the Conservation of Far Eastern Art at Kyoto, International Institute of Conservation, September 1988, pp. 149–54. Also of interest is E. Phillimore, 'Technical study of a group of Han Dynasty burial objects', *Annual* (of the Art and Archaeology Division of the Royal Ontario Museum, Toronto), 1962, pp. 50–7, the first in a projected series of articles.

For the Lohans, see M. Wolf, 'The Lohans from I-Chou', *Oriental Art*, n.s. xv. i, 1969, pp. 51–7. Wolf notes that the figures are made of coarse, greyish clay with an outer layer of finer white clay about one-quarter of an inch thick – also that there is a rusted iron armature. That they are moulded and then modified by modelling is likely in the light of both earlier and later Chinese practice, but clearly the method was unusual.

Doubts concerning the antiquity of the Italic female cult statue were expressed when it was on the market in Rome in 1913. It was first published in G.M.A. Richter's *Handbook of the Classical Collection in the Metropolitan Museum New York*, 1917, p. 167, but soon afterwards was withdrawn as a fake. D. von Bothmer and J.V. Noble, in *An Inquiry into the Forgery of the Etruscan Terracotta Warriors in the Metropolitan Museum of Art* (Metropolitan Museum Papers, II), New York 1961, p. 14 and n. 24, also argued that it was a fake, and it was published as such by K. Türr in *Falschungen antiker plastik seit 1800*, Berlin 1984, pp. 118–19. However, the numerous terracotta votive statues excavated at the site of the Temple of Minerva at Lavinium in 1977 and published in *La Leggenda di Enea nel Lazio*, the catalogue of the exhibition held at Palazzo dei Conservatori, Rome, 1981, have supplied spectacular confirmation of the statue's antiquity: they are made of similar clay, with a similar technique; some have the same facial type and divided hair; many have similar cast

jewellery – see especially D202, D206, D215, D218, D224, D227 and D234, pp. 226 ff.

For the figures of Fondukistân, see J, Hackin, 'Le Monastère Bouddhique de Fondukistân', in 'Diverses Recherches Archéologiques en Afghanistan 1933–40', published in *Mémoires de la Délégation Archéologique française en Afghanistan*, VIII, 1959, pp. 47–58.

The glazed earthenware tondo is attributed to Andrea della Robbia in J. Pope-Hennessy, *Luca della Robbia*, Oxford 1980, pp. 267–8, fig. 43 and cat. no. 66, but G. Gentilini, in *I della Robbia: La Scultura invetriata nel Rinascimento*, 2 vols, Florence 1992, I, p. 138, argues that it is by Luca. For a general discussion of moulded work in stucco and clay in fifteenth-century Italy, see A. Radcliffe, 'Multiple production in the fifteenth century: Florentine stucco Madonnas and the della Robbia workshop', in *The Thyssen-Bornemisza Collection: Renaissance and Later Sculpture*, London 1992, pp. 16–23.

G. Yanki, 'Raw materials for making porcelain and the characteristics of porcelain wares in north and south China in ancient times', *Archaeometry*, 29, i, 1987, pp. 3–19, challenges many of the conventional assumptions concerning the way Chinese porcelain was made.

The Ying Ch'ing porcelain seated Guanyin is published in L. Sickman, 'A Ching-pai porcelain figure bearing a date', *Archives of the Chinese Art Society of America*, xv, 1961, p. 34, and the small group of comparable figures and ceramic vessels of comparable technique are discussed by J. Ayers in 'Buddhist porcelain figures of the Yüan dynasty', *Victoria and Albert Yearbook*, 1969, pp. 97–109.

Blanc de Chine porcelain is the subject of an admirable monograph: P.J. Donnelly, *Blanc de Chine: The Porcelain of Têhua in Fukien*, London 1969. This is limited in its analysis of the technique of making the figures, but see pages 38–9 for a discussion of the use of moulds.

For the Japanese palace and its animals, see O. Walcha, *Meissen Porcelain*, London 1981 (Dresden 1973), pp. 76–8.

For Bustelli's work in general, see R. Rückert, *Franz Anton Bustelli*, Munich 1963. The quotation on Bustelli is taken from J. Fleming and H. Honour, *The Penguin Dictionary of Decorative Arts*, Harmondsworth 1977, p. 134.

For the colouring of Meissen animals, see the exhibition catalogue *The Treasure Houses of Britain*, National Gallery of Art, Washington, D.C., 1985, pp. 440–1 (entry by T.H. Clarke). The filling of the cracks in the large animals was a matter of dispute within the factory – hence the record of how it was done, cited in Walcha, *op. cit.*, p. 100.

The very important question of the material out of which models were made in the European porcelain factories deserves

further investigation. Pear wood was used for an important early documented model at Meissen by Johann Jacob Irminger; Kirchner's contract with the factory referred to both clay and wood models; Kaendler frequently carved in limewood (and also worked in sandstone); other sculptors employed by the factory were wood carvers (and, in the case of Johann Christoph Ludwig Lücke, a distinguished carver in ivory as well). See Walcha, *op. cit.*, pp. 72, 73, 74, 106, 110, 116.

For the composition of soft paste porcelain and the possible origin of the term 'biscuit', see S. Eriksen and G. de Bellaigue, *Sèvres Porcelain*, London 1987, pp. 40–3 and 57.

The Sèvres biscuit-porcelain figure of Pascal after Pajou is catalogued in N.B. Penny, *Catalogue of European Sculpture in the Ashmolean Museum, 1540 to the Present Day*, 3 vols, Oxford 1992, II, pp. 56–8, no. 293.

For the techniques of porcelain manufacture generally, see the 'Introduction technique' in M. Brunet and T. Préaud, *Sèvres: des origines à nos jours*, Fribourg 1978, pp. 13–23.

The origins of slip casting and the introduction of gypsum plaster moulds for this purpose are not entirely clear. A. Brongniart in his *Traité des arts Céramiques*, Paris 1844, I, p. 154 – a fundamental text – asserted that 'coulage' (slip) was a technique introduced sixty years previously, but this reflects its relatively late introduction at Sèvres. It is certain that many European porcelain factories had introduced it by the mid-eighteenth century, and figures made at the English factories of Chelsea, Derby and Longton Hall were slip cast from the start. It was said that gypsum plaster moulds were seen in use in a French factory and adopted in Staffordshire in the 1730s; there is also evidence for their use in Staffordshire in the 1690s – see G.W. Elliot, 'Staffordshire Red and Black Stonewares', *English Ceramic Circle Transactions*, X, ii, 1977, pp. 84–94. It seems to me possible that there were intermediate methods. It is also possible that factories practised both methods simultaneously – superficial examination of Nymphenburg porcelain suggests this.

'Gypsum moulds were not actually perfected in Japan until after the Vienna Weltausstellung of 1873, when Nōtomi Kajirō and Kawahara Chūjirō (two Arita potters who had been part of the Japanese delegation sent to Vienna and Europe to study techniques) imparted the knowledge they had acquired on their study trip to Hayata [a potter working in Edo who had been experimenting with European moulds at an earlier date]. Hayata developed the method successfully, and it subsequently spread to Arita, Seto and Kutani.' Information from Clare Pollard, citing T. Yōsai, *Ōkoku Hakurankai Sandō Kijō*, Tokyo 1903, III, pp. 122–8.

For artificial stone, see A. Kelly, *Mrs Coade's Stone*, Upton-upon-Severn 1990. Chapter 4 provides an admirable technical account of this material. For the series of figures to which the *Clio* belongs, see *ibid.*, pp. 129–31. Kelly is vague and at times misleading concerning Coade's artistic contribution to the work made at her factory. There is no good evidence that she modelled anything – see my review in the *Burlington Magazine* for December 1990, pp. 879–80. Clio was paired with Urania and could also make a set with a Vestal and a Sibyl. These figures could also be purchased with oil lamps in place of attributes – as a statue Clio supports a lyre, with her raised right arm. *Clio* is likely to correspond with the 'figure for a candelabra' exhibited at the Society of Artists in 1775, or with those exhibited in 1777 and 1778. The female figure in Charles Townley's collection which the Clio imitates is that which Townley believed to be an Isis, the 'largest known ancient terracotta' found 'about 1770 in a well of fine masonry about a mile from the Lateran gate near Via Latina'. It is now in the British Museum (1805-7.3.34) and dated AD 50–100.

13 Stucco and Gesso

L. D'Alessandro and F. Persegati, *Scultura e Calchi in gesso* (Studia archaeologica 47), Rome 1987, includes much valuable information on the composition of plaster (gesso and stucco) and the methods of casting it and working it, together with an historical survey of its use in the west. See also *La Sculpture*, pp. 96–7, and J.-P. Adam, 'Modellage et moulage, de la fouille au musée', in *Le Moulage* (Actes du Colloque International, 10–12 April 1987), Paris 1988, pp. 61–74.

An admirable and succinct introduction to Roman stucco work is supplied in R. Ling, 'Stucco work', in D. Strong and D. Brown (eds), *Roman Crafts*, London 1976, pp. 209–21.

Stucco and the use of moulds in casting it are discussed in Vasari-Milanese, I, pp. 140, 165–6 (*Vasari on Technique*, pp. 86, 170–2). Vasari's description of the use of wooden moulds could be taken to mean that moulds were pressed on top of plaster that had already been built up *in situ*, but this is not likely. Many of the low reliefs employed by Giovanni da Udine derive from antique gems, and it may well be that investigations of how to make impressions from intaglios were as important for him as the study of ancient stucco ceilings.

Technical aspects of the stucco at Fontainebleau are discussed briefly by S. Pressouyre in 'Les restaurations – les stucs . . . à la galerie François I er au Château de Fontainebleau', *Revue de l'Art*, XVI–XVII, 1992, p. 32 and the notes on p. 42. There is very little published on the techniques of stucco sculpture as practised in Germany and Italy in the seventeenth and eighteenth centuries. In fact, no major technique has been less studied. For a spectacular pictorial review of Italian stucco, see G. Ferrari, *Lo stucco nell'arte Italiana*, Milan n.d. The use of gesso in Sicilian stucco is mentioned in F. Meli, *Giacomo Serpotta*, Palermo 1934, pp. 15–16 (quoted, but with gesso translated as 'plaster', in D. Garstang, *Giacomo*

Serpotta and the Stuccatori of Palermo 1560–1790, London 1984, p. 48).

For gypsum in Egypt, see A. Lucas, *Ancient Egyptian Materials and Industries* (1926), revised and enlarged edition by J.R. Harris, London 1989, p. 78. For differing opinions concerning the plaster casts discovered at Tell el Amarna, see G. Roeder, 'Lebensgrosse Tonmodelle aus einer altägyptischen Bildhauerwerkstatt', *Jahrbuch der Preussischen Kunstsammlungen*, LXII, Berin 1942, and the review of this by E. Bille-De Mot in *Chronique d'Égypte*, XVIII, 1943, p. 107. Also C. de Wit, *La statuaire de Tell el Amarna*, Brussels and Antwerp 1950, especially pp. 11, 20, 28, 52.

The mummy mask is catalogued in *Kimbell Art Museum: Catalogue of the Collection*, Fort Worth 1972, pp. 16–17. The mask was also examined at my request in October 1992 by Mr Ahmad Hussein, archaeological conservator from the Assut Egyptian Antiquities Organization (Claire Berry kindly forwarded his conclusions to me).

For the technique and materials employed in the plaster sculpture of Gandhāra, see the contribution by A. Middleton and A. Gill to W. Zwalf's *Catalogue of Gandhāra Sculpture in the British Museum* (forthcoming) which Dr Zwalf kindly let me consult. Evidence for the use of moulding in Gandhāran sculpture is neither strong nor conclusive. This topic is discussed also by K.M. Varma in the *Techniques of Gandhāran and Indo-Afghan Stucco Images*, Proddu 1987, pp. 91–8.

The stucco figure from Gandhāra illustrated here is catalogued in J.C. Harle and A. Topsfield, *Indian Art in the Ashmolean Museum*, Oxford 1987, p. 17, no. 21 (entry by Harle).

For an analysis of Salzburg *stein guss*, see *Sculpture allemandes de la fin du Moyen Age*, catalogue of the exhibition held at the Musée du Louvre, Paris 1991, pp. 55–7. That gesso may have been used as the mould investment in northern European bronze casting is speculation. It is excellent for this purpose provided sand is added as a grog, but there is no evidence that it was so used before the late fifteenth century in Italy (according to R.E. Stone, 'Antico and the Development of Bronze casts in Italy at the end of the Quattrocento', *Metropolitan Museum Journal*, XVI, 1981, p. 108).

Gelatine – elastic animal glue – is the oldest flexible material used for moulding. It is made from boiling bone and animal waste and is brittle when dry, but softened by soaking in water and then boiled in a *bain-marie* until it melts. A gelatine mould has only a brief life before it dries and cracks. Such moulds are sometimes said to have been invented by Hippolyte Vincent in 1844 (*La Sculpture*, p. 123), and they were doubtless much improved about then, but elastic moulds of animal glue had been used at an earlier date – see, for instance, S. Shaw, *The Chemistry of the several natural and artificial heterogeneous compounds used in manufacturing porcelain, glass and pottery*, London 1837, pp. 256–7; Shaw is not

describing a novelty. The introduction of agar (vegetable gelatine), gutta percha, latex and later of PVC and silicon gums have transformed the whole business of casting. There are some valuable observations on this topic in R.E. Stone, *op. cit.*, p. 95.

Full and illustrated accounts of the gypsum plaster piece mould are provided in *La Sculpture*, pp. 115–19 and in E. Lanteri, *Modelling: A Guide for Teachers and Students*, 3 vols, London 1902–11, III, pp. 203–28. The techniques of casting with plaster of Paris in use today, both solid and hollow, are described in J. Mills, *The Encyclopedia of Sculpture Techniques*, London 1990, pp. 51–6. See also J.C. Rich, *The Materials and Methods of Sculpture*, New York 1947, pp. 57–89.

The elder Pliny's references to Lysistratos come in *Historia Naturalis*, XXXIV, 51, and XXXV, 153. A valuable commentary on this is supplied in C.C. Mattusch, *Casting Techniques of Greek Bronze Sculpture*, Ph.D. dissertation, University of North Carolina, Chapel Hill 1975, pp. 52–5, together with an assessment of the evidence for piece moulding in antiquity, pp. 55–8.

For Vasari's account of Verrocchio and his innovations, see Vasari-Milanesi, III, pp. 372–3.

For finishes on gypsum plaster, see Shaw, *op. cit.*, pp. 256–7, also Rich, *op. cit.*, pp. 77–82.

For the medallion portrait of Millais by Munro, see Penny, *op. cit.*, III, p. 130, no. 547.

Attitudes to casts from the life in nineteenth-century France are reviewed in A. Le Normand-Romain, 'Moulage', in *La Sculpture Française au XIXᵉ Siècle*, catalogue of the exhibition at the Grand Palais, Paris 1986, pp. 67–71. An account (with photographs) of casting from life, as practised today using proprietary plaster bandage, is supplied in Mills, *op. cit.*, p. 45.

14 Modelled Clay

Chinese greenware is discussed in Y. Mino and K. Tssang, *Ice and Green Clouds*, Indianapolis 1986, and W. Watson, *Pre-Tang Ceramics of China*, London 1991. For the figure illustrated here, see M. Tregear, *Catalogue of Chinese Greenware in the Ashmolean Museum*, Oxford 1976, p. 30, no. 47. Shelagh Vainker kindly informs me that two comparable figures of larger size, on display in the new National Museum of Southern Song Guan Ware in Hangzhou, are from a tomb of the W. Jin dynasty (AD 265–316) at Xiaoshan, south-west of Hangzhou in n.Zhejiang province.

For modelling in clay generally, see the preliminary note to chapter 12 above, also Vasari-Milanesi, I, pp. 153–4 (*Vasari on Technique*, pp. 149–50).

A stimulating general survey of European terracotta sculpture can be found in the catalogue of the Arthur M. Sackler collection, *Finger Prints of the Artist*, by C. Avery and A. Laing (which includes also a valuable introductory essay by C. Avery). The collection was exhibited at the National Gallery of Art, Washington, D.C., 1979–1980, the Metropolitan Museum of Art, New York, 1981, and the Fogg Art Museum, Cambridge (Mass.) 1981–2. See also J.D. Draper, *French Terracottas*, Metropolitan Museum, New York 1992.

An admirable account of the development of terracotta sculpture in Florence in the fifteenth century is supplied by G. Gentilini in the catalogue of the exhibition at Impruneta, *La civiltà del cotto. Arte della terracotta nell'area fiorentina dal XV al XX secolo*, ed. A. Paolucci and G. Conti, Florence 1980, pp. 67–88.

Michele da Firenze is documented as working in terracotta in Verona in 1436 and in Ferrara in 1441. He can perhaps be identified with the Michele di Niccolò Dini documented among Ghiberti's assistants in 1403. G. Fiocco, 'Michele da Firenze', *Dedalo*, XII, 1932, pp. 542–62; J. Pope-Hennessy, *Italian Gothic Sculpture*, London 1955, p. 216; *Da Biduino ad Algardi*, catalogue of the exhibition at the gallery *Antichi Maestri Pittori*, Turin 1990, pp. 36–7, no. 3 (entry by G. Gentilini). The group of the Virgin and Child is unusually large; an even larger figure baked in one piece is the Virgin – 175 cm. in height – in the Capella Villani of SS Annunziata, Florence, of about 1445 plausibly attributed by Gentilini to the workshop of Luca della Robbia.

The terracotta evangelist is one of three such in the Palazzo Ducale, Mantua, where there is also a Virgin Annunciate and an angel evidently by the same hand and very similar in technique. They were previously incorporated into the façade of a fifteenth century house in Mantua. The proposal that they were made by Mantegna has not met with favour but there is some relationship to his style (G. Paccagnini, 'Il Mantegna e la plastica dell'Italia settentrionale', *Bollettino d'Arte*, 1961, pp. 65 ff). There are affinities with terracotta statues in the Museo Civico, Padua which have been attributed to Giovanni Minelli and Domenico Boccalaro.

An account of hollowing clay models is given in J. Mills, *The Encyclopedia of Sculpture Techniques*, London 1990, pp. 155–8.

For the armatures and hollowing of modelled clay sculpture see *La Sculture*, pp. 65–71 and pp. 90–94. Techniques of modelling are discussed pp. 59–61; the nature of clay, pp. 95–6.

With reference to the subject of iron armatures in terracotta figures the evidence of H.E. Fernal's paper 'Discovery of Iron Armatures and Supports in Chinese Grave Figures of the 6th and early 7th Centuries', in *Far Eastern Ceramic Bulletin*, II, 1950, pp. 105–8 is of interest. It demonstrates that the ancient Chinese practised what a modern potter would deem to be impossible.

For Niccolò dell'Arca and the lamentation group in Bologna, see G. Agostini and L. Ciammitti, 'Niccolò dell'Arca: il compianto sul Cristo di Santa Maria della Vita', in *Tre artisti nella Bologna dei Bentivoglio*, catalogue of an exhibition held in Bologna 1985, pp. 227–362.

Bandinelli's terracotta head is catalogued in N.B. Penny, *Catalogue of European Sculpture in the Ashmolean Museum, 1540 to the Present Day*, 3 vols, Oxford 1992, I, pp. 9–10, no. 8.

The fragment of an antique terracotta statue was excavated in Rome in 1882 on the Esquiline and sold to C.D.E. Fortnum by the sculptor Francesco Fabi-Altini. It was published by Fortnum in *Archaeologia*, XLIX, 1885, pp. 453–5 and by L.R. Farrell, 'On some works of the School of Scopas', *Journal of Hellenic Studies*, VII, 1886, pp. 114–25.

Rossellino's *Virgin with the laughing child* is the subject of an article by J. Pope-Hennessy, republished in his *Essays on Italian Sculpture*, London 1968, pp. 72–7. See also J. Pope-Hennessy with R. Lightbown, *Catalogue of Italian Sculpture in the Victoria and Albert Museum*, London 1964, 3 vols, I, pp. 126–7, no. 104.

For speculation as to the origins of the practice of making small clay models for sculpture, see I. Lavin, 'Bozzetti and Modelli. Notes on sculptural procedure from the Early Renaissance through Bernini', in *Stil und Überlieferung in der Kunst des Abendlandes* (Acts of the 21st International Congress of Art History, Bonn 1964), Berlin 1967, III, pp. 93–104.

For the practice of stiffening fabric, see *Léonard de Vinci: les Études de Draperie*, catalogue of the exhibition at the Musée du Louvre, Paris, 1989. The most notable surviving Renaissance terracotta to incorporate fabric is the *Virgin and Child* by Jacopo Sansovino in the Szépmüvészeti Múzeum, Budapest.

For Antonio Calegari see V. Ferraroli, 'La Scultura del Settecento nella Lombardia orientale', in *Settecento Lombardo*, catalogue of the exhibition at the Palazzo Reale and Museo della Fabbrica del Duomo, Milan, 1991, pp. 298–301. The model of Saint Stanislas and its companion of Saint Luigi Gonzaga are catalogued in *ibid.*, p. 300, nos II. 10 and 11.

The terracotta *Fortitude* is catalogued in Penny, *op. cit.*, I, pp. 46–7, no. 37.

For Clodion's relief, *Satyr piping to a nymph*, see the entry in *Clodion*, catalogue of the exhibition at the Musée du Louvre, Paris, 1992, pp. 161–4, no. 24 (entry by G. Scherf). The catalogue also provides the fullest account of Clodion's work. For contemporary practice in Britain, see M. Greenacre, 'A Technical Examination of Some Terracottas by Michael Rysbrack', in *Michael Rysbrack* by K. Eustace, catalogue of the exhibition at the City of Bristol Museum and Art Gallery, 1982, pp. 49–59.

15 Modelled Wax

For wax modelling, see *Atti del Primo Congresso Internazionale sulla Ceroplastica nella scienza e nell'arte*, Florence 1975, 2 vols, Florence 1977, and *Proceedings of the Second International Congress on Wax-modelling*, London 1978, published London 1981. See also F. Drilhon and S. Colinart, 'La Cire', in *La Sculpture Française au XIXᵉ Siècle*, catalogue of the exhibition at the Grand Palais, Paris, 1986, pp. 135–47. J.C. Rich, *The Materials and Methods of Sculpture*, New York 1947, pp. 52–3, gives modern recipes for modelling wax.

The quotation concerning wax – 'la cera sempre aspetta' – comes from Sirigatti's treatise of 1584, cited by C. Avery in *Proceedings* (cited above).

For wax modelling and the colouring of wax, see Vasari-Milanesi, I, pp. 152–3 (*Vasari on Technique*, pp. 148–9, 188–90).

The miniature coloured-wax portrait illustrated here is catalogued in J. Pope-Hennessy with R. Lightbown, *Catalogue of Italian Sculpture in the Victoria and Albert Museum*, 3 vols, London 1964, II, pp. 557–8, no. 595.

The argument presented here for the origin of the small coloured-wax profile portrait in small uncoloured models for medals gains support from the fact that in northern Europe the models for medals made in box and pear wood and in Solnhofen stone (the very fine-grain Jurassic limestone often mistakenly called honestone) were preserved and also, it seems, made as medals for their own sake – see the medal by Weiditz discussed in chapter 10 above and the notes relating to this.

The wax model made by Giambologna for his *Rape of a Sabine* is catalogued in *Giambologna Sculptor to the Medici*, catalogue of the exhibition at the Royal Scottish Museum, Edinburgh and the Victoria and Albert Museum, London, 1978, p. 220, no. 226 (entry by Charles Avery); also Pope-Hennessy with Lightbown, *op. cit.*, II, pp. 468–9, nos 490 and 491.

Mène's wax of a racehorse is catalogued in N.B. Penny, *Catalogue of European Sculpture in the Ashmolean Museum, 1540 to the Present Day*, 3 vols, Oxford 1992, II, p. 52, no. 228.

16 Bronze and Other Copper Alloys: Part 1

R.F. Tylecote, *A History of Metallurgy* (The Metals Society), London 1976 supplies an introduction to the alloys discussed here.

The alloy used by the great French foundry of Barbedienne in the last century was 90 per cent copper, 6.5 per cent tin and 3.5 per cent lead; that favoured by the great French founder of the late seventeenth century, Keller, was 90 per cent copper, 2 per cent tin, 1 per cent lead and 7 per cent zinc (approximately) – for these, see *La Sculpture*, p. 333. The alloy known as 'statuary bronze', 'navy bronze', 'Admiralty standard bronze' or 'gunmetal', much favoured by foundries during the last hundred years in Europe and the U.S.A., is 85 per cent copper with 5 per cent tin, 5 per cent zinc and 5 per cent lead. Its trade name is LG2. No less popular are LG3, known as 'architectural bronze', which consists of 86 per cent copper, 7 per cent tin, 2 per cent lead and 5 per cent of zinc, and LG4, which consists of 87 per cent copper, 7 per cent tin, 3 per cent zinc and 3 per cent lead. Standard casting yellow brass in use today, trade name SCB 3, consists of 65 per cent copper with 35 per cent zinc.

An admirable general introduction to bronze casting is supplied by P.K. Cavanagh's 'Practical considerations and problems of Bronze Casting', in the papers of the symposium held at the J. Paul Getty Museum in March 1989, *Small Bronze Sculpture from the Ancient World*, Malibu 1990, pp. 145–60. For a fully illustrated account of all the processes of lost-wax casting, see *La Sculpture*, pp. 242–4, 248–74, 624–7. A description of lost-wax casting as practiced in Europe today is given in J. Mills, *The Encyclopedia of Sculpture Techniques*, London 1990, pp. 47–51. See also J. Mills and M. Gillespie, *Studio Bronze Casting*, London 1969. A description of lost-wax casting as practised in the Himalayas today is supplied by E. Lo Bue in W.A. Oddy and W. Zwalf (eds), *Aspects of Tibetan Metallurgy*, British Museum Occasional Paper 15, London 1991, pp. 69–86.

The fullest discussion of Luristan bronzes is supplied in P.R.S. Moorey, *Catalogue of the Ancient Persian Bronzes in the Ashmolean Museum*, Oxford 1971. The finial illustrated here is his number 164 (p. 148). Finials are discussed generally on pages 140 to 146, wild goat finials on pages 146 to 148.

The bronze Etruscan warrior is illustrated and mentioned briefly in A. Brown, *Ancient Italy before the Romans*, Oxford 1980, pp. 64–5. It was given to the Ashmolean Museum, Oxford, in 1888 by C.D.E. Fortnum and is B.7 in his manuscript catalogue. He bought it in Rome whence it had been brought by 'contadini from the Sabine or Umbrian hills'. He thought it represented Mars and was 'possibly votive to the temple of Mars Ultor, in the Aemilia by Gubbio, in Umbria'. As Fortnum noted, 'the upraised right hand has held a spear, the left a shield'. It is close to a statuette of a spear-thrower dated to the late fifth-century in the British Museum (Br. 444) which is discussed, together with other examples of this type of bronze sculpture in O.J. Brendel, *Etruscan Art*, Harmondsworth 1978, pp. 312–14. Analysis of the alloy in this statuette was carried out for me at the Research Laboratory for Art and Archaeology, and I am very grateful to Michael Vickers for arranging this. The composition was 56 per cent copper, 18 per cent lead, 16 per cent tin, 4 per cent arsenic, 6 per cent iron (percentages given to the nearest decimal point – it was hard to obtain readings). The reading for iron is most unusual and may be explained

by the nature of the soil in which the bronze was buried. But see also P.T. Craddock and N.D. Meeks, 'Iron in ancient copper', *Archaeometry*, XXIX, 2, 1987, pp. 187–204.

For a general introduction to Nigerian bronze sculpture, see P. Dark, *An Introduction to Benin Art and Technology*, Oxford 1973; P. Ben-Amos, *The Art of Benin*, London 1980; and K. Ezra, *Royal Art of Benin: The Perls Collection*, Metropolitan Museum of Art, New York, 1992. The last-mentioned publication includes an entry on the statue discussed here. This sculpture was examined at my request by Livy Ekechukwu of the Department of Objects Conservation in the Metropolitan Museum. The exact alloy has not been analysed but has been found to be brass in comparable Benin sculpture of this period. The report sent to me on 6 January 1993 noted that X-rays reveal numerous chaplets, 'probably similar in composition to the rest of the piece. These wrought chaplets also appear similar in nature and type to those found on other hollow Benin pieces here.' They were square in section and not easy to discern on the surface. In addition, 'The X-rays show that the arms and legs are solid. A piece of iron-rod around which the clay core was built and which extends through the length of the piece, on the inside, was revealed by the X-rays. The point where the rod was filed-off below the skin was located with a piece of magnet. The design on the skirt was done with a tracing tool on the wax model.' It might have been supposed that the relative broadness of the legs reflected the fact that they were hollow cast or at least that the thinness of the arms reflected the fact that they were not, and this seems to be the case with some examples in Nigeria.

Professor Willett informs me that, in his experience, the decoration of ancient Benin metal sculpture is almost always in the wax. This is also the observation of other scholars. However, there are cases where decoration goes round or over casting damage and so must have been added after casting. That punching was sometimes applied after casting is clear from the indented reverse of the brass in cases noted by P.T. Craddock and J. Picton in 'Medieval copper alloy production and West African bronze analyses – Part 2', *Archaeometry*, XXVIII, 1, 1986, pp. 19–21. Professor Willett observes that an exceedingly fine clay must have been employed for the moulds but perhaps only as a first coat, 'applied with a feather (as I have seen used in Obo, Ekiti, Nigeria)'.

The assumption that knowledge of copper alloys and lost-wax casting must have been imported to West Africa may spring from European paternalism (disguised as common sense); equally, the determination to prove that it originated independently seems animated by national pride, or by the deference to that pride that is characteristic of the inverted colonialism of much modern anthropology. It has, however, been established conclusively that there was an indigenous copper and copper-alloy industry in West Africa and that the bronzes of Igbo Ukwu are the most remarkable products of this. See P.T. Craddock, 'Medieval copper alloy production and West African bronze analyses – Part 1', *Archaeometry*, XXVII, 1, 1985, pp. 17–41, and Craddock and Picton, *op. cit.*, pp. 3–32. For the origins and early use of brass, see P.T. Craddock, 'The Composition of copper alloys used by the Greek, Etruscan and Roman civilizations – Part 3', *Journal of Archaeological Science*, 1978, V, pp. 1–16.

Chinese bronze ritual vessels are discussed in W. Watson, *Ancient Chinese Bronzes*, London 1962; M. Loehr, *Ritual Vessels of Bronze Age China*, New York 1968; and J. Rawson, *Ancient China, Art and Archaeology*, London 1980.

For a sensible review of the present state of archaeological evidence and of the recent, often lamentable, polemics concerning the origins of bronze working in antiquity, and in particular the question of whether or not the technology evolved independently in China, see J.D. Muhly, 'The beginnings of metallurgy in the old world', in R. Maddin (ed.), *The Beginning of the Use of Metals and Alloys*, Papers from the Second International Conference on the Beginning of the Use of Metals and Alloys, Zhengzhou, China, October 1986, Cambridge (Mass.) 1988, pp. 2–18.

The ritual wine server discussed here is catalogued in R.W. Bagley, *Shang Ritual Bronzes in the Arthur M. Sackler Collections*, Cambridge (Mass.) 1987, pp. 413–15, no. 73.

The most complete analysis yet published of the alloys of early Chinese ritual bronzes and of the evidence of the casting techniques employed in such work is to be found in R.J. Gettens, *The Freer Chinese Bronzes*, II (Technical Studies), no. 7, Freer Gallery of Art Oriental Studies, *passim*; P. Meyers, 'Characteristics of casting revealed by the study of ancient Chinese bronzes', in Maddin, *op. cit.*, pp. 288–95; and Bagley, *op. cit.*, pp. 37–45. For the material used for the moulds, see I.C. Freestone, N. Wood and J. Rawson, 'Shang dynasty casting moulds from North China', in M.D. Notis (ed.), *Cross-Craft and Cross-Cultural Interactions in Ceramics*, American Ceramic Society, Westerville 1989, pp. 253–73.

The lost-wax bronze interlaced disk in the Ashmolean Museum, Oxford (X. 1642) is unpublished. Shelagh Vainker has pointed out to me that it may have surmounted the lid of a *you* (a ritual wine container). Spectacular instances of intricate lost-wax bronze casting of this type are illustrated in *The Tomb of Marquis Yi of State Zeng*, Museum of Hubei Province, 2 vols, Beijing (cultural relics publishing house) 1989, and in *Chu Tombs of the Spring-Autumn Period at Xiasi, Xichuan*, Institute of Archaeology Henan Province, Beijing (cultural relics publishing house) 1991.

For the statuette of Ptah, see H. Whitehouse, 'A Statuette of Ptah the Creator, Beautiful of Face', *The Ashmolean*, XII, summer-autumn 1987, pp. 6–8. The sculpture was first published by J.W. Trist and J.H. Middleton in *Proceedings of the Society of Antiquaries*, 2nd series, XI (1887), pp. 333–5.

Middleton includes some interesting speculations on the nature of the black patina. On this subject, see also J.D. Cooney, 'On the meaning of hasty km.' *Zeitnung für Ägyptische Sprache und Altertumskunde*, XCIII, 1966, pp. 43–7. Dr Whitehouse informs me that the analysis of the alloy carried out by the Oxford University Research Laboratory for Art and Archaeology was 87.7 per cent copper, 0.8 per cent lead, 0.1 per cent arsenic and 11.4 per cent tin.

For a survey of Egyptian bronze sculpture of this period, see R.S. Bianchi, 'Egyptian Metal Statuary of the Third Intermediate Period (circa 1070–656 BC), from its Egyptian antecedents to its Samian examples', in the J. Paul Getty Museum symposium cited above, pp. 61–77. The earliest surviving example of bronze inlaid with silver in Egyptian art is the kneeling figure of Tuthmosis IV, *c*.1385 BC, for which see C. Aldred, *Egyptian Art*, London 1980, p. 167, pl. 131.

For the origins of Greek bronze casting in Samos and its possible connection with Egypt, see H. Kyrieleis, 'Samos and some aspects of archaic Greek bronze casting', in the J, Paul Getty Museum symposium cited above, pp. 15–29, also the paper by R.S. Bianchi in the same publication.

The Riace bronzes are fully published in a special two-volume edition of the *Bollettino d'Arte*, Rome 1984, the third special edition of that journal, edited by L.V. Borrelli and P. Pelagatti, *Due Bronzi da Riace: rinvenimento, restauro, analisi ed ipostesi di interpretazione*. My account of the technique derives entirely from the admirable paper by E. Formigli, 'La tecnica di costruzione delle statue di Riace', I, pp. 107–42. Formigli's findings in this case are very much in line with the observations and deductions in C.C. Mattusch, *Casting techniques of greek bronze sculpture*, Ph.D. dissertation, University of North Carolina, Chapel Hill, 1975.

For the lead used in Etruscan and Roman bronze alloys, see P.T. Craddock, 'The Composition of Copper Alloys used by the Greek, Etruscan and Roman Civilizations', parts 1 and 2, *Journal of Archaeological Science*, III, 1976, pp. 93–113, and IV, 1977, pp. 103–23; *ibid.*, 'The Metallurgy and composition of Etruscan bronzes', *Studi Etruschi*, LII, 1986, pp. 211–71; also D.A. Scott and J. Podany, 'Ancient Copper Alloys: some metallurgical and technological studies of Greek and Roman bronzes', in the J. Paul Getty Museum symposium cited above, pp. 34–5.

The statuette of Mercury is catalogued in R. Payne Knight's manuscript catalogue of his bronzes kept in the Department of Greek and Roman Antiquities, British Museum (LX. 4), also by Knight, anonymously, in *Specimens of Antient Sculpture*, London 1809, I, text for plates XXXIII, XXXIV, and in H.B. Walters, *Catalogue of Bronzes, Greek, Roman and Etruscan in the Department of Greek and Roman Antiquities, British Museum*, London 1879, pp. 148–9, no. 825. When found, the statuette had a gold twisted torc, probably a Gaulish addition, and a silver caduceus.

For the attitude of Chinese connoisseurs to ancient patina, see *Chinese Connoisseurship – the Ko Ku Yao Lun (The Essential Criteria of Antiquities)*, trans. and ed. Sir Percival David, London 1971, pp. 9–13; also other literary evidence conveniently discussed in R. Kerr, *Later Chinese Bronzes*, Victoria and Albert Museum, London 1990, pp. 13–29, 68–79.

Japanese alloys are discussed in F. Brinkley, 'Metallurgy and Metalworking', in *Japan, Its History, Art and Literature*, III, London 1903–4. Also W. Gowlead, 'Metals and Metalworking in Old Japan', *Transactions of the Japan Society*, XXX, 1914–15, pp. 20–100; E. Savage and C.S. Smith, 'The Technique of the Japanese Tsuba Maker', *Ars Orientalis*, 1979, pp. 291–328.

Magical formulae for alloys in northern India are discussed in Lo Bue, *op. cit.*, p. 83

The Colouring, Bronzing and Patination of Metals, by R. Hughes and M. Rowe, a manual for the fine metalworker and sculptor published by the Crafts Council, London 1982, provides a general introduction to this subject with numerous recipes accompanied by colour plates and a useful bibliography. G. Gee, *The Goldsmiths' Handbook*, London 1903, J. Girard, *La Coloration des Métaux*, Paris 1898, A.H. Hiorns, *Metal Colouring and Bronzing*, London 1892, provide interesting evidence of how bronze was coloured a hundred years ago.

For Pliny's account of bronze alloys, see *Historia Naturalis*, XXXIV, 6–12, and for his account of Aristonidas, *ibid.*, XXXIV, 140. These passages may be conveniently consulted in E. Sellers (ed.), *The Elder Pliny's Chapters on the History of Art*, trans. K. Jex-Blake, Chicago 1968, pp. 7–11 and 81. For Silanion's statue of Jocasta, see J. Overbeck, *Die antiken schriftquellen zur geschichte der bildenden Künste bei den Griechen*, Leipzig 1868, pp. 1128, 1350, 1354. For the *Descriptions* of Callistratus (probably dating from AD 500), see the Loeb Classical Library edition of the *Imagines* of Philostratus to which they are appended – for blushing bronze, see numbers 6 and 11 (pp. 397 and 415) and for a green thyrsus, number 8 (p. 407).

17 Bronze and Other Copper Alloys: Parts 2

The Cambodian *Enthroned Buddha* is catalogued in *Kimbell Art Museum: Catalogue of the Collection*, Fort Worth, Texas 1972, pp. 240–3. G. Coedès, *Bronzes Khmèrs* (Ars Asiatica, V), Paris and Brussels 1923, pp. 13–16, discusses the alloys employed in the bronzes of South East Asia: brass (*tombac*) was used, also copper or a very high copper alloy (*thong deng*) and copper alloys with precious metals (*samrit*). Recipes dating from the seventeenth century are cited and the suggestion made that older traditions are reflected in these. Analysis has, however, revealed that recipes were often unrelated to practice in the case of north-Indian bronzes and this may be true also of South East Asia.

The *Śiva Nataraja* discussed here is catalogued in P. Pal, *Indian Sculpture in the Los Angeles County Museum of Art*, II, Los Angeles 1988, no. 138a. For the iconography of Śiva, see S. Kramrisch, *Manifestations of Shiva*, Philadelphia Museum of Art, 1981; also D.P. Leidy, *The Cosmic Dancer*, catalogue of the exhibition at the Asia Society Galleries in New York, 1992.

For the traditions of copper-alloy casting in Tamil Nadu, see C. Sivaramamurti, *South Indian Bronzes*, New Delhi 1963; R. Nagaswamy, *Masterpieces of South Indian Bronzes*, Nanmal Museum, New Delhi 1983, and *idem*, 'South Indian Bronzes', in A.R. Mather (ed.), *Indian Bronze Masterpieces*, New Delhi 1988, pp. 142–79. But there is, it seems, no account of the alloys and foundry practices favoured in southern India to compare with those supplied in W.A. Oddy and W. Zwalf (eds), *Aspects of Tibetan Metallurgy*, British Museum Occasional Paper 15, London 1991.

The gilt-bronze shrine assembled out of many parts is very similar to another one also in the Metropolitan Museum of Art, New York, which is dated in accordance with AD 524. There is a good discussion of Buddhist bronze sculpture in China in this period in H. Munsterberg, *Chinese Buddhist Bronzes*, Tokyo and Rutland (Vermont) 1967 (pp. 126–7 for this piece). See also L. Sickman and A. Soper, *The Art and Architecture of China*, Harmondsworth 1971, pp. 103–6. I have not examined the shrine myself out of its case. One conservator whom I consulted thought it more likely that the lines in the figure were traced in the metal, not cut out of it; however, the lines are both sharp and jagged and taper at the ends, as is also the case with similar small Chinese bronzes of similar date in the British Museum (most notably 1947.7–12.390, dated in accordance with AD 530, and 1958.4–28.1 dated in accordance with AD 471) which I was able to examine with Jessica Rawson and Hazel Newey who confirmed my impression that these were cut.

An account of mercury gilding is given in *La Sculpture*, pp. 349–50. See also Oddy and Zwalf, *op. cit.*, pp. 97–100, for an account of the practice in Patan today (one of the few places where traditional methods are still employed).

For gilding in antiquity, see W.A. Oddy, M.R. Cowell, P.T. Craddock, and D.R. Hook, 'The Gilding of Bronze Sculpture in the Classical World', in the papers of the symposium held at the J. Paul Getty Museum in March 1989, *Small Bronze Sculpture from the Ancient World*, Malibu 1990, pp. 103–21. For the origin of fire gilding in China, see P.A. Lins and W.A. Oddy, 'The Origins of Mercury Gilding', *Journal of Archaeological Science*, II, 1975, pp. 365–73. See also S. Boucher, 'Surface working, chiselling, inlays, plating, silvering, and gilding', in the J. Paul Getty Museum symposium cited above, pp. 161–78. It is interesting that Boucher believes (p. 174) that bronze with a high lead content was fire-gilded by the Romans, although Oddy, Cowell etc. arrive at an opposite conclusion. The preference

for copper as a metal for gilding in Tibet is discussed in Oddy and Zwalf, *op. cit.*; p. 92 and elsewhere.

The gilt-bronze seated Bodhisattva of the Sung period is illustrated and discussed in relation to Court and Ch'an Buddhist arts of the early twelfth to early fourteenth centuries in chapter 8 of M. Tregear, *Chinese Art*, London 1980, pp. 120–35. David Armstrong (using a microscope) confirmed my impression that the decoration was cut out of the metal.

The Limoges crozier is discussed by M.E. Frazer in *Medieval Church Treasuries*, Metropolitan Museum of Art, New York 1986, pp. 34–7. There is another crozier of this pattern in the Bayerisches Nationalmuseum (MA 4090). For metal working in medieval Europe, see *On Divers Art, the Treatise of Theophilus*, trans. and ed. J.G. Hawthorne and G.S. Smith, Chicago 1963, book 3, pp. 77–192.

For Ghiberti in general, see R. Krautheimer, *Lorenzo Ghiberti*, 2 vols, Princeton 1970 (1956). The relief of Christ among the Doctors and other reliefs of the North Door are discussed in volume I, pp. 103–34. For a technical account of his bronzes, see M.C.M. Russo, 'Le techniche', in *Lorenzo Ghiberti, 'materia e ragionamenti'*, catalogue of the exhibition at the Museo dell'Accademia and the Museo di San Marco, Florence 1978–9, pp. 576–80.

For bronze casting in the sixteenth century, see *Vasari on Technique*, pp. 158–66; also C.R. Ashbee, *The Treatises of Benvenuto Cellini on Goldsmithing and Sculpture*, New York 1967, pp. 111–33, and V. Biringuccio, *Pirotechnia*, 1540, trans. C.S. Smith and M.T. Gnudi, Cambridge (Mass.) and London 1966. M. Baxandall, 'A Masterpiece by Hubert Gerhard', *Victoria and Albert Museum Bulletin*, 1965, i. no. 2, provides a vivid account of Gerhard's casting and gilding citing documents. For the technique of using thin shells of wax cast from piece moulds made of an original model to form a casting model into which a liquid core could be poured, as developed for small bronze sculpture in the late fifteenth century, see R.E. Stone, 'Antico and the Development of Bronze casting in Italy at the end of the Quattrocento', *Metropolitan Museum Journal*, XVI, 1981, pp. 87–116. The only point that should now be added to this classic account is that the technique had been used in antiquity. Whether Antico realised this is a very interesting question. Two valuable surveys of the European bronze since the Renaissance are J. Montagu, *Bronzes*, London 1963, and A. Radcliffe, *European Bronze Statuettes*, London 1966.

The male nude, probably intended for Adam, is catalogued in N.B. Penny, *Catalogue of European Sculpture in the Ashmolean Museum, 1540 to the Present Day*, 3 vols, Oxford 1992, I, pp. 101–3, no. 74.

For Vincenzo Danti, see especially H. Keutner, 'The Palazzo Pitti "Venus" and other works by Vincenzo Danti', *Burlington Magazine*, C, 1958, pp. 427–31. Also J. Pope-Hennessy,

Italian High Renaissance and Baroque Sculpture, London 1970, pp. 377–80. For the relief of the *Descent from the Cross*, see C.C. Wilson, *Renaissance Small Bronze Sculpture and Associated Decorative Arts at the National Gallery of Art*, Washington, D.C. 1983, pp. 191–2.

There is an interesting discussion of casting from nature in J. Montagu, *Roman Baroque Sculpture: The Industry of Art*, New Haven and London 1989, pp. 52–5; also in A.M. Massinelli, *Bronzi e anticaglie nella Guardaroba di Cosimo I*, Museo Nazionale del Bargello, Florence, 1992, pp. 74–9, and in N. Gramaccini, 'Das genaue Abbild der Natur – Riccios Tiere und die Theorie des Naturabgusses seit Cennino Cennini', in *Natur und Antike in der Renaissance*, catalogue of the exhibition at the Liebieghaus, Frankfurt am Main, 1986, pp. 198–225. The reproduction of the textures of real cloth and skin was a feature of Donatello's bronze sculpture. His methods of casting and especially of casting drapery in his statues of Saint Louis of Toulouse and of Judith are described by B. Bearzi in 'Considerazioni di technica sul S. Ludovico e La Giuditta di Donatello', *Bollettino d'Arte*, XXXVI, 1961, pp. 119–23.

The bronze Juno, together with its companion piece, Jupiter, is catalogued in Penny, *op. cit.*, I, pp. 92–4, nos 70 and 71.

Gouthière's urns are catalogued in Penny, *op. cit.*, II, pp. 43–4, nos 281 and 282.

For French furniture and applied bronzes generally, see H. Ottomeyer and P. Pröschel (eds), *Vergoldete Bronzen*, 2 vols, Munich 1986.

For the tooling of metal after casting, see *La Sculpture*, pp. 287–93, 640–2.

For a fully illustrated account of all the processes of sand casting, see *La Sculpture*, pp. 245, 274–83, 628–32. See also J.C. Rich, *The Materials and Methods of Sculpture*, New York 1947, pp. 141–6.

Bronze casting in nineteenth-century France is investigated in J.L. Wasserman (ed.), *Metamorphosis in Nineteenth-Century Sculpture*, catalogue of the exhibition at the Fogg Art Museum, Harvard University, Cambridge (Mass.), 1975–6; see especially A. Beale, 'A Technical View of Nineteenth-Century Sculpture', pp. 29–56.

For electro-deposit, see *La Sculpture*, pp. 307–12, 329–30, and for electro-gilding, pp. 351–2.

For zinc, lead and iron sculpture, see *La Sculpture*, pp. 301–3 (but the survey of lead and iron ignores German sculpture and so is of limited value).

Other notable German and Austrian sculptors to work in lead were Balthasar Ferdinand Moll (1717–85), Jakob Gabriel

Mollinarolo (1717–80) and Johann Perger (1729–74). There is a good brief essay on lead sculpture by B.W. Lindemann in the catalogue of the exhibition *Edles aus Blei* organized by the Kaiser-Friedrich-Museums-Verein and held at the Dresdner Bank Berlin in 1990.

I know of no analysis of the alloy of lead used in superior works by such artists, but I have been informed that the equestrian statue of William III in Hull by Scheemakers contains between 27 and 30 per cent of tin and 3.5 per cent of antimony.

For Gilbert's *Eros*, see R. Dorment, *Alfred Gilbert*, New Haven and London 1985, pp. 108–14. Dorment discusses aluminium on p. 111. Gilbert attended lectures by William Anderson at the Society of Arts in March 1889 describing the Delville-Castner process developed in the previous year which made possible relatively cheap castings of the new metal. For aluminium, see Rich, *op. cit.*, pp. 131–3.

18 Embossed and Chased Metal

A useful general account of the working of silver is supplied in G. Holden, *The Craft of the Silversmith*, London 1934, and (compactly) in D. Sherlock, 'Silver and silversmithing' in D. Strong and D. Brown (eds), *Roman Crafts*, London 1976, pp. 11–23. For gold and some more recent techniques of working it,, there is an excellent introductory section entitled 'Materials and Techniques', in A.K. Snowman, *Eighteenth Century Gold Boxes of Europe*, London 1966, pp. 48–63.

Repoussé, with special reference to French medieval work in silver, copper and bronze, is discussed and illustrated in *La Sculpture*, pp. 313–24.

Ciselets and *ciseaux* are illustrated in *La Sculpture*, pp. 640–2.

The gold cup decorated with gazelles is discussed by H. Pittman in P.O. Harper (ed.), *Ancient Near Eastern Art*, Metropolitan Museum of Art, New York 1984, p. 31.

Jerry Podany, Conservation of Antiques at the J. Paul Getty Museum, kindly supplied me with information as to the parts of the gilded silver *rhyton* that are solid cast and those that are formed by raising and repoussé (letter of 17 November 1992).

The Greek repoussé bronze, perhaps originally a mirror back, is discussed in *Specimens of Antient Sculpture*, 2 vols, London 1832, II, text for plate XX, and by C. Smith in 'The new bronze relief in the British Museum', *Burlington Magazine*, VI, November 1904, pp. 99–101 – both engraving and photograph include the wax additions probably by Flaxman which have since been detached.

The statuette reliquary of Saint Christopher is discussed by M.E. Frazer in *Medieval Church Treasures*, Metropolitan Museum of Art, New York 1986, pp. 49–50.

There is a discussion of Canzler's *Joseph* and other reliquary busts by M. Hering-Mitgau in 'Von Holzmodell zur Silberplastik', in *Entwurf und Ausführung in der europäischen Barockplastik*, R. Volk (ed.), papers from an international colloquium held at the Bayerisches Nationalmuseum and the Zentralinstitut für kunstgeschichte, Munich, June 1985, Munich 1986, pp. 135–56.

The repoussé copper *White Tārā* is discussed in J.C. Harle, *The Art and Architecture of the Indian Subcontinent*, Harmondsworth 1987, p. 475, as part of a survey of Nepalese art (pp. 467–88).

Linda Scheifler Marks, Head of Conservation in the Asian Art Museum of San Francisco, kindly confirmed this analysis of the structure of the gilded-copper *White Tārā*. The alloy has not been tested, but its rosy colour reveals a high copper content. Ms Marks points out that, in addition to turquoise of various shades and what appears to be lapis and garnet, there are other green stones (some clear, some dark) and some rock crystals, some of which have red or green foil backing.

The white Tārā cast in silver is discussed in *Wisdom and Compassion: The Sacred Art of Tibet*, catalogue of the exhibition at the Asian Art Museum of San Francisco and the IBM Gallery, New York, 1991, and at the Royal Academy, London, 1992, p. 134, no. 26. The technical description there is, however, misleading: 'silver with gold and inlays of copper and semiprecious stones' – I could find no copper, and the gold is fire gilding with some traces of a gold paste. The blue pigment, much of which still covers the head, conceals lines of the hair carefully cut in the metal. There is a trace of vermilion on the lips and many traces of gold paste (as distinct from fire gilding) remains in the ears but also on the eyes and nose. There are holes beside the crown for attaching pendants and large sockets in the upper arms for attaching a cast lotus which originally coiled up the side of the figure. Iron chaplets can just be discerned to right and left above the waist. The cast is very heavy.

The Coins of Greek Sicily, by C.K. Jenkins, British Museum, London 1976 (1966), is a good introduction to this subject: the coin illustrated here is discussed on pp. 36–8. This booklet also supplies a succinct account of the technique of coin-making in the ancient world on pages 9 to 11. See also, for Greek coins more generally, C.K. Jenkins, *Ancient Greek Coins*, London 1972, and for Euainetos in particular, A. Gallatin, *Syracusan Medallions of the Euainetos Type*, New York 1930.

Glossary and Index of Materials, Tools and Techniques

THIS IS NOT A GLOSSARY of all materials, tools and techniques used for sculpture. It is confined to the types of sculpture that are covered by this book. So it does not include exposion casting, oxy-acetylene welders or polyester resins. It does, on the other hand, include adze, intermodel and spelter which, although not discussed in the previous chapters, are closely related to things that are: the reader might well expect to find such terms there. It includes only porcelain factories and stone quarries that are mentioned in the book, but attempts to be broader in its coverage of tools. Many foreign terms are included, but only such that enjoy some international currency (however limited) among experts – whether craftsment or scholars.

Ablaq Persian for 'piebald'. Islamic ornament, especially inlaid **marble**, which is black and white: 50.

Acacia Tree or shrub with many species. It was the most common and useful of the native woods in ancient Egypt: 280n.

Acrolithic Ancient Greek sculpture in which the extremities were made of stone or **marble** – literally 'stone-ended'. Originally used of wooden sculpture with head and arms and feet of marble. By extension applied to **limestone** sculpture with such marble adjuncts: 41, 70, 93, 274n, 277n; pl. 44.

Ad'apertura See **Book-matched**.

Adze A variant on the axe in which the metal blade is horizontal to the handle. It is used for much the same purpose as a wood **chisel** and often for work of similar detail, especially by African carvers.

Africano Italian masons' name for a mauve, pink and grey marble, with a bruised, broken and flecked pattern, quarried by the ancient Romans on the peninsular of Teos in Turkey (the site was rediscovered in 1966): 96; pl. 89.

After-cast A cast, generally in metal, made from moulds taken from a finished sculpture. The after-cast can usually be distinguished from its model by blunter details, but this is not inevitable, for the wax cast taken from the moulds can be carefully tooled before **investment** to match the finish of the original. The after-cast will, however, inevitably be slightly smaller than the original because metal shrinks on cooling – if the after-cast is in **clay** it will shrink still more, if in **gypsum plaster** it will expand.

Agate A gemstone, often banded, much favoured for **cameos**. A type of **Chalcedony**: 16, 21, 30, 95, 271n.

Aggregate Inert material mixed with a binder or cement to form a solid compound. Sand is the most common form of aggregate. See also **Grog**.

Alabaster A form of **gypsum**. Alabaster is a soft stone, often white or nearly so, favoured for sculpture that is not exposed to the elements – for instance, the wall reliefs of ancient Assyrian palaces and the tomb effigies of medieval European churches. The word is used also of a type of calcite which should, however, be distinguished as **calcite 'alabaster'**: 35–8, 60–7, 167, 276n; pls 35, 57, 58, 59, 60, 61, 62, 150.

Alabastro a pecorella Italian masons' name for a calcite 'alabaster' with a fleecy pattern quarried by the ancient Romans in Algeria: 98; pl. 87

Alabastro d'Egitto Italian masons' name for a **calcite** 'alabaster' broadly banded yellow and white, reworked from ancient Roman remains: pl. 90

Alabastro fiorito Italian masons' name for a **calcite** 'alabaster' with a pattern of concentric bands resembling rose petals quarried by the ancient Romans perhaps in Asia Minor.

Alabastro listato Italian masons' name for a **calcite** 'alabaster' with a banded pattern, generally reworked from ancient Roman remains, the best-known and most

294

prized type of which was *alabastro listato di Palombara*, named after the villa on the Esquiline Hill in Rome where it was excavated: 98–100; pl. 90

Aluminium Modern white metal obtained from bauxite. Aluminium first became available to the sculptor in the late nineteenth century: 254, 292n; pl. 219

Alwalton marble A dark, fossiliferous **limestone** quarried near Peterborough and used in some medieval ecclesiastical buildings for purposes very similar to **Purbeck 'marble'**: 114

Amethyst A gemstone. A type of **quartz**, purple or violet in colour, much favoured for **intaglios**: 16

Anneal To heat and then cool a metal to restore its malleability when it has become brittle or is showing a tendency to crack (often as a consequence of hammering): 219

Antimony Brittle metallic element of grey colour used especially in alloys, commonly with **lead**: 254

Antler Stag horn. The non-deciduous branched outgrowth on the head of the deer occasionally used for sculpture, e.g., in Japanese *netsuke*: 154; pls 139a and b

Aphrodysias Quarries in Turkey used by the ancient Romans for white marble: 44

Armature The internal support or skeleton used chiefly for modelling in a soft material (**clay** or **wax** especially) but also inserted into a cast of clay or plaster or into a **core** before it hardens. Sometimes used in the interior of a cast-metal sculpture – for instance, a steel armature is common inside a lead cast – or as a support for sculpture with a hammered copper skin: 172, 204, 215, 284n, 287n; pl. 193

Arsenic Brittle, grey, metallic element frequently used in early **copper** alloys: 219, 290n

Artificial stone A term sometimes applied to various cements and reconstituted stones but originally to a **stoneware** employed for sculpture and for architectural ornaments, and especially to **Coade stone**, which was, confusingly, also known as **terracotta**: 188, 285n

Bamboo Tropical giant grass of the genus *Bambusa* with a hollow jointed stem, used for weapons, pipes, food and also, in China, for ornamental carving: 137, 148, 282n; pl. 135

Basalt A dark, hard **igneous rock** sometimes employed for sculpture, especially in ancient Egypt. It is

occasionally confused with **basanite**. The type of black ceramic invented by Joshua Wedgwood and marketed as black basaltes was in fact an imitation of **basanite**: 24, 30, 105, 228

Basanite A type of greywacke formed by decomposed basaltic rock used for sculpture by the ancient Egyptians and by the Romans, and greatly prized. It varies in colour from very dark green to dark rusty brown and is often described as **schist** or even as **basalt**. Basanite, known to the Egyptians as the stone of Bekhan, came from Mount Uadi Hammâmât. It forms the matrix for the spectacular *breccia*, known as *breccia verde*, extracted from the same mountain: 1, 30, 228, 273n; pl. 28

Beader A punch with a hollow end used in **chasing** to fashion dotted ornaments in metal.

Bed The horizontal structure of **sedimentary rocks** – such as **limestone** and **sandstone** – formed by deposit in horizontal layers. Such stones are for the most part stronger if used in building in accordance with their natural bed, and many are vulnerable to frost outside and often also to damp inside if they are **face-bedded**: 114

Berchères The local limestone quarry used for the building (but not for the sculpture) of Chartres cathedral: 114

Bianco e nero antico Italian masons' name for spectacular black-and-white *breccia* quarried by the ancient Romans at Saint-Girons in the French Pyrennees. Available only from Roman ruins until the rediscovery of the quarries about a century ago: 96; pl. 89

Bigio morato Italian masons' name for the dark brown to grey marble (sometimes nearly black) quarried by the Romans at Matapan in Greece and sometimes used for sculpture: 93

Biscuit porcelain Unglazed **soft-paste porcelain**. That used by Sèvres for statuettes and groups in the second half of the eighteenth century was especially noted: 198, 285n; pl. 168

Black Helmet Common name of the *Cassis tuberosa* (or *Madagascariensis*), a helmet shell obtained off Jamaica, Nassau and New Providence much favoured for **shell cameos** in which the ground colour ranges from near black or deep claret to a pale fawn: pl. 17

Black marble Black marbles are usually, strictly speaking, **limestones** that can be polished. The chief source in Europe is Belgium. They were known also as

touch, touchstone and paragone. **Tournai** marble used in Britain for fonts and tombslabs in the Middle Ages is from Belgium, as is the huge slab of **Dinant** marble used by Sluter for the tomb of Philip the Bold. By the end of the sixteenth century Flemish black marble was being used in Italy – a striking example of its use is the statue of Stanislas Kostka by Legros. There were, however, limited supplies of black marble in Tuscany, and *nero antico* could also be used – as could *bigio morato*. Black marble was also found in Ireland and certainly used in England and possibly exported: 62–3, 96; pls 53, 60, 86, 90

Blanc de Chine European name for the Chinese **porcelain** made at Tê Hua in Fukien province in south-east China from the seventeenth century: 178–81, 184, 284n; pls 163, 164

Bloodstone 16, 33; pl. 136; see also **Heliotrope**.

Bole A fine compact clay which can be pale pink or dark greyish blue or green but which is usually an orange or red. It is used on top of **gesso** or other **whiting** as a preparation for **water gilding**. Its colour affects that of the gold leaf placed on top of it: 133

Book-matched Cabinet-makers' term for a common device in veneering. Two or four sheets of **veneer** are cut consecutively and thus have similar patterns. These sheets are reversed and turned so as to form a symmetrical pattern. When four sheets are used, this pattern is often called 'quarter-matched', and when the figure in the veneer consists of strong diagonals that are thus joined, the pattern is called 'diamond veneer' – there is also a 'reverse diamond'. The same method of decoration is used for marble veneering or **cladding**. A book-matched pattern is described by Italian masons as 'ad'apertura': 44, 96; pls 89, 90

Botticino marble A very fine and durable white **limestone** quarried near Brescia in North Italy and much used in that city and its neighbourhood, also further afield (most notably in Rome for the Vittorio Emmanuele monument): 58–60, 276n; pl. 56

Boucharde A pounding hammer of steel with rows of pyramidal teeth on the striking face (or faces). It is struck at right angles to a stone surface with the effect of a dense bundle of **points**. The word is French and the textures achieved with the *boucharde* are much favoured as a finish in traditional French masonry. **Granite** and other **igneous rock** is worked with a *boucharde* – this seems to have long been established in southern India. Today the *boucharde* can be operated by

electric power. North American masons call a *boucharde* a **bush hammer**: 88

Box Small evergreen tree or shrub of the genus *Buxus*, the dense golden or ruddy wood of which is much favoured for precise miniature carving and turning and also as a surface for wood engraving and for hollowing into moulds for **stucco** and **composition** ornament: 3, 144–50, 282n; pls 132a and b, 133, 134a and b, 136

Bozzetto Italian term for a sketch model generally of **clay** or **wax**, adopted by Italophile English-speaking art historians.

Brass A **copper** alloy, generally yellow in colour and often polished, which contains **zinc** in place of, or in addition to, tin used to make **bronze**. Brass was introduced into Europe from Asia by the Romans, and it remained for centuries after the decline of the Roman Empire the principal European copper alloy. In medieval Europe, metal sculpture tended either to be of brass or copper. This is true of north Indian sculpture made during the last five or six centuries: 2, 219, 221, 232, 242, 244, 254, 266, 288n, 289n; pls 57, 196, 210

Brazing A method of joining one piece of metal to another by making both red hot so that the metal fuses, sometimes used in conjunction with a molten metal of slightly different alloy, or **solder**.

Breccia Marble consisting of fragments of one or several marbles or limestones within a natural cement of a contrasting colour.

Breccia di Seravezza A *breccia* from the Tuscan quarries of **Seravezza**, commonly favoured for ornamental architectural features and especially highly prized in the eighteenth century for table tops: 95; see also *Brèche violette* and *Mischio di Seravezza*.

Breccia di Trapani A vivid orange and pale green *breccia* quarried near Trapani in Sicily. It is the most familiar of the *diaspri teneri* of that island and was popular throughout Europe as a **veneer** in the seventeenth and eighteenth centuries. In recent decades fragments of it (or of a very similar stone) have made an appearance in the *terrazzo* of more than one international airport terminal: 96, 278n; pls 85, 89

Brèche violette Common name for *breccia di Seravezza*. French is used because of its great popularity with French cabinet-makers: 95

Brocatello Italian masons' name for a marble with a small and elaborate fossiliferous pattern, bearing a very superficial resemblance to complex patterned brocade (after which it takes its name). The most common marble of this type was quarried by the ancient Romans at Tortosa in Spain. The quarries were opened again in the sixteenth century and the marble was used all over Europe.

Bull's Mouth Also Bulmouth. Disgusting common name for the *Cassis rufa*, a helmet shell from the coast of Sri Lanka, much valued for **shell cameos** in which the ground colour approaches the rich orange of **sardonyx**: 272n

Bronze An alloy of **copper** containing more than one or two per cent (in some definitions more than five per cent) of **tin** and sometimes also significant quantities of other metals, most notably **lead**. Bronze has not always been so defined. In Britain two centuries ago and before all ancient bronze sculptures were described as **brass**, whereas in most museums today brass sculpture – the 'bronzes' of Benin for example – are labelled as bronzes. Bronze is the material most favoured for metal sculpture. It was also important as a material for tools – and was used before iron was for the chisels used to work wood and stone: 2, 40, 73–6, 130, 176, 197, 198, 217–55, 288–92n; pls 85, 87, 89, 92, 194–5, 197–202, 211, 213–16

Burin A small steel tool with a square, lozenge or triangular section cut to a sharp point and used for engraving on a hard surface, especially one of metal. It is designed to be pushed by hand and generally has a mushroom-shaped handle. Also known as a **graver**: 130, 244

Burnish To polish by rubbing with a hard, smooth surface such as a piece of **agate** or a tooth, especially used for the high polish of **water gilding** or **fire gilding**. Often contrasted with **matt** or **semi-matt** gilding: 133

Bush hammer See **Boucharde**.

Cabochon Polished gemstone of rounded form: 133

Caenstone A limestone of a pale beige colour from Caen in Normandy, much employed for architecture and sculpture in Normandy and in England during the Middle Ages; revived in the nineteenth century: 279n

Calamander Streaky, exotic wood, related to **ebony**: 145; see also **Coromandel**

Calcagnolo A claw chisel with two long points, also known as a *pied de biche*: 84

Calcite 'alabaster' A white or near-white soft and often translucent type of limestone formed by direct precipitation of lime in spring water which is sometimes marked by banding and other patterns. The ancient Egyptians obtained this stone from Alabastron, hence the name 'alabaster' – the word has, however, since been appropriated by mineralogists for the superficially similar **gypsum alabaster**. Banded calcite 'alabaster' is known also as **onyx marble**, which can create still further chains of confusion: 2, 35, 41, 93, 98–101, 125, 273n; pls 34, 86, 92

Cameo A small-scale low relief in a stratified or banded material, usually a **hardstone** such as **onyx** or **sardonyx**, but also in **calcite 'alabaster'** or shell or glass, in which the ground is of one colour and the figure in relief in another colour (or colours): 16–19, 216, 272n; pls 15, 16, 17, 18

Campiglia White-marble quarry in the Maremma exploited by Florentines in the fourteenth century: 57

Candoglia Quarry in the Alps north of Milan yielding white – and often slightly rose – coarse crystalline marble. Much used for sculpture in Milan and its neighbourhood from the fourteenth century. There is, however, evidence that the leading Lombard sculptors by the late fifteenth century preferred to use **Carrara** marble when it was available: 53

Capodimonte The Royal Neapolitan porcelain factory founded in 1743, noted for its statuettes modelled by Giuseppe Gricci. The factory staff moved to Madrid in 1759: 183

Carrara Town in the Apuan Alps which has come to be identified with all the white marble quarried in that area: 52–60, 96, 274–5nn; pls 55, 77–80, 82–3

Carrières-sur-Seine Quarry of fine-grained durable limestone near Paris and on the River Seine: pl. 103

Cartapesta 176, 192; see also **Papier mâché**.

Cased glass See **Glass cameo**.

Cassis rufa See **Bull's Mouth**.

Casting on A process whereby an accessory (e.g., a sword), a projecting extremity (e.g., a handle) or a major repair (e.g., a new leg) is added to a cast-metal sculpture or object by attaching a wax model, making an **investment** and pouring in molten metal etc. according to the **lost-wax** method. By this process the

new metal is not actually fused (as is the case with **brazing** or **solder**), and as it cools it tends to contract from the main body of metal, but fixing is effected by a prong or **tang** projecting from or into the addition: 224

Cedar An evergreen coniferous tree of the genus *Cedrus* with hard and fragrant wood greatly prized both for architecture and for sculpture in ancient Egypt and in the near East: 143–4, 282n; pl. 131

Ceppo The conglomerate stone used for building in Milan and the vicinity. At its finest, a type of **sandstone**; at its coarsest, an ugly but interesting puddingstone: 53

Chalcedony Gemstone. A microcrystalline **quartz**, generally grey or green. Sometimes used for miniature sculpture: 12, 16, 271–2nn; pl. 14

Chalk A soft **limestone**. Chalk can be carved for interior use. It can also be pulverized and bound with animal glue in a form of **whiting**: 132, 194; see also **Clunch**.

Champlevé enamel Enamel that is fired within grooves cut into a metal surface and afterwards polished down: pl. 209

Chaplet Chaplets (there are always more than one and often very many) are **core pins**. They can consist of thin drawn wire in a statuette or thick bars of metal in a massive work. The chaplets are driven through the hollow wax prepared for a **lost-wax cast** into the **core** within. Their projecting points are then incorporated into the mould **investment**. When the wax is melted out the chaplets prevent the core from drifting out of place. When the metal is poured in they are incorporated into it, and when the investment is broken off they project from the surface of the metal. When they are made out of the same copper alloy as the cast (as is not uncommon) they are hard to discern once they have been filed down. When made of iron they are often visible and may be located with a magnet. When the bronze wall is thin and the core is removed, the chaplets commonly fall out or are removed, leaving a hole to be plugged. The term 'chaplet' is sometimes used today for a refractory spacing block between core and mould rather than for a pin attaching them: 222, 228, 289n

Chasing The tooling of metal which involves the denting rather than the engraving of the surface. Chasing tools are **tracers**, *ciselets*, **punches** and **matting tools**: 257; pls 221–8

Cherry A fruit tree, the wood of which was favoured for small sculpture and miniature carving.

Chestnut Trees of the genus *Castanea*, the wood of which was sometimes used for sculpture in medieval southern Europe: 130

Ching-te Chen Site of important southern Chinese porcelain kilns which in the thirteenth century and later made some sculptural figures: 178; pl. 162

Chipping out The method of removing the **investment** using a blunt **chisel**.

Chisel A metal tool (bronze, iron or steel) for carving. Chisels for stone are generally designed to be struck with a hammer (in which case they are constructed entirely of metal). Chisels for wood are generally designed to be struck with a mallet (in which case they have a wooden handle): 40, 84–91, 130, 248, 257; see also *Calcagnolo*, *Ciselet*, *Ciseau*, **Claw chisel**, *Dente di cane*, **Drove**, **Gouge**, *Gradina*, **Graver**, *Pied de bliche*, **Pitcher**, **Point**, **Tooth chisel**.

Cintoia Limestone quarry near Pistoia, a source for the pink-and-russet stone used in combination with white marble in Florence: 52; pl. 50.

Cipollino Banded green-and-grey marble, so called from the resemblance of its bands to the layers of an onion; quarried by the ancient Romans at Carystos on Euboea: 274n

Cire perdue See **Lost-wax**.

Ciseau A chisel that cuts or engraves the surface of metal; distinguished by the French from a *ciselet*: 254, 257, 292n

Ciselet A chasing **chisel** or **tracer** which dents rather than cuts a metal surface: 254, 257, 292n

Cladding The application of **marble** or other stone to a wall, generally in rectangular slabs. A heavy and large-scale **veneer**: 30, 44

Claw chisel A **chisel** with two or more points: 84–91, 277n; see also **Tooth chisel**, *Gradina*, *Pied de biche*, *Calcagnolo*, *Dente di cane*.

Clay Stiff and sticky natural substance – a common form of soil – which is composed in its pure form of the dust from **igneous rocks** combined with water. It can be used both for moulding and (in most forms) for modelling and is commonly fired: 4–5, 16, 70, 165–91, 201–14, 221, 270, 283–7nn; pls 148, 149, 151–61, 178–89

Cloisonné enamel **Enamel** that is fired within compartments divided by narrow walls of metal, often forming pictures or patterns out of contiguous shapes of different colours.

Clunch A type of **chalk**, harder than common chalk, used for sculpture, especially architectural sculpture (but only such that is protected from the elements): 119, 280n; pls 106–8

Coade stone Known also as 'Coade's Stone' or 'Mrs Coade's Stone', a so-called **artificial stone**; in fact, a highly durable **stoneware**, consisting of **grog**, flint, **quartz** sand, ground glass and **clay**, available in Britain from about 1770 and popular for architectural ornaments and garden sculpture. It was hollow cast from **piece moulds** and tooled with great precision before casting: 188–9, 285n; pl. 169

Cold colours Colouring applied (generally painted) to **bronze** or other metals after casting and to ceramics after firing: 184

Colombara Grotta Colombara. White statuary-marble quarry in the Apuan Alps near **Carrara**, opened during the fourteenth century: 52

Colorado-Yule marble Near-white limestone, pinkish when polished, much used for monumental architecture, and sometimes employed for sculpture, in North America: 58

Composition A material, commonly abbreviated as 'compo', consisting of **whiting** and linseed oil or some similar mixture, used for casting ornament of a small size often in **boxwood** moulds, commonly applied to wood.

Conflans-Sainte-Honorine Quarry of fine-grained durable limestone near Paris and on the River Seine at its confluence with the Marne: pl. 103

Copeland Ceramic factory at Stoke-on-Trent, Staffordshire, previously owned by the Spode family and acquired from them by W.T. Copeland in partnership with T. Garrett in 1833. Especially noted in the mid-nineteenth century for **Parian ware**: 67

Copper A metal used for sculpture, often as an alloy (see **Bronze** and **Brass**). More or less pure copper has been used for sculpture in some periods and parts of the world – for many of the solid-cast sacred 'bronzes' of southern India, for example, and for many sculptures that were **fire gilded** or worked in **repoussé**. Fragile and flexible accessories in bronze sculpture (e.g., horses' reins or martyrs' palms) are often made of copper, and

it was used also as an inlay or plating (e.g., for the nipples and lips of Greek and Roman bronzes): 219, 221, 232, 236, 237, 239, 254, 257–67, 288n, 289n, 290n, 293n; pls 55, 113, 190, 200, 201, 202, 203, 204, 212, 217, 218

Core The centre (in Italian, the 'anima', the soul) of a hollow metal cast, often extracted after casting. A core is generally composed of either clay or plaster with **grog**. The advantage of removing it is to lighten a cast (a statuette is thus made easier for a connoisseur to handle and a statue less of a burden for the devout to carry in procession). A core can consist of an original model pared down. More usually, either it consists of a simple shape over which a wax model was formed or it was poured into a hollow wax cast (see **Lost-wax casting**, **Direct cast** and **Indirect cast**). It frequently contains an **armature**: 221, 226, 289n

Core pin 222; see also **Chaplet**.

Cornelian A gemstone. A type of **quartz**, red or pink, much favoured for seals or **intaglios**: 16

Coromandel Streaky exotic wood, related to **ebony**: 145; see also **Calamander**

Corundum Crystallized allumina used as an abrasive and polish: 11, 14; see also **Emery**.

Crevole Quarry for dark **serpentine** near Siena, used in conjunction with white marble in the architecture of that city: 52

Cypress A coniferous tree of the genus *Cupressus*, the wood of which was much favoured for sculpture both in the ancient Mediterranean and the Near East but also in Japan: 138–42; pls 112, 128, 129

Da-li Ta-li. Marble with grey-and-green patterns often suggestive of misty landscapes quarried in Yunnan province, China, in the eighteenth century: 47, 275n

Death mask A cast of a dead human face taken from a mould made by pressing **gesso** onto it. **Piece moulds** can be employed, but a face is generally sufficiently flexible for it to be freed from the hardened mould, provided a **parting agent** has been employed. A mask can also be made from the face of a living human being, but precautions must be taken to enable the subject to continue breathing: 197

Dente di cane Dog's teeth. Italian for a fine form of **claw chisel**, consisting of a flat chisel with half a dozen (or so) fine notches: 84

Diaspro di Sicilia Literally Sicilian **jasper**. A term applied to *diaspro tenero*, although confusingly because Sicily abounds in real (hard) **jasper**: 96, 278n

Diaspro tenero Plural *diaspri teneri*. Literally soft **jasper**. The name given by Italian masons to a range of brilliantly coloured calcites which take a high polish and are found in Sicily: 96; pl. 85

Die The metal form engraved in negative or **intaglio** by which a coin is made by striking: 267–8; see also **Trussel**.

Dinant See **Black marble**.

Diorite A hard **igneous rock** occasionally used for sculpture in the ancient Near East: 2, 24, 30, 273n

Direct cast The technique of **lost-wax casting** in which the original model is lost. In such work – if hollow – the wall of metal is generally heavy, for the wax model is modelled thickly over a **core** of very simple shape. Cf. **Indirect cast**.

Dokimeion Quarries for white and other marbles in the Roman province of Phrygia, near present-day Afyon in west central Turkey. The quarries were most famous for *pavonazzo* and *pavonazzetto*, much valued by the ancient Romans for **monoliths** and **cladding**, but they also supplied numerous white-marble sarcophagi, partly sculptured on site. The quarries' products were exported in the second and third century AD by road and river across Asia Minor and then by sea to the Western Empire: 44, 81; pl. 74

Dolerite A hard **igneous rock**, related to **basalt** and **diorite**, and sometimes used for sculpture, but also favoured as a tool for pounding other, less hard igneous rocks (e.g., **granite**): 22

Dowel A method of joining, whereby a peg or headless pin (generally turned if of wood, or naturally cylindrical, e.g., bamboo) is inserted into drilled holes in the two pieces to be joined. Dowel is used as a noun (refering to the peg or pin) as well as a verb: 119, 137; pls 68, 115, 116

Drill A tool that bores a hole when revolved. In the most primitive examples it is revolved between the palms; then it was operated by means of a bow, and later also with a brace. The cutting is generally achieved by a metal point, but in some cases the point of the drill is used with abrasives: 7, 16, 79, 81–4, 268; see also **Running drill**.

Drove A flat **chisel** with a broad head generally used for broad, and often only for preliminary, working on stone.

Earthenware Baked clay which remains porous unless glazed: 165, 169, 176–7, 195, 214, 269; see also **Terracotta**.

Ebony Hard, heavy black or nearly black wood from the heart of tropical trees of the genus *Diospyros*, much prized in ancient Egypt and in other Mediterranean civilizations, for small sculpture and ornamental utensils, and also favoured in Europe from the second half of the sixteenth century onwards for small sculpture but especially for *de luxe* cabinets. For this last purpose it was often applied as a **veneer**, giving its name in France to the craft of *ébéniste*: 145, 148, 282n; pl. 136

Electroplating The coating of base metal (generally nickel, but also **copper**) with **silver** or **gold** by electrolysis: 254, 292n

Electrotype The reproduction of a model by coating a mould taken from it with metal (most commonly **copper**) by electrolysis: 254, 292n

Electrum A natural alloy of **gold** and **silver**, pale gold in colour: 257

Emery Coarse **corundum** used as a powder or paste for the abrasion and polishing of stone or metal: 11, 14, 38

Emboss **Repoussé**. To work relatively thin and malleable metal with hammers, **punches** etc. mostly from behind: 257–67

En basse taille **Enamel** of translucent colour applied over gold or gilded **copper** (or, less commonly, **silver**), and sometimes over reliefs, in which case the colour is richest where the relief is deepest.

En ronde bosse **Enamel** that is used to cover metalwork in the round or in high relief – a miniature stag might thus be of white enamel upon a field of **gold** with green enamel *en basse taille*.

Enamel A coloured glass flux which can be combined with metal by heating. Enamel is generally applied ground-up as a paste. The colours are obtained by heating silicon with metallic oxides: green from copper, yellow from iron or silver, blue from cobalt, red from gold, purples from manganese: 242

Enamel colours Pigment used for decorating metal-work, glass and (above all) ceramics, consisting of metallic oxides mixed with powdered glass fixed by a separate firing, chiefly used for the colouring of **porcelain**: 183–4; pl. 166

Épouser French to marry, applied metaphorically to the penetration of a mould: 194

Face-bedding When a **sedimentary rock** is turned away from its natural **bed** in order to obtain a larger vertical block: 114

Fettling **Repairing**. The trimming and cleaning of clay and other ceramic bodies before firing. Also used for the cleaning of metal after casting: 196

File A metal tool with a roughened surface or surfaces used for shaping and smoothing. Files for smoothing metal and often for wood consist of **steel** that has a grooved surface. When the file's surface is both toothed and perforated, the file is a **rasp**: 81, 248

Fire gilding Process for the gilding of metal – usually **copper**, copper alloy or **silver** – known also as **mercury gilding**. Milled **gold** (*or moulu* – hence **ormolu**) mixed with mercury is applied to the surface of the metal as a paste and then fired. The mercury evaporates as (highly toxic) fumes, and the gold is fixed. It then has to be **burnished**: 237–44, 252, 266, 291n; pls 190, 205, 207a and b, 209, 217, 218, 228, 229, 237

Firing cracks Cracks caused by tension from the different rates of shrinkage of a cooling material – for example, in metal after it has been cast or in clay after it has been fired: 169, 184, 201, 221, 240, 244, 247; pls 179, 196, 211, 212a and b

Firing skin The hard, smooth surface of earthenware or other ceramic body: pl. 178

Flashing The fine but rough-edged projections or fins on a casting made from a **piece mould** where the metal has seeped or forced its way into seams, joins or cracks in the mould. On the exterior of a cast these are generally sawn off and filed down: 221, 228; pl. 196

Formatore Italian for a maker of *forme* (moulds), especially applied to **gesso** moulds and casts; a specialized profession in which Italians excelled and were employed all over Europe in the nineteenth century: 199; pl. 177

Foxglove-tree Tree of the genus *Paulownia* used for sculpture in China: 138, 281n

Free carving Carving that dispenses with the **pointing machine**, and instead follows a drawing on the faces, or merely on the principal face, of a block. The term was favoured by purists among European artists working in the early twentieth century who were eager to re-establish the fundamental difference between the processes of modelling and carving.

Galvanoplastic See **Electrotype**.

Garnet A semi-precious hard stone of glassy character, the deep red variety of which is valued for jewellery. It has been used also as an abrasive: 11, 293n

Gelatine Material made of animal glue which is flexible when warm and can be used for mould-making: 196, 286n

Georgia State marble Principal true-white statuary marble of North America, quarried at Tate in Pickens County: 57–8; pl. 54

Gesso A type of **whiting** and commonly confused with lime composition (see **Stucco**) and even **slip**. Gesso is made from **gypsum**. It is much used for casting and also known as **plaster of Paris**. When applied as whiting it is made with glue. Gesso is used as a material for moulds as well as a material poured or pressed into moulds. But if used for moulds into which molten metal is poured, it must be hardened with sand as a **grog**. The finest gesso is reputed to be that manufactured at Bologna and Volterra: 132–5, 143, 188, 194–9, 204, 205, 237, 284–5nn, 285–6nn; pls 14, 39, 113, 170, 175–7

Giallo antico Italian masons' name for a yellow marble, sometimes with a pink tinge, and also available as a **breccia**, quarried by the ancient Romans at Chemtou (Simitthus) in North Africa. The quarries were discovered and reworked in the last century: 93, 96; pls 86, 90

Gilding See **Oil gilding**, **Water gilding**, **Fire gilding**, **Mercury gilding**.

Glass cameo Cameo cut in layers of glass of more than one colour – generally white on blue – known also as **cased glass**: 19, 272n; pl. 18

Glyptic Greek for that which is carved, or can be carved. Distinguished from **plastic**: 70

Gold Precious metal remarkable for its ductility and incorruptibility, generally alloyed with **copper**

or **silver** when used for sculpture: 225, 230, 232, 257–8, 290n, 292–3nn; pls 199, 221, 222

Gold leaf Gold 'to airy thinness beat', available in different colours according to the proportion of copper or other metal in the alloy. Used in **water gilding** and **oil gilding**: 103, 143; pl. 113

Gouge A **chisel**, generally for carving wood, the blade of which has a curved section and leaves a concave cut. There are numerous varieties, many of which are designed to be pushed by hand rather than used with a mallet: 130

Gradina Italian for **claw chisel**: 84

Granite An **igneous rock** consisting of feldspar, mica and **quartz**, used for sculpture by a few civilizations. Granite is often used loosely to refer to related igneous rocks, e.g., **granodiorite**: 4, 21–30, 32, 69, 93, 111, 272n, 275n; pls 21, 25–7

Granodiorite A hard **igneous rock** related to both **diorite** and **granite** and described often as **black granite** by archaeologists. The granodiorite quarried near Assuan by the ancient Egyptians is dark brown and grey with gold flecks and dirty pink bands or blots: 21–4, 272n; pls 19, 20, 22

Graver A sharp tool, generally of steel, with a triangular section, used to cut into metal or wood. It is generally designed to be pushed by the hand and hence has a mushroom handle. See **Burin**.

Greenstone Green or greenish-coloured **igneous rock** containing feldspar and hornblende; a meta-**basalt** containing abundant unaltered augite and labradorite, used for sculpture in southern India: 26; pl. 24

Greenware Chinese **stoneware** with a high-fired green glaze: 201, 286n; pl. 179

Grog More or less inert filler such as pulverized brick or pottery mixed with **clay** or plaster, used both for moulds and **cores** and for objects cast and modelled. When added to clay it raises its firing temperature and makes it more stable – but it can also alter its appearance: 188, 191, 226, 286n

Gypsum The mineral calcium sulphate dihydrate, one form of which is **alabaster**. When heated it forms the powder calcium sulphate hemihydrate – **gesso** or **plaster of Paris** – which, when mixed with water, sets hard: 35, 138, 184, 194, 286n

Hardstone Imprecise term for stones used for inlay, ranging from **marbles** and **calcite** 'alabasters' to semi-precious **agate** and **jasper**: 5, 16–17, 73, 252; see also **Pietra dura**.

Heartwood The dense interior part of a tree trunk yielding the hardest timber. It is generally separated from the outer wood – or **sapwood** – by sculptors because these two parts of the tree dry out at different rates. Sculptors working on a small scale tend to use only the heartwood. Those working on a larger scale generally use only the sapwood.

Heliotrope A variety of **quartz**, opaque, dark green and speckled and streaked with dark red, known also as **bloodstone** and as Bohemian jasper: 150

Hollowing Wooden sculpture is often made hollow or partly hollow to avoid strain caused by the different rates of shrinkage in **sapwood** and **heartwood**. Stone is also hollowed out, but to enable it to be supported (in the case of bust sculpture especially) or to be transported and lifted more easily (in the case of a statue such as Donatello's for the cathedral façade in Florence, pl. 52). **Bronze** and ceramic sculptures are made hollow, chiefly to ensure that no part is much thicker than any other; such differences in thickness would create tensions in the metal when cooling and in the ceramic during firing, when both materials shrink: 127, 139–42, 201, 204, 221

Honestone See **Solnhofen Stone**.

Horn The deciduous outgrowth of the head of many types of mammal. The horn of the **rhinoceros** was favoured for sculpture in China: 1, 152; pls 138, 139a and b

Hornton Quarry for limestone in north-west Oxfordshire: 121, 280n; pl. 111

Hungarian marble Red mottled **limestone** similar to **Verona marble** quarried near Esztergom on the Danube, and much employed throughout Central Europe: 112, 279n

Igneous rock Rock formed by the cooling and solidifying of the subterranean molten mass of the earth, e.g., **granite**, **granodiorite**, **diorite**, **dolerite**, **obsidian**, **basalt**, **porphyry**: 21–33

Indirect cast **Lost-wax** metal cast in such a way that the model that is 'lost' is not the original model but a wax cast of the latter – this cast sometimes being known as an **intermodel**. The cast is made from a **piece mould**. If the cast is hollow, a **core** is poured into it. The ancient Greeks developed this method of casting – which has the advantage of ensuring an

even wall of wax (and hence bronze), and of enabling repairs to be made, if part of the cast was defective, or another version to be made (the whole cast having failed). And, of course, it also facilitates the repetition of a bronze, for the original model is preserved. The method was rediscovered in the Renaissance.

Intaglio Small-scale hollow or negative relief or seal usually cut in a **hardstone** or metal die which, when pressed or stamped into a soft substance, gives as an impression a positive relief: 16, 166, 168, 268, 285n; pl. 13

Intarsia Properly, *lavoro di intarsia*. The inlay of woods of varied figure, grain and colour (both natural colour and stained) to form a pattern or picture. **Ivory** or, more commonly, bone is sometimes incorporated into the designs: 148, 282n

Intermodel Known sometimes as counter model. See **Indirect cast.**

Investment The mould around the wax model in the **lost-wax casting** method, consisting of plaster or **clay** mixed with **grog.** It can be applied in layers, with the finest and softest layers painted or gently worked over the wax model and the outer layers reinforced with wire: 221

Iron Silver-white metal more familiar as dark ruddy brown from oxidization, used for tools – **chisels, drills, hammers, files** – and as an **armature,** but also forged into ornamental forms and hollow cast as sculpture. Cast-iron sculpture is particularly associated with ancient China, but was popular also in Britain, France and Germany in the last century: 40, 119, 221, 254, 269, 273n, 289n, 292n.

Istrian stone Limestone from Capo d'Istria on the coast to the east of Trieste, used extensively for architecture under the Byzantine Empire, when it was transported by sea to Ravenna and further. After the quarries had became part of the Venetian Empire the stone was used extensively throughout their mainland territories and in Venice itself for both architecture and sculpture. Like **Portland stone** and other limestones, it bleaches on exposure to the elements. Thus the Istrian stone façades of Palladio's churches are brilliant white against the blue sky, but inside the entablatures and columns of the same material are grey against white plaster: 58, 276n; pl. 55

Ivory White or near-white organic substance obtained from the tusks or teeth of mammals, most notably from the elephant but also from the walrus, hippo-

potamus and whale: 3–5, 143, 148, 153–63, 184, 186, 270, 282–3nn, 285n; pls 140–7

Jade A semi-precious **hardstone,** a member of the tremolite-actinolite family of minerals, obtained as a pebble or boulder in many colours and worked with abrasives to form sculpture and ornaments, usually small in size, especially in China: 2–4, 7–14, 21, 148, 154, 266, 271n; pls 4–11; see also **Nephrite.**

Jadeite A semi-precious **hardstone,** once considered as a type of **jade** and superficially similar to it. It is worked in a similar way to jade and often by the same craftsmen (in China and Mexico), but it is of different structure, and a member of the pyroxene group of minerals: 12

Jalee work Or jali. Urdu for a pierced stone screen usually of white **marble** or fine red **sandstone,** typical or Mughal architecture: 50; pl. 48

Jasper Opaque variety of **quartz,** brilliantly figured and coloured red, yellow or brown; 95, 98, 150; see also *Diaspro tenero.*

Jet A black fossil found in lumps which takes a polish. It is often worked into small ornaments and sometimes into sculpture: 1–3, 271n; pls 3a and b

Juniper Evergreen tree or shrub of the genus *Juniperus,* the wood of which was used in ancient Egypt and Greece for sculpture: 144, 282n; pls 132a and b

Kanshitsu Japanese technique of building up layers of **lacquer** reinforced with hemp over a clay **core** to form hollow sculpture: 142

Kaolin Fine white primary **clay,** known also as China clay, made from the decomposition of feldspar, used in the making of **porcelain.** The material is used for casting and for **slips** but is insufficiently **plastic** to use as a material for modelling. It is used also as a **whiting** both on earthenware and on wooden sculpture: 138, 165

Lacquer Sap of the lacquer-tree (*Rhus vernicifera*) used in China and Japan especially, as a material for a special form of sculpture in which layers are built up, often on a base of silk around a model of another material which is later removed. When hard, those layers can be carved. Also a varnish made from this material (but more commonly from **shellac**) is used as a protective or ornamental coating on many different materials: 138, 142, 240, 247, 252; pl. 208; see also *Kanshitsu.*

Lamination The superimposition and fixing of layers – in wood, the assembly of a block for carving out of several planks, or, better, out of several pieces of the same plank. The planks can also be carved or partially carved prior to their assembly: 129

Lapis lazuli Sodium aluminium silicate sulphate, a bright blue, hard stone containing golden specks, which is the source of the precious pigment ultramarine and is also used for **intaglios** and for decorative inlays. Before the nineteenth century lapis lazuli was obtainable only from mines in Badakshan in what is now north-eastern Afghanistan: 33, 293n

Larvikite Dark **igneous rock** from Sweden, shimmering when polished, much employed by modern architects as a **veneer**: 114

Latex Cold curing rubber forming an elastic skin used for flexible moulds. Latex replaced or supplemented **gelatine** as the material favoured for this purpose. Largely replaced by silicone compounds and polyurethane plastics.

Lead Heavy, easily fusible, and malleable base metal of a dull grey colour. Lead was added to **bronze** alloys especially by the ancient Chinese, by the Etruscans and by the Romans, forming an alloy sometimes known as leaded bronze. Lead was used also as the principal metal in some alloys used for cast sculpture generally combined with **tin** (see **pewter**) or **antimony**. Such sculpture often requires an **armature**: 219, 222, 230, 254, 290n, 292n

Lead glaze A vitreous coating applied for practical and ornamental purposes to **earthenware**, consisting of a powder of lead oxide with silacious sand, salt and potash which fuses to the surface when fired. It is transparent but colour can be added: 172, 176

Lime Lime (North American, **linden**) is a tree of the genus *Tilia*, with a soft and pale wood much used for sculpture in some parts of Europe, especially in Bavaria, Swabia and Austria: 130–3, 135–6, 150, 280n, 285n; pls 120, 121, 136

Lime Powder made by roasting, chopping and slaking **limestone**. It is the chief component of common plaster and mortar – and also of **stucco**: 191, 193

Limestone Stone composed mainly of calcium carbonate, much of it sedimentary and formed by fossil deposits. Limestone that can be polished is commonly decscribed as **marble**: 4, 23, 38, 40, 41, 65, 69, 112–21, 181, 193, 273n, 276n, 278–80nn; pls 33, 36, 44, 57, 63, 81, 101–9, 111

Linden See **Lime**.

Loess The fine dust of wind-eroded **igneous rock** used in some **earthenware**: 224

Loop tools Tools made of non-ferrous metal, often a copper wire, devised for working clay. A loop of wire with a finer wire wound around it has a toothed cut.

Lost-wax casting *Cire perdue*. The casting of sculpture (or objects) by a process in which a wax model in a refractory mould or **investment** is melted (and poured or burned out), leaving a cavity into which molten metal is poured. In its most primitive form this is a method of solid casting, but hollow lost-wax casting is usual. It necessitates a **core**: 218, 220, 225, 254–5, 288–90nn; pls 194–6, 203–19, 223, 229; see also **Direct casting** and **Indirect casting**.

Luna marble The Roman name for marble quarried in the Apuan Alps at Luni near modern **Carrara**: 274n

Luting A potter's term for the application of smaller moulded or modelled ceramic components to a larger moulded or turned form using **slip** as a cement: 169

Mahogany Ruddy brown wood, often beautifully figured, obtained from a variety of tropical trees and much used for furniture; frequently carved, generally polished, especially in western Europe during the eighteenth and nineteenth centuries: 150

Main case See **Mother mould**.

Maiolica Or *majolica*. **Tin-glazed earthenware**, so named from Majorca whence early specimens were imported to Italy from Islamic Spain. The term is sometimes confined to Italian work, faience and Delftware being applied to the wares made in imitation of such work at centres north of the Alps (faience deriving from Faenza, a major Italian centre of production): 176

Makrana A major quarry of white marble in west central India. Much used by the Mughals – most famously for the Taj Mahal. It has large crystals, like some Greek island marbles: 49; pl. 48

Malachite Banded green ornamental stone, available only in very large quantities in Russia; much used as a semi-precious stone in jewellery: 19

Marble A **metamorphic rock** much used for sculpture. White marble has been quarried for sculpture in Italy, Greece and Turkey, also in parts of India and China and in the U.S.A. The chief source of supply in recent centuries has been the area near **Carrara** in the Apuan Alps. In common usage, 'marble' is used of any

stone that takes a polish, but in the trade such stones are generally divided into **granites**, **serpentines**, **alabasters** and marbles. Many stones that are described as marbles by the trade – and for centuries by craftsmen who used them – are, in fact, **limestones**: 2–4, 35–101, 105, 111, 198, 270, 273–8nn; pls 37, 38, 40, 41, 43–55, 64–80, 82–4, 86, 88, 89, 90–2

Marquetry Inlay or, more commonly, **veneers** of wood forming a pictorial design: 148; see also **Parquetry**.

Marmara See **Proconnesos**.

Matt A dull or non-reflective surface. In gilding, often used of **water gilding** which has been burnished and then subdued with a toned varnish or glaze, in Italian 'velato'. In metal sculpture, a surface that has been given a minutely textured surface.

Matting tools Punches with patterned striking faces – commonly criss-crossed and granulated – used to texture metal surfaces after casting. Part of the process of **chasing**: 254; pl. 217

Meissen The first European factory to make true **porcelain**. It operated under the patronage of the Elector of Saxony and was founded in 1710: 181–4, 284n; pl. 165

Mercury gilding See **Fire gilding**.

Metamorphic rock Rock formed from **igneous** or **sedimentary rock** subjected to great heat and pressure and hence changed in crystalline structure: 38; see also **marble**, **slate**, **schist**.

Mischio A smoky pattern in a **marble**: 95; pl. 88

Mischio di Seravezza A marble with a smoky pattern of violet and pink found in the Tuscan quarries of Seravezza and first exploited in the mid-sixteenth century: 95; pl. 88

Monolith Greek for a single stone, applied to large sculpture or, more commonly, to column shafts made of a single large stone: 2–3, 21, 120; pl. 51

Monsummano Limestone quarry near Pistoia; a source for the pink-and-russet stone used in combination with white marble in Florence: 52; pl. 50

Montagnola Quarry for white marble near Siena: 51

Monte Pisano Quarry for white marble near Pisa: 51

Montieri Quarry for red limestone near Siena: 52

Mother mould Founders' term for the outer part of a mould, generally composed of two large pieces embracing the numerous sections of the **piece mould**. Known also as **main case**.

Nanto Limestone quarry near Padua: 56

Naxos Cycladic island with white-marble quarries. The marble is noted for its coarse grain: 40, 42; pls 37, 64

Nephrite 7; see also **Jade**.

Nero antico See **Black marble**.

Niello A soft, black alloy, generally a compound of silver sulphide, used as an inlay in metalwork. There are many recipes, some involving **lead** and **copper**. It is generally inserted as a powder into lines or slots cut in the metal and then hardened by firing: 230; pl. 202

Nymphenburg The porcelain factory near Munich under the patronage of the Elector of Bavaria founded in 1747: 146, 183–6; pls 166, 167

Oak Tree of genus *Quercus*, the hard timber of which is much valued for building and shipbuilding and also favoured for sculpture, especially in northern Europe: 126–30, 280; pls 116a and b, 117, 118, 122–3

Obsidian An **igneous rock**, black or very dark volcanic glass, shattering into razor sharp blades which were used as tools, for instance for working marble on a small scale, and also as an ornament and for one small but vital sculptural purpose – the pupils of inserted eyes: 9, 35, 38, 125, 143, 195; pls 113, 131

Oil gilding Gold leaf applied to a surface prepared with a mordant size or adhesive (generally consisting of linseed oil boiled with a drier, and often with a colouring agent). Unlike **water gilding**, it can be applied without **whiting** onto wood or (less commonly) stone, but it cannot be burnished as water gilding can be, and it does not last as well, the oil often perishing or darkening: 133, 281n

Onyx A semi-precious, translucent **hardstone**, a type of **quartz**. It is in most definitions banded black (or near black) and white, but it is frequently confused with **sardonyx**. Onyx is commonly used for **cameos**. The word is also used of calcite 'alabaster': 16–18, 98, 271n

Onyx marble The modern trade name for banded calcite 'alabaster' which resembles in its markings and translucency the semi-precious stones **onyx** and

sardonyx – which are, however, available in much smaller pieces and are far harder: 35, 98–101

Ormolu From the French for milled gold, *or moulu*: 237; see also **Fire gilding**.

Papier mâché Known also as *Carta pesta*. Material for **press moulding**, composed of paper pulp and off-cuts in a variety of formulae. At first used for low reliefs in Italy in the fifteenth century and subsequently popular from time to time elsewhere in Europe for ornamental furniture etc.: 176

Paraffin Colourless inflammable oil or wax obtained by the distillation of petroleum or shale and used as a substitute for bee's wax, or to supplement it, as a material for modelling: 216

Parian ware Unglazed **porcelain** or porcelaineous **biscuit** ceramic ware popular for statuettes in mid-nineteenth-century Britain: 67, 186, 276n; see also **Copeland**.

Paros Cycladic island with white-marble quarries and mines, the mines producing the most highly prized of all white Greek marbles among the ancients: 42; pls 37–8, 44, 64

Parquetry **Marquetry** of a geometric design: 148

Parting agent The substance employed in the casting of **clay** or plaster that prevents the body pressed or poured into the mould from adhering to it. In the case of clay which, as it dries, shrinks from the mould, talc or **chalk** is often used; in the case of **gypsum** plaster, which expands as it sets, a grease or oil or soap is used.

Pastiglia Surface decoration by controlled dripping of **gesso** to build up the surface into a pattern of soft low relief which was then **water gilded** – the result resembling **embossed** gold or gilt metal: 133; pls 122, 123

Pâte sur pâte Low-relief decoration in **porcelain** achieved by painting successive coats of **slip** onto the main ceramic body and sometimes tooling these when hard: 19

Patina The colouring, and occasionally incrustation, of metal sometimes devised or anticipated, but, often, at least in its extreme forms, unintended, by the sculptor. The rich greens and occasional blues and reds that **bronze** can acquire when long buried in soil or immersed in water were probably unknown to the sculptors of ancient China or Greece whose work has since been enormously prized for this adventitious beauty. Natural patinas are often stimulated, or simulated, by pickles and other chemical treatments of the metal (see **Sulphides**). The term 'patina' is often used also of varnishes and even paints applied to the surface of the metal: 4, 130, 217, 228, 230, 232, 290n

Pavone Literally a peacock. *Pavone*, *pavonazzo* and *pavonazetto* are Italian masons' terms for white marble with mauve or purple stains and veins esteemed by the Romans especially for **monoliths** and **cladding**. This marble was obtained chiefly from the quarries of **Dokimeion**, which also yielded white marble.

Pear The fruit tree whose wood was most favoured for small sculpture and miniature carving. **Cherry** was also popular: 145–6, 150, 285n; pls 133, 136

Pentelikos Mountain to the north-east of Athens yielding marble that was much quarried by the ancient Greeks. Pentelic marble is characterized by its golden tone, deriving from the presence of both **iron** and mica, which were, however, disadvantages to the quarrymen, spoiling many blocks. The other decisive disadvantage for the development of the quarries was the lack of water transport: 42, 277n; pl. 41

Pewter An alloy of **lead** and **tin** most familiar as tableware but, in fact, not uncommon in sculpture, although such sculpture is often described simply as of lead.

Pick A tool consisting of a curved iron bar with a chisel edge at one end and a point at the other, handled as an axe and used to quarry, mine and break stones and also to shape them in the most basic way: 88

Pickling Metal founders' term for soaking newly cast metal in dilute acid to clean it or to achieve an artificial **patina**. **Bronze**, when newly cast, is inevitably discoloured by black copper oxides which are removed by pickling.

Piece mould Mould assembled out of separate pieces – like a three-dimensional jigsaw – generally of plaster but also of **clay**: 183, 188, 197–9, 224, 246

Pied de biche Literally, deer's foot. French for a **claw** chisel with two long points: 84; see also *Calcagnolo*.

Piecing The joining of parts to form a whole sculpture, usually the joining of projecting extremities or accessories, especially in marble sculpture: 76–9, 119, 277n; pls 72, 117–18, 119a and b, 215–16

Pietra bigia Dark grey **sandstone** from Fiesole: 53, 119–20, 280n; see also *Pietra serena*.

Pietra dura Plural *Pietre dure*. Italian for **hardstone** used for ornamental work, especially inlay of a pictorial character which was a speciality of the Grand ducal workshops in Florence from the sixteenth to nineteenth century. The inlay of coloured stone in the white marble of gothic architecture such as the bell-tower of Florence (p. 52) is a precedent for work of this type and the inlay in Mughal architecture a striking parallel to it (p. 50).

Pietra forte The sandy **limestone** quarried in or near Florence and much used for building there and occasionally also used for sculpture: 53; pl. 81

Pietra Serena The very fine, grey **sandstone** from Fiesole near Florence much used for architectural elements (columns, architraves, balustrades etc.) and for sculpture in that city: 53, 56, 119–20, 280n; pl. 110

Pine Evergreen tree of the genus *Pinus*, the relatively cheap and soft wood of which was used for carved, gilded and painted furniture of sculptural character in Britain and elsewhere in Europe (including Italy), especially in the eighteenth century: 130, 135; pls 124a and b

Pipe clay Very pure secondary clay excellent for casting but insufficiently **plastic** for modelling: 176

Pitcher A hard **chisel** used for the preliminary blocking-out of stone. A pitching hammer is one that is used directly on the stone face

Planishing Hammering with overlapping blows producing small indentations on the surface of soft metal, especially silver, when forming it by **raising, sinking** or **embossing**

Plaster of Paris 194–9; see also **Gesso**

Plastic That which is modelled, or can be modelled. Distinguished from **glyptic**: 70

Plug An insertion, generally cylindrical in shape, which, when applied to metal sculpture, refers to an insert of the same or similar alloy as the sculpture. Such an insert is often threaded, screwed into a drilled hole (for example where there has been a flaw), and then sawn off and filed down

Point A pointed **chisel** used chiefly for the rough dressing of stone. Hammered vertically and with force at the stone face, it not only punctures the surface but causes a rough circle of stone to burst off around this puncture. Handled softly it can gradually reduce the surface, giving it an overall crumbly or pulverized appearance. A fine punch can also be driven into the

stone as a defining hole. In addition, the point can be used obliquely to score the stone in long jagged lines – a popular form of handling with Florentine masons (as the very paving stones of Florence testify): 88

Pointing machine A device for transferring measurements from a three-dimensional model to a block of stone (or to another model). At its most elementary a cage is constructed around the model, corresponding in its dimensions to the block. Measurements are then taken from the top and sides to various key salients, the block being cut down in accordance, generally by the sculptor's assistant, or even by machine. Pointing machines are essential for any carved sculpture with a complex form which is based on a **plastic** model. They were used by Greek and Roman sculptors and reinvented in the fifteenth century in Italy. Sophisticated developments were devised in the eighteenth and nineteenth centuries which included pantographic devices whereby measurements could be taken from a small model and scaled up. Together with the complex **piece mould**, the pointing machine has done much to distinguish European sculpture from that made anywhere else in the world

Polvaccio White-statuary-marble quarry in the Apuan Alps near Carrara: 52, 54

Poplar Tree of the genus *Populus*, the relatively cheap and soft wood of which was used for sculpture, especially in Italy: 130

Porcelain Ceramic in which felspathic **quartz** and sericite rocks and the purest **kaolin** is fired so that the whole is fused into a hard and translucent white body: 4, 178–88, 269, 284–5n; pls 162–8

Porphyry A hard **igneous rock**, originally confined to the material now distinguished as 'Imperial' porphyry which is deep red or purple with specks of feldspar. 'Imperial' porphyry was quarried at Mons Igneus, Gebel Dokham, in Egypt, and was greatly prized by the ancient Romans and by subsequent European civilizations. For the mineralogist, porphyry now denotes many rocks of different colours including green porphyry from Greece with distinctive pale green flecks of feldspar formerly and confusingly called ancient **serpentine** by Italian masons: 3, 30–3, 93, 145, 273n; pls 29–32

Porphyritic basalt An **igneous rock** common in the Deccan traps of southern central India. Often described as **granite**: 24, 272n; pl. 23

Portasanta Italian masons' name for a vivid pink, russet and grey marble distinguished by streaks and veins crossing cloudy stains and by combinations of **breccia** and smoky patterns. It was quarried on the Greek island of Chios by the Romans (the quarries were rediscovered in 1887). The name derives from the Porta Santa of the basilica of Saint Peter's in Rome. Sometimes known as Holy Gate in English: pl. 87

Portland stone **Limestone** from Dorset, highly durable, consistent in quality, pure in colour, like **Istrian stone**, bleaching to white where exposed to the elements. Portland stone became the principal stone for grand architecture, especially of a classical character, all over Britain in the nineteenth century, when it could be transported by canal or rail. It was established in London as the material for such architecture (and also for outdoor sculpture) in the seventeenth century, in large measure by Sir Christopher Wren. The finest and most daring carving of it – as, for instance, the florid trophies and rich Corinthian capitals of Hampton Court Palace and Saint Paul's Cathedral belong to the late seventeenth century. Its extensive use was conditional on improvements in steel tools: 189

Potato Founders' term for nodules of metal on the surface of a cast where the metal has escaped into a fault in the mould, or into hollows caused by air bubbles in a plaster **investment**

Praticien French for a skilled marble carver, assistant to a sculptor. Increasingly in nineteenth-century Europe and North America, sculptors confined themselves to modelling and the *praticiens* transferred the design to marble using **pointing machines**. The majority of them were Italian: 58

Press moulding A method of casting, especially of **clay** in which the material is pressed, by hand, or with a spatula or other tool, into a mould: 178, 188, 283n

Princess-tree Tree of the genus *Paulownia* used for sculpture in China: 138, 281n

Proconnesos Site of marble quarries on the island of **Marmara** in the Sea of Marmara between the Bosphoros and the Dardanelles. The quarries yielded both a slightly blue-grey white marble with large crystals and a white marble with large crystals and grey-blue streaks. The quarries, which are still worked today on a limited scale, were much used by the Romans and extensively in the Byzantine Empire: 44, 51, 112, 274n; pls 45, 49, 75

Pumice A light, porous and easily powdered **igneous rock**, formed from the foam of lava. As a powder it is much used as a polish for **marble** sculpture: 38

Punch A tool hammered at right angles into a hard surface (e.g., metal or wood) or pressed by hand into a soft surface (e.g., of **clay** or **wax**). A punch can be annular or bird's eye or can be decorated with a star or other such design. Some punches can be described as **chasing** tools: 26, 220, 260

Purbeck 'marble' A dark densely fossiliferous **limestone** from the Isle of Purbeck in Dorset, much used in medieval cathedrals in England and in some in Normandy for column shafts, tomb slabs and some ornamental purposes. 112–14, 119, 279n; pls 93, 102

Quartz Mineral form of silica. It is valued when tinted rose or smoky grey or when transparent (when it is known as **rock crystal**): 14, 16, 106, 188

Quartzite Metamorphosed **sandstone** of extreme hardness, beige or brown in colour, sometimes streaked, used by the ancient Egyptians for monumental and colossal sculpture: 21

Raising The shaping of **silver** or other malleable metal by hammering it around a domed model generally of pitch, to extend it from a sheet to a hollow form. 260, 292n

Rasp A toothed metal (now generally a **steel**) file used for shaping and smoothing plaster, wood, **ivory**, stone etc. A rasp is usually perforated so that the particles of waste do not clog it. See also **riffler**. A rasp generally leaves a scratchy surface which can be smoothed by abrasives: 81, 91; pl. 82

Ravaccione Slightly grey statuary **marble** from Monte Sagro, west of Carrara in the Apuan Alps, which was marketed in the early nineteenth century (and perhaps before) with the claim (which is justified) that it was especially durable and suitable for exterior use, even in northern Europe. For some unknown reason it is sometimes known in Britain as Sicilian marble: 58

Release agent See **Parting agent**

Repair French *réparation*. The cleaning, trimming and correction of cast clay or ceramic figures (or other objects) preparatory to firing, especially when these have been **piece moulded**. See also **Fettling** and **Tow**. The term is applied also to the process of assembling complete figures from separately cast components. And

it can be used for the tooling of **whiting** on wood carving preparatory to **water gilding**

Repoussé The working of metal in relief by hammering and punching chiefly from behind: 257–67, 292n, 293n; pls 221–8; see also **Embossing**

Resin Substance secreted by plants, and in large quantities by some trees, now distinguished as 'natural resin' on account of synthetic compounds with similar characteristics: 125, 143; pl. 113; see also **Turpentine** and **Lacquer**

Rhinoceros horn 153, 283n; pl. 138; see also **Horn**

Riffler A fine, small, usually double-edged and frequently curved **rasp**: 157

Riser A channel that permits gases and air to escape from a mould into which molten metal is poured. The metal itself will follow into the channel. The channel is made by attaching a wax rod to the wax image prior to **investment** in the **lost-wax** method of casting. See also **Sprue** and **Runner**. Although invariably used in modern lost-wax casting in Europe, risers are not always employed elsewhere, and the gas can escape through the porous walls of an **earthenware** mould: 221, 228

Rivet A metal peg or staple, usually round in section, passed or driven through two metal surfaces, or through one metal surface and a **tenon** lodged beside or within that surface, to fix them together. When in place, both ends (or the headless end) of the rivet are beaten or pressed down. Rivets are used for attaching separate components of **repoussé** figures and also for attaching cast components of **bronze** or other copper alloys to each other by **roman joints**: 263

Rock crystal Clear **quartz** used for ornamental vessels and some figurative sculpture, also for eyes or parts of eyes in sculpture of wood, bronze or stone, or for the *urna* or spot of sanctity on the Buddha's forehead: 1, 3, 14, 16, 21, 138, 261, 293n; pl. 12

Roman joint A joint consisting of a tapering **tenon** fixed with a locking pin or **rivet**. The pin is designed to be detachable in the case of some plaster casts, to facilitate disassembly for storage and convenience in transport. The rivet is intended to be permanent and is favoured for **bronze** sculpture assembled out of separately cast units

Rosewood Exotic hardwood used for **veneers** in cabinet-making and in China for furniture and table ornaments: 148, 252

Rosso antico Italian masons' name for a deep, slightly tawny, red 'marble' with occasional white streaks, quarried by the ancient Romans at Matapan in Greece and used for cladding, paving and sometimes sculpture, including some sculpture on a large scale: 93

Rosso di Francia Italian masons' name for the mottled russet marble of Languedoc which was exported from France in large quantities in the seventeenth century: 96

Runner A channel through which the molten metal is poured into a mould from a funnel or runner cup. The channel is made by attaching a wax rod to the wax image prior to **investment** in the **lost-wax** method of casting. When the mould is full the runners themselves fill with metal and so when the sculpture is cool they have to be sawn or filed off. Runners can, however, be incorporated into the design – the body haloes of some Indian sculpture represent a complex example of this, and a simple example is the **tang** or fixing prong emerging from the base or feet of a statuette: 221, 228; pl. 195

Salzburg marble Red mottled limestone similar to **Hungarian marble**, but generally darker and with white streaks: 279n

Samrit Alloy involving precious metals as well as **copper**, reputedly traditional in south-east Asia: 233, 290n

San cai Chinese term for a three-colour glaze freely applied and often intermingling on **earthenware** sculpture and vessels. The glazes are all **lead glazes** and the colours are orange, green and straw or cream: 172; pls 157, 158

Sand casting Casting of metal in which the mould – equivalent to the **investment** in **lost-wax casting** – is a type of **piece mould** made out of very fine and highly compacted sand. Only relatively simple forms can be cast in this way, and sculpture of complex form has to be pieced. The method was favoured for casting medals in the Renaissance and then for casting ornament of a kind that it was desirable to repeat and eventually (chiefly in the nineteenth century) for the creation of bronze sculpture in edition. Sand casting is closely associated with French foundries, and the best sand for this purpose was that of the River Seine: 254, 292n

Sandstone A **sedimentary rock** composed of particles of grit or sand with a high silica content bound in a natural cement. Many sandstones are soft and

easily eroded, but some, such as the Yorkshire grit-stones or the many sandstones of India, are exceedingly hard and durable. Sandstone is generally more difficult to carve than **limestone**, for the particles wear down the metal of the **chisel**. Some sandstone can be polished: 23, 40, 105–11, 114, 189, 278–80nn, 285n; pls 96–100, 110

Sapwood See **Heartwood**.

Sardonyx A semi-precious **hardstone**, a type of **quartz**, translucent, banded red, orange and white; frequently confused with **onyx** and commonly used for **cameos**: 16–18, 30, 98, 216, 271n

Satinato See **Semi-matt**.

Schist A **metamorphic rock** of foliate character and dark silvery grey colour, sometimes tending to blue or green. Used for the great school of Buddhist sculpture in Gandhāra: 4, 103–5, 278–9nn; pl. 94

Sedimentary rock Rock formed by the deposit of eroded **igneous rock**, often in strata or **beds**. See **Limestone** and **Sandstone**.

Semi-matt A finish in gilding which is often achieved by giving a polish to the bole or other surface that is to receive the **gold leaf**, known in Italian as *satinato*.

Seravezza Quarry town on the Tuscan side of the Apuan alps, the source of white marble, but also of *breccia* and *mischio*: 57, 95, 276n, 278n; pl. 88

Serpentine A **metamorphic rock** consisting largely of hydrated magnesium silicate, usually green and sometimes with reptilian spots or mottling. It takes a polish and is often classed as marble. Green Greek **porphyry** (quarried by the ancient Romans near Sparta) was in the Renaissance described as antique serpentine: 93, 111

Sèvres The Royal French **porcelain** factory near Paris, noted for its **soft-paste porcelain**. Statuettes in **biscuit porcelain** of superlative quality were produced there: 186–8, 194, 285n; pl. 168

Sgraffito Technique of decoration or design involving scratching through one surface to reveal another, as when **water gilding** is covered with a layer of paint which is then removed to reveal the burnished gold beneath. Also used for techniques of revealing the ceramic body beneath a **glaze**: 133

Shakudo Alloy of **copper** and **gold** used in Japan: 232

Shell cameo 18–19, 272n; pl. 17; see also **Cameo**.

Shellac Lac (the resinous secretion of insects found on trees in south east Asia) in the form of flakes (resembling thin shells – hence 'shellac'), used for a common type of varnish naturally golden and translucent which darkens with age. This frequently serves as a coating (often toned) for bronzes, plaster casts and wood: 198

Shibuichi Alloy of **copper** and **silver** used in Japan: 232

Shim The thin fencing or divider used to separate the elements of a **piece mould**, generally made of **brass** or some other non-ferrous metal.

Siltstone A type of **schist**, dark grey and brown in colour. Used for sculpture in Bihār: 105, 279n; pl. 95

Silver A precious metal much used for both **embossed** and cast sculpture – but the largest figures of silver far more commonly embossed than cast. Silver is used also as an inlay, often worked as wire or foil – and as thin leaf: 2, 225, 228, 257, 261, 290n, 292–3nn; pls 200, 201, 202, 223

Silver leaf Silver 'to airy thinness beat'. Applied in the same manner as **gold leaf**. Silver leaf tarnishes easily and the surfaces to which it has been applied are now generally black. It was often coated with a varnish to form a pale gold colour, and this effect has sometimes survived: 281n; pl. 117

Sinking The shaping of **silver** or other malleable metal by hammering it into a depression.

Slate A **metamorphic rock** of foliate character, most commonly used for roofing but also sometimes for sculpture – for example, near Genoa in Italy. Black slate can be polished to resemble **black marble**. Slate is also often used as the bed for marble inlay: 105

Slip A liquid **clay**, often a very pure or primary clay or **kaolin**, used to coat **earthenware** before firing or afterwards, and also sometimes as **whiting** on wooden sculpture. Used also as a material for casting (see **Slip casting**): 169, 172, 188, 194, 196, 284n; pls 155–6, 186

Slip casting Casting method in which clay **slip** is poured into a **gypsum plaster piece mould** which absorbs the moisture and facilitates the drying. Introduced into many European **porcelain** factories in the eighteenth century and common in the nineteenth century for the casting of **terracotta** sculpture: 188, 196, 283n, 285n

Slush casting A method of hollow casting in which a molten substance is hardened against the walls of cold mould, generally with the aim of making a cast with very thin walls (or 'light font'). The mould is rotated or rolled about to ensure that all interstices are reached and the walls are more or less even. Excess molten material is often poured out. **Lead** and **tin** soldiers were made in this way, also chocolate eggs and animals. The **indirect cast** wax model in **lost-wax casting** is cast in this way in a **gesso** mould which has been made wet first. **Gesso** or **gypsum plaster** can itself be cast in this way (although light-weight plaster casts usually seem to date from the last century). **Slip casting** is a variant on slush casting.

Snakewood Slightly ruddy gold exotic hardwood with distinctive streaks, known also as letterwood and leopardwood, from Guyana and Honduras: 151; pl. 137

Soapstone See **Steatite**.

Soft-paste porcelain Imitation of true **porcelain**, less vitreous in character and not as translucent. It was based on complex recipes not always involving any natural **clay**. The earliest was made at the Medici factory in Florence between 1575 and 1587: 186, 285n; pl. 168; see also **biscuit porcelain**.

Solder To solder is to join or to reinforce one metal using another metal (or, more commonly, an alloy of the same metal) with a lower melting point, this metal used being known as a solder: 257; pls 204, 224

Solnhofen stone Exceptionally fine limestone which was used for miniature carvings and for precise models for casting in Germany especially in the fifteenth and sixteenth century, often and erroneously identified as **honestone**: 288n

Spatula Small tool, with a flat blade, often slightly flexible, commonly made of metal, hardwood or **horn**, used for working with soft materials such as **wax** or **clay**: 212

Spelter See **Zinc**

Sponda White-statuary-marble quarry in the Apuan Alps near **Carrara** opened in the fourteenth century: 52

Sprue A channel that enables both molten metal to enter a mould and air and gas to escape from it during the process of **lost-wax casting**. The word is used for the wax rods attached to the wax model that form these channels, and also for the projections formed by the metal which fills up the channels when the mould itself is full. Sprue is used as a verb by foundrymen in North America, meaning to form and fit the wax rods: 228

Stearin Ester of glycerol and stearic acid used for candles and as a modelling material, often supplementing bee's **wax**: 216

Steatite Known also as talc and **soapstone**. Hydrous magnesium silicate in compact form. The material is used in China for small figurative sculpture similar to work in **jade**, and in Byzantium it was used for sculpture similar to work in **ivory**, whilst in India whole temples with highly ornate carving have been carved out of it: 12

Steel An alloy of **iron** and carbon capable of being tempered to many different degrees of hardness: 26, 33

Stein guss Literally, cast stone. A material used in Germany for sculpture in the fifteenth century. It seems, in fact, to be **gypsum plaster**: 195–6, 286n

Stele A block or slab of stone generally decorated with relief sculpture on one face: 105, 279n

Stoneware A hard, non-porous, high-fired **clay** which has partially vitrified. It is intermediary in character between **earthenware** and **porcelain**: 201; pl. 179

Stucco The finest and whitest European hard plaster used for modelling and moulding. It is made by combining **lime** (often from **marble** or **travertine**) with white-marble dust and other ingredients, including sometimes wax, milk and other organic substances. Also applied to related lime compositions: 136, 176, 191–9, 214, 279n, 285–6n; pls 171–3

Stucco lustro A **stucco** that takes a polish; apparently an Italian invention. The ratio of marble dust is higher than in ordinary stucco and **gesso** is sometimes added. *Scagliola* is a close relation.

Sugar Sugar was used to form small sculptures as table ornaments (especially in Italy, but also elsewhere in Europe) in the sixteenth and seventeenth centuries. It could be cast in molten form and built up by controlled dripping, but also carved. No sculpture has survived in this form, but much is recorded in engravings, and it is perhaps reflected in small bronzes and sculptures in other materials: 183

Sulphides Sulphides (either in solution or as a paste) are among the chemicals most commonly employed to obtain an artificial black or near-black **patina** on **bronze** or other **copper** alloys. A solution of ammonium sul-

phide is a common recipe; potassium sulphide and barium sulphide are also employed: 226

Sycamore fig *Ficus sycomorus*, a species of fig tree, one of relatively few trees easily available to the ancient Egyptians. The wood was used by them for much of their sculpture: 126, 143, 280n; pls 113–15

Tang A projecting prong cast with a metal figure or tool and used to attach it to a base or handle: 220

Tenon A type of join, especially in wood but also used in stone and metals consisting of a projection, often a rectangular section, designed to be fitted into a hollow, mortice or groove of equivalent size: 70, 224, 226; pl. 114

Terracotta Literally, baked earth. The term is especially used for sculpture of **earthenware**. It is applied also to ceramic architectural ornament, of the type especially popular in Europe in the second half of the nineteenth century, much of it derived from the **artifical stone** (most notably, **Coade stone**) made in the late eighteenth century which is, in fact, a type of **stoneware**: 56, 165, 189

Thasos Northern Aegean island with white-marble quarries. Much of the marble has large glittering crystals.

Thong deng Casting alloy with a very high **copper** content, traditional in South East Asia: 290n

Tin A white, malleable metal, resistant to corrosion, much used in alloys. It is an essential ingredient in **bronze**, and **lead**, when used for sculpture, is alloyed with it: 210, 220, 222, 225, 230, 233, 242, 254, 290n

Tin glaze A development of a **lead glaze** in which tin and the silicates of potash are added to lead oxides to form an opaque and smooth white porous coating which is applied to **earthenware**, then painted with metallic oxide pigments and fixed by refiring. It is not uncommonly rendered more lustrous by an additional lead glaze: 167, 176, 178

Tombac **Brass** or similar alloy traditional in South East Asia: 290n

Tonnerre French **limestone** of a pale beige colour much favoured for sculpture in France. It was used in the Middle Ages, for example for the cathedral of Troyes, also for the sculpture at Dijon, but it continued in favour and was used in the eighteenth century by Parisian sculptors, who normally worked in marble: 114, 276n; pls 60, 104–5

Tooth chisel North American for **claw chisel**: 84

Tournai See **Black marble**

Tow Broken part of flax or hemp used as a binder in **clay** or plaster. Used also to smooth clay or ceramic bodies, especially after casting and before they are fired: 196, 204

Tracer A **chasing** tool. See *Ciselet*.

Travertine A **limestone** formed by the direct precipitation of the calcium carbonate in spring water upon exposure to the air. It is characterised by irregular spongy hollows. Large quantities are found in the Tiber valley near Rome where it has been especially favoured for architecture and for some forms of outdoor sculpture. Exported from Italy in great quantities in recent decades as a cladding material that can endure the company of concrete and vinyl: 96, 114, 120–1, 280n; pls 85, 109

Trussel The upper or hammer **die** used for the striking of coins: 267

Turpentine **Resin** secreted by several types of coniferous tree, distilled into a volatile pungent oil: 215

Veneer The thin slice of a material – often a valuable material – applied, generally with a glue or cement, but also (and sometimes only) with pins, to a carcasss or surface of a humbler material. **Ebony**, **rosewood**, tulipwood and other exotic woods are more often used as veneers in cabinet-making than they are used 'in the solid'. **Copper**, **pewter**, **brass**, tortoiseshell, mother of pearl and **ivory** can also be used and are often combined with such woods. Semi-precious **hardstones** such as **lapis lazuli** also used for inlay are sometimes employed as a veneer, as are the more splendid types of **calcite 'alabaster'**. Veneering is more easily achieved on a flat surface, but thin slices of wood can be bent, for example into the hollow of a moulding. Stone cannot be bent, so its veneering on curved or complex forms is particularly difficult: 96, 148, 252; pls 85, 89, 90

Verde antico Roman masons' name for the grey, green and white **serpentine** *breccia* quarried by the ancient Romans at Thessaly in northern Greece: 96; pl. 89

Verde di Prato Dark green, mottled **serpentine** from Monte Ferrato near Prato in Tuscany used from the fourteenth century as an inlay with white marble

in the ecclesiastical architecture of Florence. Much exported in the second half of the nineteenth century when favoured all over Europe for socles and pedestals, especially for bronzes: 51

Vermilion Brilliant red to orange pigment made by grinding cinnabar. Used as a colouring in **wax** and **lacquer** as well as for a paint: 216

Verona marble A **limestone** that takes a polish and ranges in colour from a deep orange pink to pale cream, always with a mottled pattern (sometimes only vestigial). It is quarried in the Adige Valley between Verona and Trent and much employed in the Veneto and also commonly in Lombardy. Since the last century it has been exported all over the world: 112, 114, 279n; pl. 101

Walnut Tree of the genus *Juglans*, the hard and richly coloured (and often beautifully figured) wood of which is much valued for the making of furniture, especially in the Mediterranean (wood carvers still sigh when they recall the walnut of Ancona). Carving in walnut is often **oil gilt** in parts: 129–30, 150, 281n; pls 119a and b

Waste mould A **piece mould** that is designed so that work may be cast from it but not so that the model from which it is made (generally a clay or wax model) is preserved. It is, consequently, simpler in design than most piece moulds. The model is scraped (or, if of plaster, chipped) out. Confusingly, the term is sometimes used for a mould that is itself destroyed in the making of a cast, as in the **investment** used in **lost wax** casting.

Water gilding The application of **gold leaf** to wet **bole** on a preparation of **whiting**. The gold is then **burnished**: 133–5, 281n; pls 124a and b, 125a and b

Wax Malleable yellowish substance secreted by bees to form the cells of a honeycomb. Wax, when bleached and purified, forms a base for candles and polishes and a material used for casting or modelling, generally over an **armature**. Synthetic waxes are also available: 5, 16, 70, 129, 191, 196, 215–18, 226, 247, 270, 288n, 292n; pls 190–3; see also **Paraffin**

Webbed The retention of a supporting membrane of stone between fingers, or similar fine extremities, especially in marble or stone sculpture: 105

Whiting The preparatory layer of white mineral and animal glue used to cover stone, wood and **earthenware** preparatory to painting and gilding. Whiting is often loosely described as **gesso**, and fine **gypsum plaster** is often employed, but so, too, is fine **chalk** and white **slip** – the slip sometimes without a glue: 132–5, 138, 194, 284n

Yew Evergreen coniferous tree of the genus *Taxus*, the wood of which has sometimes been used sculpture, notably in ancient Egypt: 144

Yosegi zukuri Japanese technique of sculpture in Cypress wood in which figures are composed out of parts that have been split and hollowed and reunited, creating light forms of great stability: 139

Zandobio White – and slightly grey-and-rose – marble quarried in the Alps near Bergamo. The marble is, in fact, a cryptocrystalline dolomitic limestone: 53; pl. 51

Zinc A white metal, essential to **brass**, sometimes also alloyed with **silver**, but also much used for cast sculpture in the nineteenth century, often under the commerical name **spelter**, with an varnish intended to resemble the colours of **bronze**: 221, 254, 288n, 292n

Index of People and of Places

Photograph Credits